FERGUSON

CAREER COACH

MANAGING YOUR CAREER IN THE

Art
Industry

The Ferguson Career Coach Series

FERGUSON

CAREER COACH

MANAGING YOUR CAREER IN THE

Art
Industry

Shelly Field

Ferguson
An imprint of Infobase Publishing

Ferguson Career Coach: Managing Your Career in the Art Industry

Ferguson
An imprint of Infobase Publishing, Inc.
132 West 31st Street
New York NY 10001

Library of Congress Cataloging-in-Publication Data

Field, Shelly.
 Ferguson career coach : managing your career in the art industry / Shelly Field. — 1st ed.
 p. cm. — (Ferguson career coach)
 Includes bibliographical references and index.
 ISBN-13: 978-0-8160-5356-8 (hardcover : alk. paper)
 ISBN-10: 0-8160-5356-1 (hardcover : alk. paper)
 1. Art—Vocational guidance—United States. 2. Career development—United States. I. Title.
II. Title: Managing your career in the art industry.
 N6505.F54 2009
 702.3'73—dc22
 2008038015

Ferguson books are available at special discounts when purchased in bulk quantities for businesses, associations, institutions, or sales promotions. Please call our Special Sales Department in New York at (212) 967-8800 or (800) 322-8755.

You can find Ferguson on the World Wide Web at http://www.fergpubco.com

Text design by Kerry Casey
Cover design by Takeshi Takahashi

Printed in the United States of America

VB Hermitage 10 9 8 7 6 5 4 3 2 1

This book is printed on acid-free paper and contains 30 percent postconsumer recycled content.

Disclaimer: The examples and practices described in this book are based on the author's experience as a professional career coach. No guarantee of success for individuals who follow them is stated or implied. Readers should bear in mind that techniques described might be inappropriate in some professional settings, and that changes in industry trends, practices, and technology may affect the activities discussed here. The author and publisher bear no responsibility for the outcome of any reader's use of the information and advice provided herein.

CONTENTS

1

INTRODUCING YOUR CAREER COACH

Have you decided that you want a career in some aspect of the art industry? Great! You've just chosen to work in an industry that impacts all of us in some manner.

Art surrounds us and makes our world a more beautiful place. Maybe it's a painting on the wall, a sculpture, or a creative photograph. Possibly it's the design of a piece of clothing or the fabric on a living room couch. Perhaps it's the design on your dinner plates, the design of your silverware, or some pretty gift wrap. Maybe it's some jewelry, a graphically pleasing magazine advertisement, or even the way flowers are arranged. The importance of art in our day-to-day life is clear. Without it, our world would not be the one we know today.

When you think of a career in art, what professions come to mind? Many first think of fine artists like painters, sculptors, and illustrators. And while fine artists are prominent in the field, the industry encompasses a wide variety of career options, both in the creative segment of the industry as well as on the business side.

Options are available for fine artists, commercial artists, multimedia artists and animators, graphic artists, designers, and craftspeople, among others. There are food stylists, teachers, writers, photographers, and the list goes on.

There are also opportunities for curators, exhibit designers, exhibit developers, educators, conservationists, and more. The business side of the industry offers a wide array of options, including agents, publicists, managers, and more. Some choose to work in galleries, while others work in museums. Some work in schools, while others work in art shops and crafts stores. Many take part in crafts shows and arts shows. Some work for television shows or magazines or a variety of corporate businesses. Others are self-employed. The option is yours.

Whether you've just decided that you want to work in some aspect of the art industry, it's been your dream for some time, or you already work in the industry and you want to move up the career ladder, this book can help you make your dreams come to fruition.

This book can help you achieve success, whether you want a career as a fine artist, graphic artist, craftsperson, or any type of designer; you want to work in a museum, a gallery, or part of the corporate world; or you want a career showcasing your work in art shows, craft shows, museums, galleries, or stores.

This book can also be your guide to success if you want a career in the business or administration segments of the industry, teaching, sup-

port services, or any of the peripherals of the art industry.

One of the wonderful things about a choosing a career in art is that there are so many diverse opportunities. Some parts of the industry are easier to enter. Some are more competitive. Can you make it? Can you succeed?

I'm betting you can, and if you let me, I want to help you get where you want to be. What makes me such an expert?

I have been where you are, perhaps not in your specific career choice, but that doesn't matter. I know what it's like to want to have the career of your dreams so badly you can almost taste it. I know what it's like to want to experience success. And I know what it's like to have a dream.

It doesn't matter if your dream is exactly like my dream or my dream is like yours. It doesn't even really matter exactly what you want to do. What matters is that if you have a dream—whatever it is—you can find a way to attain it.

Like many others, growing up I had a number of dreams of what I wanted to do. In second grade I had an art teacher who came in the first day of school and told us how she designed and made all her own clothes. From that moment on, I wanted to be a clothing designer. As time went on, of course, I had other dreams. As soon as I realized there was a music business, I wanted a career in that too. When I heard a comedian on television and realized that you could actually *get paid* to be funny, I wanted to do that too. There were also a variety of other dreams I'll tell you about as we go on, not because the book is about me but because sometimes hearing about the dreams of others can often help you attain yours. Throughout the book, I'll also share some of my stories of my successes in hopes that they inspire and motivate you as well as giving you some ideas to help you succeed yourself. I'll also share some of my failures so you can see that just because something doesn't work out perfectly, doesn't mean your career is over.

Over the years, I have designed and sold clothing, accessories, toys, quilts, store window decorations, wall sculptures, and batiks, among other things. I've owned a seminar business, teaching people how to design, create, and market a variety of things from designer jeans and lingerie to crafts. I've also owned a business promoting both craft shows and art shows throughout the country.

I was lucky. Both my mother and father were creative. As a child, I remember my parents building a full-size puppet theater and crafting a large set of papier-mâché puppets so everyone in my elementary school could put on puppet shows. When she had time, my mother created unique household items. My father was a talented, award-winning wood carver.

When my parents were first married, they, like other young couples, needed extra cash. One night they were sitting around discussing what type of birth announcements they would use when my older sister was born. After looking around, they discovered there was nothing that really caught their eye.

Seeing a need, they decided to start a silkscreen business, designing inventive and imaginative birth announcements. Excited about the prospect of a new, fun business, they quickly designed samples. Using a combination of phone and direct mail marketing, they tried to sell their creative announcements.

The good news was they were very lucky. Within a very short amount of time, they had tons of orders, many from some of the largest department stores in the country. The bad

news was that their success was also their failure. They got so many orders that they couldn't physically fulfill them.

They couldn't continue their business, and it folded. They took with them the knowledge that they could successfully start a business and the understanding that they needed to be prepared for success because success can happen at any time. This was an important lesson for them— and later for me—and now for you.

After hearing my second grade art teacher tell us how she made everything she wore, it wasn't surprising that I decided to start designing too—for my dolls. Not knowing anything about how clothing was put together, I used what I had on hand, which at the time were socks. My dolls were all dressed to the T in perfectly fitting "sock dresses" of different patterns and colors. These doll dress designs were the predecessors of the sweater knit dresses I designed and created for adults when I was older.

When I was in junior high, my mom bought a sewing machine to mend things, and I decided to teach myself to sew. Although my mother never sewed clothes herself, she always encouraged me. I took every opportunity to find anyone I could to teach me what they knew, not only about sewing but designing. My father knew a man whose wife was an expert seamstress and asked her if she would give me some pointers. She taught me how adding even a small detail and using a bit of creativity could result in designs no one else had created. My mom called a local dressmaker and asked her if she would

give me some other tips. I loved sewing, and as a young teen I realized that making my own clothes was a great way to get all the clothes I wanted. I also realized that if I made them, I could have things that were *different* from everyone else.

Before long, other people were asking about the clothes I was wearing and wanted them too. It wasn't only the kids I was going to school with who wanted my designs. It was their moms as well. First, the mother of one of the girls I went to school with asked me to make her (the mom) a similar tunic to the one I was wearing. Next she wanted a couple of the sweater dresses she had seen me wear. Then a doctor asked me to make his daughters vests like the ones I had made for myself. As any young teen would be, I was flattered.

The problem was, while everyone said they would pay me, I didn't know how to charge for my services. I was afraid my price would be too high. I ended up just charging for the materials. After making a number of things for other people, I stopped sewing for others because I just couldn't figure out how to charge for my time and started feeling undervalued.

By the time I entered high school, however, I realized I could actually make money by creating things. I wasn't yet old enough to get a real job, and I was positive I could earn more money making things than I could babysitting.

I was reading a fashion magazine one day and saw a picture of some male and female models in an advertisement wearing some really different multicolored knitted and woven belts. I hadn't seen any of those around my area and figured, "Hmmm—this might be a good idea." I went to a local discount store, bought some yarn, and a set of knitting needles and told my parents I was going into business.

I came up with a unique design and started knitting the first belt. By the next day I had it almost completed and brought it to school to finish it in homeroom. One of the girls sitting next to me started poking fun at me. "It's not cool to knit," I remember her saying. "Don't you have anything better to do with your time?"

Before I had a chance to answer, one of the guys sitting on the other side of me said, "Hey, that's cool. Do you know where I can get one?"

"You can buy this one as soon as I finish it," I said.

"Do you have more of them?" another guy asked. "I want one too."

"Me too," said one of the girls sitting a couple rows back.

By the time homeroom was over," I had five orders.

I remembered a candy store in Atlantic City making candy in front of everyone and it seemed to increase their sales, so I figured it might work for me too. I decided the best way to build up my new business was to knit the belts in school. While it didn't make my teachers happy, I had a photographic memory and could remember everything they were saying without taking notes, so I knit away.

Business was going well—so well that my best friend decided she could do the same thing. The only problem was that she decided the way to run *her business* was to try to get *my business* by selling her belts cheaper.

I learned something about business and competition. Sometimes you have to outwit your competition. You have to think outside of the box. Instead of asking my friend why she was *stealing* my idea, I smiled and came up with a plan of action to save my business. I went to a specialty store, bought a variety of more expensive unique yarns, and raised my prices, market-ing my belts as "designer" quality. I was lucky. It worked.

While I didn't sell a belt to everyone in school, I did saturate the market, sometimes even selling more than one to a customer. My friend, by the way, gave up after a week or two; according to her, the payoff wasn't worth the time and effort she was putting into it.

After a while, like all other fads, knitted belts were out. Like others who experience minor success, I hadn't thought ahead enough to realize that if I wanted to stay in business, I needed another product. So before I was even old enough to get my driver's license, I was out of business until I came up with a new product.

Fast forward. Over the next few years I finished high school, went to college, and experienced success in a number of ventures in both the talent and business end of the art and design industry, which you'll read about as the book progresses. I could have continued in that direction, climbing the career ladder, but I had other ideas. As I mentioned a moment ago, working in the art industry was not my only dream. I did have another one and I wasn't about to give it up. Although it wasn't related to art in any way, I'm going to share it with you for a number of reasons.

Why? To begin with, I want to illustrate to you that dreams can come true. I want to

★ Tip from the Coach

While pricing is a very important part of marketing a product, sometimes the price point isn't the deal breaker, especially when you are dealing with art or a creative product. You need to take everything into account when pricing your artwork.

show you how perseverance in your career (or anything else for that matter), can help you achieve your dreams and goals. Furthermore, you also might find it interesting to see how sometimes things you do in your career are stepping-stones to the career of your dreams. I also want you to know one of the reasons I do coaching, help people get the career they want, and attain success.

I've done a lot of things in my life while pursuing *my* dreams. Some worked out and some didn't. What I can say, however, is that I never will have to look back at my life and say, "I wish I had done this or that," because when I wanted to try something, I always did. My hope is that you will be able to do the same.

It's important to remember that dreams can change, but as long as you keep going toward your goals, you're on the right road.

With that in mind, here's the story of how I landed my dream career. Perhaps as you read the story, you'll relate your circumstances in some manner and grab the ray of hope you need to know that you can get what you want, no matter what it is and how difficult it seems.

For as long as I can remember, I wanted to be in the music industry, probably more than anything else in the world. I struggled to get in. Could I find anyone to help? No. Did I know anyone in the business? No. Did I live in one of the music capitals? No. The only thing I had going for me was a burning desire to be in the industry and the knowledge that I wasn't going to quit until it happened.

At the time I was trying to enter the industry, I wished there was a book to give me advice on how to move ahead, to guide me toward my goals, and give me insider tips. Unfortunately, there wasn't. I wished that I had a mentor or coach or someone who really knew what I should be doing and could tell me what it was. Unfortunately, I didn't have that either.

Did anyone ever help me? It wasn't that no one wanted to help, but most of the people in my network just didn't have a clue about the music industry. Did they know that the music industry was a multibillion dollar business? Did they know that it offered countless opportunities? It really didn't matter, because no one I knew could give me an edge on getting in anyway.

A couple of times I did run into some music industry professionals who did try to help. In one instance, a few months after I had started job hunting, I finally landed an interview at a large booking agency. I arrived for my appointment and sat waiting for the owner of the agency to meet with me. I sat and sat and sat.

A recording artist who was a client of the agency walked over to me after his meeting with the agent and asked how long I had been there. "Close to three hours," I replied. My appointment was for 1 P.M. and it was almost 4 P.M. "What are you here for?" he asked. "I want to be in the music industry," was my answer. "I want to be a tour manager."

"Someday," he said, "you'll make it and this joker [the agency owner] will want something from you and you can make *him* wait. Mark my words; it will happen." He then stuck his head inside the agency owner's door and said, "This woman has been sitting out here for hours; bring her in already." As I walked into the office, I had a glimmer of hope. It was short-lived, but it was hope just the same.

The agency owner was very nice. During our meeting he told me something to the effect of, "If he ever needed someone with my skills and talents, he would be glad to give me a call and I should keep plugging away." In other

words, thanks for coming in. I talked to you; now please leave. Don't call me; I'll call you.

He then explained in a hushed voice, "Anyway, you know how it is. Most managers don't want *girls* on the road with their acts." Not only was I being rejected because of my skills and talents, but now it was because I was a *girl*. (Because my name is Shelly, evidently many people incorrectly assumed I was male instead of female when their secretaries were setting up appointments. The good news is that this got me into a lot of places I probably wouldn't have had a chance to get into. The bad news: Once I got there, they realized I was not a man.)

I smiled, thanked the agent for meeting with me, and left wondering if I would ever get a job doing what I wanted. Was it sexual discrimination? Probably it was, but in reality the agent was just telling me the way it was at that time. He actually believed he was being nice. Was it worth complaining about? I didn't think so. I was new to the industry and I wasn't about to make waves *before* I even got in. The problem was, I just couldn't find a way to get in.

On another occasion, I met a road manager at a concert and told him about how I wanted to be a tour manager. He told me he knew how hard it was to get into the industry so he was going to help me. "Call me on Monday," he told me Saturday. I did. "I'm working on it," he said. "Call me Wednesday." On Wednesday he said, "Call me Friday." This went on for a couple of weeks before I realized that while he was trying to be nice, he really wasn't going to do anything for me.

I decided that if I were ever lucky enough to break into the music industry, I would help as many people who ever wanted a job doing *anything* to fulfill their dream as I possibly could. I wasn't sure when I'd make it, but I knew I would get there eventually.

While, like many others, I dreamed about standing on a stage in front of thousands of adoring fans, singing my number one song, in reality, I knew that was not where my real talent was. I knew, though, that I did have the talent to make it in the business end of the industry.

I did all the traditional things to try to get a job. I sent my resume, I searched out employment agencies that specialized in the music industry, I made cold calls, and I read the classifieds.

And guess what? I still couldn't land a job. Imagine that? A college degree and a burning desire still couldn't get me the job I wanted. I had some offers, but the problem was they weren't offers to work in the music industry. I had offers for jobs as a social worker, a newspaper reporter, a teacher, and a number of other positions I have since forgotten. Were any of these jobs I wanted? No! I wanted to work in the music business, period. End of story.

As many of you might experience when you share your dreams, I had people telling me I was pipe dreaming. "The music industry," I was told "is for *the other people*. You know, the *lucky ones*." I was also told consistently how difficult

> ⭐ ### Tip from the Top
>
> During that interview I learned two important lessons. One, use what you have to get your foot in the door. If someone thought I was a man because of my name, well, my idea was not to correct them *until* I got in the door. At least that way I could have a chance at selling myself.
>
> The second lesson is choose your battles wisely. Had I complained about sexual discrimination at the point, I might have won the battle, but I would have lost the war.

the music industry was to get into and, once in, how difficult it was to succeed. In essence, I was being told not to get my hopes up.

Want to hear the good news? I eventually did get into the music industry. I had to "think outside of the box" to get there, but the important thing was I found a way to get in. Want to hear some more good news? If I could find a way to break into the industry of my dreams and create a wonderful career, you can find a way to break into the industry of your dreams and create a wonderful career too! As a matter of fact, not only can you get in, but you can succeed.

Coming full circle, remember when I said that if I got into the music business, I would help every single person who ever wanted a job doing anything?

Well, you want to work in some aspect of the art industry and I want to help you get there. I want to help you succeed. And I want to help you live your dreams.

My career has evolved in various directions over the years. I am a career expert and have written numerous books on a wide array of career-oriented subjects. I give seminars, presentations, and workshops around the country on entering and succeeding in the career of your dreams. I'm a personal coach and stress management specialist to people in various walks of life, including celebrities, corporate executives, and people just like you who want a great career and a great life. Unfortunately, as much as I wish I could, I can't be there in person for each and every one of you.

So with that in mind, through the pages of this book, I'm going to be your personal coach, your cheerleader, and your inside source to not only finding your dream career but getting in and succeeding as well.

A Personal Coach—What's That?

The actual job title "personal coach" is relatively new, but coaches are not. Athletes and others in the sports industry have always used coaches to help improve their game and performance. Over the past few years, coaches have sprung up in many other fields.

There are those who coach people toward better fitness or nutrition; vocal coaches to help people improve their voices; acting coaches to help people with acting skills; and etiquette coaches to help people learn how to act in every situation. There are parenting coaches to help people parent better; retirement coaches to help people be successful in retirement; and time management coaches to help people better manage their time.

There are stress management coaches to help people better manage their stress; executive business coaches to help catapult people to the top; life coaches to help people attain a happier, more satisfying life; and career coaches to help people create a great career. Personal coaches often help people become more successful and satisfied in a combination of areas.

"I don't understand," you might be saying. "Exactly what does a coach do and what can he or she do for me?" Well, there are a number of things.

Basically a coach can help you find your way to success faster. He or she can help motivate you, help you find what really makes you happy, get you on track, and help you focus your energies on what you really want to do. Unlike some family members or friends, coaches aren't judgmental. You, therefore, have the ability to freely explore ideas with your coach without fear of them being rejected. Instead of accepting your self-imposed limitations, coaches encourage you to reach to your full potential and improve your performance.

Coaches are objective, and one of the important things they can do for you is to point out things that you might not see yourself. Most of all, a coach helps *you* find the best in you and then shows *you* ways to bring it out. This, in turn, will make you more successful.

As your coach, what do I hope to do for you? I want to help you find your passion and then help you go after it. If a career in some segment of art is what you want, I want to help you get in and I want you to be successful.

If your career choice is in the talent end of the industry, I'm going to help you find ways to get in and succeed.

Is your career aspiration to be a fine artist? Do you want to paint? Do you want to sculpt? Do you want to be a designer in some medium? What about a career as an interior designer? How about a theatrical set designer? Maybe you want to be a jewelry designer. Is it your passion is to be a clothing designer or a fabric designer? Perhaps you want a career as a graphic artist. Maybe you want a career as a craftsperson.

"But I don't want to be an artist" you say. "What if I want to work in another segment of the industry? What if I want to work in the business or administration segment of the industry?"

If you want to be in the business or administrative end of the industry, I'm going to help you find ways to get in too. Then we'll work on finding ways to catapult you to the top. If you're already in, we'll work on ways to help you climb the career ladder to your dream position.

Whatever your dream is, we'll work together to find a way to help you get in and achieve those goals.

Look at me as your personal cheerleader and this book as your guide. I want you to succeed

and will do as much as possible to make that happen. No matter what anyone tells you, it is possible to not only get the job of your dreams but succeed at levels higher than you dare to dream. Thousands of people have done so and now one of them can be you!

Did you ever notice that some people just seem to attract success? They seem to get all the breaks, are always at the right place at the right time, and have what you want. It's not that you're jealous, but you just want to get a piece of the pie.

"They're so lucky," you say.

Well, here's the deal. You can be that lucky too. Want to know why? While a little bit of luck is always helpful, it's not just chance. Some people work to attract success. They work to get what they want. They follow a plan, keep a positive attitude, and know that they're worthy of the prize. Others just wait for success to come, and when all you do is wait, success often just passes you by.

The good news here is you can be one of the lucky ones who attract success if you take the right steps. This book will give you some of the keys to control your destiny; it will hand you the keys to success in your career and your life.

Through the pages of this book, you'll find the answers to many of your questions about a career in art. You'll get the inside scoop on how the industry works, key employment issues, and finding opportunities.

You'll find insider tips, tricks, and techniques that have worked for others who have succeeded in the industry. You'll discover secrets to help get you get in the door and up the ladder of success, as well as the lowdown on things others wish they had known when they were first beginning their quest for success.

If you haven't attended any of my career seminars, my workshops on climbing the career ladder and succeeding in your dream career, my marketing or business workshops, my stress management seminars, or any of the other presentations I offer, you will get the benefit of being there. If you have attended one, here is the book you've been asking for!

Change Your Thinking, Change Your Life

Sometimes, the first step in getting what you want is just changing the way you think. Did you know that if you think you don't deserve something, you usually don't get it? Did you know that if you think you aren't good enough, neither will anyone else? Did you know that if you think you deserve something, you have a much better chance of getting it? Or if you think you are good enough, your confidence will shine through?

When you have confidence in yourself, you start to find ways to get what you want, and guess what? You succeed!

And while changing your thinking can change your life, this book is not just about a positive attitude. It's a book of actions you can take.

While a positive attitude is always helpful in order to succeed in whatever part of the industry you're interested in pursuing, you need to take positive actions, too.

If all it took for you to be successful was for me to tell you what you needed to do or even me doing it for you, I would. I love what I do and love my career and truly want to help everyone live their dreams too.

Here's the reality of the situation. I can only offer advice and suggestions and tell you what you need to do. You have to do the rest. Talking about what you can do or should do is fine, but without your taking action, it's difficult to get where you want to go.

This is your chance to finally get what you want. You've already taken one positive step to getting your dream career simply by picking up this book. As you read through the various sections, you'll find other actions to take that will help get you closer to the great career you deserve.

One of the things we'll talk about is creating your own personal action plan. This is a plan that can help you focus on exactly what you want and then show you the actions needed to get it.

Your personal action plan is a checklist of sorts. Done correctly, it can be one of the main keys to your career success. It will put you in the driver's seat and give you an edge over others who haven't prepared a plan themselves.

We'll also discuss putting together a number of different kinds of journals to help you be more successful in your career and life. For example, one of the problems many people experience when they're trying to get a new job, move up the career ladder, or accomplish a goal is that they often start feeling like they aren't accomplishing anything. A career journal is a handy tool to help you track exactly what you've done to accomplish your goals. Once that is in place, you know what else needs to be done.

Is This the Right Career for Me?

Unsure about exactly what segment of the art industry in which you want to become involved? As you read through the book, you'll get some ideas.

"But what if I'm already working at a job in another industry?" you ask. "Is it too late? Am I stuck there forever? Is it too late to become an artist? Is it too late to be a designer? Is it too late to have a career in the art world? Is it too late to get the job I have been dreaming about?"

> ⭐ **Tip from the Coach**
> Don't procrastinate. Every day you wait to get the career you are passionate about is another day you're not living your dream. Start today!

Here's the deal. It is never too late to change careers, and going after something you're passionate about can drastically improve the quality of your life.

Thousands of people stay in jobs because it's easier than going after what they want. You don't have to be one of them.

We all know people who are in jobs or careers that they don't love. They get up every day waiting for the work week to be over. They go through the day, waiting for it to be over. They waste their lives waiting and waiting. Is this the life you want to lead? I'm guessing you don't.

You now have the opportunity to get what you want. Are you ready to go after it? I'm hoping you are.

As we've discussed, there are countless opportunities in all aspects of the art industry. In addition to the traditional ones most people think of, there is an array of others for you to explore. No matter what your skills or talents, you can almost always find a way to parlay them into some aspect of a career in the art world, if you think creatively.

Don't be afraid to put your dreams together.

"Like what?" you ask.

Let's say you're a graphic artist and you also want to work around the music industry. You might be able to find a job working for a record label designing CD covers. You might also design creative T-shirts for recording artists or tours.

Let's say you love food and you love art and you want to work in the publishing industry. What about a career as a food stylist for a magazine?

Perhaps you are interested in forensic science and also are interested in art. You might look into a career as a forensic artist. Do you like to travel? Are you interested in a career with a museum? You might be able to find a job with a traveling museum exhibit.

Are you interested in theater? Are you enthralled with theatrical sets? What about a career as a theatrical set designer?

A Job versus a Career: What's the Difference?

What do you want in life? Would you rather just have a job or do you want a career? What's the difference? A job is just that. It's something you do to earn a living. It's a means to an end. A career, on the other hand, is a series of related jobs. It's a progressive path of achievement, a long-term journey. A career is something you build using your skills, talents, and passions.

You might have many jobs in your career. You might even follow more than one career path. The question is, what do you want?

If all you want is to go to work—day after day, week after week—just to get paid, then a job is all you need, and there is nothing wrong with that. On the other hand, if you would like to fill your life with excitement and passion while getting paid, you are a prime candidate for a great career.

How can you get that? Start planning now to get what you want. Define your goals and then start working toward them.

Not everyone starts off with a dream job. If you just sit and wait for your dream job to come to you, you could be sitting forever. What you can do, however, is to take what you have and make it work for you until you get what you want. What does that mean?

It means that you can make whatever you do better at least for the time being. The trick in this whole process is finding ways to give the job you have some meaning. Find a way to get some passion from what you're doing. If you get that mindset, you'll never have a bad job. Focus on your ultimate career goal and then look at each job as a benchmark along the way to what you want.

How to Use This Book to Help You Succeed in the Art Industry

Ideally, I would love for you to read this book from beginning to end, but I know from experience that that's probably not the way it's going to happen. You might browse the contents and look for something that can help you *now*, you might see a subject that catches your eye, or you might be looking for an area of the book that solves a particular problem.

For this reason, as you read the book, you might see what appears to be some duplication of information. In this manner, I can be assured that when I suggest something that may be helpful to you in a certain area, you will get all the information you need even if you didn't read a prior section.

You should be aware that even if you're interested in a career as an artist, knowing about the business or administrative segment of the industry will be helpful to succeeding in your career. Conversely, if your career aspirations are in the business or administrative segment of the art industry, understanding the talent area of the industry is useful as well.

You might have heard the saying that knowledge is power. This is very true. The more you know about the art industry and how it works, the better your chances are of succeeding. This book is full of information to help you learn everything you need to know about the industry and how it works. I'm betting that you will refer back to information in this book long after you've attained success.

As you read through the various sections, you'll find a variety of suggestions and ideas to help you succeed. Keep in mind that every idea and suggestion might not work in every situation and for every person. The idea is to keep trying things until one of them works. Use the book as a springboard to get you started. Just because something is not written here doesn't mean it's not a good idea. Brainstorm to find solutions to barriers you might encounter in your career.

My job is to lead you on your journey to success in whatever segment of the art industry you choose. Along the way, you'll find exercises, tasks, and assignments that will help get you where you want to be faster. No one is going to be standing over your shoulder to make you do these tasks. You alone can make the decision on the amount time and work you want to put into your career. While no one can guarantee you success, what you should know is that the more you put into your career, the better your chances of having the success you probably are dreaming about.

Are you worth the time and effort? I think you are! Is a career in art worth it? If you have the passion and desire to work in this industry, it can be one of the most rewarding industries in the world in which to work. Aside from the opportunity to make a living and fulfill your dreams, you have the opportunity to impact the lives of others in a positive way.

No matter what level or capacity you're currently at in your career, this book is for you. You might not need every section or every page, but I can guarantee that there are parts of this book that can help you.

Whether you're just starting to think about a career in the art world, have been in the industry a while, or are anywhere in between, this book can help you experience more success in your career and help you have a happier, more satisfying and stress-free life.

A Sampling of What This Book Covers

This informative guide to success in the art industry is written in a friendly, easy-to-read style.

Let it be your everyday guide to success. Want to know how a segment of the industry works? Want to learn how to focus on what your really want to do? Check out the book!

Want to learn how to plan and prepare for your dream career? Do you want to focus in on job search strategies geared especially for the art industry? How about tips for making those important industry contacts? Need some ideas on how to network? How about how to create the ideal resume or cover letter? Check out the book!

Do you need to know how to develop your action plan? Do you want to get your portfolio together? Want to know what business cards can do for you and your career? Check out the book!

Want to learn how to get your foot in the door? How about checking out tried-and-true methods to get people to call you back? Do you want to learn the best way to market yourself and why it's so important? Do you want to learn how to succeed in the workplace, deal with workplace politics, keep an eye out for opportunities, and climb the career ladder? You know what you have to do: Check out the book!

Want to know how to succeed as an artist or craftsperson? What about as a graphic artist or designer? Need to know how to market your products? You got it. You need to read this book.

Do you need important contact information so you can move your career forward? Check out the listings of important organization, unions, and associations. Want some Web sites to get you started looking for a great career? Check out the appendix of the book.

While this book won't teach you how to paint a picture, create a sculpture, design a product, or run a museum, it will help you to find ways to garner success wherever your passion lies.

Anyone can apply for a job and hope they get it. Many people do just that. But I'm guessing you do not just want a job. You want a career you can be passionate about. You want a career you love. You want a career that gives you joy! Take charge of your career now and you can have all that and more.

If you dream of not only working in some aspect of art but having a successful career and don't know how to make that dream a reality, this book is for you. Have fun reading it. Know that if your heart is in it, you can achieve anything.

Now let's get started.

2

FOCUSING ON A GREAT CAREER IN ART

Focusing on What You Really Want to Do

Unless you're independently wealthy or just won the mega million dollar lottery, you, like most people, have to work. Just in case you're wondering, life is not supposed to be miserable. Neither is your job.

Life is supposed to have a purpose. That purpose is not sleeping, getting up, going to a job that you don't particularly care about, coming home, making dinner, and watching TV, only to do it all over again the next day.

In order to be happy and fulfilled, you need to enjoy life. You need to do things that give you pleasure. As a good part of your life is spent working, the trick, then, is to find a career that you love and that you're passionate about—the career of your dreams.

This is not something everyone does. Many people just fall into a career without thinking about what it will entail ahead of time. Someone may need a job, hear of an opening, answer an ad, and then go for it without thinking about the consequences of working at something for which he or she really has no passion. Once hired, it's either difficult to give up the money or just too hard to start job hunting again, or they don't know what else to do, so they stay.

They wind up with a career that is okay but one they're not really passionate about.

Then there are the other people: The ones who have jobs they love, the lucky people. You've seen them. They're the people who have the jobs and life you wish you had.

Have you noticed that the people who love their jobs are usually successful not only in their career but in other aspects of their life too? They almost seem to have an aura around them of success, happiness, and prosperity. Do you want to be one of them? Well, you can!

Finding a career that you want and love is challenging but it is possible. You are in a better position than most people. If you're reading this book, you've probably at least have zeroed in on a career path. You likely decided that you are passionate about some segment of the art industry. Now all you have to do is determine exactly what you want to do.

> ### ⭐ Tip from the Coach
> Okay is just that: It's okay. Just so you know, you don't *want* just okay; you don't *want* to settle; you *want* GREAT! That's what you deserve and that's what you should go after.

What's *your* dream career? What do you really want to do? This is an important question you need to ask yourself. Once you know the answer, you can work toward achieving your goal.

If someone asked you right now what you really wanted to do, could you answer the question? Okay, one , two, three: "What do you want to do with your life?"

If you're saying, "Uh, um, well—what I really want to do is—well, it's hard to explain," then it's time to focus in on the subject. Sometimes the easiest way to figure out what you want to do is to focus in on what you don't want.

Most people can easily answer what they don't want to do. "I don't want to be a doctor. I don't want to be a nurse. I don't want to work in a factory. I don't want to work in a store. I don't want to sell. I don't want to be a teacher. I don't want to work with numbers. I don't want to work in a job where I have to travel," and the list goes on. The problem is that just saying what you don't like or don't want to do doesn't necessarily get you what you want to do. You can, however, use this information to your advantage.

It may seem simple, but sometimes just looking at a list of what you don't like will help you see more clearly what you do like.

Sit down with a sheet of paper or fill in the Things I Dislike Doing/Things I Don't Want To Do worksheet and make a list of work-related things you don't like to do. Remember that this list is really just for you. While you can show it to someone if you want, no one else really has to see it, so try to be honest with yourself.

Here's an example to get your started. When you make your list, add in things you don't like or you want to do.

- I hate the idea of being cooped up in an office all day.
- I don't want to be bored in my job.
- I don't want to do the same thing every day.
- I hate the idea of having to work with numbers.
- I don't want to work in a big city.
- I don't want to have to do a lot of reports.
- I don't want to have to go to work early in the morning.
- I don't want to have to work evenings.
- I don't want to have to sell my own work.
- I don't want to have to travel for my job.
- I don't want a job where I have to work on a computer a lot of the time.
- I don't want to have to speak in front of large groups of people.
- I don't want to have to commute for an hour each way every day.
- I don't want to work in sales.
- I don't like doing the same thing day after day.
- I don't like being in charge.
- I don't like taking risks.
- I don't like working under constant pressure.
- I don't like being under constant deadlines.
- I don't like not having challenges.
- I don't like having a boss working right on top of me.
- I don't like someone telling me what to do every minute of the day.
- I don't like working where I don't make a difference.
- I don't like working for someone.
- I don't like working where I'm not appreciated.
- I don't like working in situations where I don't interact with a lot of people.
- I don't like working in stressful situations.

Things I Dislike Doing/Things I Don't Want to Do

We now know what you don't like. Use this list as a beginning to see what you do like. If you look closely, you'll find that many of the things you enjoy are the opposite of the things you don't want to do.

Here are some examples to get you started. You might make another list as well as using the Things I Enjoy Doing/Things I Want to Do worksheet. Remember that the reason you're writing everything down is so you can look at it, remember it, and focus in on getting exactly what you want.

◎ I hate the idea of being cooped up in an office all day.
 ▫ But I really would love to move around as part of my job. I think I would love selling my work at craft shows where I get to see new people all the time. I might like handing the marketing for a traveling art exhibition. I might like working as an interior designer where I get to go meet clients during part of the day.
◎ I don't want to be bored in my job.
 ▫ I want to be challenged. I want to do something new every day.
◎ I don't want to do the same thing every day.
 ▫ That is why I am really excited about learning how to develop art exhibits.
◎ I don't want to work in a big city.
 ▫ Maybe I can find a gallery to work in located in a tourist area or perhaps someplace where they have a large population of artists or craftspeople.
◎ I don't want to have to sell my own work.
 ▫ But I really want to be a successful artist. Perhaps I can find someone to represent me. Then I can concentrate on creating.

◎ I don't want to have to go to work early in the morning.
 ▫ That is what the great thing about a career as an artist (or craftsperson). I can set my own hours to create. I will probably have to work some early hours selling my work, but hopefully, it won't be on a constant basis.
◎ I don't want to have to commute for an hour each way every day.
 ▫ If I can't find a job close to where I live, I'm going to consider moving.
◎ I don't like being in charge.
 ▫ I don't have to be the director of a department to be successful. If I'm doing something I love, in my eyes, I will be successful.
◎ I don't like working under constant pressure.
 ▫ But I realize that we all make a lot of our own pressure. I think I'm going to take a class or seminar on dealing with stress and pressure.
◎ I don't like not having challenges.
 ▫ Whatever job I have, I will challenge myself to do better. I will push the limits. I can't wait to finish college and start my career.
◎ I don't like someone telling me what to do every minute of the day.
 ▫ Perhaps instead of looking for a job, I would be better off becoming a consultant or having my own business of some sort. I know I would still have clients telling me what to do, but I think I would be happier. I'm going to have to look into some possibilities.
◎ I don't like working where I don't make a difference.

▫ I really want to make a difference. And I really want to make a difference working in some aspect of the art industry. My dream job will be working as an art therapist with children where I know I *will* be making a difference.

◎ I hate the idea of having to work with numbers.

▫ But I really like working with people. I think I would really like a job in an art museum working with volunteers or docents.

◎ I don't want to have to do a lot of reports. The thought of it bothers me.

▫ I don't want to do reports because I'm not confident in my writing skills. Perhaps if I take some writing classes I'll begin to feel more confident.

◎ I don't want to work in a large art museum, but I want to work around art.

▫ I would really like working in a smaller gallery so I could be around beautiful art and artists.

◎ I don't like creating art myself.

▫ But I really want to work around art. Perhaps I should use my sales skills either to help artists or craftspeople sell their work or even to sell art supplies.

As you can see, once you've determined what you don't like doing, it's much easier to get ideas on what you'd like to do. It's kind of like brainstorming with yourself.

You probably know some people who don't like their job. There are tons of people in this world who don't like what they do or are dissatisfied with their career. Here's the good news. You don't have to be one of them.

★ The Inside Scoop

When I was first trying to get into the music industry, I met a young woman at a convention who was showcasing her band. "Your group is awesome," I told her after one of the showcases. "I bet someone (an agency or manager) picks you up."

"We already had a couple of bites," she said. "By the way, do you know anyone who is interested in stage clothes? I design them." She gave me a black-and-white photocopied brochure with some of her designs. "Wow, these are great too," I said. "If I run into anyone, I'll be sure to let them know about you."

The next year I attended the same convention. While walking around the trade floor, I ran into the woman. "How's the group going?" I asked her.

"The group broke up," she said.

"I'm sorry to hear that," I said.

"Don't be," She replied. "I really didn't want to do that anyway. When the group broke up, I was going to put a new one together, but it just wasn't what I wanted to do. I know being a singer in a recording group is a lot of people's dreams, but it just wasn't mine. I know it was a risk, but I had to take it. My real dream was designing clothing. I love designing. I love the music industry, and I found a way to put them together. I have a booth here. I decided to go into designing stage clothes for people in the music business full time and it's going great."

Had the woman not taken the risk, she might have had a successful career as a recording artist, but she probably wouldn't be as happy.

Things I Enjoy Doing/Things I Want to Do

You and you alone are in charge of your career. Not your mother, father, sister, brother, girlfriend, boyfriend, spouse, or best friend. Others can care, others can help, and others can offer you advice, but in essence, you need to be in control. What this means is that the path you take for your career is largely determined by the choices you make.

The fastest way to get the career you want is by making the choice to take actions now and going after it! You can have a career you love and you can have it in the area of the art industry you want. And when you're doing something that you love, you'll be on the road to not only a great career but a satisfied and fulfilled life.

The next section will discuss how to develop your career plan. This plan will be your road map to success. It will be full of actions you can take not only to get the career you want in the art industry but to succeed in it as well. Before you get too involved in the plan, however, you need to zero in on exactly what you want your career to be.

At this point you might be in a number of different employment situations. You might still be in school, planning your career; just out of school, beginning your career; or in a job that you don't really care for. You might already be in a career in some aspect of the art industry and want to either move up the career ladder or change directions within the industry.

Perhaps you always wanted to work in some segment of art or maybe you've done some research on various career areas and decided that the art industry is for you. With so many options to choose from, do you know what your dream career is?

There are hundreds of exciting career choices in the art industry and the peripheral areas no matter where your passion lies. So let's take some time to focus in for a bit on exactly what you want to do.

What's Your Dream?

I'm betting that you already have an idea of what your dream job is, and I'm sure that you have an idea of what it should be like. I'm also betting that you don't have that job yet, or if you do, you're not at the level you want to be. So what can we do to make that dream a reality?

One of the challenges many people often have in obtaining their dream job is that they just don't think they deserve it. They feel that dream jobs are something many people talk about and wish they had but just don't. Many people think that dream jobs are for the lucky ones.

Well, I'm here to tell you that you are the lucky one. You can get your dream job, a job you'll love, and it can be the art industry.

If I had a magic wand and could get you any job you wanted, what would it be? Would it be as an artist? What about a craftsperson? How about a career in a museum? What about working as some sort of designer?

Is it your dream to work as an art teacher? How about an art archivist? What about an art

appraiser? Is it your dream to be an arts administrator? What about an art therapist? Do you think you might like to be a curator in a museum? Is it your dream to be some sort of photographer?

Is your goal to work as an illustrator? How about as a graphic designer? Do you want to be an art critic? How about a courtroom sketch artist? Is it your dream to design exhibits at art museums? What about designing toys? Have you dreamed about a career as a glassblower? Do you want to be the one designing the displays you see in some of the most famous windows in New York City?

Is it your dream instead to be an artist's agent? What about an art buyer? How about working in the administrative segment of a museum? Have you always wished you could be the director of a large, prestigious art museum?

No matter what segment of the industry interests you, your dream job can be a reality if you prepare.

Not sure what you want to do? Then read on!

Determining what you really want to do is not always easy. Take some time to think about it. Throughout this process, try to be as honest with yourself as possible Otherwise you stand the chance of not going after the career you really want.

Let's get started with another writing exercise. While you might think these are a pain now, if you follow through, you will find it easier to attain your dream.

Get a pad of paper and a pen and find a place where you can get comfortable. Maybe it's your living room chair. Perhaps it's your couch or even your bed. Now all you have to do is sit down and daydream for a bit about what you wish you could be and what you wish you were doing.

"Why daydream?" you ask.

When you daydream, your thinking becomes freer. You stop thinking about what you can't do and start thinking about what you can do. What is your dream? What is your passion? What do you really want to do? Admit it now or forever hold your peace!

Many people are embarrassed to admit when they want something because if they don't get it, they fear looking stupid. They worry that people are going to talk badly about them or call them a failure. Is this what you worry about?

Do you really want to be a fine artist, but you're afraid you'll fail? Is your dream to be a sculptor, but you're not sure you'll make it? Do you want a career in one of the major art museums but aren't sure anyone else will think you're good enough to get hired? Do you want to be an art critic, but you're worried everyone will think it's a stupid idea?

First of all, don't ever let fear of failure stop you from going after something you want. While no one can guarantee you success, what I can guarantee you is that if you don't go after what you want, it is going to be very difficult to get it.

One thing you never want to do is get to the end of your life and say with regret, "I wish I had done this or I wish I had done that." Will you get each and every thing you want? While I would like to give you a definitive yes, that probably wouldn't be true.

The truth of the matter is you might not succeed at everything. But, and this is a major but, even if you fail, when you try to do something, it usually is a stepping-stone to something else. And that something else can be the turning point in your career.

"How so?" you ask. "What do you mean?"

There are often things that you do in your life and your career that, though you can't see the importance at the time, end up impacting your career in a positive way.

At one point in my life, I wanted to become a comedienne and do stand-up comedy on a professional basis. Wanting to at least give something I wanted to do a shot, I overcame my fear and for a short while, did stand-up. The reason I bring it up here is to illustrate the point that while I didn't turn into a mega star stand-up comedienne, performing comedy was certainly a major stepping-stone for me to do other things I wanted to accomplish in my career. Had I not done stand-up, I probably would never have ended up teaching stress management, becoming a motivational speaker, doing corporate training, or even coming up with ideas about doing something in those areas. I most certainly wouldn't be writing this book.

Had I been too scared to try it or not wanted to take the risk for fear I would fail, I would have missed out on important opportunities that helped shape my career. I also would have always looked back and said, "I wish I had."

I also will share my story of wholesaling my designs to a major department store. Once again, if I had been too scared to walk in the door, I might have missed out on other important opportunities.

And while your dreams are probably totally different from mine, what you need to take from the story is the concept that taking risks and pursuing your dreams can lead to wonderful things.

Let's get started. Think about things that make you happy. Think about things that make you smile. Continue to indulge your passions as you daydream. As ideas come to you, jot them down on your pad. Remember, nothing is foolish, so write down all the ideas you have for what you want to do. You're going to fine-tune them later.

Here's an example to get you started.

◎ I want to be a painter. As a matter of fact, I want my paintings to be hanging in some of the most prestigious museums in the world. Years from now, I want people to talk about my paintings, the way others now speak of the Mona Lisa.

◎ I want to be an art director. It's my dream to be an art director in one of the biggest advertising agencies in New York City.

◎ I want to be a graphic designer for a big corporation. I want to be the one

> ### Tip from the Coach
> If there is something that you want to do or something that you want to try in your career or your life, my advice is go for it. No matter what the risk, no matter how scared you are, no matter what. Your life and career will benefit more than you can imagine and you'll never look back with regrets. Even if it doesn't work out, you'll feel successful because you tried.

designing the graphics for some of the most known brands.

◎ I want to be a jewelry designer. I want to have my own boutique.

◎ I want to be an art teacher helping young people find their artistic talents. I would love to teach in a charter elementary school in my home area of Philadelphia.

◎ I want to be the director of a big art museum in New York City.

◎ I want to be the director of special events in a big museum. I think that would be fun and rewarding. I want to create noteworthy events that generate a positive buzz.

◎ I want a career as an interior designer. As a matter of fact I want to design the homes for Hollywood stars.

◎ I want to be a courtroom sketch artist, sketching the action of cases shown on television.

◎ I want to be a window designer for a store on Fifth Avenue in New York City. I want my Christmas windows to gain national acclaim.

◎ I want to coordinate the docents and other volunteers for a large art museum. I want to be part of others enjoying their visit to an art museum.

◎ I want to own a string of successful art galleries throughout the country.

◎ I want to be an art critic for a major newspaper in New York City. (Okay, I want to be an art critic for the *New York Times*!)

◎ I want to be a craftsperson traveling around from craft fair to craft fair successfully selling my work.

◎ I want to design the security for a large, prestigious art museum.

Do you need some help focusing on what you really want to do in the art industry? In order to choose just the right career, you should pinpoint your interests and what you really love doing. What are your skills? What are your personality traits? What are your interests? Fill in the following worksheet to help you zero in even more.

Focusing on the Job of Your Dreams

Finish the following sentences to help you pinpoint your interests and find the job of your dreams.

In my free time I enjoy

In my free time I enjoy going

My hobbies are

(continues)

Focusing on the Job of Your Dreams (continued)

Activities I enjoy include

When I volunteer, the types of projects I enjoy most are

When I was younger I always dreamed of being a

My skills are

My talents are

My passions are

My best personality traits include

I am great at

My current job is

Prior types of jobs have been

The subjects I liked best in school were

If I didn't have to worry about any obstacles, the three jobs I would want would be

What do I love about each of these three jobs?

What steps can I take to get one of those jobs?

⭐ The Inside Scoop

When you write down your ideas, you are giving them power. Once they are written down on paper, it makes it easier to go over them, look at them rationally, and fine-tune them.

What Is Stopping You from Getting What You Want?

Now that you have some ideas written down about what you want to do, go down the list. What has stopped you from attaining your goal?

Is it that you told people what you wanted to do, and they told you that you couldn't do it? Did they tell you it was too difficult and your chances of making it were slim?

Is it that people told you there was too much competition in the industry, and you didn't have the confidence that you could make it?

Is it that you don't have the confidence in yourself to get what you want? Or is it that you need more education or training?

Is it that you are concerned that you aren't talented enough? Or is it that you don't have the training you need?

Perhaps it's because you aren't in the location most conducive to your dream career. Perhaps you need more skills. If you can identify the obstacle, you usually can find a way to overcome it, but you need to identify the problem first.

Do you know exactly what you want to do but can't find an opening? Have you, for example, decided that you want to be the director of volunteers at an art museum, but there aren't any current openings? Are there current openings in an art museum in Seattle, but you had your heart set on a career in New York City?

Sometimes you know what type of job you want, but you just can't find a job like that. Don't give up. Keep looking. Remember, you may have to think outside of the box to get what you want, but if you're creative, you can succeed. Try to find ways to get your foot in the door, and then once it is in, don't let it out until you get what you want.

Have you interviewed for a promotion but didn't get the job you hoped for? The good news is that other promotions will be on the horizon. So will other opportunities. Don't let one disappointment stop you from going after your dreams. Keep plugging away and you will get what you want.

Have you found the perfect job and interviewed for it, but then the job wasn't offered to you? While at the time you probably felt awful about this, there is some good news. Generally when one door closes, another one opens.

Hard to believe? It may be, but if you think about it, you'll see it's true. Things generally work out for the best. If you lost what you thought was the job of your dreams, a better one is out there waiting for you. You just have to find it!

Perhaps you're just missing the skills necessary for the type of job you're seeking. This is a relatively easy thing to fix. Once you know the skills that are necessary for a specific job, if you don't have them, take steps to get them. Take classes, go to workshops, attend seminars, or become an apprentice or intern.

"But," you say. "I'm missing the education necessary for the job I want. The ad I read said

⭐ Tip from the Coach

Start training yourself to practice finding ways to turn *can'ts* in your life into *cans*.

I needed a minimum of a bachelor's degree. What can I do?"

Here's the deal. In certain cases, educational requirements may be negotiable. Just because an ad states that a job has a specific educational requirement doesn't mean you should just pass it by if your education doesn't meet the requirement. First of all, advertisements for jobs generally contain the highest hopes of the people placing the ads, not necessarily the reality of what they will settle for. Second, many organizations will accept experience in lieu of education. Lastly, if you're a good candidate in other respects, many organizations will hire you while you're finishing the required education.

Is a lack of experience what's stopping you from your dream career? Take every opportunity that presents itself to get the experience you need. Depending on what you want to do and where you live, you might need to get creative, but you can definitely find a way to do it. Volunteer when you can to get any additional experience under your belt. In addition to getting experience, volunteering is a great way to make contacts and learn the ropes of a job.

Do you need more experience as an artist, designer, or craftsperson? Practice makes perfect. Take part in competitions. Look for a mentor to help you take your career to the next level. Keep working. You would be surprised at how much better you can get at your art or craft if you just keep doing it.

Is one of the obstacles you're facing that you just aren't in the geographic location of the opportunities you're looking for? Do you, for example, want to work in a large, metropolitan art museum, yet you don't live anywhere near a large city?

There's no question that living in an area that doesn't have the opportunities you're look-ing for makes your job search more difficult. If this obstacle is what is holding you back, put some time into developing a solution and find a way to move forward. If you're not prepared to move and don't want to give up your career dreams, you might want to start your career working in a smaller museum or even a gallery, closer to where you live. After a year or two, perhaps you might be ready to move on.

Is what's holding you back that you don't have any contacts? Here's the deal. You have to find ways to make contacts. If you are just starting your career, make sure when you are going to school, taking classes or workshops, or going to seminars so that you get to know people, both your instructors and your classmates. If you're further along in your career, don't stop your education just because you've graduated from college. Continue taking classes, seminars, and workshops in subject areas related to the segment of the art industry in which you're interested.

As we just mentioned, volunteer when you can. Even if you aren't directly volunteering in the area in which you want a career, it doesn't matter. You will begin to make contacts. You'll get known in the community and people will begin to know who you are.

Make cold calls. Network, network, network, and network some more. Put yourself in situations where you can meet people in various aspects of the art industry and sooner or later you will meet them.

What else is standing between you and success? "The only thing between me and success," you say, "is a big break." Getting your big break may take time. Keep plugging away. Most of all, don't give up. Your break will come when you least expect it.

Are you just frightened about going after what you want? Are you not sure you have the talent

or the skills? Are you not sure you can make it? If you start doubting yourself, other people might do the same. As we just discussed, do not let fear stop you from doing what you want.

Most importantly, don't let anyone chip away at your dream, and whatever you do, don't let anyone burst your bubble. What does that mean?

You know how it is when you get excited about doing something and you're so excited that you just can't keep it to yourself. You might share your ideas of what you want to do with your family and friends. And while you want them to be excited too, they start trying to destroy your dream by pointing out all the possible problems you might encounter.

It's not that they're trying not to be supportive, but for some people it seems to be their nature to try to shoot other people's dreams apart.

Why? There are a number of reasons. Let's look at a few scenarios.

Scenario 1—Sometimes people are just negative. "You'll never make it," they tell you. "Do you know how many people want to be artists?"

"Well," you say. "I'm talented."

"There are a lot of talented people who never make it," they say. "Haven't you ever heard the saying *starving artist*? You don't want to be one of them, do you? Why don't you just get a real job and let your artist thing be a hobby? Be smart. Get a real job."

Scenario 2—Sometimes people are jealous. They might hate their job and be jealous that you are working towards finding a great career. They might have similar dreams to yours and be jealous that you have a plan and they don't. Some might just be jealous that you might make it before them.

Scenario 3—Sometimes people are just scared of change. In many cases friend or family are concerned about your well-being and are just scared of change. "You have a job," your girlfriend may say. "Why do you want to change careers? Why don't you think about it for a while?"

Scenario 4—Sometimes people just think you're pipe dreaming. "You're a pipe dreamer," your family may say. "What you need is a dose of reality. Just because you sold one of your pieces of work does not mean that you're going to make it big. There are thousands of people who want to work as an artist. You're just one in a million. The odds are not good."

Scenario 5—Sometimes people really think that it's unrealistic to think you should make a living doing something you love. "Nobody likes their job," a family member may tell you. "Work is just something you have to do. Find an easier job. Work your 40 hours a week and suffer like the rest of us."

Whatever the scenario, there you sit, starting to question yourself. Well, stop! Do not let anyone burst your bubble. No matter what anyone says, at least you are trying to get the career you want. At least you are following your dream.

While I can't promise you that you will definitely achieve every one of your dreams, I can promise you if that if you don't go after your dream, it will be very difficult to achieve.

Tip from the Coach

Almost everything you can wish for in life, including your career, starts with a dream. Go after yours!

What I want you to do is not listen to anyone who is negative about your dreams. Just tune them out and keep working toward what you want. No one can stop you from doing what you want, except you!

What Gives You Joy? What Makes You Happy?

Let's zero in further on what you want to do. Let's talk about what gives you joy. Let's talk about what makes you happy. Did you ever notice that when you're doing something that you love, you smile? It's probably subconscious, but you're smiling. You're happy inside. And it's not only that you're happy; you make others around you happy.

Let's think about it for a few minutes. What makes you happy? What gives you joy? Is it creating things? Is it using your talent? Is it helping others? Is it teaching others? Is it writing? Is it organizing things? Is it developing things? Is it developing a solution to a problem? Is it a combination?

Does the thought of seeing one of your paintings hanging on a wall make you smile? Are you smiling thinking about a new piece you just created? What about having someone stop by your booth at a craft show and not only admire one of your designs but buy it as well? When you close your eyes, can you see yourself as a successful artist?

Can you almost hear yourself training a group of docents on the history of an exhibit in the museum? Are you smiling as you think about seeing the words *Museum Director* and your name on a sign outside of your new office? Can you almost see the article in the paper praising you for developing a unique exhibit of new artists?

Are you smiling as you think about pulling up to your new art gallery? Can you almost imagine your heart beating as you make your first sale? Then maybe that's your dream—that is what would make you happy.

Can you see yourself as the director of special events at a large art museum? Are you smiling thinking of all the great events you might put together? Can you see yourself doing something different every day? Can you see yourself working as a grant writer? Are you getting excited thinking about writing the grants that bring in huge amounts of money for your museum? Would it make your heart happy to have a career as the director of development of a museum you visited since you were a child?

Can you imagine yourself teaching art to elementary school students? What about teaching students in high school? Can you see yourself developing a program using art for young people, which will help them succeed in other parts of their life?

Are you smiling as you think about designing someone's engagement ring? What about designing the dress for an excited bride? Can you just feel your heart beating in your position as the head interior designer for a major hotel chain?

Can you hear yourself speaking to the media about an event that transpired in the museum? When you see a spokesperson at a museum giving a press conference on a new exhibit, do you wish you were behind the microphone?

Can you imagine how you'll feel when you close the sale on a large order of your designs?

Are you smiling as you think about all the wonderful possibilities that might unfold in your career in the art industry? Then you have chosen the right field.

Keep dreaming. Keep asking yourself what makes you happy? What gives you joy? Are you having a hard time figuring it out? Many of us do. Here's an idea to help get your juices flowing.

Take out your pad and a pen again. Make a list of any jobs or volunteer activities you've done, things you do on your "off time," and hobbies. If you're still in school, you might add in extracurricular activities in which you've participated.

Note what aspects of each you like and what you didn't like. This will help you see what type of job you're going to enjoy.

What are your special talents, skills, and personality traits? What gives you joy and makes you happy?

Do you truly enjoy helping others? Are you a leader? Do you have good communication skills? Have you always been good at motivating others? Are you inspiring? Do people feel comfortable talking to you?

Are you artistic? Are you creative? Perhaps you want a career as a fine artist, craftsperson, or designer. There are so many options for you to choose from.

Tip from the Coach

If you dream large and reach high, you can have a life and career that is better than you can ever imagine. If, on the other hand, you just settle, you will never feel fulfilled.

Do you have great communications skills? Are your talents and passions in computers and information technology? There are tons of possibilities from which you can choose.

Are your talents in writing? Do you love to craft words? There are dozens of ways you can parlay these talents into a wonderful career in the peripherals of the art industry.

Are you the one who is always volunteering to do the publicity for a charity or community organization? Do you deal well with the media? Do you enjoy developing press releases? What about acting as a spokesperson? If you love doing that, you probably would really love working in the marketing or media relations department of a museum or gallery.

Are your special skills in administration? You need only decide what area of art industry administration you want to pursue. The choice is yours.

Are your skills in teaching? Can you find ways to explain information so others can understand and absorb it? There are a plethora of possibilities.

Tip from the Coach

Whether I'm giving a radio interview, a seminar, or consulting with someone on career-oriented subjects, people always want to know the best careers to pursue? The answer is that the best careers are those where you use your talents and skills with passion.

Words from the Wise

The first requisite for success is the ability to apply your physical and mental energies to one problem incessantly without growing weary.

—Thomas Edison

The choice is yours. What you have to do is use your special skills, talents, and passions to create your career. What is going to give you joy? What are your aspirations?

What Are Your Talents?

It's very important in this process to define your talents. Sometimes we're so good at something that we just don't even think twice about it. The problem with this is that often we don't see the value in our talents. What does this mean? It means that we may overlook the possibilities associated with our talents.

It is also important to know that you can have more than one talent. Just because you are a talented artist doesn't mean you can't be a great writer. Just because you're a talented writer doesn't mean you can't be a great speaker. Just because you are great working with numbers doesn't mean you're not good at organizing. Just because you're creative doesn't mean you can't make people laugh. Just because you are a great negotiator doesn't mean that you can't be a great problem solver.

Most of us have more than one talent. The trick is making sure you know what *your* talents are and then using them to your advantage.

Do you know what your talents are? Can you identify them? This is another time you're going to have to sit down with a pad and start writing. Write down everything that you're good at. Write down all of your talents, not just the ones you think are related to the area of the art industry in which you're interested.

This is not the time to be modest. Remember that this list is for you, so be honest with yourself.

Can you finish this sentence? "I am a talented (fill in the blank)." You might be a talented artist, designer, craftsperson, negotiator, problem solver, motivator, teacher, administrator, writer, publicist, care giver, photographer, salesperson, and so on.

Now finish the sentence: "I am talented in _____." You might be talented in painting, organizing, supervising, cooking, or baking. You might be talented at negotiating, teaching, making people feel better about themselves, listening, writing, persuasion, painting, drawing, decorating, or public speaking. Whatever your talents, there is usually a way you can use them to help your career.

How? Let's say your ultimate goal is to be the director of development at an art museum. You are talented at problem solving, motivation, and leadership. You have great people skills, and you are very creative, persuasive, and a great negotiator. In addition, you are a gourmet cook. Good people skills and the ability to motivate and lead others are talents that can help you become a great director of development. So are being creative and the ability to persuade others when need be.

What can being a talented gourmet cook do for your career in a museum? It depends. If you think outside of the box, your talent might help you get involved with the community, it might garner some publicity, and it might just help your career.

I know a number of people in various careers (not related to the food service industry) who are gourmet chefs. They frequently volunteer to cook their gourmet specialties for fund-raisers for not-for-profit or community organizations. This helps get their face out in the community in a positive manner and helps people get to know them in a capacity outside of their specific position. Generally, when these types of events occur, there is media coverage. The end result is that individuals may get a mention in the paper

or some type of publicity. This brings both the individuals and their organization to the attention of the public in a positive manner.

While gourmet cooking may not be your special talent, I'm sure you have your own. Use every talent you have to catapult you to the top. Don't discount those you feel are not "job" related. Whether your extra talent gets you in the door, helps you stand out, or climb the career ladder, they will be a useful tool in your career.

Getting What You Want

How do you get what you want? How do you turn your dream into reality? One of the most important things you need to do is have faith in yourself and your dream. It is essential that you believe that you can make it happen in order for something to actually take place.

As we've discussed, you need to focus on exactly what you really want. Otherwise you're going to be going in a million different directions. Remember that things may not always come as fast as you want. No matter how it appears, most people are not overnight successes.

Generally, in life, you have to "pay your dues." What does that mean? On the most basic level, it means you probably have to start small to get to the big time. Before you get to ride in a limo, you're going to have to drive a lot of Chevys. (There's nothing wrong with a Chevy; it's just not the same as having a chauffeured limo.)

Depending on your situation, it might mean working in smaller art museums or galleries before landing that coveted position in the large prestigious museum or gallery you have been dreaming of. It might mean taking part in smaller craft shows before being asked to participate in juried shows. It might mean being assigned less-desirable shifts instead of the more-

desirable time slots. It might mean getting less-desirable assignments before being assigned the plum ones. It might mean working as a coordinator before you become a director.

Paying your dues means you may have to pound on a lot of doors before the right one opens. It means you may have to take jobs that are not your perfect choice to get experience so you can move up the career ladder and get the job of your dreams. You may have to do a lot of the grunt work and stay in the background while others get the credit. While all this is going on, you have to be patient with the knowledge that everything you do is getting you closer to your goal.

If you look at every experience as a stepping-stone to get you to the next level of your career, it's a lot easier to get through the difficult things or trying times you may have to go through.

Setting Goals

Throughout this whole process, it's essential to set goals. Why? If you don't have goals, it's hard to know where you want to end up. It's hard to know where you're going. If you don't know where you're going, it's very difficult to get there.

It sometimes is easier to look at *goals* as the place you arrive in at the end of a trip. You can also look at *actions* as the trips you take to get to your destinations.

What's the best way to set goals? To start with, be as specific as you can. Instead of your

Tip from the Top

Successful people continue setting goals throughout their careers. That ensures their careers don't get stagnant and they always feel passion for what they do.

goal being, "I want to be an artist," your goal might be, "I want a career as a successful sculptor with my work commissioned by corporate clients and large galleries." Or, "I want a career as a successful fine artist where I can make a good living and my work is respected in the art world." Instead of your goal being, "I want to be an artist," your goal might be "I want to be a sketch artist covering notable trials for a major New York City television station."

Instead of your goal being, "I want to be a designer," your goal might be, "I want to be a successful designer in the fabric arts field selling my designs to high-end clients."

Instead of "I want to advance my career in the art industry," your goal might be, "I want to first become the director of development for a large art museum and then the museum director." Instead of your goal being, "I want to work in the graphic arts," your goal might be, "I want to work as a graphic artist in the publishing industry." Instead of your goal being, "I want to work in an advertising agency," your goal might be, "I want to be the art director of a large, prestigious advertising agency."

Instead of your goal being, "I think I want to work in a museum in some manner," your goal might be, "I want a career in the special events area of a large, prestigious art museum." Or it might be, "I want a career developing new art exhibits for a major art museum," depending on your goals and desires.

You should try to make sure your goals are clear and concise. You'll find it easier to focus in on your goals if you write them down. Writing down your goals will help you see them more clearly. Writing down your goals will also give them power, and power is what can make it happen.

Take out your pad or notebook and get started. As you think of new ideas and goals, jot them

Tips from the Top

Goals are not written in stone. Just because you have something written down does not mean you can't change it. As you change, your goals might change as well. This is normal.

down. Some people find it easier to work toward one main goal. Others find it easier to develop a series of goals leading up to their main goal.

To help you do this exercise, first develop a number of long-term goals. Where do you think you want to be in your career in the next year? How about the next two years, three years, five years, and even 10 years?

Need some help? Here is an example of goals for someone currently in college and looking forward to a career as a graphic designer.

First-Year Goals
◎ I want to get a summer internship in an advertising agency or corporate company in the art department.
◎ I want to complete my bachelor's degree in fine arts.
◎ I want to learn Web design.

Second-Year Goals
◎ I want to get a job in an advertising agency in the art department.
◎ I want to continue on with my education toward a Master of Fine Arts.

Long-Term Goals
◎ I want to either be promoted to assistant art director in an agency or find a job in a larger, more prestigious agency.
◎ I want land a job as the director of the art department in a large, prestigious advertising agency.

◎ I want to be recognized as a talented and innovative art director by my peers.

Along the way, this individual may change his or her goals. For example, long-term goals might instead be:

◎ I want to start my own graphic arts business with a large roster of good clients.

Once you've zeroed in on your main goals, you can develop short-range goals you might want or need to accomplish to reach your long-range goals. Feel free to add details. Don't concern yourself with situations changing. You can always adjust your goals.

When focusing in on your goals, remember that there are general work-related goals and specific work-related goals. What's the difference? Specific goals are just that. See the following examples:

◎ General Goal: I want to get a promotion.
 ☐ Specific Goal: I want to become the director of the marketing department.
◎ General Goal: I want to work in some segment of the art industry.
 ☐ Specific Goal: I want a career as an accessory designer designing high-end bags.
◎ General Goal: I want a career in crafts.
 ☐ Specific Goal: I want to design and create stained glass pieces both for the wholesale and retail market.
◎ General Goal: I want to work in some sort of communications job in some area of the art industry.
 ☐ Specific Goal: I want to be the public relations director for a large art gallery.

Visualization Can Help Make It Happen

Visualization is a powerful tool that can help you succeed in all aspects of your career and your life. Visualization is "seeing" or "visualizing" a situation the way you want it. It's setting up a picture in your mind of the way you would like a situation to unfold.

How do you do it? It's simple. Close your eyes and visualize what you want. Visualize the situation that you long for. Think about each step you need to take to get where you want to go in your career and then see the end result in your mind. Want to see how it's done?

What do you want to be? How do you want your career to unfold? What is your dream?

The options in the art industry are endless. The decision is yours. Whatever your dream career is, visualization can help you get there!

How so? Visualize where you are, where you want to be, and how you will get there. It often helps with the process.

For example, let's say you are currently applying to art school or college. Start visualizing there. Think about how excited you are to be accepted at the school of your choice. Then think about how excited you are to be on campus. Imagine all you are going to learn. Visualize sitting in class. Now visualize all the new skills you are going to acquire. What does each classroom look like? What are your classes like? Imagine your professors and other students. Visualize the experience. Keep thinking about each step of the process.

Now imagine yourself graduating. Imagine how proud your family is. Imagine how proud you are of yourself. You now have a fine arts degree. Wow! You did it.

Visualize yourself looking for a job, filling in applications, and then seeing the job that you

> ⭐ **The Inside Scoop**
> Visualization works for more than your career. Use it to help you make all your dreams come true in all facets of your life.

really, really want. Visualize going to the interview. Are you nervous? It's okay; you are now visualizing yourself doing well. Visualize being offered the job. Fill in pieces of the process as you go along.

Can you feel the excitement of getting ready for your first day? Can you see yourself in your new suit? Can you see yourself walking into your job on your first day? You have butterflies in your stomach, but it's okay. Your new co-workers are making you feel right at home.

Now imagine your first assignment. You're nervous, but you complete it and give it to your supervisor. Can you hear her saying, "Great job"?

You've finished your first day at work. You're ecstatic. Wow! You can hardly believe you are living your dream.

Now visualize yourself waking up the next day and doing it again—only the next day, your job is even better. You are assigned a project that really excites you. You think about it, work on it for a bit. Can you smell the coffee you're drinking? Can you see your colleagues poking their heads in your office and saying hello? You finally finish your assignment and show it to your supervisor. You are nervous until she says, "That's great. We're lucky to have you on board."

You are doing what you prepared for and trained to do. What a feeling. It's a good day and it's only one of many. Got the picture? That's visualization!

Are you getting the idea? You need to visualize your life and your career the way you want it to be. Visualize yourself as you would like others to see you.

No matter what you want to do, you can visualize it to help make it happen. Visualize the career you want. Visualize the career you deserve. See yourself going for the interview, getting the job, and then sitting at your desk. Visualize speaking to co-workers, going to meetings, and doing your work.

If you are an artist, designer, or craftsperson, visualize the work you are doing. Visualize success.

The more details you can put into your visualization, the better. Add in the colors of things around you, the fragrance of the flowers as you walk into your office, the aroma of the coffee in your mug, the appearance of the clothing you are wearing, and even the bright blue sky outside. Details will help bring your visualization to life.

Whatever your dreams, concentrate on them, think about them, and then visualize them. Here's the great news. If you can visualize it, you can make it happen! No one really knows why, but it does seem to work and it works well. Perhaps it's positive energy. Perhaps you're just concentrating more on what you want.

One of the tricks in visualizing to get what you want is actually visualizing all the actions you need to take to achieve your goal. If you

> ⭐ **Tip from the Coach**
> Make a commitment to your dream and stick to it. Without this commitment, your dream will turn into a bubble that will fly away and burst in midair.

don't know what these actions are or should be, an easy exercise that might help you is called reverse visualization. In essence, what you're going to do is play the scenes in reverse.

Start by visualizing the point in your life where you want to be and then go back to the point where you are currently. So what this means is if your dream is to be the director of a large art museum, that's where you're going to start. If you currently are in college finishing up your bachelor's degree, that's where you're going to end up in this specific visualization exercise.

Let me show you briefly how it works. As we just did a moment ago, start visualizing that you have what you want. You have a great job as the director of an art museum. Now visualize the museum you work in, its location, and what the building looks like from the outside. Visualize what it looks once you walk in the door. Visualize the setup of the rooms, the desks, the offices, the museum exhibit areas. Add in every detail you can.

Now visualize the people in that building. Imagine saying, "Good morning," as you walk in the door. Can you smell the coffee brewing? Imagine yourself grabbing a cup.

Now, take one step back. Right before you got to that point in your career, what did you do? There were probably a number of things. Let's make a list of how events might have unfolded in reverse.

◎ You were appointed the director of development for a museum.
◎ You got your master's in fine arts.
◎ You were a successful grants officer.

◎ You graduated from college with a bachelor's in fine arts and a minor in business.
◎ You interned in the development office at a large, prestigious art museum.
◎ You were called back and took the fitness test and a drug screening test.
◎ You were accepted to the college of your choice so you could fulfill your dream of a career as the director of a large art museum. (This is the point where you are now.)

You now have an idea of the steps needed to get where you want to go. This might not be the exact way your situation unfolds, but hopefully it can get you started on the visualization process. Remember that the more details you can visualize in these types of exercises, the better they work.

Paint a picture in your mind of what you want to achieve detail by detail. Whether you're using a reverse visualization or a traditional visualization technique, this powerful tool can help you get what you want. Give it a try. You'll be glad you did.

3

PLAN FOR SUCCESS IN THE ART INDUSTRY

Take Control and Be
Your Own Career Manager

You might have heard the old adage that if you want something done right, you need to do it yourself. While this might not always hold true for everything, there's a shred of accuracy in relation to your career.

It's important to realize that no one cares about your career as much as you do. Not your mother, your father, your sister, or your brother. Not your best friend, girlfriend, boyfriend, or spouse. Not your colleagues, your supervisors, your business partner, or even your mentor. It's not that these people don't care at all, because in most situations, they probably not only care but want you to be successful. But no one really cares as much as you do.

If you want more control over success in your career, a key strategy to incorporate is becoming your own career manager. What does this mean? It means that you won't be leaving your career to chance. You won't be leaving your career in someone else's hands. You will be in the driver's seat! *You* will have control and *you* can make your dream career happen!

Will it take a lot of work? Absolutely! Being your own career manager can be a job in itself. The payoff, however, will be worth it.

If you look at successful people in almost any industry, you will notice that most have tremendous dedication to their career. Of course, they may have friends, colleagues, professionals, and others who advise them, but when it comes to the final decision making, they are the ones who take the ultimate responsibility for their career.

Now that you've decided to be your own career manager, you have some work to do. Next on the list is putting together an action plan. Let's get started!

What Is an Action Plan?

Let's look at success a little closer. What's the one thing successful people, successful busi-

> ### ⭐ Words from the Wise
> Always keep control of your career. Even at the height of your success when you may have people representing you, make sure *you* oversee things. This doesn't mean you can't delegate tasks. It just means that you should be aware of what is going on, who you are dealing with, how much money is coming in and going out, and where your money is going.

42

nesses, and successful events all have in common? Is it money? Luck? Talent? While money, luck, and talent all certainly are part of the mix, generally the common thread most share is a well-developed plan for success. Whatever your goal, be it short range or long range, if you have a plan to achieve it, you have a better chance of succeeding. With that in mind, let's discuss how you can create your own plan for success.

What can you do with your plan? The possibilities are endless.

People utilize all types of plans to help ensure success. Everyone has their own version of what is best. To some, just going over what they're going to do and how they're going to do it in their mind is plan enough. Some, especially those working on a new business, create formal business plans. Some people develop action plans. That's what we're going to talk about now.

What exactly is an action plan? In a nutshell, an action plan is a written plan detailing all the actions you need to and want to take to successfully accomplish your ultimate goal. In this case, that goal is success in your chosen career.

Frequently, when we're going over the section on action plans during seminars, there are always some people who ask if they really need them.

"Why do I need a plan?" someone inevitably asks. "All I want is a job."

The answer is simple. You don't just want a job. You want to craft a great career. An action plan can help you do that.

There also are people who say, "I'm an artist. I just want to create art. Why do I need a plan?"

The answer is similar. You don't want to be *just* an artist. You want to be a successful artist. A plan can help you achieve that goal.

How an Action Plan Can Help You Succeed

Success is never easy, but you can stack the deck in your favor by creating your own personal action plan. Why is this so critical? To begin with, there are many different things you might want to accomplish to succeed in your career. If you go about them in a haphazard manner, however, your efforts might not be as effective as they could be. An action plan helps define the direction to go and the steps needed to get the job done. It helps increase your efficiency in your quest for success.

Another reason to develop an action plan is that sometimes actually seeing your plan in writing helps you to see a major shortcoming or simply makes you notice something minor that may be missing. At that point, you can add in the actions you need to take and the situation will be easily rectified.

With an action plan you know exactly what you're going to be doing to reach your goals. It helps you focus so that everything you need to do is more organized.

Many of us have had the experience of looking in a closet where everything is just jumbled up. If you need a jacket or a pair of pants from the closet, you can probably find it, but it may be frustrating and take you a long time. If you organize your closet, however, when you need that jacket or pair of pants, you can reach for them and find them in a second with no problem.

One of the main reasons you develop a plan is to have something organized to follow, and when you have something to follow, things are easier to accomplish and far less frustrating. In essence, what you're creating with your action plan is a method of finding and succeeding in your dream career no matter what segment of the art industry you are interested in pursuing.

When you put that plan into writing, you're going to have something to follow and something to refer to, making it easier to track your progress.

"Okay," you say. "I get it. I need a plan. How do I know what goes into the plan? How do I do this?"

Well, that depends a lot on what you want to do and what type of action plan you're putting together. Basically your action plan is going to be composed of a lot of the little, detailed steps you're going to have to accomplish to reach your goal.

Some people make very specific and lengthy action plans. Others develop general ones. You might create a separate action plan for each job you pursue, a plan for your next goal, or even a

plan that details everything you're going to need to do from the point where you find yourself now up to the career of your dreams. As long as you have some type of plan to follow, the choice is yours.

Your Personal Action Plan for Success in the Art Industry

Now that you've decided to be your own career manager, it's up to *you* to develop your personal action plan for success in your career in the art industry. Are you ready to get started?

A great deal of your action plan will depend on what area of the industry you're interested in and exactly what you want to do. Let's start with some basics.

Take a notebook, sit down, and start thinking about your career and the direction you want it to go. Begin by doing some research.

What do you want to find out? Almost any information can be useful in your career. Let's look at some of the things that might help you.

Your Market

One of the first things to research is your market. What does that mean? Basically it means that you need to determine what jobs and employment situations are available and where they are located. If you are an artist, craftsperson, or designer, who will buy your work? Who will your potential employers or clients be? Where will they be located?

While jobs in the art industry can be located throughout the country, in some situations you might have to relocate to find the perfect job. Where are the best opportunities for the area you're interested in pursuing? With a bit of research, you can start to find the answers.

Remember that the clearer you are in your goals, the easier it will be to reach them, so it's

⭐ **Tip from the Coach**

When you break large projects up into smaller tasks, they seem more manageable. It's kind of like spring cleaning. If you look at cleaning the entire house at one time, it can seem impossible. Yet, if you break the job up into cleaning one or two rooms at a time, it seems easier to accomplish. When you look at the ultimate task of finding the perfect career and then becoming successful, it, too, can seem like a huge undertaking. Breaking up the tasks you need to accomplish will help you reach your goal more effectively.

important when identifying your goals to clarify them as much as possible.

Let's say you've decided you want to work in an art museum. While most positions are located in larger, more culturally active cities, they are not the only places to work. If you do some research, you'll find a variety of other situations. What about smaller museums? What about positions with traveling art exhibitions?

Do you want to work in the business or administrative end of the industry? Do you want to develop art exhibits? Do you want to be a curator? Do you want to work in fundraising? What about development?

Are you interested in teaching art? Do you want to teach in a formal or informal atmosphere? Do you want to teach in an elementary school? What about a middle school or high school? How about teaching in some area of continuing education? What about teaching in a vocational or technical situation? Maybe you want to teach on a private level. Perhaps you are interested in a career teaching art at the higher education level. Where are the colleges at which you are interested in working located? These are your markets.

Maybe you're interested in a career in graphic arts. What type of situation interests you? Do you want a career working in the corporate world? Do you want to be a graphic designer in the publishing world? Where are job openings? Where are the opportunities? If you want to freelance or have your own business, who will your potential clients be? Who will your employers be? What industry within the corporate world are you interested in? The choice is yours.

Do you want a career in sales? Do you think you would like to sell art supplies? What about art books? How about selling someone else's art or crafts? What about a career as an artist's

> ### ⭐ Tip from the Top
>
> With a bit of creativity, you can weave your passions together in your career. We've already touched on this idea previously. If, for example, you have a passion for the art industry and would covet a job in a museum and you are a talented fund-raiser, you might find a position as the director of fund-raising and development in a museum. Similarly, if you love to put together events and want a career in a museum, you might find a great opportunity developing special events for museums. If you wish you could be around the glitz and glamour of the television, film, or even theatrical industry and you are a talented artist or craftsperson, you might want to search out a position as a set designer, graphic designer, or fashion designer, depending on your talents. Do you love learning about art and its history? What about a career as an art historian? Do you want to help people and love art? What about a career as an art therapist? No matter what you might have heard, you sometimes can do everything you want, if you think about it ahead of time and make a plan.

representative? If you love sales and you are talented in that area, your options are unlimited.

Do you love writing and want to work in some aspect of the art industry? You have so many options! What about writing text books? What about writing other education materials? How about writing for an art magazine or in the art section of a newspaper or magazine? Perhaps you would be interested in writing the copy seen at museum exhibits or galleries explaining the work. What about a career as an art historian?

Would any of these be possibilities for you? If so, where specifically could your markets be located?

Is your goal to work as a fine artist? What about a craftsperson? How about a designer of some type? Who will buy your work? What will your market be? Will it be selling at galleries? How about at craft shows? Maybe your market will be selling your work to stores, or boutiques, or private parties.

Why do you have to research your market now? Why do you need this information at all? Because information is power! The more you think about your potential options and markets now, the more opportunities you may find down the line.

What Do You Need to Do to Get What You Want?

Next, research what you need to do to get the career you want. Do you need additional skills? Training? Education? Experience? Do you need to move to a different location? Make new contacts? Get an internship? Do you need to get certified? Licensed? What do you need?

Would it help to take some additional art classes? How about taking a class to learn some new techniques? What about taking some writing classes? What about taking a class in a new computer software design program? Do you need to take a seminar on grant writing? What about a workshop in special skills? Would a public speaking workshop help?

Do you need to get your bachelor's degree? What about your graduate degree? Do you need your doctorate? Would additional continuing education help you get where you want to go?

Do you need to join a union? Would joining a trade association help you? Do you need to find new ways to network? Do you need more contacts?

What you need to determine is what standing in between you and the career you want. What obstacles do you face?

If you are already working in the art industry in some capacity, you need to determine what is standing in between you and the success you are looking for. How can you climb the career ladder of success and perhaps even skip a few rungs to get where you want to go?

Take some time thinking about this. If you can determine exactly what skills, qualifications, training, education, licensing, certification, or experience you're missing or what you need to do, you're halfway there.

It often helps to look at exactly what is standing between you and what you want on paper. What barriers do you face? The sample on page 47 can give you an idea.

Use the form on page 48 to help you clarify each situation and the possible solution you feel is standing between you and the career success you want.

How Can You Differentiate Yourself?

No matter what area of the art industry you want to be involved in, I can almost guarantee that there are other people who want the same type of job or situation.

There are thousands of people who want to be successful artists; thousands who want to be designers; and thousands who want to be successful craftspeople. There are thousands who want to work in some capacity of commercial and graphic art; thousands who want to work in museums; and thousands who want teach art or crafts in some capacity.

There are thousands who want to work in the business or administration segment of the art industry; thousands who want to work in advertising agencies; and thousands who aren't sure exactly what they want to do but know they want to work in some area of the art world. And don't forget all the people who want to work in the peripheral segments of the art industry en-

What Stands Between Me and What I Want?	Possible Solution
I need my Bachelor of Fine Arts degree.	I'm going to finish college.
I need experience in administration.	I'm going to see if there are any positions in administration in a museum internship program.
I can't find an opening in a museum.	I'm going to go on the Web and check out museum Web sites and newspaper classifieds to see what types of opportunities are available in other areas.
I want to sell my jewelry designs to stores and boutiques and don't know how.	I'm going to cold call stores and boutiques and send out letters to see if I can make some appointments with buyers. I'm also going to check out the Web and see if there are any other possibilities.
I'm not good at giving presentations and I need that to sell my designs.	I'm going to look into taking some workshops and seminars in giving better presentations.
I need a master's degree to succeed.	I'm going to start by taking a couple of classes. I can afford both the time and money to do it this way.
I need to find a way to advance my career and can't get a promotion because my supervisor isn't going anywhere.	I'm going to start to actively find a better job.
I want to be an artist representative and don't know how.	I'm going to start by working with someone who is in this line of work and learn the ropes.

compassing the corporate world, journalism, communications, retail, wholesale and more.

I can almost hear you say, "That is a lot of competition. Can I make it? Can I succeed?"

To that I answer a definitive yes! Lots of people succeed in all aspects of the art industry. Why shouldn't one of them be you?

Here's the challenge. How can you stand out in a positive way? What attributes do you have or what can you do so people choose you over others?

"I don't like calling attention to myself," many people tell me. "I just want to blend into the crowd."

Unfortunately, that isn't the best thing to do if you want to make it. Why? Because the people who get the jobs—the ones who succeed, the ones who make it—are the ones who have found a way to set themselves apart from others. And if you want success, you are going to have to find a way too.

How? Perhaps it's your personality or the energy you exude. Maybe it's your sense of humor or the way you organize things. Perhaps it's your calm demeanor in the eye of a storm. Maybe it's your smile or the twinkle in your eye. Some people just have a presence about them.

Perhaps you have a way of explaining something difficult in an easy-to-understand manner.

What Stands Between Me and What I Want?	Possible Solution

Maybe it's the way you calm down a situation or make people feel better. Possibly it's the way you make others feel special about themselves.

Perhaps it's the way you write grants that bring in huge sums of money. It might be the way you can look at an accounting ledger and *see* the error while everyone else has been trying to find it.

Maybe it's the way you motivate people or inspire them. Maybe it's the way you can take a complicated project and can just make it easier to understand. Perhaps it is that you are not only a visionary but have the ability to bring your visions to fruition.

It might be the special way you have of creating with color. Maybe it's the way you can bring a picture to life. Perhaps it's the way you can take that perfect photograph or create something beautiful. It might be almost anything.

Everyone is special in some way. Everyone has a special something they do or say that makes them stand out in some manner. Most people have more than one positive trait. Spend some time determining what makes you special

Tip from the Coach

If you don't know what makes you special, take a cue from what others tell you. You know those conversations where someone says something in passing like, "You're so funny, I love being around you," "You always know just what to say to make me feel better," "You have such a beautiful voice that I love listening to you sing," "You always are so helpful." Or, "You make it so easy to understand, the most difficult things." Listen to what people say and always take compliments graciously.

in a positive way so that you can use it to your advantage in your career.

How to Get Noticed

Catching the eye of people important to your career is another challenge. How are you going to bring your special talents and skills to the attention of the people who can make a difference in your career? This is the time to brainstorm.

First of all, instead of waiting for opportunities to perform to present themselves, I want you to actively seek them out. You are also going to want to actively market yourself. We're going to discuss different ways to market yourself later, but at this point you need to take some time to try to figure out how to make yourself and your accomplishments known to others.

Consider joining a not-for-profit or civic organization whose mission you believe in. And don't just join; get involved. How? That depends what your passion is and where your talents lie. You might, for example, offer to do the marketing, publicity, or public relations for a not-for-profit or one of their events. You might volunteer to do fundraising for a not-for-profit or even suggest a fund-raising idea and then chair the project.

You might volunteer at a museum. You might volunteer with a literacy program and teach adults to read or children to read better. You might volunteer to work at a food bank or library. You might volunteer with an organization that helps abused or neglected children or perhaps abused or neglected animals. You might even volunteer to teach children art or crafts.

Why volunteer when you're trying to get a job? Why volunteer when you're trying to climb the career ladder? What's the point? Aside from doing something for someone else, it can help you get noticed.

"I can see volunteering in something related to the art area," you say, " but what will volunteering for a unrelated industry and not even getting paid for it do for my career?"

It will give you experience. It will give you exposure. And maybe, just maybe, someone else involved in that not-for-profit or civic group for which you're volunteering may have some contacts in the area of the art industry in which you are seeking a job.

Need some other ideas? Think creativity. What about giving a class in choosing artwork for your home? How about a workshop on helping kids use their creative talents? What about giving a workshop on creating holiday decorations for fund-raisers? How about giving a seminar on marketing crafts? Don't forget to call the media and send out a press release on your activities.

What about coordinating a fund-raiser for a local art museum? How about offering to develop a newsletter for a hospital auxiliary? What about volunteering to put together a community cookbook for a not-for-profit organization?

Just keep coming up with ideas and writing them down as you go. You can fine-tune them later.

Why are you doing this? You want to get your name out there. You want to call attention to yourself in a positive manner. You want to set yourself apart from others. You want people in various areas of the art industry to not only know you exist but think of you and remember you when opportunities arise.

Have you won any awards? Have you been nominated for an award (even if you didn't win)? Honors and awards always set you apart from others and help you get noticed.

Have any of your designs or artwork been showcased? For example, did you design the cover or poster for a not-for-profit fund-raiser? Has any of your artwork been shown in a mu-

> ## The Inside Scoop
>
> A woman recently told me that she had landed a spread in a popular woman's magazine highlighting her design business. I asked if she knew someone at the magazine or if she had gone after the feature herself. Neither, she said. It seems that she had taken part in a popular juried fund-raiser in her area, donating a number of her exclusive holiday decorations. Each of the artists who donated items were highlighted in a booklet. An editor for the magazine happened to visit the area and stopped by the fund-raiser with one of her relatives. She bought one of the woman's decorations and loved it so much she gave her a call. You can never tell what great things can happen with your career if you put yourself in situations where you get exposure.

seum? Is your work in a gallery? What about being sold in a store, shop, or boutique?

Have you presented a paper at a conference? Have you spoken at a conference or convention? These events can help set you apart from others as well.

What have you done to set yourself apart? What can you do to accomplish this goal? Think about these possibilities. Can you come up with any more? As you come up with answers, jot them down in a notebook. That way you'll have something to refer to later. Once you determine the answers, it's easier to move on to the next step of writing your plan.

What Should Your Basic Action Plan Include?

Now that you've done some research and brainstormed some great ideas, you are on your way. It's time to start developing your action plan?

What should your basic action plan include?

Career Goals

One of the most important parts of your action plan will be defining your career goals. Are you just starting your career? Are you looking for a new job or career? Are you already in the industry and want to climb the career ladder? Are you interested in exploring a different career in the art industry other than the one you're in now?

Are you an artist who is interested in becoming an artist's representative for other artists? Do you want to branch out into another medium? Do you want to teach art? Do you want to write about art?

Is it your dream to become the director of a large art museum? How about the marketing director? Do you want to be the one developing new interesting exhibits? Do you think you might be interested in finding ways to get children interested in art? Do you want to be the human resources director of a large museum?

Do you want to be a clothing designer? Is it your dream to design clothing for the masses or do you want to design for a select few? Is it your goal to design jewelry to sell at craft shows or would you prefer to design exclusive pieces to sell at fine jewelry galleries?

Is it your goal to be a graphic designer for a large corporation? Do you know what specific industry in which you are interested in working?

What is your dream? The sky is the limit once you know what your goals are.

When defining your goals, try to make them as specific as possible. So for example, instead of writing in your action plan that your goal is to be an artist, you might refine your goal to be a successful sculptor whose work is exhibited at major museums and galleries. You might refine your goals to be a successful fine artist whose paintings are commissioned by large galleries fetching thousands of dollars each.

Instead of writing in your action plan that you want to be craftsperson, you might refine your goals to be a successful silversmith who is invited to the best juried shows and exhibiting at large galleries.

Instead of writing in your action plan that you want to work in the graphic arts in some manner, you might refine your goal as becoming an art director of a major corporation in the entertainment industry.

Instead of writing that your goal is a career in teaching art, refine your goal to be an elementary school art teacher in a small private school (if that is what you want to do). Instead of defining your goal to be the marketing director for a museum, you might define your goal as becoming the marketing director for a large, prestigious art museum in the northeast.

It's important when thinking about goals to include your short-range goals as well as your long-range ones. You might even want to include mid-range goals. That way you'll be able to track your progress, which gives you inspiration to slowly but surely meet your goals.

For example, let's say you're interested in pursuing a career as an art director. Your short-range goals might be to go to college and get your bachelor's degree with a major in graphic or commercial art. You mid-range goals might be to get a job as an illustrator or graphic artists. Your long-range goals might be to become the art director of a large, prestigious magazine.

Keep in mind that goals are not written in stone and it is okay to be flexible and change them along the way. The idea is that no matter what you want, moving forward is the best way to get somewhere.

What You Need to Reach Your Goals

The next step in your action plan is to put in writing exactly what you need to reach your goals.

Do you need some sort of training or more education? Do you need to learn new skills or brush up on old ones? Do you need to move to a different geographic location? Do you need to network more? Do you need to make more contacts?

Your Actions

This is the crux of your action plan. What actions do you need to attain your goals? What actions will get you where you want to be? There might be a variety of things you need to do. Here's a few ideas to get you started.

- ◎ Do you need to get a bachelor's degree?
 - ▫ Your actions would be to identify colleges and universities that offer the degree in the major you are interested in, apply, and graduate with the degree you need.
- ◎ Do you need to continue your education? Do you need a graduate degree? Do you need to get your doctorate?
 - ▫ Your actions would be to locate schools offering the degree you are seeking, apply, and continue your education.
- ◎ Do you need to take some classes or attend some workshops?
 - ▫ Your actions would be to identify, locate, and take classes and workshops.
- ◎ Do you need to find seminars and attend them?
 - ▫ Your actions would be to investigate potential seminars to see if they will assist in accomplishing your goals, and if so, attend them.
- ◎ Do you need to hone your craft?
 - ▫ Your actions would be to find ways to hone your skills. Perhaps you need to take some classes. Maybe

you need to apprentice with a skilled craftsperson. Perhaps you need to practice more.
- ◎ Do you need to learn how to write better? Do you need better written communications skills?
 - ▫ Your actions would be to find classes to help you hone your skills.
- ◎ Do you need to find a way to feel more comfortable speaking in public?
 - ▫ Your actions would be to find and take a course in public speaking.
- ◎ Do you need to move to another geographic location?
 - ▫ Your actions would be to find a way to relocate.
- ◎ Do you need to attend industry events, conferences, and conventions?
 - ▫ Your actions would be to locate and investigate events, conferences, and conventions, and then attend them.
- ◎ Do you need to find more ways to network or just network more?
 - ▫ Your actions would be to develop opportunities and activities to network and follow through with those activities and opportunities.
- ◎ Do you need more experience?
 - ▫ Your actions might include becoming an intern, volunteering, or finding other ways to get experience. Talk to people who might be able to help you find opportunities to volunteer.
- ◎ Do you need to join a union?
 - ▫ Your actions would be to call the specific union you need to join and check out the requirements.
- ◎ Do you need any type of license?

□ Your actions would be to call the specific state you live in and check out the requirements.
◎ Do you need to find a headhunter to help you locate the perfect job?
□ Your actions would be to talk to people in the industry, get suggestions, and then contact a number of headhunters.

Your Timetable

Your timetable is essential to your action plan. In this section you're going to include what you're going to do (your actions) and when you're going to do them. The idea is to make sure you have a deadline for getting things done so your actions don't fall through the cracks. Just saying "I have to do this or I have to do that" is not effective.

Remember there is no right or wrong way to assemble your action plan. It's what you are comfortable with. You might want yours to look different in some manner, have different items, or even have things in a different order. That's okay. The whole purpose of action plans is to help you achieve your career goals. Choose the one that works for you.

Let's look at a couple of examples starting on page 54. First is an example of what a basic action plan might look like and then look at the same plan partly filled in by someone whose specific career goal is to be a fashion designer. After that are examples of alternative action plans for someone interested in working for an advertising agency and one for someone interested in working for an art museum.

After reviewing these samples, use the blank plan provided on the next page to help you create your own personal action plan. Remember, you can start your action plan at whatever point you currently are in your career.

Tip from the Coach

Try to be realistic when setting your timetable. Unrealistic time requirements often set the groundwork for making you feel like you failed.

Copy the blank plan on page 54 and fill it in to create your own personal action plan. Feel free to change the chart or add sections to better suit your needs.

Specialized Action Plans

What things might be in your specialized action plan? Once again, that depends on the area in which you're interested in working and the level you currently are in your career.

Let's first look at some actions you might take. Remember, these are just to get you started. When you sit down and think about it, you'll find tons of actions you're going to need to take.

◎ Identify your skills.
◎ Identify your talents.
◎ Identify your passions.
◎ Look for internships.
◎ Develop different drafts of your resume.
◎ Develop cover letters tailoring them to each position.
◎ Network.
◎ Go to industry events.
◎ Make contacts.
◎ Volunteer to get experience.
◎ Obtain reference letters.
◎ Get permission to use people's names as references.
◎ Develop your career portfolio.
◎ Attend career fairs.
◎ Look for seminars, workshops, and so on in your area of interest.
◎ Take seminars, workshops, and classes.

Example 1

My Basic Action Plan

Career Goals

Long-range goals:
Mid-range goals:
Short-range goals:

My market:

What do I need to reach my goals?

How can I differentiate myself from others?

How can I catch the eye of people important to my career?

What actions can I take to reach my goals?

What actions do I absolutely need to take now?

What's my timetable?
　　Short-range goals:
　　Mid-range goals:
　　Long-range goals:

Actions I've taken: Date completed:

Example 2

My Basic Action Plan

Career Goals

Long-range goals: To be a world class woman's fashion designer. I want to be a major force in the fashion design industry. I want my own line of clothing and my own line of home décor items. I want to design all the fabric used for everything. I want to be the one who creates global fashion trends.

Mid-range goals: To work in one of the top design houses learning the ropes and honing my craft. To be respected by my peers for my designs.

Short-range goals: To finish college and get my degree. To go to Paris for a summer internship in one of the Paris design houses.

My market (short term): Colleges with major in fine art in fashion design; Paris design houses (for internships).

My market (long term): My own design house.

Possibilities for employment (after getting my degree): Design houses in New York City.

What do I need to reach my goals?
Graduate from college.
Look into internships and apprenticeships.
Look for workshops and seminars to help me hone my craft.
Look for competitions.
Search out opportunities.
Get a job.
Get my master's degree.
Network in the industry.
Learn as much as I can—continue education.
Market myself.

(continues)

Example 2, continued

How can I differentiate myself from others? I have a 4.0 GPA; I took part in a number of design competitions and won the grand prize twice. I received an award of excellence in school for my designs. I've networked and have a number of good contacts. I interview well.

How can I catch the eye of people important to my career? Get involved in some industry not-for-profit projects. Continue taking part in competitions.

What actions can I take to reach my goals? Explore seminars and workshops in design; continue my education; talk to a number of people involved in this area to see if they have other ideas. Look for a mentor to help guide me through the process.

What actions do I absolutely need to take now? Graduate college and get my undergraduate degree. Look for internships.

What's my timetable?
Short-range goals: Within the next two years.
Mid-range goals: Within the next three years I want a job in a design house.
Long-range goals: Within the next eight years. (I want it now, but I am going to be realistic)

Actions I've Taken:
Finished two years of college toward my bachelor's degree.
Spoken to my advisor about my goals.
Found a couple of internships.
Sent in applications.
Started developing my resume.
Continue on with actions.

⭐ The Inside Scoop

Don't start panicking when you think you are never going to reach your career goals. Just because you estimate that you want to reach your long-range goals within the next five years or seven years or whatever you choose does not mean that you can't get there faster. Your timetable is really just an estimate of the time you want to reach a specific goal.

Example 3

My Basic Action Plan

Career Goals

Long-range goals: To become the art director for a major advertising agency. I want advertisements from my agency to be the best. I want my agency to win awards for their creative designs.

Mid-range goals: To work as an assistant art director at a large advertising agency in New York City. To continue my education; get my master's degree in fine art.

Short-range goals: To finish my bachelor's degree, double majoring in fine arts and advertising. To get a job as a graphic artist or illustrator at an advertising agency.

Possible employers: Large and mid-sized advertising agencies in New York City.

What do I need to reach my goals? Finish college; get experience possibly by first interning in an advertising agency and then getting a job as a graphic artist or illustrator.

How can I differentiate myself from others? I worked at a local magazine while in high school in the art department; I won a competition for the most creative advertisement in the local newspaper. I designed the poster used by the state chapter of a large not-for-profit. I have a great sense of humor. I'm empathetic, compassionate, and patient. I am creative. I relate well to most people.

How can I catch the eye of people important to my career? I am going to continue volunteering my art services to not-for-profits. I am going to look for competitions to showcase my talent.

What actions can I take to reach my goals? Look for an internship at a large advertising agency. Contact my school's career center to see if they know of any part-time openings for graphic artists.

What actions do I absolutely need to take now? Contact my advisor to see if our school takes part in any internship programs with advertising agencies. Contact advertising agencies myself to check into internship programs.

What's my timetable?
 Short-range goals: Finish college in the next two years.
 Mid-range goals: Within the next four years.
 Long-range goals: Within the next six years. (I really want it in less, but I'm trying to be realistic.)

Actions I've taken (short term):
1. Spoke to my supervisor about internships.
2. Completed two years of college towards my bachelor's degree.
3. Attended a number of seminars and workshops on advertising.
4. Attended a number of workshops on computer graphics.
5. Continue on with actions.

Example 4

My Personal Action Plan

CAREER GOALS (Long-range): Director of Development–Art Museum

CAREER GOALS (Short-range): Grant Writer

Action to Be Taken	Comments	Timetable/ Deadline	Date Accomplished
Short Range			
Finish my bachelor's degree in arts administration.		December	December
Speak to Dr. Everett, Museum Director.	Discuss goals and get suggestions.	Within the month	September
Look for seminars, workshops, etc., related to grant writing and arts administration.	Contact the Art Museum Development Association; look on Internet.	ASAP	
Read industry periodicals and visit Web sites to get familiar with trends in museums and museum administration.	See if the public library or college library subscribes to any pertinent periodicals; check with local art museum to get additional names.	This week and continually.	
Look into industry conferences and conventions to network.	Try to attend one or two.		
Read books about museums, art and development.	Do search on Amazon.com, then go to library to borrow books.	Browse through at least one a week.	
Startworking on resume.		Finish first draft by end of next month.	
Volunteer to write grants for not-for-profit.	Call local arts organization.	Now	
Start building career portfolio.		Start now and keep going.	

Example 4, continued

Action To Be Taken	Comments	Timetable/ Deadline	Date Accomplished
Find networking events.	Call chamber of commerce.	Start now and continue.	
Make up business cards.	Find printer; check out other people's business cards for ideas.		
Contact museums to see about openings.	Send letters and resumes asking about openings.		
Contact industry associations.	Check to see if there are any networking events or career fairs.	Start now.	
Check out trades for job openings.			
Continue on with actions.			

- Get a college degree.
- Make business cards.
- Perform research online.
- Learn about industry trends.
- Make cold calls to obtain job interviews.
- Read books about art, museums, development, and so on.

Now look at some actions you might have if your career aspiration is to become a craftsperson. Specific actions will, of course, be dependent on the particular area of crafts you are targeting. Remember, this list is just to get you started thinking. It is by no means a complete list.

- Take classes to hone skills and learn new ones.
- Look for markets to sell products.
- Take classes in marketing.

- Look into wholesaling opportunities.
- Search out juried shows.
- Design craft booth.
- Take slides or photos of work.
- Check into state rules and regulations for collecting sales tax.
- Look into Web site.
- Subscribe to trade journals.
- Join trade associations.
- Join appropriate unions.

Now let's say you might be interested in a career as an interior designer. What other actions might you add?

- Take courses, seminars, and workshops in interior design.
- Take courses in staging (to add new opportunities).

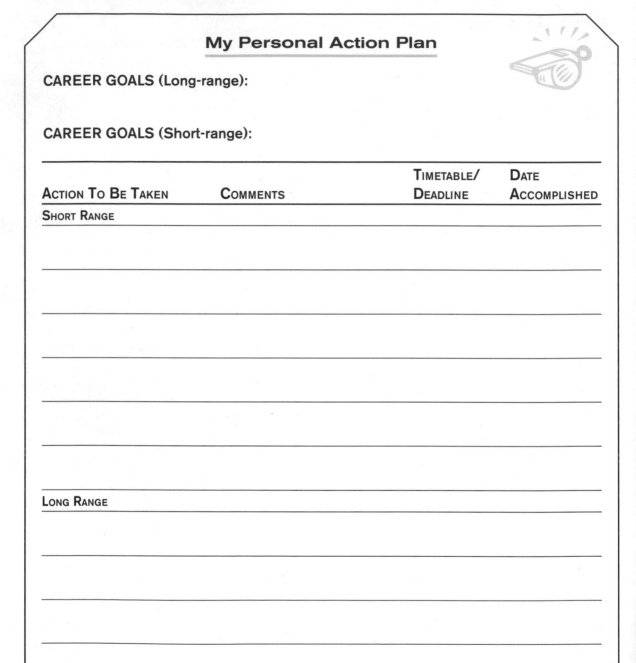

My Personal Action Plan

CAREER GOALS (Long-range):

CAREER GOALS (Short-range):

ACTION TO BE TAKEN	COMMENTS	TIMETABLE/ DEADLINE	DATE ACCOMPLISHED
SHORT RANGE			
LONG RANGE			

- Make up business cards.
- Research companies.
- Send out cover letters and resumes to larger interior design companies, asking about openings.
- Send out cover letters and resumes to furniture stores asking about possible openings.
- Find relevant trade magazines and read them on a regular basis.
- Get experience.

When developing your own action plan, just keep adding in new actions as you think of them.

Using Action Plans for Specific Jobs

Action plans can be useful in a number of ways. In addition to developing a plan for your career you might also utilize action plans when looking for specific jobs. Let's look at an example.

Copy the blank plan provided on page 63 to use when you find specific jobs in which you're interested to keep track of your actions. Fill in this worksheet for any of the jobs you apply to. Feel free to change the chart or add sections to better suit your needs.

How to Use Your Action Plan

Creating your dream career takes time, patience, and a lot of work. In order for your action plan to be useful, you're going to have to use it. It's important to set aside some time every day to work on your career. During this time, you're going to be *taking actions*. The number of actions you take, of course, will depend on your situation. If you are currently employed and looking for a new job, you may not be able to tackle as many actions as someone who is unemployed

> ★ **The Inside Scoop**
> Once you start writing in your daily action journal, you'll be even more motivated to fulfill your career goals.

and has more time available every day. Keep in mind that some actions take may take longer than others.

For example, putting together your career portfolio will take longer than making a phone call. So if you're working on your portfolio, you might not accomplish more than one action in a day.

Try to make a commitment to yourself to take at least one positive action each day toward getting your dream career or becoming more successful in the one you currently have. Do more if you can. Whatever your situation, just make sure you take *some* action every single day.

In addition to an action plan, you'll find it helpful to keep an action journal recording all the career-related activities and actions you take on a daily basis. Use the journal to write down all the things that you do on a daily basis do to help you attain your career goals. You then have a record of all the actions you have taken in one place. Like your action plan, your action journal can help you track your progress.

How do you do this? Here's a sample to get you started. Names and phone numbers are fabricated for this sample.

With your daily action journal, you can look back and see exactly what you've done, who you've called, who you've written to, and what the result was. Additionally, you have the names, phone numbers, times, dates, and other information at your fingertips. As an added bonus, as you review your daily action journal,

Action Plan for Specific Job

Job Title: Assistant Director of Museum Marketing

Job Description: Market museum in local area as well as helping create a destination for out of town visitors.

Company Name: Sington Mills Art Musuem

Contact Name: Michael Jones

Secondary Contact Name:

Company Address: 49 South Main Street, Sington Mills, NY 11111

Company Phone Number: (222) 222-2222

Company Fax Number: (222) 222-3333

Company Website Address: www.singtonmillsartmu.org

Company E-mail: singtonmillsartmu@singtonmillsartmu.org

Where I Heard about Job: Saw ad in *The Record.*

Actions Taken: Asked for application. Filled in application. Tailored resume and cover letter to job; spoke to references to tell them I was applying for job and make sure I could still use them as references; faxed and mailed application, resume, and cover letter.

Actions Needed to Follow Up: Review career portfolio; make extra copies of my resume; call if I don't hear back within three weeks.

Interview Time, Date, and Location: Received call on 6/11 asking me to come in for interview; interview set for 2:00 p.m. on 6/17 with Michael Jones.

More Actions to Follow Up: Get directions to administration office; pick out clothes for interview; try everything on to make sure it looks good; rehearse giving answers to questions most likely to be asked during interview.

Comments: Went to interview; they gave me a tour of museum; very nice people working there; I would like the job; Mr. Jones seemed impressed with some of my volunteer activities; he also seemed interested in my career portfolio; he said he was conducting interviews for the next week and would get back to me one way or another in a couple of weeks.

Extra Actions: Write note thanking Mr. Jones or interview.

Results: 6/30–Mr. Jones called and asked me to come back for another interview to meet with some others in administration. 6/31–Mr. Jones called and asked if I would be interested in the job!!! He asked me to come in next week to discuss salary and benefits!

Action Plan for Specific Job

Job Title:

Job Description:

Company Name:

Contact Name:

Secondary Contact Name:

Company Address:

Company Phone Number:

Company Fax Number:

Company Web site Address:

Company E-mail:

Secondary E-mail:

Where I Heard about Job:

Actions Taken:

Actions Needed To Follow Up:

Interview Time, Date, and Location:

Comments:

Results:

Daily Action Journal

Sunday, June 8

Read Sunday papers. Checked education section of papers for interesting stories. Read through classifieds. Found four openings I was interested in. Surfed Internet looking for job openings in other areas.

Monday, June 9

Refined resume for specific jobs. Wrote cover letter for each job . Mailed resumes and cover letters.

Tuesday, June 10

Read daily newspapers and checked out classifieds.

Called Amy Morrison, human resources director for Some City Art Museum. I saw her doing an interview on news discussing careers in museums (111-111-1111). Cold called, not in. Her secretary, Carolyn, said she would not be in today but would send me an application.

Surfed Internet looking for stories about art museums, art, etc.

Wednesday, June 11

Read daily paper and scanned classified section.

Read art section from a couple of Sunday papers online.

Got a "Thank you for coming in for an interview, but we've decided to hire someone else" letter. Called and thanked Ms. Anderson for letting me know and asked if she could make any suggestions on how I could interview better or other places I could look for a job. She told me no one had ever called her and asked about that and she suggested I revamp my resume to highlight my education and volunteer experience. She suggested I call a museum in Green County. She heard they were looking an exhibit development coordinator.

Thursday, June 12

Called Sharon Grubber and told her how much I enjoyed her TV news interview talking about using art to give kids self-esteem. I asked if I could set up an appointment to come see her. I told her I just got my BA in fine art and was looking for a job, but I was really interested in volunteering with her project. It turns out she went to my alma mater. We set up a meeting for next Wednesday at 11 a.m. I sent a note thanking her for taking the time to speak to me and told her I looked forward to meeting her.

Friday, June 13

Worked on my career portfolio. Received a call from Norm Warner. He told me he was impressed with my resume and asked me to come in for an interview next Tuesday at 9:15 a.m. His number is 111-333-6666.

instead of feeling like you're not doing enough, you are often motivated to do more.

Now What?

In this section, we've discussed being your own career manager, and we've talked about developing action plans and putting together a daily action journal. The next step is to discuss your personal career success book.

Your Personal Career Success Book

What is your personal career success book? It's a folder, scrapbook, notebook, binder, or group of notebooks where you keep all your career information. Eventually, you might have so much that you'll need to put everything in a file drawer or cabinet, and that's okay too. That means your career is progressing.

You will find your personal career success book useful no matter what segment of the art industry you are pursuing.

What can go in your personal success career book? You can keep your action plans, your daily action journals, and all of the information you have and need to get your career to the level you want to reach.

What else can go into your personal success career book? What about career-related correspondence? It's always a good idea to keep copies of all the letters you send out for your career, as well as the ones you receive that are career related. Don't forget copies of e-mail.

Why do you want to keep correspondences? First of all, it gives you a record of people you wrote to as well as people who wrote to you. You might also find ways to make use of letters people send you. For example, instead of getting a rejection letter, reading it, crumpling it up, and throwing it in the trash, take the name

of the person who signed it, wait a period of time, and see if you can pitch another idea, another job possibility, anything that might further your career or get you closer to where you want to be. Call that person and ask if he or she can point you in another direction. Ask what you could have done better or differently. Take the advice constructively (whatever it is) and then use it for next time.

Will the person at the other end always help? Probably not, but they might, and all you need is one good idea or suggestion to get you where you want to go. It's definitely worth the call or the letter.

What else can go in your book? Keep copies of advertisements for jobs that you might want or be interested in now and even in the future. Keep copies of information on potential companies you might want to work or may offer employment opportunities.

"I don't need to write it down," you say. "I'll remember it when I need it."

Maybe you will and maybe you won't. Haven't you ever been in a situation where you do something and then say to yourself, "Oh, I forgot about that. If I had only remembered whatever it was, 1 wouldn't have done it like that"? Or, "It slipped my mind"? Writing things down means you're not leaving things to chance.

Keep lists in this book of potential support staff or people who might be helpful in your career. Keep names and addresses of recruiters, headhunters, artist representatives, and so on. You might not need an attorney now, but if you needed one quickly, who would you call? If you need an accountant, who would you use? How about a printer or banker? As you hear of professionals who others think are good, write down their names. That way you'll have information when you need it.

If everything is in one place, you won't have to search for things when you need them.

What else? You might keep lists of media possibilities, names, addresses, phone and fax numbers, and e-mail addresses. Let's say you're watching television and see an interesting interview about something in the area of the art in which you're interested. It might be an interview with a fine artist, a graphic artist, a craftsperson, an art director, the director of a museum, the special events director of a museum, or a gallery owner. At the time, you think you're going to remember exactly what you saw, when you saw it, and who the reporter or producer was. Unfortunately, you will probably forget some of the details. You now have a place to jot down the information in a section of your book. When you need it, you know where to look!

Don't forget to clip out interesting interviews, articles, and feature stories. Instead of having them floating all over your house or office, file them in this book. Want to network a bit? Write the reporter a note saying you enjoyed his or her piece and mentioning why you found it so interesting. Everyone likes to be recognized, even people in the media. You can never tell when you might make a contact or even a friend.

It goes without saying you should also clip and make copies of all articles, stories, and features that appear in the print media about you. Having all this information together will make it easier later to put together your career portfolio.

What else is going into your personal career success book? Copies of letters of recommendation, notes that supervisors or colleagues have sent you, even letters from customers who have bought your work.

As your career progresses, you will have various resumes, background sheets, and so on. Keep copies of them all in your book as well (even after you've replaced them with new ones). What about your networking and contact worksheets? They now have a place too.

We've discussed the importance of determining your *markets* and possible employers. This is where you can keep these lists as well. Then, when you find new possibilities, just jot them down in your book. With your personal career success book, everything will be at your fingertips.

If you are like most people, you may attend seminars or workshops and get handouts or take notes. You now know where to keep them so you can refer to them when needed. The same goes for conference and convention material. Keep it in your personal career success book.

You know how sometimes you just happen to see a company or business where you would love to work? You just know you would fit right in. Until you have a chance to brainstorm and get your foot in the door there, jot down your ideas. You'll be able to come back to them later and perhaps find a way to bring that job to fruition.

You'll find success is easier to come by if you're more organized, and having everything you need in one place is key.

If you're now asking yourself, "Isn't there a lot of work involved in obtaining a career you want?" the answer is a definite yes.

"Can't I just leave everything to chance like most people and hope I get what I want?" you ask.

You can, but if your ultimate goal is to succeed in some aspect of the art industry, the idea is to do everything possible to give yourself the best opportunity for success.

Planning for a successful career does take some work. In the end, however, you'll find that it will be well worth it. It's also easier to do everything if you remember that all the time and effort you put into your career today will have a positive impact on your career tomorrow.

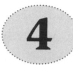

4

GET READY, GET SET, GO: PREPARATION

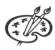

Opportunity Is Knocking: Are You Ready?

If opportunity knocks, are you ready to open the door, let it in, and take advantage of the possibilities? Are you prepared?

"What do you mean?" you ask. "Of course, I'm ready. And if I'm not, when opportunity knocks, I'll *get* prepared."

Unfortunately, that's not the way it always works. Sometimes you don't have a chance to prepare. Sometimes you need to be prepared at that very moment or you could lose out on an awesome opportunity.

"Really?" you say.

Absolutely! Let's look at a few scenarios.

First, imagine you are walking along the beach thinking about your career. "I really want a career working in an art museum," you say out loud, even though no one is there to hear you. "I wish there was a job opening as the director of a major art museum," you continue as you're planning how success might come your way. "I wish I could just get a break and meet someone who could help me get a job doing that," you continue. As you're walking, the surf washes up

and you see something shiny. You reach down to see what it is and pick up what appears to be a small brass lamp. All the while, you're still planning your career as you're walking. "I wish I had an interview with the board of directors of the most prestigious art museum in the country," you say as you absentmindedly rub the side of the lamp.

You see a puff of smoke and a genie appears. "Thank you for releasing me," he says. "In return for that, I will grant you your three wishes."

Before you have a chance to ask, "What wishes?" you find yourself standing in a large board room. Evidently, the genie had been listening to you talking to yourself and picked up on your three wishes.

"How do you do?" a woman says to you, extending her hand. "I understand you are interested in becoming our new director. What are your qualifications?"

Here's the opportunity you've been wishing for! You're shaking hands with the president of the board of one of the most prestigious art museums in the country. And she wants to talk to you about the job of your dreams? Are you

ready? Or is this big break going to pass you by because you're not prepared? Not sure? Read on.

Let's look at another scenario. Now imagine you have a fairy godmother, who comes to you one day and says, "I can get you a one-on-one meeting with the owner of one of the biggest art galleries in the world. The only catch is you have to be ready to walk in his office door in half an hour." Would you be ready? Would you miss your big break because you weren't prepared? If your answer is, "hmm, I might be ready—well, not really," then read on.

Want to think about another one? Let's imagine you're a junior fashion designer working for a women's casual line. For as long as you remember, it has been your aspiration to design hip clothing for celebrities. You are on your way to a weekend getaway to Las Vegas and you just got upgraded to first class. You're relaxing in your aisle seat, thinking that this is the life and happy in the fact that to top off the trip, no one is even sitting next to you. At the very last minute, a very well-dressed man rushes onto the plane. He says excuse me and steps over you to sit in the window seat. As he does, he drops a couple of sheets of paper out of his briefcase right on your lap.

You've seen him before but can't place where. You search your memory and all of a sudden it hits you. He is the manager of some of the hottest stars in Hollywood. You just read a story about him in the *Times* and saw a feature on *Entertainment Tonight*.

"I'm sorry," he says to you as you hand him back the paper. "The traffic was horrible and my limo was late. That's a great outfit, by the way. Very hip."

"Thanks," you say. "I just saw the piece on you on *Entertainment Tonight* yesterday. Great story. You've had a great career."

"Thank you," he says. "On your way to Vegas for a couple days of fun?"

Before you answer, think about this: Can you take advantage of the opportunity sitting right next to you? Do you have your business cards with you? What about a background sheet? Do you have a conversation prepared in your mind so you can bring up the fact that you are a fashion designer and would love to show your designs to his clients? Do you have a mini-portfolio with you that you can pull out to illustrate your designs and show your talents? Or would you let the opportunity pass you by because the only thing you were prepared for at the moment was going on vacation?

Here's the deal on opportunity. It may knock. As a matter of fact, it probably will knock, but if you don't open the door, opportunity won't stand there forever. If you don't answer the door, opportunity, even if it's *your* opportunity, will go visit someone else's door.

While you might not believe in genies, fairy godmothers, or even the concept that you might just be at the right place at the right time, you should believe this. In life and your career, you will run into situations where you need to be ready "now" or miss your chance. When opportunity knocks, you need to be ready to open the door and let it in.

How can you do that? Make a commitment to get ready now. It's time to prepare. Ready, set, let's go!

Look Out for Opportunities

Being aware of available opportunities is essential to taking advantage of them. While it's always nice when unexpected opportunities present themselves, you sometimes have to go out looking for them as well.

How many times have you turned on the television or radio or opened the newspaper and

⭐ The Inside Scoop

For some reason we never understood, my grandmother always kept a suitcase packed. "Why?" we always asked her. "You can never tell when you have an opportunity to go someplace," she replied. "If you're ready, you can go. If you're not prepared, you might miss an opportunity."

Evidently she was right. While she didn't work in the art world, her story does prove a point about being prepared, which is why I'm going to share it with you. Here it is.

Many years ago my grandmother worked as a sales associate in a women's clothing store in a well-known resort hotel. The hotel always had the top stars of the day in theater, music, film, and television performing night club shows on holiday weekends. One weekend, Judy Garland was doing a show at the hotel. According to the story we were told as children, Judy Garland evidently wanted a few things from the clothing store and called the store to see if someone could bring up a few pieces for her to choose from.

The store was busy and the manager assigned my grandmother the job. She quickly chose some items and brought them up to the star's room. Judy was pleased with my grandmother's choices and, after talking to her for a short time, was evidently impressed with her demeanor and attitude.

While signing for the purchases, she said to my grandmother, "I need a nanny for my children. I think you would be the right one for the job. I'm leaving tomorrow morning. If you're interested, I need to know now." Without missing a beat, my grandmother took the job and by the next afternoon was on the road with Judy Garland, serving as nanny to her children.

While clearly she didn't give two weeks' notice to her sales job, being at the right place at the right time certainly landed her an interesting job she seemed to love. I don't really remember how long she kept the position. What I do know, however, is that when an opportunity presented itself, my grandmother was ready. Had she not been ready or hesitated, no doubt, someone else would have gotten the job. The moral of the story is when opportunity knocks, you have to be ready to open the door.

seen an opportunity you wished you had known about so *you* could have taken advantage of the chance it offered?

Take a minute to think about these situations. Would you rather open up the newspaper and read a feature story profiling an artist or be the artist they are profiling? Would you rather be in invited to a gallery opening or be the artist with the work showcased at the gallery?

Would you rather attend a big fund-raiser for an art museum or be the individual who coordinated the entire event? Would you rather visit a new museum exhibit or be the curator of that exhibit? Would you rather meet the human resources director of an advertising agency or hear that your friend met him or her and soon after was offered a job as the agency's art director?

No matter what your goal is in the art world and what area of the industry you want to work in, you want to be the one taking advantage of every available opportunity.

Here's the deal. If you don't know about opportunities, you might miss them. So it is very important to take some time to look for opportunities that might be of value to you.

Where can you find opportunities? You can find them all over the place. Read through the papers, listen to the radio, look through the trade journals, and watch television. Visit galleries, museums, and art and craft shows. Check

out newsletters, Web sites, organizations, associations, and college campuses.

Even if you're not a student, schools, universities, and colleges often offer seminars or have programs that might be of interest and are open to the public for a small fee. Contact associations and ask about opportunities. Network, network, network, and network some more, continually looking for further opportunities.

What kind of opportunities do you have? What types of opportunities are facing you? Is a gallery looking for new artists? Is a magazine holding a competition for unique designs? Is an artist's representative giving a seminar at a local college? Is a museum offering an internship in the development office? Have you heard that one of the local printers is seeking a new art director?

Does a museum have an opening in the marketing department? Will internship opportunities at a big advertising agency be announced soon? Will a trade association conference be hosting a career fair? Is an acclaimed artist speaking at a conference? Is the author of a book on marketing your crafts doing a book signing at the book store?

Did you hear a news story on radio show discussing how many jobs the new art museum would generate? These are all potential opportunities. Be on the lookout for them. They can be your keys to success.

Keep track of the opportunities you find and hear about in a notebook or if you prefer, use the Opportunities Worksheet provided. Here is a sample to get you started.

Opportunities Worksheet

Book signing by author of a book on marketing your craft at Barnes & Noble, July 9 at 2:30 p.m.

Gallery opening. Friday, July 15. Lots of people in art industry will be there.

Seminar: How to Get into a Juried Show, August 11, in New York City; call about info: 212-212-2121.

Newspaper looking for people to interview who are aspiring to have careers in art. Call up and get information.

Read story in paper that new museum exhibit is opening November 1. Put in calendar to make sure I don't miss it.

Chamber of Commerce is holding large networking event, August 23, at 5:30 p.m. Call Chamber and make reservations.

Radio show on the history of art, September 18.

Art museum is looking for publicist—call Marie Sears to ask about application.

Opportunities Worksheet

Self-Assessment and Taking Inventory

Now let's make sure you're ready for every opportunity. One of the best ways to prepare for anything is by first determining what you want and then seeing what you need to get it. Remembering that now you are your own career manager, this might be the time to do a self-assessment.

What's that? Basically your self-assessment involves taking an inventory of what you have and what you have to offer and then seeing how you can relate it to what you want to do. Self-assessment involves thinking about yourself and your career goals.

Self-assessment helps you define your strengths and your weaknesses. It helps you define your skills, interests, goals, and passions, giving you the ability to see them at a glance.

Your self-assessment can help you develop and write your resume and make it easier to prepare for interviews.

Do you know what you want? Do you know what your strengths and weaknesses are? Can you identify the areas in which you are interested? Can you identify what's important to you in your career?

"But I already _know_ what I want to do," you say. "This is a waste of my time. Do I have to do it?"

Well, that's up to you, but answering these questions now can help your career dreams come to fruition quicker. It will help give you the edge others might not have.

Doing a self-assessment is a good idea no matter what segment of the art industry in which your career goals lie. If you do this now, you'll be prepared when an opportunity presents itself.

Strengths and Weaknesses

We all have certain strengths and weaknesses. Strengths are things you do well. They are advantages that most others don't have. You can exploit them to help your career. Weaknesses are things you can improve. They are things you don't do as well as you could.

What are your strengths and weaknesses? Can you identify them? It is important that you can, because once you know the answers, you know what you have to work on.

For example, if one of your weaknesses is you're shy and you don't like speaking in front of groups of people, you might take some public speaking classes or you might force yourself to network and go into situations that could help make you more comfortable around people. If you need better written communication skills, you might take a couple of writing classes to make you a better writer.

Are you a good painter who could be great? Think about taking some classes or workshops to hone your skills and learn new techniques. Could you be a better sculptor with some classes? Take them.

Are you an aspiring photographer? Consider taking some photography workshops to better your techniques. Do you need to learn better ways to present your work? Visit art shows, craft shows, museums, and galleries to get some ideas. Learn from others.

Are you a fund-raiser or development officer who wants to move to the next level? Consider going to some association events and networking. Think about taking some workshops to improve your presentations.

Do your writing skills need some help? A class or seminar on writing might help get you on track. Do your publicity skills need some tweaking? You might want to look for a seminar to give you some new ideas.

> ### ⭐ Tip from the Top
> If there is something that you need to do or determine that can help you in your career, do it—now! Don't procrastinate. In other words, don't put off until tomorrow what could have been done today (or at least this week.) If you need a degree, get it. Don't put it off until "you have time." If you need to work on your portfolio or resume, do it—now! If you need to find a way to improve any of your skills, do it. Get it done. Procrastinating can seriously affect your career because it means you didn't get something done that needed to be accomplished. Just the sheer thought of *having* to get something done takes time and energy. Instead of thinking about it, do it!

Is your portfolio weak? Work on it. Do you need better photos of your work? Find a way to get them done so they are the best they can be.

Is your education or training weak? Would you be more employable if you had a college degree? Find a way to get it. Do you need to go to art school? Find a way to go. Do you need some type of certification? Do you need to learn a new skill? Do what you need to do to get you where you want in your career. Take every weak link in your career chain and do something about it now!

Take some time now to define your strengths and weaknesses. Then jot them down in a notebook or use the Strengths and Weaknesses Worksheet. Be honest and realistic. Here are a couple of sample worksheets to help you get started. One was filled in by someone interested in the business segment of the industry, another by someone pursuing a career as a fine artist, and still another by someone pursuing a career as a graphic artist.

Strengths and Weaknesses Worksheet— Career in the Business Segment of the Art Industry

My strengths:
I have a lot of energy.
I can get along with almost everyone.
I can follow instruction.
I'm a team player yet can work on my own.
I'm organized.
I learn fast.
I can write well.
I know how to do Web design and am an accomplished Web designer.
I am a successful grant writer.
I have a lot of contacts in the industry and out.

My weaknesses:
I'm a perfectionist.
I don't like speaking in front of groups of people.
I'm shy.
I need better written communication skills.
I'm not good with numbers.

What's important in my career?
I want a career in a major art museum first as a grant writer, then in development, and eventually as the director.

Strengths and Weaknesses Worksheet— Career as a Fine Artist

My strengths:
I am a talented artist.
I have an eye for color.
I can work in multimedia.
I'm organized.
I have won a number of awards for my work.

My weaknesses:
I'm a perfectionist.
I am not a good salesperson.
I don't like calling attention to myself.
I have a difficult time getting things done at time.

What's important in my career?
I want to have a successful career in the fine arts. I want to be able to create art using my passion, but also earn a good living. I want to be at respected by people in the art world. I want my work to be exhibited in some of the finest art museums in the world.

Strengths and Weaknesses Worksheet—
Career as a Graphic Artist

My strengths:
I am a talented graphic artist
I have a double major in graphic arts
 and advertising.
I have a lot of energy.
I can get along with almost everyone.
I am passionate about my work.
I can follow instruction.
I'm a team player, yet can work on my own.
I'm organized.
I learn fast.
I know how to do Web design and am an
 accomplished Web designer.

My weaknesses:
I'm a perfectionist.
I don't like speaking in front of groups
 of people so it's difficult to *sell* my
 ideas.
I'm shy.
I need better written communication
 skills.
I'm not good with time frames.

What's important in my career?
I want a career as a graphic artist working in a major advertising agency. I eventually want to
be the art director in one of the top advertising agencies in the country.

Tip from the Top

Remember that as friendly as human resources directors, headhunters, or interviewers may seem during interviews, their job is screening out candidates. You don't ever want to give someone a reason not to hire you.

If one of these individuals asks you what your weaknesses are, be prepared. Come up with something you can *say* is a weakness but really could also be perceived as a strength. So, instead of mentioning your *real* weaknesses, you might, for example, say you are a perfectionist and like to do things right. Or you might say you are an eternal optimist and never see the negative side of a situation.

Tip from the Coach

In certain situations, an interviewer might zero in on a weakness they feel you have in regard to a job. A good way to deal with an interviewer asking you how you will deal with a specific weakness that *they* identify is by saying you are actively trying to change it into a strength. For example, if one of your weaknesses is you don't like speaking in public, you might say you are working on that particular area by taking a public speaking class. Telling an interviewer you are working on your shortcomings helps him or her form a much better picture of you.

Strengths and Weaknesses Worksheet

My strengths:

My weaknesses:

What's important in my career?

Now that you know some of your strengths and weaknesses, it's time to focus on your personal inventory. Your combination of skills, talents, and personality traits are what helps determine your marketability.

What Are Your Skills?

Skills are acquired things that you have learned to do and you do well. They are part of your selling tools. Keep in mind that there are a variety of relevant skills. There are job-related skills that you use at your present job. Transferable skills are skills that you used on one job and that you can transfer to another. Life skills are skills you use in everyday living such as problem solving, time management, decision making, and

★ Tip from the Top

At almost every interview you will go on, you will be asked your strengths and weaknesses. Preparing a script ahead of time gives you the edge. Remember when doing this to tailor your answer to the specific position you are going after.

interpersonal skills. Hobby or leisure time skills are skills related to activities you do during your spare time for enjoyment. These might or might not be pertinent to your career. There are also technical skills connected to the use of machinery. Many of these types of skills overlap.

Most people don't realize just how many skills they have. They aren't aware of the specialized knowledge they possess. Are you one of them?

While it's sometimes difficult to put your skills down on paper, it's essential so you can see what they are and where you can use them in your career. Your skills, along with your talents and personality traits, make you unique. They can set you apart from other job applicants, artists, craftspeople, designers, salespeople, and so on, and can help you land the career of your dreams.

Once you've given some thought to your skills, it's time to start putting them down on paper. You can either use the Skills Worksheet or a page in a notebook. Begin with the skills you know you have. What are you good at? What can you do? What have you done? Include everything you can think of from basic skills on up, and then think of the things people have told you you're good at.

Don't get caught up thinking that "everyone can do that" and so a particular skill of yours is not special. *All* your skills are special. Include them all in your list.

Review these skill examples to help get you started. Remember this is just a beginning.

- computer proficiency
- public speaking
- time management
- analytical skills
- organizational skills
- writing skills
- listening skills
- verbal communications
- management

Tip from the Top
Some skills also require *talent*. For example, computer graphics is a skill. It can be learned. To be great at computer graphics, however, you generally need talent. Similarly, learning writing a press release is a skill. The talent is *how* you write it. Painting might be a skill. A great painter must be talented.

- sales skills
- computer graphic skills
- problem solving
- language skills
- leadership
- math skills
- decision-making skills
- negotiating skills
- money management
- word-processing skills
- computer repair
- teaching
- customer service
- cooking
- Web design
- singing
- playing an instrument
- interior decorating
- sewing skills
- instrument repair
- sculpting
- painting

Tip from the Coach
Don't limit the skills you list to just those that relate to the art industry. Include all your skills. Even when a skill seems irrelevant, you can never tell when it might come in handy.

Skills Worksheet

Your Talents

You are born with your talents. They aren't acquired like skills, but they may be refined and perfected. Many people are reluctant to admit what their talents are, but if you don't identify and use them, you'll be wasting them.

What are your talents? You probably already know what some of them are. What are you not only good at but better at than most other people? What can you do with ease? What has been your passion for as long as you can remember? These will be your talents.

Are you a great painter? Can you bring a picture to life? Are you a great writer? Can you bring a story to life? Are you a talented marketer? Can you come up with unique ideas? Are you a talented fund-raiser? Do you have that something extra others just don't have?

Are you a talented graphic artist? Can you use graphics to create great advertisements or other layouts?

Can you *see* raw talent? Can you look at an artist and just *know* that with a little training and work he or she can be great?

Are you a talented teacher? Do you have that special ability to motivate and teach others to go to the next level?

Is your talent that of making people comfortable in every situation? Is your talent making people laugh and seeing the humor in situations? Can you tell stories and jokes in such a manner that those listening just can't stop themselves from laughing?

Does your talent fall in the science area? How about math? What about art? Think about it for a bit and then jot your talents in your notebook or in the Talents Worksheet. Here are a few examples to get you started.

Talents Worksheet—Director of Volunteers, Museum

I am talented at teaching people how to do things.

I motivate and inspire people.

I am a good communicator. I can explain things well.

I don't get stressed and I have the ability to de-stress even stressful situations.

I have the ability to make people around me feel good about themselves.

Talents Worksheet—Interior Designer

I am a talented designer.

I can see unique color combinations that others might not see.

I am equally talented at designing all styles of room.

I am a charismatic.

I am a team player.

I'm a talented listener. I can translate the ideas that people say they want to what they really mean.

Talents Worksheet—Jewelry Designer

I am a talented jewelry designer.

I am very creative and have unique ideas.

I am talented designing jewelry in a variety of mediums.

I am talented in putting together gems and metals.

I'm a talented salesperson.

Talents Worksheet—Museum Publicist

I am a talented writer.

I am very creative and have unique ideas.

I am talented at putting a positive spin on most situations.

I have a great sense of humor. I can make almost everyone I'm around feel better by making them laugh.

I have the ability to inspire people.

People generally like me and I like them. I'm a people person.

Talents Worksheet

Your Personality Traits

We all have different personality traits. The combination of these traits is what sets us apart from others. There are certain personality traits that can help you move ahead no matter what segment of the industry in which you work. Let's look at some of them.

◎ ability to get along well with others
◎ adaptable
◎ ambitious
◎ analytical
◎ assertive
◎ charismatic
◎ clever
◎ compassionate
◎ competitive
◎ conscientious
◎ creative
◎ dependable
◎ efficient
◎ energetic
◎ enterprising
◎ enthusiastic
◎ flexible
◎ friendly
◎ hard worker
◎ helpful
◎ honest
◎ imaginative
◎ innovative
◎ inquisitive
◎ insightful
◎ observant
◎ optimistic
◎ outgoing
◎ passionate
◎ personable
◎ persuasive
◎ positive

> ### ★ The Inside Scoop
> In some instances, you might find that your talents mesh with your personality traits or even your skills. The combination of what you have to offer makes you unique.

◎ practical
◎ problem solver
◎ reliable
◎ resourceful
◎ self-starter
◎ self-confident
◎ sociable
◎ successful
◎ team player
◎ understanding

What are your special personality traits? What helps make you unique? Think about it, and then jot them down in your notebook or in the Personality Traits Worksheet on page 81.

Special Accomplishments

What special accomplishments have you achieved? Special accomplishments help distinguish you. They make you unique and often will give you an edge over others.

Have you won any awards? Did you win a ribbon at an art show? Were you awarded a scholarship? Did you get a great write-up about your work?

Were you the president of your class? Were you the chairperson of a special event? Have you won a community service award? Were you nominated for an award even if you didn't win? Has an article about you appeared in a regional or national magazine or newspaper? Have you written an article that appeared in a publication? Have you

Personality Traits Worksheet

been a special guest on a radio or television show? Are you sought out as an expert on some subject in the art industry or even something else?

All these things are examples of some of the special accomplishments you may have experienced. Think about it for a while and you'll be able to come up with your own list. Once you identify your accomplishments, jot them down in your notebook or on your Special Accomplishments Worksheet on page 82.

Special Accomplishments Worksheet

Education and Training

Education and training are important to the success of your career. A college background or art school can't guarantee you a job in the art industry, but it often helps prepare you for life, whether it be as an artist, designer, or craftsperson, or in the workplace.

If your goal is a career in the business or administrative segment of the industry, most positions will either require or prefer that you have a college background. Depending on the school you're attending and your career choice, a college education will also be helpful in helping you hone skills, learn about the business, and make important contacts.

If your goal is a career as an artist or craftsperson, in many situations, college or art school can help you develop your talent and refine your skills. It also gives you exposure, giving you easier access to people who might be important in your career.

Keep in mind that education may encompass a variety of training opportunities. This may include classes, courses, seminars, workshops, programs, apprenticeships, and learning from your peers.

What type of education and training do you already possess? What type of education and training do you need to get to the career of your

★ Tip from the Coach

Courses, seminars, and workshops are great ways to meet and network with industry insiders. Actively seek them out.

dreams? What type of education will help you get where you want to go?

Would art school or specialized training help you reach your career goals? Is there a workshop or seminar that will give you the edge? Is there someone you can apprentice with? Is there someone who gives classes in an area where you can learn new techniques or new skills? Are there other forms of training that might help your career move in a forward direction?

Is a college degree what you're missing to give you the edge over other applicants seeking jobs in the business or administrative segment of the industry? How about some workshops or seminars? What about attending some conferences? The options are yours.

⭐ **Words from a Pro**

Give yourself every opportunity possible. Look for classes, seminars, and workshops with the best teachers and instructors you can find. They will help give you the blocks to build a successful career.

Now is the time to determine what education or training you have and what you need so that you can go after it. Below is a sample to get your started. Fill in the blank Education and Training Worksheet on page 84 with your information so you know what you need to further your career and meet your goals.

Education and Training Worksheet

What education and training do I have?
Associate's degree with a major in commercial art.
Two semesters away from bachelor's degree in fine art.
Seminars and workshops in illustration, Web design.

What education or training do I need to reach my goals?
Finish college to get my bachelor's degree in fine art.
Additional seminars and workshops in illustrating and animation.

What classes, seminars, workshops, and so on have I taken that are useful to my career aspirations?
Web Design
Art Industry Overview
Animation

What classes, seminars, workshops, courses, and other steps can I take to help my career?
Take electives in business.
Publicity workshops
Look for internships at printers or advertising agencies in art department.

Education and Training Worksheet

What education and training do I have?

What education or training do I need to reach my goals?

What classes, seminars, and workshops have I taken that are useful to my career aspirations?

What classes, seminars, workshops, and courses can I take to help advance my career?

Location, Location, Location: Where Do You Want to Be?

As we discuss throughout this book, success comes from a combination of a number of things, including talent, luck, perseverance, and being at the right place at the right time. What are the best locations if you want to work in the art industry? That depends on what you want to do.

There's something to be said about being at the right place at the right time. No matter what career area you want to pursue in the art industry, in deciding where you want to be headquar-

tered, remember that it is helpful to be *where it's happening*. You have more opportunities to meet the people you need to meet to help you get to the top level of your career quicker. You will also have more opportunities to make important contacts necessary to your career success.

Luckily, while there are certain locations which will provide more opportunities, depending on exactly what you want to do, the art industry has opportunities throughout the country.

Many art museums, for example, are located in larger cities in the country. There are, however, many smaller museums located in other regions that may offer a wealth of opportunities. The same is true of art or craft galleries. While some of the better-known galleries may be located in metropolitan areas, there are smaller galleries that offer good opportunities just the same.

One of the good things about less-metropolitan areas is that opportunities are often easier to locate and land. There are a number of reasons for this. A major reason for this is the high turnover rates in these positions as people obtain experience and advance their careers.

> ## ★ The Inside Scoop
>
> If you are planning on striking out on your own as an artist's representative, you will generally have an easier time if you are located in a more metropolitan area or at least an area closer to where your clients and the media are located.

While as an artist or craftsperson you can almost live anywhere to create your work, you still need to find markets to sell it. Your choices of the best location will depend on whether you have someone representing your work or you are wholesaling, retailing or selling it yourself.

If your career interest is in the area of commercial art or the graphic arts, opportunities exist throughout the country. The most options, however, will still be in larger cities.

These are all things you have to think about when planning your career. Location is just another of the keys you need to consider in your plan for success.

Location Worksheet

Type of area I reside in now:

Location of job or career choice I want:

Other possible locations:

Reviewing Your Past

Let's now look at your past. What have you done that can help you succeed in your career in the art industry?

I really haven't done anything remotely related," you might say. "At least nothing anyone else would count."

I'm betting you have.

Make a list of all the jobs you have had and the general functions you were responsible for when you held them. Look at this information and see what functions or skills you can transfer to your career in the art industry. Did you have a summer job as a craft counselor at a summer camp? Have you volunteered and helped a not-for-profit organization execute a special event? Have you worked in the craft department of a major retailer or at a craft store? Have you worked in any aspect of sales? Are you an art teacher? Have you worked or volunteered with any not-for-profit organization? Have you worked in a museum in any capacity? Have you interned at a television station? Did you have a summer job as a reporter?

"None of my past jobs have anything to do with the art industry," you say. That's okay. Many skills are transferable.

"Give me examples," you say.

Have you held a job as a reporter for a local newspaper? That shows that you know how to develop and write an article or news story and can do it in a timely fashion. These skills can easily be transferred if you are interested in a career as a journalist for an art magazine or art columnist for a newspaper. You might use those same skills to become a publicist for an artist, the promoter of an art or craft show, a gallery, or a museum.

Have you worked in a bank? That illustrates that you work well with money.

Have you worked as a bookkeeper? These skills can be transferred to working as a bookkeeper for an art gallery. With some education and certification you might be able to fulfill your goals of working as an accountant for an art museum. You might even become a business manager for a hot artist.

Have you sold advertising for a newspaper or radio station? Transfer those skills to selling artwork, crafts, sponsorships, tickets, or almost anything else in the art industry.

Remember the idea is to use your existing talents, skills, and accomplishments to get your foot in the door. Once in, you can find ways to move up the ladder so you can achieve the career of your dreams. When going over your list of past positions, include both part-time jobs you had as well as full-time ones. Look at the entire picture, including not only your jobs but your accomplishments and see what they might tell about you.

"Like what?" you ask.

Did you graduate from high school in three years instead of four? That illustrates that you're driven and can accomplish your goals. Were you the chairperson for a not-for-profit charity event? That illustrates that you take initiative, work well with people, and can delegate and organize well.

Have you volunteered to teach art or crafts to kids? This shows you can help motivate others. Were you an administrative assistant? This illustrates you are organized and can work well with others.

Now that you have some ideas, think about what you've done and see how you can relate it to your dream career. Everything you have done in your life, including your past jobs, volunteer and civic activities, and other endeavors, can help create your future dream career in whatever area of the art industry you want to pursue.

Using Your Past to Create Your Future

When reviewing past jobs and volunteer activities, see how they can be used to help you get what you want in the art industry. Answer the following questions:

- What parts of each job accomplishment or volunteer activity did you love?
- What parts made you happy?
- What parts gave you joy?
- What parts of your previous jobs excited you?
- What skills did you learn while on those jobs?
- What skills can be transferred to your career in the art industry?
- What accomplishments can help your career in the arts industry?

Jot down your answers in your notebook or use the Using Your Past to Create Your Future worksheet provided below.

Using Your Past to Create Your Future

Past Job/ Volunteer Activity/ Accomplishment	Parts of Job/ Volunteer Activity/ Accomplishment which I Enjoyed	Skills I Learned and Can Transfer to Career in the Art Industry

> ### ⭐ Tip from the Top
>
> If you're just out of school, your accomplishments will probably be more focused on what you did while in school. As you get more established in your career, your accomplishments will be more focused on what you've done *during* your career.

The more ways you can find to use past accomplishments and experience to move closer to success in your career in the art industry, the better you will be. Look outside the box to find ways to transfer your skills and use jobs and activities as stepping-stones to get where you're going.

Passions and Goals

Once you know what you have, it's easier to determine what you need to get what you want. You've made a lot of progress by working on your self-assessment, but you have a few more things to do. At this point, you need to focus on exactly what you want to do.

What is your passion? What are your goals?

In what area of the art industry do you want to be involved? What are your specific interests? Do you want to be a fine artist? What specific medium are you planning on specializing?

Do you want to be a commercial artist? What about a cartoonist? How about an illustrator? Is your passion designing in some manner? What about being a craftsperson? The possibilities are endless.

Do you want to work in the business or administration segment of the art world? Do you want to work in the communications area? Is your dream to be an artist's representative? What about a gallery manager?

Perhaps you're interested in working as a journalist, columnist, or reporter. Maybe you want a career as a publicist or press agent. Maybe you want to work in an art museum. Maybe you want to work in a gallery. Is it your dream to be an art or craft show promoter? There are many opportunities; you just need to choose exactly what you want to do.

Do you like working behind the scenes or is it your goal to work on the front line? Do you like working with numbers? What about public speaking? Do you like organizing things? Is selling your passion? What about teaching? Do you want to create special events in some aspect of the art industry? What is your dream? It's all up to you.

You began working on this task with the worksheets in an earlier chapter. Continue to refine your list of things that you enjoy and want

> ### ⭐ The Inside Scoop
>
> I recently sat in during an interview of two people for a position. The first gentleman came to the interview dressed to the tee, with a perfect resume. He had experience, he had the background, and he was full of confidence. When asked why he wanted the job, his response was that he wanted a change.
>
> The next person who came in to be interviewed was a woman who didn't have a great resume. She didn't have the background that the man had. She didn't have the experience that the man had. And she didn't have the skills that the man had. When asked why she wanted the job, her response was that she thought she could be an asset to the organization. She passionately said she was excited about the opportunity, rattled off a few ideas about what she could do, and mentioned that she had always dreamed of that type of job. And while she was not the most qualified, she was the most passionate and got the job. The moral of the story is that illustrating a burning passion for a job can often overcome any lack of qualifications.

to do. Previously you defined your career goals. Now that you've assessed the situation, are they still the same?

What are your passions? You can be the most talented artist in the world, but if you don't have a passion for art, it's a bad career choice. You might be a talented writer, but if you don't enjoy writing, it's not a good career choice either. Similarly, you might be great at coordinating events, but if it stresses you out and you can't wait until the event is over, a career as a special-event planner at a museum probably wouldn't be the best career choice.

You owe it to yourself to have a career that you love, that you're passionate about, and that you deserve. Take the time now to make sure that you get it by going after your passions. Believe it or not, passion in many cases can override talent.

What does that mean? It means that while talent is important, the desire to do something you're passionate about can make it happen.

There are thousands of people in all aspects of the art industry who are less talented than others, yet they've made it big. They've succeeded where their more talented counterparts have not. What's the difference? They had more passion for what they wanted, they had drive, they had determination, and they never gave up on their goals. If *you* have that passion, you can reach your goals too.

Your Support Team

If you're working toward a successful career as an artist or professional craftsperson, you might take some time to think about your support team. While at the beginning of your career you might be managing and advising yourself, sooner or later you probably are going to have a support team.

> ⭐ **Words from the Wise**
> No matter what anyone tells you about a contract or agreement being routine, read and understand every line before you sign it.

Exactly what is a support team? Basically it's the team of people who help guide your career. These might include personal managers, agents, representatives, business managers, accountants, attorneys, publicists, and press agents.

We're going to discuss more about your support team later. At this point, however, let's take a moment to discuss attorneys. Why? Because I want you to protect yourself.

Do you need an attorney? Yes, if you are in the position where you are being asked to sign contracts and agreements, it is time to find an attorney.

Your best bet is an attorney who specializes in the area of the art industry in which you are involved. An attorney specializing in this area will be up on lingo and have more knowledge about the industry and its contracts. Additionally, he or she may have contacts within the industry that could be helpful to you.

It's a good idea to have an attorney review your contracts *before* you sign them. Keep in mind that contracts are legally binding agreements. Before you sign any agreement, (even if an attorney is handling it for you), read and fully understand contracts and documents you are asked to sign. If you don't understand something, don't be embarrassed to ask what it means. This is *your* career on the line.

Prepare yourself and success will follow. You are now on your way to the career of your dreams.

5

JOB SEARCH STRATEGIES

If you've decided that your dream career is in some aspect of art, you are in luck. There are thousands of jobs and opportunities in the various segments of the industry as well as the peripherals. One of them can be yours!

We've talked about some of the various options in previous chapters. Some jobs are easier to obtain. Some may be more difficult. This section will cover some traditional and not so traditional job search strategies.

It's important to recognize that *getting* the job is just the beginning. What you want is a career.

Using a Job to Create a Career

Unfortunately you can't just go to the store and get a great career. Generally, it's something you have to work at and create. How do you create your dream career? Developing the ultimate career takes a lot of things, including sweat, stamina, and creativity. It takes luck and being in the right place at the right time. It takes talent and experience. It takes education and training. It takes perseverance and passion. And it takes a faith in yourself that if you work hard for what you want and don't give up, you will get it.

You have to take each job and opportunity you get along the way and make it *work* for

you. Think of every job as a rung on the career ladder, every assignment within that job as a stepping-stone. To complete the puzzle takes lots of pieces and lots of work, but it will be worth it in the end.

Of course, if you know your ultimate goal is a career in some aspect of the art industry, it's much easier to see how each job you do can get you a little closer. Every job, no matter how small, gives you another experience, hones your skills, helps you gain confidence, and gives you the opportunity to be discovered by a potential employer. Every job can lead you to the career you've been dreaming about.

And this doesn't just apply in the business or administrative end of the industry; it relates to those such as artists, designers, and craftspeople in the talent area as well.

One of the things you should know is that while most anyone can get a *job*, not everyone ends up with a career. As we discussed in a previous section, the difference between a job and a career is that a job is a means to an end. It's something you do to get things done and to earn a living. Your career, on the other hand, is a series of related jobs you build using your skills, talents, and passions. It's a progressive path of achievement.

When you were a child, perhaps your parents dangled the proverbial carrot in front of you, tempting you to eat your dinner so that you could have chocolate ice cream and cake for dessert. Whether dinner was food you liked, didn't particularly care for, or a combination, you probably ate it most of the time to get to what you wanted—dessert. In this case, your dessert will be ultimate success in your career in the art industry.

Use every experience, every job, and every opportunity for the ultimate goal of filling your life with excitement and passion while getting paid. Will there be things you don't enjoy doing and jobs you wish you didn't have along the way? Perhaps, but there will also be things you love doing and jobs you look back on and remember with joy.

Every job you get along the way helps to sharpen your skills and adds another line to your resume. Every situation is an opportunity to network, learn, and get noticed in a positive manner.

If you know what your ultimate goal is, it is much easier to see how each job you do can get you a little closer. Every situation, no matter how small or insignificant you think it may be, gives you another experience, hones your skills, helps you gain confidence, and gives you the opportunity to be seen and discovered. Every job can lead you to the career you've been dreaming about no matter what area of the art industry in which you aspire to succeed.

Tip from the Coach

It may take some time to get where you want to in your career. Try to make your journey as exciting as your destination.

Tip from the Coach

Don't get so caught up in getting to your goal that you don't enjoy your journey.

Your Career: Where Are You Now?

Where are you in your career now? Are you still in school? Are you just starting out? Are you in another field and want to move into a career in some aspect of the art industry? Are you currently working in one segment of the art industry yet want to work in another? Do you know what you want to do with the rest of your life? If any one of these scenarios is yours, read on.

Moving into the Art Industry: Career Changing

Are you currently working in another industry but really want to be in some segment of the art world? If so, you're not alone. Many people have dreamt about a career in art for years but for a variety of reasons ended up doing something else. Is this you? If so, read on.

Perhaps at the time, you needed a job. Possibly it looked too difficult to obtain a career in the aspect of the art industry you chose. Maybe you couldn't afford the time or money to finish your education.

Maybe you just didn't know how to go about it. Maybe you weren't ready. Maybe people around you told you that you were pipe dreaming. Maybe you were scared. Or maybe someone offered you a job in a different industry and you took it for security. There might be hundreds of reasons why you wanted a career in the art industry but you didn't pursue it at the time. The question is, do you want to be there now?

"Well, "you say. "I do, but..."

Before you go through your list of *buts,* ask yourself these questions. Do you want to give up your dream? Do you want to live your life saying, "I wish I had" and never trying?

Wouldn't you rather find a way to do what you wanted than never really be happy with what you're doing? Wouldn't it be great to look at others who are doing what they want and know that *you* are one of them? Here's the good news. You can! You just have to make the decision to do it.

How can you move into the art industry from a different industry? How can you change your career path? First, take stock of what you have and what you don't have. Learn how to transfer skills. That means going over your skills and finding ways you can use them in the career of your choice.

"Don't I need to do more than just transfer skills?" you ask.

In some situations you might, but it is a beginning. Transfer any applicable skills you have. Then, depending on what you want to do, you'll need to ascertain what additional education, training, or experience you might need before going on your job search.

⭐ **Tip from the Coach**

Are you living someone else's dream? You can't change your past, but you can change your future. If your dream is to work in an aspect of the art industry, go for it. Things might not change overnight, but the first step you take toward your new career will get you closer to your dream. Every day you put it off is one more day you're wasting doing something you don't love. You deserve more. You deserve the best.

What kinds of skills are transferable? Almost any skill you use at one job that you might be able to use at another would be a transferable skill. These might include writing skills, people skills, number-crunching skills, computer skills, marketing skills, and so on.

Do you have strong writing skills? Consider seeking out a position at a museum in the public relations department. Think about working in the publications department. What about the marketing department? How about a job working with a public relations or publicity firm that specializes in handling artists or art galleries? What about looking for a job as an art critic for a newspaper, magazine, or even one of the trades?

Do you have strong people skills? Do you love art? What about using your skills to teach docents? What about becoming the director of volunteers at an art museum?

Are your skills in number crunching? What about seeking out a position in an art museum's accounting department? What about working with a CPA who specializes in handling artists and galleries? What about going on the road with a major art or craft show promoter handling their books?

Do you have office skills? Are you a good manager? Do you have good organizational skills? Consider a job as an administrative assistant at an art council, not-for-profit art group, or art museum. What about a position as the manager of an art gallery? One of the exciting things about these types of positions is that you get to learn the ropes and often have a great chance of moving up the career ladder.

Do you have information technology (IT) skills? Are you a webmaster? Do you have other computer skills? Today, most museums have Web sites even if they have no IT department.

So do most galleries. What about creating Web sites for individual artists?

Are your skills in marketing? Are you working in marketing in another industry? Consider a position in an art museum's marketing department. What about a position as a marketing director for a large gallery? What about a position in a firm that markets artists? How about marketing art shows or craft shows?

Are your skills in sales? Lucky you! The possibilities are endless. Every industry needs salespeople, and the art industry is no exception. There are tons of retail positions selling art and craft supplies. There are also positions selling merchandise in art museum shops. What about a position as an artist's rep selling their work? How about selling in a gallery? What about selling your own work at a craft fair?

"Wait a minute," you say. "What if I don't want to work in the area where my skills are? What if I want to be something like a top exec at a museum but I'm working as an artist? What if I want to work in the administrative segment of the industry but I'm a graphic artist? What if I'm working in administration but want to totally change my direction and pursue a career as an artist. What then?"

Here's the deal. If you have skills and talents that can help you get your foot in the door, use them. Once in, you have a better opportunity to move into the area you want.

Can you do it? Can you find the career of your dreams? Yes! Thousands of people are successful in the industry. You can be too!

Should you quit your present job to go after your dream? And if so, when should you make the move? Good questions. Generally, you are much more employable if you are employed. You don't have that desperate "I need a job" look. You don't have the worries about finan-cially supporting yourself and your family, if you have one. You don't have to take the wrong job because you've been out of work so long that *anything* looks good.

It's best to work on starting your dream career while you have a job to support yourself. Ideally, you'll be able to leave one job directly for another much more to your liking.

Of course, in some situations, that idea doesn't work. In some situations you might want to (or need to) devote most of your time to your career. Only you can make the decision on how to go about starting your career. Take some time to decide what would be best for you.

You should focus on exactly what you want to do, set your goals, prepare your action plan, and start taking action now. You're going to have to begin moving toward your goals every day; a job in itself, but a job that can lead to the career of your dreams.

Let's take a moment to talk about the "talent" segment of the industry. In order to survive financially, many aspiring artists hold down other jobs sometimes referred to as "day jobs" to earn a living and make ends meet until they have their big break.

Whether you're working as a waiter, waitress, secretary, administrative assistant, or sales

★ Words from the Wise

If you are working at another job until you get the one you want, it's not a good idea to keep harping on the fact that you're only there until you get your big break or the job of your dreams. If your supervisor thinks you are planning on leaving, not only will you probably not get the choice assignments, but coworkers who are *stuck* in the job you are using as a stepping-stone often feel jealous.

associate, or you hold an administrative or managerial position, your goal should be to make enough money to support yourself until you *make it* in as an artist.

No matter what segment of the art industry you aspire to work in, the question many ask is, "When do I quit the job I have to go after the job I want?" No one can answer this for you, but try to be realistic. You don't want to ever be in the position where you *can't* do what you want because you don't have any funds. Do you have a nest egg put away? In order to have the best shot at what you want to do, you need to be as financially stable as possible.

We've already discussed that you are usually more marketable if you are currently employed. This doesn't mean you shouldn't work toward your goals. Continue searching out ways to get where you're going.

"Working takes all my energy," you say. "I don't have time to do everything." If I'm working, I just don't have enough time to put into creating my dream career."

You're going to have to make time. It's amazing how you can expand your time when you need to. Remember your action plan? It's imperative that you carve time out of your day to perform some of your actions.

If you think you don't have the time, look at your day a little closer. What can you eliminate doing? Will getting up half an hour early give you more time to work on your career? How about cutting out an hour of TV during the day or staying off the computer for an hour? Even if you can only afford to take time in 15-minute increments, you usually can find an hour to put into your career.

Moving from One Segment of the Art Industry to Another

Are you currently working in one segment of the art industry and want to work in another? If you want to change careers within the industry, find what you need to do to get the career of your dreams and then do it! Don't procrastinate. Check out the requirements of the job or opportunity you are seeking. Look into what education you need to reach your goals. Look into the training needed. Find a mentor. Ask questions.

Talk to people. Look for books in the career area in which you are interested. Check out Web sites. See what you need to get the job and go after it.

No matter what area of the art industry you want to move from and what area of you are considering moving to, if you research what you need to do and take it step by step, you will be on your way to getting the job of your dreams.

What should you *not* do? The most important piece of advice I can give you is don't give up before you get started. Don't get so caught

⭐ The Inside Scoop

In your journey toward obtaining your perfect career in the art industry, you might take some jobs that, while considered stepping-stones, are not where you ultimately want to end up career-wise. No matter what type of career you aspire to, it is essential that you remember your ultimate goal. Don't get so wrapped up in the job you have that you forget where you're going.

Over the years I've often seen people take a job because the money was there, even though it wasn't exactly what they wanted. Then, as time goes on, they are offered more money or promotions and find it difficult to give it up" even to pursue their goals. Don't get so busy that you forget where you're going and what you want. If you have a dream, don't forget your goals.

up in how difficult something will be that you don't look for a way to do it. Most of all, don't discount your dreams.

Finding the Job You Want

Perseverance is essential to your success no matter what you want to do, what area of the industry you want to enter, and what career level you want to achieve. Do you want to know why most people don't find their perfect job? It's because they gave up looking *before* they found it.

Difficult as it might be to realize at this point, remember that your job, your great career, is out there waiting for you. You just have to locate it. How do you find that all-elusive position you want? You look for it!

Later in the book, we're going to focus on how you can achieve better success if your career goal is to work as a fine artist or craftsperson. Right now, what we are going to discuss, however, is actually locating a job.

Basically, jobs are located in two areas: the open job market and the hidden job market. What's the difference? The open job market is comprised of jobs that are advertised and announced to the public. The hidden job market is comprised of jobs that are not advertised or announced to the public.

Where can you find the largest number of jobs? Are they in the hidden job market or the open job market? That depends on what you specifically want to do in the industry. While many positions are often advertised in the open market, you should be aware that there are also a great many jobs that may not be advertised. Why?

There are a few reasons. Some employers don't want to put an ad in the classified section of the newspaper, because it might potentially mean that there could be hundreds of responses if not more.

"But isn't that what employers want?" you ask. "Someone to *fill* their job openings?"

Of course they want their job openings filled, but they don't want to have to go through hundreds of resumes and cover letters to get to that point. It is much easier to try to find qualified applicants in other ways, and that is where the hidden job market comes in.

The smart thing to do to boost your job hunt is to utilize every avenue to find your job. With that being said, let's discuss the open job market a bit, and then we'll go on to talk about the hidden job market in more detail.

The Open Job Market

When you think of looking for a job, where do you start? If you're like most people, you head straight for the classifieds. While, as we just noted, in certain situations, this strategy may not always be the best bet, it's at least worth checking out. Let's go over some ways to increase your chances of success in locating job openings this way.

The Sunday newspapers usually have the largest collection of help wanted ads. Start by focusing on those. You can never tell when an employer will advertise job openings, though you might also want to browse through the classified section on a daily basis if possible.

Will you find a job you want advertised in your local hometown newspaper? That depends on what type of job you're seeking and where you live. If you live in a small town and you're looking for a position developing special art exhibits for a major art museum, probably not. If you're looking for a position as an elementary school art teacher, your chances are better.

What do you do if you don't live in the area you want to look for a job? How can you get the newspapers?

There are a number of solutions. Larger bookstores and libraries often carry Sunday newspapers from many metropolitan cities in the country. If you're interested in getting newspapers from specific areas, you can also usually order short-term subscriptions. One of the easiest ways to view the classified sections of newspapers from around the country is by going online to newspapers' Web sites. The home page will direct you to the classified or employment section. Start your search from there.

What do you look for once you get to the classified or employment section? That depends on the specific job you're after, but generally look for key words. You might look for key words such as, "Museum," "Art Museum," "Art Gallery," "Art Director," "Graphic Artist," "Art Buyer," "Interior Designer," "Fabric Designer," "Art Teacher," "Special Events Director—Art Museum," "Jewelry Designer," "Executive Director—Art Museum," "Curator," "Traveling Art Exhibit," and so on.

Don't forget to look for specific company or organization names as well: "Some Town Art Museum," "New Artist Gallery," "ABC Craft Show Promotion," and so on.

Keep in mind that in many situations, large museums, galleries, or other companies may also use boxed or display classified ads. These are large ads that may advertise more than one job and usually have a company name and/or logo.

The Trades, Newsletters, Bulletins, and Web Resources

Where else are jobs advertised? The trades are often a good source. Trades are periodicals geared toward specific industries. Every industry has these publications and the art industry is no exception. Generally, each segment of the industry has its own trades.

Where do you find them? Contact trade associations geared toward the specific area of the industry in which you are interested. (Trade associations are listed in the appendix in the back of this book.)

How can you use the trades to your advantage? Read them faithfully. If you don't want to invest in a subscription, go to your local or college library to see if they subscribe. Many of the trades also have online versions of their publications. Browse through the "Help Wanted" ads in the classified section each issue to see if your dream job is there.

Newsletters related to the various areas of the art industry might offer other possibilities for job openings. What about Web sites such as monster.com, hotjobs.com, and other employment sites? Don't forget Web sites oriented toward the area of the art industry in which you are interested. As we discussed earlier, many museums, galleries, and so on have Web sites. Many of these sites have specific sections listing career opportunities. It's worth checking out.

Are you already working in the industry and seeking to move up the career ladder? Check out employment listings in human resources departments, employee newsletters, and bulletins.

What do you do if you don't have a job yet and are interested in finding out about internal postings? This is where networking comes into play. A contact at the organization or company can help keep you informed. While employment listings for many companies are generally available to the public, it's always good to know what is happening first so you can prepare.

If you're still in college or graduated from a school that has programs in the area in which you are interested, check with the college placement office. Organizations seeking to fill specific positions often go to these schools in hopes of finding qualified candidates.

Employment Agencies, Recruiters, Headhunters, and Executive Search Firms

Let's take a few minutes to discuss employment agencies, recruiters, and headhunters. What are they? What's the difference? Should you use them?

Employment agencies may fall into a number of different categories. They may be temp agencies, personnel agencies, or a combination of the two. Temp agencies work with companies to provide employees for short-term or fill-in work. These agencies generally specialize in a number of career areas. Some agencies even provide workers for longer-term projects.

How do they work? Basically a company tells an agency what types of positions they are looking to fill, and the temp agency recruits workers who they feel are qualified for those positions. The business then pays the agency, and the agency pays the employee.

When you work in this capacity, you are not working for the company, organization, museum, and so on. You are an employee of the temp agency. Generally in this type of situation, you do not pay a fee to be placed.

Personnel agencies, on the other hand, work in a different manner. These agencies try to match people who are looking for a job with companies that have openings. When you go to

a personnel agency, they will interview you, talk about your qualifications and if the interviewer feels you are suitable will send you to speak to companies who have openings for which you are qualified. You may then meet with an HR director or someone else in the human resources department of the company with the opening. You may or may not get the job. There are no guarantees using a personnel agency.

If you do get the job, you will generally have to pay a portion of your first year's salary to the personnel company that helped you get the job. In some cases, the employer will split the fee with you. Check ahead of time so you will have no surprises.

You should not be required to pay anything up front. You may be asked to sign a contract. Before you sign anything, read it thoroughly and understand everything. If you don't understand what something means, ask.

Recruiters, headhunters, and executive search firms are all similar. These firms generally have contracts with employers who are looking for employees with specific skills, talents, and experience. It is their job to find people to fill those positions.

The difference between recruiters, headhunters, and executive search firms and the employment or personnel agencies we discussed previously is that you (as the job seeker) are not responsible for paying a fee. The fee will instead be paid for by the employer.

How do these companies find you? There are a number of ways. Sometimes they read a story in the paper about you or see a press release about an award you received. Sometimes someone they know recommends you.

In some cases they just cold call people who have jobs like they are trying to fill and ask if they know anyone who might be looking for a similar job whom you might recommend. You might recommend someone or you might even say you are interested yourself.

What if no one calls you? Are you out of luck? Not at all. It's perfectly acceptable to call recruiters and headhunters yourself.

What you need to do is find the firms that specialize in the industry in which you are seeking a job. So, for example, if you are the director of development at an art museum and are looking for a job in that field, you would look for executive recruiters who specialize in the administrative area of museums or not-for-profits.

How do you find them? There are over 5,000 executive recruiting agencies in the United States. You can search out firms on the Internet or look in the Yellow Pages of phone books from large, metropolitan areas.

Don't forget to check out trade magazines and periodicals. Many have advertisements for recruiters in their specific career area.

Why do companies look to recruiters to find their employers? Generally, it's easier. They have someone screening potential employees, looking for just the right one. As recruiters don't generally get paid unless they find the right employee, they have the perfect incentive.

Should you get involved with a recruiter? As recruiters bring job possibilities to you, there really isn't a downside. As a matter of fact, even if you have a job that you love, it's a good idea to keep a relationship with headhunters and re-cruiters. You can never tell when your next great job is around the corner.

Here are a few things that can help when you are working with a recruiter.

◎ Tailor your resume or CV to the specific sector of the industry in which the recruiter works. You want your qualifications to jump off the page.
◎ Make sure you tell your recruiter about any companies or organizations to which you do not want your resume sent. For example, you don't want your resume sent to your current employer. You might not want your resume sent to a company where you just interviewed, and so on.
◎ Call the recruiter on a regular basis.

The Hidden Job Market

While a good number of jobs in the art industry *may be* advertised, let's talk a bit about the hidden job market and jobs that are not actively advertised. Many people think that their job search begins and ends with the classified ads. If they get the Sunday paper and their dream job isn't in there, they give up and wait until the next Sunday. I am betting that once you have made the decision to pursue a career in your specific area of the art industry, you're not going to let something small like not finding a job opening in the classifieds stop you. So what are you going to do?

While there may be job openings in which you are interested advertised in the classifieds, it's essential to realize that many jobs are not advertised at all. Why? In addition to not wanting to be bombarded and inundated by tons of resumes and phone calls, for example, some employers may not want someone in another museum or gallery or company to know that they are looking for a new marketing director or a

new publicity director until they hire one. As a matter of fact, they may not want the person who currently holds the job to know that he or she is about to be let go. Whatever the reason, once you're aware that all jobs aren't advertised, you can go about finding them in a different manner.

Why do you want to find jobs in the hidden job market? The main reason is because you will have a better shot at getting the job. Why? To begin with, there is a lot less competition. Because positions aren't being actively advertised, there aren't hundreds of people sending in their resumes trying to get the jobs. Not everyone knows how to find the hidden job market, nor do they want to take the extra time to find it, so you also have an edge over other potential job applicants. Many applicants in the hidden job market also often come recommended by someone who knew about the opening. This means that you are starting off with one foot in the door.

While there are entry-level jobs to be found in the hidden job market, there are also a good number of high-level jobs. This can be valuable when you're trying to move up the career ladder.

How does the hidden job market work? Basically, when a company needs to fill a position, instead of placing an ad, they quietly look for the perfect candidate. How do they find the candidates without advertising? Let's look at some ways this is accomplished and how you can take advantage of each situation.

◎ Employees may be promoted from within the company.
 ▫ That is why it is so important once you get your foot in the door and get a job to keep yourself visible in a positive manner. You want supervisors to think about you when an opening occurs. For example, if

you're working in the grant-writing department of a museum and your goal is a career in marketing, drop subtle hints during conversations with both supervisors of your department and the marketing department. You might, for example, say something like, "I love working in the grants department. Learning how to find and write effective grants for the museum was one of my goals when I decided to work in this sector. I've also always wanted to learn about marketing. I find it fascinating being able to locate new markets, especially in this field."

You're not saying you don't like your job. You're not saying you want to leave your job. What you're doing is planting a seed. If you have been doing an amazing job in your current position and anything opens up in marketing, you just might be suggested.

◎ An employee working in the company may recommend a candidate for the position.
 ▫ This is another time that networking helps. Don't keep your dreams to yourself. Tell others what type of job you're looking for and what your qualifications are. You can never tell when a position becomes available. Employers often ask their staff if they know anyone who would be good for this job. If you've shared your qualifications and dreams, someone just might recommend you.
◎ Someone who knows about an opening may tell their friends, relatives, or co-workers who then apply for the job.
 ▫ In some cases, it's not another employee who knows about an

opening, but it might be someone who has contact with the company. For example, a museum director of development at one art museum might be at a conference and hear that another facility is looking for a new director of development. The museum director might tell his brother's neighbor to call up and apply for the job. He might also mention it to a colleague who mentions it to someone else.

- Sometimes it may be someone outside the company who hears about the job. The UPS delivery person, for example, may be delivering packages to a gallery when he or she overhears a conversation about the administrative assistant leaving. If you had networked with the UPS delivery person and mentioned you were looking for a job, he or she might stop by and tell you about the opportunity. Then all you would have to do is contact the gallery.

◎ People may have filled in applications or sent resumes and cover letters to the company asking that they be kept on file. When an opening exists, the human resources department might review the resumes and call one of the applicants.

- Even if there are no jobs advertised, it is often worth your while to send a letter and your resume to the human resources department, asking about openings. Be sure to ask that your resume be kept on file.

◎ Suitable candidates may place cold calls at just the right time.

> ⭐ **The Inside Scoop**
> When making a cold call, try to get the name of the person you're trying to reach ahead of time so you can ask for someone by name. How? Just call up and ask the receptionist.

- Difficult as it can be to place cold calls, it might pay off. Consider committing yourself to making a couple of cold calls every day. Do some research. Then, depending on the area of the art industry in which you are interested in working, make some calls in an attempt to set up interviews. Who can you call? The beauty of a cold call is that it can be made to anyone. You can learn more about making cold calls later in this chapter.

◎ People may have networked and caught the eye of those who need to fill the jobs.

- Finding positions in the hidden job market is a skill in itself. One of the best ways to do this is by networking. Through networking you can make contacts and your contacts are the people who will know about the jobs in the hidden market.

Networking in the Art Industry and Peripheral Areas

Often, it's not just what you know but who you know. Contacts are key in every industry; the art industry is no exception. Networking is, therefore, going to be an important part of succeeding. It is so important that, in some situations, it can often make you or break you.

"How so?" you ask.

If you don't have a chance to showcase your skills and your talents to the right people, it's difficult to get the jobs you want, the promotions you want, and the career of your dreams.

Networking is important in every area of art, no matter what segment you aspire to work. The fact of the matter is that without the power of networking, it is often difficult to get your foot in the door. That doesn't mean you *can't* get your foot in the door; it just is harder.

Earlier chapters have touched on networking, and because of its importance to your career success, we will continue discussing it throughout the book. What is essential to understand is that networking isn't just something you do at the beginning of your career. It's something you're going to have to continue doing as long as you work.

How do you network? Basically, you put yourself into situations where you can meet people and introduce yourself. Later in the book, we discuss more about networking basics and offer some networking exercises you'll find useful. What you should be doing at this point is learning to get comfortable walking up to people, extending your hand, and introducing yourself.

"Hi, I'm Peter Green. Isn't this an interesting event? What a great opportunity this was to learn more about innovative methods of marketing your crafts," you might say at a seminar.

★ **Tip from the Top**

When networking at an event, don't just zero in on the people you think are the *important* industry insiders and ignore the rest. Try to meet as many people as you can. Always be pleasant and polite to everyone. You never can tell who knows who and who might be a great contact later.

The people you meet will then tell you their name and perhaps something about themselves. You can then keep talking or say, "It was nice meeting you. Do you have a card?"

Make sure you have your business cards handy, and when you are given a card, give yours as well.

Every situation can ultimately be an opportunity to network, but some are more effective than others. Look for seminars, workshops, and classes that professionals in the area of the art industry in which you are interested potentially might attend.

Why would an industry professional be at a workshop or seminar? There are many reasons. They might want to network just like you do, they might want to learn something new, or they might be teaching or facilitating the workshop.

Where else can you meet and network with professionals in the art industry? What about at their place of work? Schools, colleges, universities, art-oriented trade associations and organizations, corporations, art museums, galleries, art shows, craft shows, and the list goes on.

"But I can't just walk in someone's office I don't know and introduce myself," you say.

You're right. That probably won't work. So what can you do?

If you don't know someone in the type of company or organization you want to work for,

★ **Voice of Experience**

You never want to be in the position where someone remembers that they met you and thinks that you would be perfect for a job yet has no idea how to get a hold of you. Don't be stingy with your business cards. Give them out freely.

you're going to have to get creative in your networking. How can you network with employees of those companies? Here's a strategy you might want to try.

Find one or two organizations, companies, galleries, or museums in which you might be interested in working and locate their physical addresses.

Choose a day when you have some time to spare. Generally, it needs to be on a weekday because those are the days most business takes place. Get dressed in appropriate clothing, and go to the location of the company, facility, museum, or organization that you've chosen. Now stand outside the building and look around. Are there restaurants, coffee shops, diners, or bars nearby? There probably are. If it's an art museum, is there a cafeteria or lunchroom? Is it open to the public? Why does all this matter?

Because people working in these offices or facilities have to eat lunch somewhere and get their coffee somewhere. After work on Friday night, they might want to stop into the bar on the corner for happy hour.

What does that mean to you? If you can determine where the company employees hang out, you can sometimes put yourself in situations in which to network with them.

Can you find out which restaurants, diners, and coffee shops the employees frequent? You often can, if you stand outside around lunchtime and watch to see who goes where.

But what if you're interested in working at a company housed in a building where there are thousands of employees all from different businesses? For example, what if you are interested in working in the art department of an advertising agency that is in an office building with a large number of other businesses. How do you know which are the employees from the company you have targeted? You might have to eavesdrop a little and listen for clues in things people say as they walk out the door. You might stop in the building and ask someone. Get on the elevator and ask the elevator operator. Ask the security guard standing in the lobby. You might even stop into a couple of the coffee shops, diners, or restaurants and ask the host or hostess.

"Hi, I was supposed to have a lunch meeting with someone from The Perfect Advertising Agency and I'm embarrassed to say, I'm not sure which coffee shop the meeting was set for," you might say. "Do a lot of the employees from there come in here?"

At this point, the hostess will either give you a blank look that means you probably are in the wrong place (or she really doesn't know) or tell you that you are indeed in the right location. She might even say, "Yes, we just did a take-out order for them a few minutes ago," or something to that effect.

Once you've found the correct location, wait until it's nice and busy and there is a slight line. People will usually talk to other people even if they don't know them when they are standing in lines. Start up conversations and hope that you're standing near the people from the organization you're looking for. What about sitting at the counter (if there is one)? It you get lucky, you might end up sitting next to someone from the company you are targeting.

This whole process is often a lot easier if you are trying to network with people who work at a museum and there is a cafeteria or lunch room because the odds are you will be running into people who work in the facility.

The tricky part in this entire procedure is being able to network in this type of situation. Some people are really good at it and some people find it very difficult. What you're deal-

ing with when doing this is first finding the correct people and then starting a conversation that may let you turn the person into a networking contact. If you do it right, it can pay off big time. You might meet someone, for example, who works in one of the administrative offices of the art museum or in the art department of an advertising agency.

You never can tell what happens from there. You might mention you were thinking about filling in an application because you were looking for a job at the museum in the marketing department. Your new contact might say, "I don't think there are any positions in that department, but this morning I heard that the special events coordinator just put in her letter of resignation." You might get a referral, set up an interview, or even end up with a job.

Does this technique always work? Sometimes it does and sometimes it doesn't. The important thing to know is that it might help you get your foot in the door where you otherwise might not have.

If you find networking in this manner difficult, it might be easier for you to do at a bar during "happy hour" because people tend to talk more in these situations. Remember, though, that while it's okay to drink socially, your main goal is to network and make contacts. You won't do yourself any favors becoming intoxicated and then acting outrageously or saying something inappropriate.

Where else might people who work in the art industry congregate? Once again, that depends on what area of the art industry you are targeting. What about joining a local arts council or art society and volunteering to work on some events? What about volunteering to help with one of their fund-raisers? What about going to a gallery opening? What about becoming a volunteer at an art museum?

What about finding out if any of the museums in the area are having galas, cultural activities, or other types of fund-raising events? They often need volunteers to help with these events as well.

It is far more effective to your career to meet the executive director of an art-oriented trade association or the HR director of a museum when you're being introduced as a volunteer who helped pull an event together than knocking on his or her door saying, "Hi, do you have a minute?"

How else can you get to the right people? Sometimes all it takes is making a phone call. Consider calling a trade association, for example, asking to speak to the communications director and telling him or her about your career aspirations. Ask if he or she would be willing to give you the names of a couple of industry people you might call. Contact a museum PR director and ask who you might talk to if you were interested in a career in exhibit development. Contact an art critic or reporter and ask if he or she can give you some insight into career opportunities. Call the art director of a large advertising agency and ask for some advice. You just might be surprised.

⭐ ## The Inside Scoop

It's great to network with those at the top, but a good and often more practical strategy is to try networking with their assistants and support team. The people at the top might not always remember you; those a step or two down the line usually will. Additionally, a recommendation from these people about you to their boss can do wonders for your career.

"Why would anyone want to help me?" you ask.

Most people like to help others. It makes them feel good. Don't expect everyone to be courteous or to go out of their way for you, but if you find one or two helpful people, you may wind up with some useful contacts.

"But what if I ask someone something and they say no?" you ask. "What if they won't help?"

Well, that might happen. The conversation may not go in the direction you want it to. Some people will say no. So what? If you don't ask, you'll never know.

"But what do I say if someone says no?"

Simply thank them nicely for their time and hang up. Don't belabor the point. Just say, "Thanks anyway. I appreciate your time."

It might be difficult the first couple of times you make call like that, but as you begin to reach out to others, it will get easier. Pretty soon, you won't even think about it.

Where else can you network? A lot of that depends on what segment of the industry you are trying to target. Look for opportunities.

"How else can I network with industry professionals?" you ask.

You're going to have to be creative. For example, let's say you read a press release in the paper about an upcoming event to benefit a local art museum. Or perhaps you see that a local gallery owner is being honored. There might be any number of similar situations. How do you use these types of events to your advantage? What do you do?

First of all, make sure you go. Then get creative. You want to stand out from the crowd, if you can. If you can volunteer to help with the event in any manner, do so. Call up and ask. Volunteer to help do the publicity. Volunteer to be a host or hostess. Offer to help serve. See if you can cover the event for the newspaper. Think outside of the box.

Events don't always have to be geared specifically to the art industry to be good networking opportunities. What they need to be, however, are events where people in the segment of the art industry in which you are interested potentially will congregate. For example, you might want to join Kiwanis or Rotary or another similar civic organization. You might want to join the chamber of commerce and go to their events. Why? Industry professionals attend these events. When you meet people in these situations, you are meeting them on a more even playing field.

Remember that these are business functions. Behave professionally and make sure to watch for any opportunities to network—the main reason that you're there. Here are some tips on what to do and what not to do:

◎ Do not bring anyone with you. Go alone. It will give you more opportunities to meet people.
◎ Do not smoke even if other people are. You can never tell what makes someone remember you. You don't want it to be that you smell of tobacco.
◎ Don't wear strong perfume, cologne, or aftershave. Aside from the possibility of some people being allergic to it, you don't want this to be the reason people remember you.
◎ While this goes without saying, do not use any illegal drugs.
◎ Don't drink to excess. You don't want to be remembered as "the one who was drunk at the event."

Here are some things you *should do.*
◎ Do bring business cards to give out to everyone.

> ### ⭐ Tip from the Coach
>
> Remember that networking is a two-way street. If you want people to help you, it's important to reciprocate. When you see something you can do for someone else's career, don't wait for them to ask for help. Step in, do it, and do it graciously.

◎ Do bring a pen and small pad to take down names and phone numbers of people who don't have cards.

◎ Do meet as many people as possible. If given the opportunity, briefly tell them what your goal is and ask if they have any suggestions about who you can contact.

◎ Dress appropriately.

Follow up on the contacts and information you gather at these meetings. Don't neglect this step or you will have wasted the opportunity. Call, write, or e-mail contacts you have made in a timely fashion. You want them to remember meeting you.

The Right Place at the Right Time

Have you ever looked down while you were walking and saw some money sitting on the ground? It could have been there for a while, but no one else happened to look down. You just happened to be at the right place at the right time.

It can happen anytime. Sometimes you hear about an interesting job opening from an unlikely source. You might, for example, be standing in a long line at the bakery. The woman in back of you asks if you would mind very much if she went ahead of you because she is rushing out of town to visit her daughter. It seems she needs to

pick up the bakery's famous chocolate cake because it is her daughters favorite and she misses it since moving away to take a job in the city.

You of course agree to let her get ahead of you. While standing in line chatting, the portfolio you are carrying slips out of your hand and a few of your sketches fall out. The woman helps you pick them up and looks at them. "Wow," she said. "These are amazing. Are you an artist?"

You mention that while you just finished college and your dream is to work as a courtroom sketch artist, you probably are going to have to do something else.

"It must be difficult to find a job like that," the woman says to you. "But you really are good," she says, looking at your sketches.

"It's your turn," you say to the woman. "Have a good trip. Here's my card. Maybe you'll run into someone who needs someone like me."

"I hope I do," the woman says. "Thanks for letting me go ahead of you."

You forget about the incident until a few weeks later when you get a phone call.

"Hi, this is Mary Jean Morrow. You don't know me, but you met my mom in the bakery a couple of weeks ago. She said you let her get ahead of you. Do you remember?"

"Yes, she was going to visit you and she was in a rush," you say.

"Well, I know this is coming out of left field, but I'm a news producer for WABA TV and my mom was telling me about meeting you. She told me you are an amazing sketch artist. You'll never believe this, but the station really needs to find a courtroom sketch artist pronto. I'm not sure what your qualifications are, but I hear your sketches are great. Would you be interested in something like that?"

"I would love a job like that," you say.

"I can't promise anything, but if you are as good as my mom says, we would love to see your portfolio. I don't suppose you would be available to come into the city in the next couple of days to meet with my boss? Our sketch artist left and we have a position open—immediately. You probably have heard the Jerome trial is starting next week. It's going to be a long trial, I think."

"I can fax my resume as soon as we get off the phone," you say, "and my portfolio is ready. I can drive into the city tomorrow morning if that would be good for you. I'm so excited. I can't tell you how glad I am we both have a sweet tooth, your mom was in a hurry and I gave her my card."

"I'm glad you gave my mom your card too," she says. "Let me give you our fax number and the address and I'll see you tomorrow."

Think things like this can't happen? They can and do. It's just a matter of being at the right place at the right time.

There is no question that being in the right place at the right time can help. The question is, however, what is the right place and the right time and how do you recognize it?

The simple answer is that it's almost impossible to know what the right place and right time is. You can, however, stack the deck in your favor. How? While you never know what the right place or the right time to be someplace is, you can put yourself in situations where you can network. Networking with people outside of the industry can be just as effective and just as important as networking with industry professionals.

The larger your network, the more opportunities you will have to find the job you want. The more people who know what you have to offer and what you want to do, the better.

Who do you deal with every day? Who do these people know and deal with? Do any of these people in your network and your extended network may know about your dream career?

If you aren't currently employed and don't have to worry about a boss or supervisor hearing about your aspirations, spread the news about your job search. Don't keep it a secret. The more people who know what you're looking for in a career, the more people who potentially can let you know when and where there is a job possibility.

If I haven't stressed it enough, if at all possible do not keep your career aspirations to yourself. Share them with the world.

Cold Calls

What exactly is a cold call? In relation to your career, a cold call is an unsolicited contact in person, by phone, letter, or e-mail with someone you don't know in hopes of obtaining some information, an interview, or a job. It is a proactive strategy.

Let's focus on cold calls you make by phone. Many find this form of contact too intimidating to try. Why? Because not only are you calling and trying to sell yourself to someone who may be busy and doesn't want to be bothered, but you are also afraid of rejection. None of us like rejection. We fear that we will get on the phone, try to talk to someone, and they will not take our call, hang up on us, or say no to our requests.

The majority of telemarketing calls made to homes every day are cold calls. In those cases, the people on the other end of the phone aren't trying to get a job or an interview. Instead, they are attempting to sell something such as a product or a service. When you get those calls, the

first thing on your mind is usually how to get off the phone. The last thing you want to do is buy anything from someone on the other end. But the fact of the matter is that people do buy things from telemarketers if they want what they're selling.

With that in mind, your job in making cold calls is to make your call compelling enough that the person on the other end responds positively. Why would you even bother making a cold call to someone? It's simply another job search strategy and it's one that not everyone attempts, which gives you an edge over others.

How do you make a cold call? It's really quite simple. If you want to make a cold call to a potential employer, you just identify who you want to call, put together a script to make

> ### ★ Voice of Experience
> You will find it easier to make cold calls if you not only create a script but practice it as well. In order to be successful in cold calling, you need to sound professional, friendly, and confident.

it easier for you and give you a boost of confidence, and then make your call.

Keep track of the calls you make. You may think you'll remember who said what and who you didn't reach, but after a couple of calls it gets confusing. Check out the Cold Call Tracking Worksheet sample below for the type of information you should record. Then use the Cold Call Tracking Worksheet provided.

Cold Call Tracking Worksheet					
Company	**Phone Number**	**Name of Contact**	**Date Called**	**Follow-up Activities**	**Results**
Anytown Art Museum	111-222-2222	John Barrows	5/9	Send resume.	Asked for resume, will get back to me after reviewing my qualifications.
Sometown Art Society	111-111-1111	Barry Jamison	5/12	Send resume.	Will keep resume on file, no current opening. Call back in a few months.
New City Children's Art Museum	111-222-3333	Edward Michaels	5/9	E-mailed resume.	Will review resume and get back to me.
Taylors Traveling Exhibits	800-111-1111	Janice Stockton	5/11		Call back in two weeks.

Cold Call Tracking Worksheet

Company	Phone Number	Name of Contact	Date Called	Follow-up Activities	Results

Who do you call? That depends on who you're trying to reach and what you're trying to accomplish. You might call museums or art societies. You might call television stations, retail establishments, restaurants, book publishers, or corporations who may need the services of graphic designers, graphic artists, or art directors. You might call advertising agencies. What about art industry–oriented Web sites?

You might call art galleries or promoters of art and craft shows. You might call human resources directors or hiring managers. You might call trade associations involved in various aspects of the art industry. It all depends on your qualifications and your career aspirations.

What about contacting a newspaper or television stations to see if you can create a position as an art critic or art reporter? How about calling a television station to see if they might need a courtroom artist to illustrate courtroom activity on air?

Every call you make is a potential opportunity that can pan out for you.

Need an example to get you started? Read on.

You: Hi, Mr. Rudolph. This is Elaine Masters. I'm not sure you're the right person to speak to, but I was hoping I could tell you what I was looking for and perhaps you could point me in the

right direction. Are you available to talk now or would it be better if I called back later?

Mr. Rudolph: What can I do for you?

You: I have my bachelor's degree in fine arts and I'm working toward completing my master's. I was wondering if you knew who I would talk to about possible career opportunities I might pursue in your company?

Mr. Rudolph: What do you specifically want to do?

You: I'm interested in working as a graphic designer. I've won a number of awards while in school designing both innovative brochures and packaging.

Mr. Rudolph: We don't have any positions like that open here. Sorry.

You: I understand and I thank you for your time. I'm just trying to get some leads on where to call. Do you have any suggestions?

Mr. Rudolph: You might want to call our corporate office. They might be able to tell you more about positions in that area. We have nothing to do with that in our office.

You: Thanks so much. Who would I call there?

Mr. Rudolph: Why don't you try speaking to Sally Anderson. Her number is 222-4444.

You: Thanks for your help.

Sally Anderson: Sally Anderson, can I help you?

You: Hi, Ms Anderson. This is Elaine Masters. Mr. Rudolph from one of your local offices suggested I call you. I was trying to find out more about opportunities in your company for graphic designers. Are you the right person to speak to?

Sally Anderson: What kind of background do you have?

You: I have a bachelor's degree in fine arts from State University. I'm working toward completing my master's degree. While in school, I took part in a number of competitions and won a number of awards for designing innovative brochures and packaging. I have a certificate in Web design. One of the Web sites I redesigned the graphics for was recently voted most innovative. I would be glad to give you the Web address so you can see if for yourself.

Sally Anderson: That's pretty impressive. We don't really have any positions open right now in that area, but any company would be lucky to have someone with those qualifications.

You: Do you have any suggestions of people I might call?

Sally Anderson: Not really. You know, I'm busy, but you've piqued my interest. I'm interested in seeing your portfolio. We might be working on a new project in the next few months. Why don't you come in and we can chat. Do you have any time, next week? Wednesday would be good for me. How about you?

You: Wednesday would be great. Thank you.

Sally Anderson: Why don't you come in around 1:00 p.m. You have our address, don't you?

You: Yes, it's 329 Main Street in Anytown isn't it?

Sally Anderson: I'm on the 10th floor. See you next week.

You: Thanks. I look forward to meeting you.

As you can see, it's not all that difficult, once you get someone on the phone.

"But what if they say no?" you ask.

So they say no. Don't take it personally. Just go on to your next call and use your previous call as practice.

Where do you find people to call? Browse Web sites for names. Read trade journals. Read the newspaper. Look for magazine articles and feature stories. Watch television and listen to the radio. Go through the yellow pages. You can get names from almost anywhere. Call up. Take a chance. It may pay off.

Depending on where you're calling and the size of the organization, in many cases when you start your conversation during a cold call, the person you're speaking to will direct you to the HR department. If this is the case, ask who you should speak to in HR. Try to get a name. Then, thank the person who gave you the information and call the HR department asking for the name of the person you were given. Being referred by someone else in the company will often get you through.

Believe it or not, the more calls you make, the more you increase your chances of success

in getting the information you want, potential interview, or the job you want.

If you're really uncomfortable making the calls, or you can't get through to the people you're trying to reach by phone, consider writing letters. It takes more time than a phone call, but it is another proactive method for you to potentially get through to someone.

Creating Your Own Career

Do you want one more really good reason to find the hidden job market? If you're creative and savvy enough, you might even be able to *create* a position for yourself even if you are only on the first or second rung of the career ladder. What does that mean?

It means that if you can come up with an idea for a job—even if that job doesn't currently exist—and are creative and persuasive in selling that idea, you often can create your own job.

"What do you mean create your own job?" you ask.

Let's say you are an interior designer. You haven't been able to land a job with a company, and while you could start your own business, you're not quite ready, and you want benefits. What can you do? Create your own job!

How about speaking to the owner of a large real estate agency to see if he or she would like put you on staff to prep and stage homes so they are not only ready to sell but might sell at a higher price? Why would a someone hire you to do that when there are freelancers? In competitive markets, you just might give the real estate agency an edge. You just created your own position.

What about going to a furniture store and seeing if you can create a position handling the interior design needs of customers? It's worth a try.

⭐ **Tip from the Coach**

Expect rejection when making cold calls. Some people may not want to talk to you. Rejection is a lot easier to deal with when you decide ahead of time that it isn't personally directed toward you.

Let's say you are a graphic artist. What about contacting a convention center and seeing if you can create a position handling the graphic needs of exhibitors who find themselves in need of handouts or signage while in town? What about creating a position with a local party shop creating custom made invitations? Think outside of the box and you might come up with a unique position.

Let's go back to Elaine Masters for a moment and look at a different scenario. In this scenario, let's say Elaine stops by a shopping center and speaks to the manager. She has learned that the shopping center has been outsourcing their artwork for promotions and advertisements. Elaine did some research and found that the center could actually save money by doing the projects in house. They also would have more control over projects. Elaine also noticed that the center's Web site had no pizzazz. She made an appointment to meet with the shopping center manager and suggested that instead of the center outsourcing all their work, they hire her. She also made some suggestions about their Web site. Because she had done her homework, she was able to show the manager how he could not only save money but have superior artwork done on time. She explained all the pros of hiring her to handle the project. And guess what? The manager agreed and decided to create a position.

"That kind of thing doesn't really happen," I hear you saying.

The truth of the matter is that people create their own positions more often than you know—and they do it successfully.

If you are creative, have some initiative, and are aggressive enough to push your idea, you can do the same. What you have to do is come up with something you could do for an organization, company, or corporation that isn't being done now or you could do better. Then pitch it to the correct people.

Do you have any ideas? Put fear aside and think outside the box. Get creative. Come up with an idea, develop it fully, put it on paper so you can see any potential problems, and then fine-tune them. Then call up a company or organization that you want to work with, lay out the idea, and sell them on it. You've just created your own job!

Whether you use traditional job search strategies or get a little creative, the idea is to stack the deck in your favor. By taking a little time and doing a bit of research, you might just uncover the job you have been dreaming about.

6

TOOLS FOR SUCCESS

The right tools can make it easier to do almost any job. Imagine, for example, trying to paint your house without the right brushes, quality paint, and a good ladder. It could happen, but it would probably be more difficult to do a really good job. Imagine trying to bake a cake without measuring spoons, measuring cups, pans, and a good oven. You might be able to do it, but your chances of success are diminished.

Obtaining jobs and creating a great career is a project in itself. Tools can make it easier. Every trade has its own set of tools that help the tradesperson achieve success, tools that, if unavailable, would make their job more difficult, if not impossible, to accomplish.

Whatever area of the art industry you are pursuing, there are certain tools that can help you achieve success faster as well. These may include things like your resume, curriculum vitae (CV), business and networking cards, brochures, career portfolio, and professional reference sheets, among others. This chapter will help get you started putting together these tools. If your career aspirations are in the fine art or craft field, you might also want to check out Chapter 11 for additional ideas.

Your Resume as a Selling Tool

There is virtually no successful company that does not advertise or market their products or services in some manner, whether it be utilizing publicity, ads in newspapers or magazines, television or radio commercials, billboards, banners on the Web, or any other marketing vehicles.

Why do they do this? The foremost reason is to make sure others are aware of their product or service so they can then find ways to entice potential customers to buy or use a particular product or service.

What does this have to do with you? When trying to succeed in any career, it is a good idea to look at yourself as a *product*. What that means in a broad sense is that you will be marketing yourself so people know you exist, so they begin to differentiate you from others, and so that they see you in a better light.

How can you entice potential employers to hire you? How can you help people in the industry to know you exist? How can you get that all-important interview?

The answer is simple. Start by making your resume a selling tool! Make it your own personal

> ### ⭐ Tip from the Coach
> Your resume will be useful at every level of your career. It is not a "do it once, get a job, and never need it again" document.

printed marketing piece. Everyone sends out resumes. The trick is making yours so powerful that it will grab the attention of potential employers.

Resumes are important no matter what area the art industry you are pursuing. Does your resume do a great job of selling your credentials? Does it showcase your skills, personality traits, and special talents? Is your resume the one that is going to impress the employers or human resources directors who can call you in for that all-important interview and ultimately land you the job you are after? Is it going to land you the job you've been dreaming about?

If a potential employer doesn't know you, his or her first impression of you might very well be your resume. This makes your resume a crucial part of getting an interview that might ultimately lead to the job you are trying to land.

I can almost hear you asking, "Does it really matter what my resume looks like? I thought all I had to do was send one in and if my credentials were good, I'll be called in for an interview."

You might and you might not. Perhaps the powers that be liked the resume of someone else who also had good credentials. Why would you take a chance with something as important as your career?

A strong resume illustrates that you have the experience and qualifications to fill a potential employer's needs. How can you do this? To begin with, learn to tailor your resume to the job you're pursuing. One of the biggest mistakes people make in job hunting is to create just one resume and then use it every single time they apply for a position no matter the job.

If this is what you've been doing, it's time to break the habit. Begin by crafting your main resume. Then edit it to fit the needs of each specific job opening or opportunity you are applying.

"But can't I use the same resume for every job I apply for?" you ask.

> ### ⭐ Words from the Wise
>
> If you're using different versions of resumes, make sure you know which one you send to which company. Keep a copy of the resume you use for a specific job with a copy of the cover letter you send. Do it *every* time. Otherwise, when sending out numerous resumes and letters, it's very easy to get confused.

Here's the answer in a nutshell. You can use the same resume only *if* you are going for the exact same type of job. For example, you might use the same resume if you are applying for two jobs, both as art directors in similar types of advertising agencies.

However, if you are applying for one job as the art director for a major advertising agency in New York City and another as the art director for a small fashion magazine, you might want to tailor your resume to each job a bit, highlighting any skills and experiences that would be relevant to each position. Even if you were applying for jobs in two different fashion magazines, you most likely would want to tailor your resume for each job.

Before computers became commonplace, preparing a different resume for every job was far more difficult. In many cases, people would prepare their one resume and then have it professionally printed by a resume service or print-

> ### ⭐ Tip from the Top
>
> When replying to a job advertisement, use words from the advertisement in both your resume and your cover letter. It makes you look like more of a fit with the company's expectations.

er. That was it. If you wanted to change your resume, you had to go back to the printer and have it done again, incurring a major expense.

Today, however, most of us have access to computers, making it far easier to change resumes at will. Do you want to change your career objective? What about the order of the components on your resume? Do you want to add something? Do you want to delete something? You are in control. You can create the perfect resume every time with the click of a mouse.

Always keep a copy of your resume on your computer and make sure you note the date it was done and its main focus. For example, you might save your resumes as "ABA Advertising Agency art director resume May 12;" "Premier Advertising Agency art director resume May 15;" "James Fashion Company art director resume June 19;" and so on. If you don't have your own computer, keep your resume on a CD or a flash drive so you always have access to it without having to type it all over again.

★ Tip from the Top

Keep updated backup copies of your resume on a CD or a flash drive. You can never tell when your computer hard drive will die just at the time someone tells you about a great opportunity or you see an advertisement for the perfect job. If your resume is on a CD or other media, you simply need to put it in another computer, tailor your resume for that particular job, and send it off. You can also toss a CD or a USB flash drive in your briefcase or bag to keep with you if you are away from home and want to add something to your resume quickly. Adding a handwritten line when you change your phone number or address or even whiting out the wrong information just is not acceptable.

How can you make your resume a better marketing tool? Present it in a clear, concise manner, highlighting your best assets. Organize things in an order that makes it easy for someone just glancing at your resume to see the points that sell you the best and then want to take a second look.

The decision about the sequence of items in your resume should be based on what is most impressive in relation to the position you are pursuing. Do you have a lot of work experience? Put that information first. Are your accomplishments extraordinary? If so, highlight those first. Do you have little experience but just graduated cum laude? Then perhaps your education should be where your resume should start.

Sometimes it helps when creating your own resume to imagine that you just received it in the mail yourself. What would make you glance at it and say *wow*? Would you continue reading or would you glance at it and hope that there was a more interesting resume coming in?

One of the most important things to remember is that there really is no *right* or *wrong* type of resume. The right one for you will end up being the one that ultimately gets you the position you want. There are so many ways to prepare your resume that it is often difficult to choose one. My advice is to craft a couple different ones, put them away overnight, and then look at them the next day. Which one looks better to you? That probably will be the style you want to use.

Here are some tips that might help:

◎ Tailor each resume for every position.
◎ Make sure you check for incorrect word usage. No matter what position you're pursuing, most employers prefer to have someone who has a command of the English language. Check to make sure you haven't inadvertently used the word

"their" for "there," "to" for "too" or "two," "effect" for "affect," "you're" for "your," "it's" for "its," and so on.

◎ Don't rely solely on your computer's spell and grammar checker. Carefully go over your work yourself as well.

◎ Every time you edit your resume or make a change, check carefully for errors.

◎ It is very easy to miss a double word, a misspelled word, or a wrong tense. Have a friend or family member look over your resume. It is often difficult to see mistakes in your own work.

◎ Tempting as it is to use different colored inks when preparing your resume, don't. Use only black ink.

◎ Use high-quality paper at least 40-pound weight for printing your resumes. Paper with texture often feels different, so it stands out. While you can use white, beige, or cream colored papers, soft light colors such as light blue, salmon pink, gray, or light green will help your resume stand out from the hundreds of white and beige ones.

◎ Make sure your resume layout looks attractive. You can have the greatest content in the world, but if your resume just doesn't look right, people may not actually read it.

◎ You know the saying, "You can't judge a book by its cover"? Well, while you really can't, if you don't know anything about the book or its contents, you just might not pick it up unless the cover looks interesting.

◎ When sending your resume and cover letter, instead of using a standard number 10 business envelope and folding your resume, use a large manila

★ Words from the Wise

No matter what color paper you use for your resume and cover letters, make sure they photocopy well. Some colored papers photocopy dark or look messy. Even if you aren't photocopying your resume, a potential employer might.

envelope. That way you won't have to fold your resume and your information gets where it's going looking clean, crisp, and flat.

◎ Don't use odd fonts or typefaces. Why? In many large companies, resumes are scanned by machine. Certain fonts don't scan well. What should you use? Helvetica, Times, Arial, and Courier work well.

◎ Similarly, many fonts don't translate well when e-mailing or transmitting electronically. What looks great on the resume on your computer screen may end up looking like gibberish at the recipient's end, and you probably will never know. Once again, use Helvetica, Times, Arial, or Courier.

◎ When preparing your resume, make your name larger and bolder than the rest of your resume. For example, if your resume is done in 12-point type, use 14-, 16-, or 18-point type for your name. Your name will stand out from those on other resumes.

◎ Remember to utilize white space effectively. Margins should be at least one inch on each side as well as on the top and bottom of each page. White space also helps draw the reader's attention to information.

◎ Even if you view your resume on your computer screen, be sure to print out a copy to be sure the document looks good no matter how a potential employer views it.

Redefining Your Resume

You probably already have a resume in some form. How has it been working? Is it getting you the interviews you want? If it is, great! If not, you might want to consider redefining it.

You want your resume to stand out. You want it to illustrate that you are successful in your past accomplishments. You want potential employers to look at your resume and say to themselves, "That's who I want working here!"

How do you do that? Make your resume compelling. Demonstrate through your resume that *you* believe in yourself, because if *you* don't believe in *you,* no one else will. Show that you have the ability to solve problems and bring fresh ideas to the table.

First decide how you want to present yourself. What type of resume is best for you? There are three basic types of resumes. The chronological resume lists your jobs and accomplishments beginning with the most current and going backwards. Functional resumes, which may also be referred to as skills-based resumes, emphasize your accomplishments and abilities. One of the good things about this type of resume is that it allows you to lay it out in a manner that spotlights your key areas, whether they be your qualifications, skills, or employment history. A combination resume is a combination of the two other types.

What's the best type of resume for you? That depends on a number of factors, including where and what level you are in your career. If you are just entering the job market and you haven't held down a lot of jobs, but you have relevant experience through internships or volunteer activities, you might use the functional type. If, on the other hand, you have held a number of jobs in the field and climbed the ladder with each new job, you might want to use the chronological variety. You can also sometimes combine elements from both types. This is called a combination resume. As I noted earlier, there is no one right way. You have to look at the whole picture and make a decision.

Use common sense. Make sure your best assets are prominent on your resume. Do you have a lot of experience? Are your accomplishments above the bar? Did you graduate cum laude? Do you have a master's degree? Do you have a doctorate? Have you won a lot of awards? Determine what would grab your eye and find a way to focus first on that.

What Should Your Resume Contain?

What should you include in your resume? Some components are required and some are optional. Let's look at a number of them.

What do you definitely need? You absolutely need your name, address, phone number, and e-mail address, if you have one. You also should have your education and any training as well as your professional or work experience. You want to include your work accomplishments and responsibilities so potential employers know what you have done and what you can bring to the

> ⭐ **Tip from the Top**
>
> Many people sabotage themselves by giving more information than is required on their resume. When preparing your resume, always stop and think, will this information help or hinder my career?"

table. What else? You should include certifications, licenses, professional affiliations and memberships, honors, awards, and any additional professional accomplishments.

What might else *might* you want to put in your resume? Your career objective, a summary of skills, and a career summary. Anything else? How about any volunteer experience you might have?

What should you *not* put in your resume? Your age, marital status, religion, any health problems you might have, current or past salaries, and whether or not you have children. What else should you not include? Any weakness your have or think you have.

Career Summary

Let's take a moment to discuss your career summary. While a career summary isn't a required component, it often is helpful when an employer gets huge numbers of resumes and gives each a short glance. A career summary is a short professional biography, usually no longer than 12 lines, which tells your professional story. You can do it in a number of ways. Here's an example:

Seasoned graphic designer with over seven years corporate experience. Have developed successful concepts for corporate identity, print advertising, multimedia projects, and packaging. Award-winning Web designer. Skilled in all major computer software programs including QuarkXpress, Illustrator,

Photoshop and Dreamweaver. Excellent communications skills with proven ability to bring clients concepts to fruition. Fully knowledgeable in all aspects of public relations, publicity, advertising, and marketing. Bachelor of Fine Arts with minor in marketing. Master of Fine Arts. Energetic, passionate, and articulate with a good sense of humor and the goal of making a success out of every opportunity.

A potential employer looking at this might think, "This Chelsea Evans has a broad background. She has a degree in fine arts and marketing, so she probably has a full understanding of graphics as well as various aspects of marketing. She also has won at least one award for Web design. She looks like she has a great attitude and has already been successful. Why don't I give her a chance to tell me more? I think I want to bring her in for an interview and see her portfolio."

"What if I'm just out of college and have no experience?" you ask. "What would my career summary look like?"

In situations like this, you have to look toward experience and jobs you held prior to graduating. How about this:

Recent graduate of State University with a Bachelor of Fine Arts and a minor in business with a GPA of 4.0. Intern in rotating departments at the State Art Museum. Proven ability to handle various tasks quickly, effectively, and efficiently. Ability to successfully bring a project to fruition on time and under budget. Member of college campus activities board, assisting in the coordination of the annual winter art show and the booking of guest artists for State College Art Gallery. Energetic, passionate, and articulate with excellent communications skills.

If you prefer, you can use a bulleted list to do your career summary.

◎ Recent graduate of State University with a Bachelor of Fine Arts and a minor in business. GPA of 4.0.
◎ Intern at State Art Museum.
◎ Member of college campus activities board, assisting in the coordination of Annual Winter Art Show.
◎ Assisted in the booking of guest artists for State College Art Gallery.
◎ Energetic, passionate, and articulate with excellent communication skills.

Career Objective

Do you need a career objective in your resume? It isn't always necessary, but in certain cases it may help. For example, if you are just starting out in your career, having a career objective or a specific goal illustrates that you have some direction. It shows that you know where you want to go in your career.

When replying to a job opening, make sure your career objective on your resume is as close to the job you are applying for as possible. For example, if you are applying for a job as a publications assistant at an art museum, you might make your career objective, "To work in the publications department of an art museum in a position where I can fully utilize my creativity and writing skills." If you are applying for a job as a fund-raising and development director for an art museum, you might make your career objective, "Combining my passions of working around art in a museum atmosphere while utilizing my skills and talents to develop programs to bring in monies as well as find new avenues to develop museum membership.

If, on the other hand, you are sending your resume to a company, "cold" or not, for a specific job opening, don't limit yourself unnecessarily by stating a specific career objective. If you use a career objective in this type of situation, make sure it is general.

In some instances you might send copies of your resume with a cover letter to companies who aren't actively looking to fill a job. Your hope in these situations is to garner an interview. If your resume indicates, for example, that your sole goal is to work in a company's publications department, you might be overlooked for a position in the marketing or the public relations department. Your career goal in this situation instead might be, "To work in art museum in a position where my people skills can be combined with my love and understanding of art and my degree in marketing and public relations." Remember, you want the person reviewing your resume to think of all the possible places you might fit within the organization.

Education

Where should you put education on your resume? That depends. If you recently have graduated from college and you have a degree in something related to the area of the industry in which you are seeking a job, put it toward the top. If you graduated a number of years ago, put your education toward the end of your resume. Do you need to put the year you graduated? Recent graduates might want to. Other than that, you might just indicate the college or university you graduated from and your major.

"What if I went to college but didn't graduate? What should I put on my resume?" you might ask.

If you went to college but didn't graduate, simply write that you attended or are taking coursework toward a degree. Will anyone question you on it? That's hard to say. Someone might. If questioned, simply say something like, "I attended college and then unfortunately

found it necessary to go to work full time. I plan on getting my degree as soon as possible. I only have nine credits left to go, so it will be an easy goal to complete."

In addition to your college education or other schooling, don't forget to include any relevant noncredit courses, seminars, and workshops you have attended. While you probably wouldn't want to add classes like flower arranging (unless this had to do with your job in some way), you might include educational courses that are not industry oriented but might help you in your career such as public speaking, writing, grant writing, communications, or team work.

Professional and Work Experience

List your work experience in this section of your resume. What jobs have you had? Where did you work? What did you do? How far back do you go? That once again depends where you are in your career. Don't go back to your job as a babysitter when you were 15, but you need to show your work history.

In addition to your full-time jobs in or out of the art industry, include any part-time work that relates to the area of the industry you are pursuing, as well as any job that illustrates skills, accomplishments, or achievements.

Skills, Personality, and Traits

There's an old advertising adage that says something to the effect of, "Don't sell the steak, sell the sizzle." When selling yourself through your resume, do the same. Do not only state your skills and personality traits; make them sizzle! Do this by using descriptive language and key phrases.

Need some help? Here are a few words and phrases to get you started.

- creative
- dedicated
- hard working
- highly motivated
- energetic
- self-starter
- fully knowledgeable
- strong work ethic
- team player
- problem solver

Accomplishments and Achievements

What have you accomplished in your career in or out of the art industry? Did you design the new packaging for a successful product? Were you selected as the Web designer to redesign a popular Web site? Have you developed a program using art to help youngsters clean up their community? Were you a founding member of a community organization whose mission is to bring art classes to underprivileged children? Did you receive an award for designing a new advertising campaign? Are you an art teacher who has been nominated as teacher of the year?

Have you won an industry award? Have you done the publicity for an art society? Have you written a large grant? Have you written an acclaimed article on some aspect of art?

Have you implemented an innovative program? Have you designed a new line of clothing that was picked up by a major television shopping network? Were you the director of an art gallery that was just featured on in a national newspaper?

Have you been asked to speak at an industry conference? Are you the president of a civic group or not-for-profit?

Your achievements inform potential employers not only about what you have done, but also about what you might do for them.

Sit down and think about it for a while. What are you most proud of in your career?

⭐ **Tip from the Coach**

When writing about your accomplishments, use action words to illustrate your experience. Words like *achieved*, *accomplished*, *demonstrated*, *inspired*, *motivated*, *supervised*, *developed*, and so on.

What have you done that has made a difference or had a positive impact on the organization, agency, or company for which you worked? If you are new to the workforce, what did you do in school? What about in a volunteer capacity?

Just as you made your skills and personality traits sizzle and sparkle with words, you want to do the same thing with your accomplishments and achievements. Put yourself in the position of a human resources director, hiring manager, or owner of a company for a moment. You get two resumes. Under the accomplishments section, one says, "Worked as coordinator of museum marketing department, then worked as assistant director of museum's children's services department." The other says, "Worked as coordinator of museum marketing department, assisting in the marketing, promotion, and advertising of an art museum; developed new program designed to bring more children to museum resulting in a 58% increase in children's attendance. Promoted first to museum's assistant director of children's services and then director of department within four months. Wrote and was awarded $150,000 grant to expand program. Received national recognition of program on CNN strengthening museum attendance. Created pilot program for other art museums throughout the country." Which resume would catch your eye?

You can help your accomplishments and achievements sizzle by adding action verbs to your accomplishments. Use words like achieved, administered, applied, accomplished, assisted, strengthened, and others.

Honors and Achievements

When drafting your resume, include any honors you have received whether or not they have anything to do with the art industry. These honors help set you apart from other candidates.

Did one of your newspaper articles win a journalism award? Did you run for the library board of directors and win the seat? Did you start a local Big Brothers/Big Sisters chapter? Did you win the Community Service Award from a local civic group? Were you elected president of Rotary? While these accomplishments might have nothing to do with the art industry, they do show that you are a hard worker and good at what you do.

Community Service and Volunteer Activities

If you perform community service or volunteer activities on a regular basis, make sure you include it on your resume. These types of activities illustrate to potential employers that you "do a little extra." They demonstrate that you are involved in the community. Additionally, you can never predict when the person reviewing your resume might be a member of the organization with which you volunteer. An unexpected connection like that can help you stand out in a positive way. Additionally, illustrating that you are involved in civic groups and the not-for-profit world may be a plus to potential employers.

Hobbies and Interests

What are your hobbies and interests? Do you collect old baseball cards? Do you have a collection of vintage baseball bats? Do you collect NASCAR memorabilia? Are you a hiker? Do you volunteer with a literacy program? Are you a CASA volunteer? Are you involved in pet

rescue? While many career counselors feel that hobbies or personal interests have no place on a professional resume, I disagree. Why?

Here's a secret. You can never tell what will cause the person or persons reviewing the resumes to make a connection. Perhaps he or she has the same hobby as you. Perhaps he or she is a volunteer with a literacy program in which you participate. Anything that causes you to stand out in a positive manner or that causes a connection with your potential interviewer will help your resume garner attention helping you to land an interview.

References

The goal of your resume is to have it help you *obtain* an interview. If you list your references on your resume, be aware that someone may check them to help them decide if they should interview you. Of course, you will most likely have to give the names of references on your application. However, you don't really want people giving their opinions about you *until* you have the chance to sell yourself. With this in mind, it usually isn't a good idea to list your references on your resume.

If you are uncomfortable with this, include a line on your resume stating that "references are available upon request."

Your Resume Writing Style

How important is writing style in your resume? In two words: very important. Aside from con-

> **Tip from the Coach**
>
> Don't stress if you can't get your resume on one or two pages. While most career specialists insist a resume should only be one or two pages at most, I strongly disagree. You don't want to overwhelm a potential employer with a 10-page book, but if your resume needs to be three or four pages to get your pertinent information in, that's okay. Keep in mind, though, that lengthy resumes or CVs are generally used by high-level professionals who have many years of experience and work history to fill the additional pages. If your resume is longer than normal, you should use a brief career summary at the beginning so a hiring manager can quickly see what your major accomplishments are. If they then want to take their time to look through the rest of the resume, your information will be there.

veying your message, your writing style helps to illustrate that you have written communication skills.

When preparing your resume, write clearly and concisely and do not use the pronoun "I" to describe your accomplishments. Instead of writing "I developed a program to decrease graffiti," you might try, "Developed innovative program using outdoor murals which decreased graffiti in the area by 60% within a one-year period. Note the inclusion of a time period. It's good to be specific about your achievements.

Instead of "I worked as manager of an art gallery," you might try, "Managed large art gallery that showcased both established and new artists. Using creative and innovative marketing methods increased attendance resulting in a 45% increase in sales over a year long period."

> **Words from a Pro**
>
> If you are instructed to send references with your resume, attach them on a separate sheet with your cover letter.

Creating Industry-Specific Resumes

How can you create resumes specific to the area of the art industry you are pursuing? Once you've created your basic resume, tailor each resume for the specific position or area you are pursuing, and find ways to relate your existing skills to that resume.

Use all your experiences, talents, and skills to help you obtain the career you want. Transfer skills and experience when you can.

One thing you should *never* do is lie on your resume. Don't lie about your education. Don't lie about experience. Don't lie about places you've worked. Don't lie about what you've done. Don't lie about your skills. If you haven't picked up on it yet, *do not lie*.

Once someone knows you have lied, that is what they will remember about you and they may pass on that information to others.

"Oh, no one is going to find out," you might say.

Don't bet on it. Someone might find out by chance, deduce the truth based on knowledge within the industry, or hear the facts from a coworker or industry colleague. Someone, just by chance, may be surfing the net and see your name. When the truth comes out, it can end up blowing up in your face.

"By that time, I'll be doing such a good job, no one will fire me," you say.

That's the best-case scenario and there's a chance that could happen, but think about this. Once someone lies to you, do you ever trust them again? Probably not, and no one will trust you or anything you say. That will hurt your chances of climbing the career ladder. The worst-case scenario is that you will be fired, left without references, lose some of your contacts, and make it much more difficult, if not impossible, to find your next job.

If you don't have the experience you wish you had, try to impress the HR director, hiring manager, or recruiter with other parts of your resume and your cover letter. If you have the experience and you are trying to advance your career, this is the time to redefine your resume. Add action verbs. Add your accomplishments. Make your new resume shine. Create a marketing piece that will make someone say, "We need to interview this person. Look at everything he (or she) has done."

When creating your resume, you want it to reflect your knowledge of the entire industry as well as the specific area you are seeking a job. Be sure your resume shows evidence of skills, experience, productivity, and your personal commitment to excellence.

Your CV (Curriculum Vitae)

What exactly is a CV? CV is short for curriculum vitae. What's the difference between a CV and a resume? That depends on whom you ask. Some people use the words interchangeably. Some say a resume is a one- or two-page summary of your employment history, experience, and education and a CV is a longer, more comprehensive and detailed synopsis of your qualifications, education and experience. So what's the answer?

Generally, it's somewhere in between. Your resume is a summary of your employment history and education that highlights your skills, talents, and education. Your CV would be a longer

⭐ **Words from the Wise**

As people often use the words CV and resume interchangeably, don't assume that just because someone asks you for your CV that they actually want that particular document. They might really want your resume.

Tip from the Coach

One of the mistakes that many people make when preparing their resume is that they keep adding accomplishments without deleting any of the earlier or less important ones. While it's very tempting to do this, it's not always the best idea.

detailed synopsis of these things, plus teaching and research experience you might have, articles or papers you have published, research projects you have done, presentations you have made, and so on. The CV gives you the opportunity to list every paper, project, presentation, and so on.

How do you know which type of document to use? Generally, it depends on the type of job for which you are applying. You will often use your CV instead of a resume if you are applying for a job in research, administration, or education.

What About References?

We just discussed that it's not a good idea to list your references on your resume. That doesn't mean, however, that you don't need them. References are another of your selling tools. Basically, references are the individuals who will vouch for your skills, ethics, and work history when a potential employer calls. A good reference can set you apart from the crowd and give you the edge over other applicants. A bad one can seriously hinder your career goals.

The Inside Scoop

Instead of just making your resume an outline of your accomplishments, make it a powerful marketing tool.

It's always a good idea to bring the names, addresses, and phone numbers of the people you are using for references with you when you apply for a job or when you are going on an interview. If you're asked to list them on an employment application, you'll be prepared.

Who should you use for references? To begin with, you'll need professional references. These are people you've worked with or know you on a professional level. They might be current or former supervisors or bosses, perhaps the director of a department who knows your work, maybe the director of a not-for-profit organization you've worked with, internship program coordinators, former professors, instructors, and so on.

Do your references have to be from within the area of the art industry in which you choose to work? If you have references in the industry, it can't hurt. What you are looking for, however, are people who you can count on to help sell you to potential employers. Those will be your best references.

Always ask people if they are willing to be a reference *before* you use them. Only use people you are absolutely positively sure will say good things about you. When searching out your references, try to find people who are articulate and professional.

Who would be a bad reference? A boss who fired you, a supervisor you didn't get along with,

Tip from the Coach

In some cases, employers might ask for personal references as well as professional references. These are people such as family, friends, or neighbors who know you well. Be sure to have a list of three to five personal references as well as their contact information readily available in case you need it.

⭐ The Inside Scoop

If you give your references an idea of exactly what type of job you're pursuing, what skills are important in that position or even what you want them to say, you stand a better chance of them leading the conversation in the direction you want it to go. You might tell a reference, for example, that you're applying for a position as a gallery exhibitions manager and that the job description calls for someone very organized with the ability to multitask and stay calm and focused. The job description also states that the applicant needs the ability to both research exhibits and arrange for their acquisition. Hopefully, when your reference gets a call, he or she will remember what you said and stress your important selling points.

or anyone whom you had any kind of problem with whatsoever. Do not use these people for references even if they tell you that they'll give you a good one. They might keep their word, but they might not, and you won't know until it's too late.

"What if I didn't get along with my supervisor?" you ask. "Isn't a potential employer going to call her anyway?"

You are right. Your potential employer probably *will* call your former supervisor. There is nothing you can do about that. However, the trick is getting a list of three to five *good* references. That way so no matter what anyone else says, you will still look good.

You might be asked to list references on an employment application, but it's a good idea to prepare a printed sheet of your professional references that you can leave with the interviewer anyway. Basically, this sheet will contain your list of three to five references including their names, positions, and contact information. As with your resume, make sure it is printed neatly on a good, high-quality paper.

Here's an example to get you started.

Professional Reference Sheet for Elizabeth Rimes

Mr. William Thompson
Director
Broadway Art Galley
111 Broadway
Some City, NY 11111
(111) 222-2222
wthompson@somecityinternet.com

Professor Jennifer Collins
State University
100 Route 9D
Some City, NY 11111
(111) 444-4444
jcollins@stateu.edu

James Lawless
Intern Coordinator
New City Museum
529 Main Street
New City, NJ 22222
(333) 666-6666
jlawless@newcitymu.org

John Clinton
Art Director-Pro Advertising
538 Sandstone Street
Some State, NY 11111
(333) 333-3333
jclinton@proadvertising.com

Donna Malvo
Executive Director
Any City Art Society
280 Art Square
Any City, NY 11111
(111) 888-8888
donnamalvo@internet.com

Personal References

In addition to professional references, you might be asked to provide personal references. These are friends, family members, or others who know you. You probably won't need to print out a reference sheet for your personal references, but make sure you have all their contact information in case you need it quickly.

As with professional references, make sure the people you are using know you are listing them as references. Give them a call when you're going on an interview to let them know someone might be contacting them. Ask them to let you know if they get a call.

Letters of Recommendation

As you go through your career, it's a good idea to get letters of recommendation from people who have been impressed with your work. Along with references, these help give potential employers a better sense of your worth. How do you get a letter of recommendation? You usually simply have to ask. For example, let's say you are close to completing an internship.

Say to your supervisor, "I've enjoyed my time here. Would it be possible to get a letter of recommendation from you for my files?"

Most people will be glad to provide this. In some cases, people might even ask you to write it yourself and then give it to them to sign. Don't forego these opportunities even if you feel embarrassed about blowing your own horn. The easiest way to do it is by trying to imagine you aren't writing about yourself. In that way you can be honest and write a great letter. Give it to the person and say, "Here's the letter we discussed. Let me know if you want anything changed or you aren't comfortable with any piece of it." Nine times out of ten, the person will just sign the letter as is.

Whom should you ask for letters of recommendation? In many cases, people will be the same ones you ask to be your reference. If you are still in school or close to graduating, you might ask professors with whom you have developed a good relationship. Don't forget internship coordinators or supervisors; art school instructors; former and current employers; executive directors of not-for-profit, civic, or charity organizations you have volunteered with; and so on.

In some situations the people you ask may just write generic letters of recommendation stating that you were a pleasure to work with or were good at your job. If the person writing the letter knows the type of position you're pursuing, he or she might gear the letter to specific skills, traits, and talents needed.

Your letters of recommendation will become another powerful marketing tool in your quest to career success in the art industry. What do you do with them? Begin by photocopying each letter you get on high-quality white paper, making sure you get clean copies. Once that's done, you can make them part of your career portfolio, send them with your resume when applying for position, or bring them with you to interviews.

Creating Captivating Cover Letters

Unless instructed otherwise by a potential employer or in an advertisement, always send your resume with a cover letter. Why? Mainly because if your resume grabs the eye of someone in the position to interview you, he or she often looks at the cover letter to evaluate your written communications skills as well as to get a sense of your personal side. If your letter is a good one, it might just get you the phone call you've

been waiting for. On the other hand, a poorly written letter might just keep you from getting that call.

What can make your letter stand out? Try to make sure your letter is directed to the name of the person to whom you are sending it instead of "Hiring Manager," "Director of Human Resources," "To Whom It May Concern," or "Sir or Madam."

"But, the name of the person isn't in the ad," you say. "How do I know what it is?"

You might not always be able to get the correct name, but at least do some research. You might, for example, call the organization or company advertising the opening and ask the name of the person to which responses should be directed.

If you are sending your resume cold, it's even more important to send it to a specific person. It gives you a better shot at someone not only reviewing it but taking action on it.

It's okay to call an organization or company and say to the receptionist or secretary, "Hi, I was wondering if you could give me some information? I'm going to be sending my resume to your company and I'm not sure who to send it to. Could you please give me the name of the human resources director (or hiring manager or whoever you are trying to target)?"

If he or she won't give it to you for some reason, say thank you and hang up. While most companies and organizations generally will freely give out this type of information, there may be some that, for various reasons, will not give out names easily.

How do you get around this? Wait until lunch time or around 5:15 p.m. when the person you spoke to might be at lunch or done with their work day, call back, and say something to the effect of, "Hi, I was wondering if you could please give me the spelling of your HR director's name [or whoever name you're seeking]?"

If the person on the other end of the phone line asks you to be more specific about the name simply say, "Let's see, I think it was Brownson or something like that. It sounded like Brown something."

Don't worry about sounding stupid on the phone. The person at the other end doesn't know you. This system usually works. Believe it not, most companies have someone working there whose name sounds like Brown or Smith.

The person on the phone may say to you, "No, we don't have a Brownson. What department are you looking for? It was HR wasn't it?"

When you say yes, he or she will probably say, "Oh, that's not Brownson; it's John Campbell. Is that who you're looking for?"

Then all you have to say is, "You know what, you're right, sorry, I was looking at the wrong notes. So that's C-A-M-P-B-E-L-L?"

Voila. You have the name. Is it a lot of effort? Well, it's a little effort, but if it gets you the name of someone you need and ultimately helps get you an interview, isn't it worth it?

By the way, this technique not only works getting names you need but other information as well. You might have to be persistent and it might take you a few tries, but it generally always gets you the information you need.

You also can sometimes get names from the Internet. Perhaps the company Web site lists the names of their key people. Key names for large companies may also often be located on Hoovers.com, an online database of information about businesses. While part of Hoovers.com is a paid service, certain information is available free of charge. If you are targeting a museum, gallery, art society, advertising agency, or similar, and the organization has a Web site, names of key personnel are often listed there as well.

Do what you can to get the names you need. It can make a big difference when you di-

> ### ⭐ Words from the Wise
> Resist the urge to write a one-paragraph cover letter. Use your cover letter as another chance to *wow* the reader. Use it as another of your marketing tools.

rect your letters to someone specific within the organization.

No matter which segment of art industry in which you are trying to locate a job, those who are in the position to hire you may be receiving a large number of resumes, letters, and phone calls. What can help your letters stand out? Make them grab the attention of the reader. How? Develop creative cover letters.

Take some time and think about it. What would make *you* keep reading? Of course, there will be some situations when applying for jobs in some areas of the art industry where you might be better off sending the traditional "In response to your ad letter." But what about trying out a couple of other ideas when you can?

Take a look at the first sample cover letter. Would this letter grab your attention? Would it make you keep reading? Chances are it would. After grabbing the reader's attention, it quickly offers some of the applicant's skills, talents, and achievements. Would you bring in Carol Carey for an interview? I think most employers would.

CAROL CAREY
333 North Street
Another Town, NY 33333
Phone: 222-333-5555
ccarey@moreinternet.com

Mr. Jim Wiggins
Center City Art Museum
Center City, NY 11111

Dear Mr. Wiggins:
CONGRATULATIONS!

I'm pleased to inform you that you have just received the resume that can end your search for the Center City Art Museum's new public relations director. In order to claim your "prize," please review my resume and call as soon as possible to arrange an interview. I can guarantee, you'll be pleased you did!

In my current position as the director of media relations for Mayor David Davis, I have developed a close working relationship with the local, regional, and national news media. During my three-year tenure in this position, I have implemented and conducted numerous press conferences and interviews, dealt effectively with media inquiries, provided spokespeople to assure the public receives accurate information when the major wasn't available, and handled spin control when necessary.

My responsibilities additionally include preparing statements for the mayor as well as his designated spokespeople and personally giving statements to the media when directed.

When the mayor's director of public relations went on maternity leave last summer, I was asked to step in and assume her responsibilities as well. During this period of time, I supervised the department of 16 employees. Part of my responsibilities also included publicizing the city's 50th Anniversary Celebration, including all the special events. Not only was the celebration was a success, but we also received a great deal of positive publicity after the event in the local and national media.

While I love what I do now, my dream has always been a career where I could combine the skills garnered from my bachelor's degree in art history and marketing with my master's in communications.

I would welcome the challenge and opportunity to work with the Center City Art Museum and believe my experience, skills, talents, and passion would be an asset to your organization.

I look forward to hearing from you.

Sincerely yours,
Carol Carey

Here's another example of a creative cover letter.

GLEN MILLER
392 South Avenue
Different Town, NY 33333
Phone: 111-999-9999
gmiller@moreinternet.com

Ms. Cindy Grayson
Human Resources Director
Orange City Art Museum
910 Main Street
Orange City, NY 11111

Dear Ms. Grayson:

IS YOUR MUSEUM IN NEED OF FUNDS?
Thousands of dollars can be yours with just one call—to me!

I was excited to learn about the opening for the Director of Fund-raising and Development at the Orange City Art Museum. How lucky for me that just when I moved back into the area, the perfect job became available.

I recently graduated from Kingston University with a double major in business administration and marketing. Before you pass by my resume for lack of experience, I urge you to read on. I'm sure you will agree that what I lack in professional experience, I more than make up for in my volunteer activities.

While still in college, I volunteered to work on fund-raising for a large not-for-profit theater in the area. I began by assisting in the coordination of a number of fund-raising events. I soon was helping develop and implement additional fund-raising events and activities for the theater, helping to raise over $800,000. After researching and writing a number of grants, I was also able to secure three large grants totaling close to $1 million, which the theater desperately needed.

One of the members of the theater board of directors also was on the board of the local art society and asked me if I would consider writing a number of grants for them as well. I agreed and was successful in obtaining both a $25,000 grant and a $100,000 grant to help fund a project helping new artists.

In my last semester, I was looking for a project to complete an independent study when approached by a board member from the local hospital. She asked if I would be willing to volunteer to help them with their annual giving campaign.

I jumped at the opportunity and learned all about cultivating donors and prospective donors. I was very excited to help with the hospital's efforts and even more pleased when they raised over $10 million dollars. (Of course, it wasn't just my volunteer efforts bringing in that amount, but my solicitations of donors helped increase the number and amount of major gift donors.)

Although I was offered a paid position with the hospital upon graduation, I declined. I have ties in this community, and I really wanted to move back to the area to be closer to my family.

I grew up visiting the Orange City Art Museum at least once a month with my parents. It was one of my favorite family outings then, and something I truly missed visiting while I was in college. I would love the opportunity to combine my passion for art with my skills and talents raising funds and cultivating donors.

I'm an enthusiastic, creative, motivated team player who can also work effectively on my own. I am focused and goal oriented. If you give me the chance, I'll be Orange City Art Museum's number-one cheerleader.

I have enclosed my resume, copies of news stories on some of the fund-raising programs I was involved with, as well as a brief outline of a number of ideas I developed for fund-raising and development for other organizations.

I would appreciate the opportunity to meet with you to discuss this exciting opportunity.

Thanks for your consideration. I look forward to hearing from you.

Sincerely yours,
Glen Miller

While a creative cover letter may grab the attention of the reader, sometimes when apply-

ing for a position you might feel that creativity just isn't appropriate. Here's an example of a simple letter for someone applying for a job as an art teacher/art department head.

JOSH HIGGINS
342 L Avenue
Different Town, NY 33333
Phone: 999-999-9999
joshhiggins@moreinternet.com

Theresa Hendricks, Human Resources Director
Center City Central Schools
102 Third Avenue
Center City, NY 22222

Dear Ms. Hendricks:

I am submitting my resume for the position of art teacher/art department head at Center City Central School in response to your advertisement in the July 15th edition of the Center City Times.

Seven years ago, I graduated from State College at the top of my class. The day I became an art teacher was one of the best days of my life. It was then I could pursue the dream I had since an art teacher inspired me in third grade.

Since becoming a teacher, my life has been filled with wonderful challenges each and every day. I have earned promotions, become the director of the art department at Middletown High and was named Teacher of the Year in 2006. While those should be the highlights of my career, they are not.

Instead, the highlights have been the things I did every day in my job. Teaching a new art technique to students; seeing a special needs child smile when she got a compliment from her mother on her beautiful painting; helping youngsters find their creativity; helping students get an appreciation for art that they then can take with them the rest of their lives; and having a third grader tell me she wanted to be a teacher "just like me" when she grows up, are just a few of the moments that stand out in my mind.

There is not a day I am not thankful that I chose this career path. Every assignment has given me the experience that has prepared me for the job for which I now apply. While I am tenured in my present position, I would love to move back to the Center City area to be closer to my family.

I would very much appreciate the opportunity to meet with you to further discuss this opportunity. I look forward to hearing from you.

Sincerely,
Josh Higgins

More Selling Tools—Business and Networking Cards

The best way to succeed at almost anything is to do everything possible to stack the deck in your favor. Most people use a resume to sell themselves. As just discussed, done right, your resume can be a great selling tool. It can get you in the door for an interview. But putting all your eggs in one basket is never a good idea. What else can you do to help sell yourself? What other tools can you use?

Business cards are small but powerful tools that can positively impact your career if used correctly. We've discussed the importance of business cards throughout the book. Let's look at them more closely.

Whatever level you're at in your career, whatever area of the industry you're interested in pursuing, business cards can help you get fur-

★ Tip from the Coach

Business cards are networking cards. You give them to people you meet so they not only remember you and what you do but how to contact you if necessary. These are important no matter what aspect of the art industry you aspire to succeed in.

ther. If you don't have a job yet, business cards are essential. At this point, they may also be known as networking cards because that is what they are going to help you do. If you already have a job, business cards can help you climb the ladder to success. Get your business cards made up, and get them made up now! They will be very useful in your career.

Why are cards so important? For a lot of reasons, but mainly because they help people not only remember you but find you. Networking is so essential to your success in the industry that once you go through all the trouble of doing it, if someone doesn't remember who you are or how they can contact you, it's almost useless.

How many times have you met someone during the day or at a party and then gone your separate ways? A couple days later, something will come up where you wish you could remember the person's name or you remember their name, but have no idea how to get a hold of them.

How badly would you feel if you found out that you met someone, told them that you were looking for a job, they ran into someone else

The Inside Scoop

Don't try to save money making business cards on your computer. They never really end up looking professional, so in the end, you don't really end up saving any money.

who was looking for someone with your skills and talents, and they didn't know how to get a hold of you? Business cards could have helped solve that problem.

When was the last time you ran into someone successful who didn't have business cards? They boost your prestige and make you feel more successful. And if you feel more successful, you'll be more successful.

So, what's your next step? Start by determining what you want your business cards to look like. There are a variety of styles to choose from. You might want to go to a print shop or an office supply store such as Staples or Office Max to look at samples or you can create your own style.

Samples of Business and Networking Cards

Morton Garrison

Graphic Artist
Corporate Identity, Print, Package Design, Web Design
Bachelor of Fine Arts

P.O. Box 2900
Anytown, NY 11111
E-mail: mortongarrison@someinternet.com

Phone: 111-888-9999
Cell: 888-999-0000

Samples of Business and Networking Cards, continued

Charles Anthony

Art Exhibit Curator

Master's Degree in Art History

P.O. Box 909
Anytown, NY 11111
E-mail: canthony@internet.com

Phone: 111-444-9999
Cell: 888-111-1111

420 North Avenue
Anytown, NY 11111
rogerlawson@internet.com

Roger Lawson

Career Goal: Elementary School Art Teacher
Licensed – New York State

Phone: 111-444-0000
Cell: 888-888-9999

492 Circle Street
Anytown, NY 11111
E-mail: jevans@allinternet.com

Joseph Evans

Museum Security Specialist
www.josephevanssecurity.com

Phone: 222-111-1111
Cell: 111-999-0000

Samples of Business and Networking Cards, continued

Jenny Harvey
Craft Show Promoter
Jenny Harvey Craft Shows
www.jennyharveycraftshows.com

P.O. Box 1400 Phone: 111-444-5555
Anytown, NY 11111
E-mail: jenny@jennyharveycraftshows.com

JACK KLINE
Sculptor

P.O. Box 999 Phone: 111-444-5555
Anytown, NY 11111
E-mail: jackkline@someinternet.com

Lilly Margate
Interior Designer

P.O. Box 1400 Phone: 111-444-7777
Anytown, NY 11111
E-mail: lillymargate@someinternet.com

⭐ Tip from the Top

If you are currently employed, your employer will often provide you with business cards.

⭐ Words from the Wise

If you are pursuing a career in the talent end of the industry, make sure your business cards are attractive and illustrate that you have talent. It is especially important in these cases to be sure cards are eye catching and have an attractive layout and the perfect font.

Order at least 1,000 cards. What are you going to do with that many cards? You're going to give them to everyone. While everyone might not keep your resume, most people in all aspects of business keep cards.

Simple cards are the least expensive. The more design, graphics, or features you add, the more the cost goes up.

What should your cards say? At the minimum include your name, address (or P.O. box) and phone number (both home or business and cell if you have one). It's a good idea to add in your job or your career goal or objective. You might even briefly describe your talents, skills, or traits. Your business card is your selling piece, so think about what you want to sell. Look at other people's cards to get ideas.

Remember that business cards are small. The number of words that can fit on the card so the card looks attractive and can be read easily are limited. If you want more room, you might use a double-sided card (front and back) or a double-sized card that is folded over in effect giving you four times as much space. I've seen both used successfully. The double-sized card can be very effective for a mini-resume.

You have a lot of decisions on how you want your business cards to look. What kind of card stock do you want? Do you want your card smooth or textured, flat or shiny? What about color? Do you want a white, beige, or colored card? Do you want flat print or raised print? What fonts or typefaces do you want to use? Do you want graphics? How do you want the information laid out? Do you want it straight or on an angle? The decisions are yours. It just depends what you like and what you think will sell you the best.

⭐ Words from the Wise

If you don't feel comfortable putting your physical home address on your business card, get a P.O. box.

⭐ Tip from the Coach

At every career-oriented seminar I give, when we get to the section on business cards, someone always raises their hand and says something to the effect of, "I don't have a job yet. What kind of cards do I make up? What would they say? 'Unemployed?' 'Unemployed but wants to work?' 'Unemployed but wants to be an artist?' 'Unemployed but really wants a job working in a museum?'"

So before you think it or say it, the answer is no. You definitely don't put the word *unemployed* on your cards. You will put your name, contact information, and career goals on your business cards and then use them to become employed in your career of choice.

> ### ⭐ Tip from the Coach
> Look at other people's business cards in all industries to try to find a style you like. Then fit your information into that style.

Brochures Can Tell Your Story

While you're always going to need a resume, consider developing your own brochure, too. A brochure can tell your story and help you sell yourself. Sometimes, something out of the ordinary can help grab the attention of someone important.

What's a brochure? Basically it is a selling piece that gives information about a product, place, event, or person among other things. In this situation, the brochure is going to be about you. While your resume tells your full story, your brochure is going to illustrate your key points.

Why do you need one? A brochure can make you stand out from other job seekers. If you are an artist, craftsperson, or designer, brochures can be especially effective.

What should a brochure contain? While it depends to a great extent on what segment of the industry you are pursuing, there are some basic things you should include.

Of course, you need your name and contact information. Then add your selling points. Maybe those are your skills. Perhaps they are your talents or accomplishments. What about something unique or special that you do? Definitely try to illustrate what *you* can do for an organization, company, museum, gallery, and so on and what benefits they will obtain by hiring you. A brief bio is often helpful to illustrate your credentials and credibility. What about three or four quotes from some of your letters of recommendation? For example:

- ◎ "One of the best interns we ever had participate in our internship program." Ellen Tripper, Tri-City Art Museum
- ◎ "A real team player who motivates the team." Henry Atkins, CEO, ABC Advertising
- ◎ "A truly talented artist." Alicia Rose, Director-Alicia Rose Art Gallery

Keep your wording simple. Make it clear, concise, and interesting.

What should your brochure look like? The possibilities are endless. Brochures can be simple or elaborate. Your brochure can be designed in different sizes, papers, folds, inks, and colors. You can use photographs, drawings, illustrations, or other graphics.

If you have graphic design ability and talent, lay out your brochure yourself. If you don't, ask a friend or family member who is talented in that area. There are also software programs that help you design brochures. With these programs you simply type your information in and print it out. Some people with access to a laser color copier or printer create their own professional looking pieces.

The beauty of doing it yourself is that after you've sent out a number of brochures, you can improve and redesign them if they aren't doing anything for you and send out another batch. Be very sure, however, that your brochure looks professional, or it will defeat the purpose.

If you want to design your brochure but want it printed professionally, consider bringing your camera-ready brochure to a professional print shop. Camera-ready means your document is ready to be printed, and any print shop should be able to help guide you through the steps needed to prepare your work for them. In addition to print shops, you might also consider office supply stores like Staples and Office Max that do printing.

If you don't feel comfortable designing your own brochure, you can ask a printer in your area if there is an artist on staff. Professional design and printing of a brochure can get expensive. Is it worth it? Only you can decide, but if it helps get your career started or makes the one you have more successful, probably the answer is yes.

Can brochures be effective? I certainly think so. Not only do I know a great number of people who have used them successfully in a variety of industries—I personally used one when I was breaking into the music business and have continued using them ever since. Here's my story.

At the time, I was sending out a lot of resumes and making a lot of calls in an attempt to obtain interviews. I had learned a lot about marketing and noticed that many companies used brochures. My father, who was a marketing professional, suggested that a brochure might just be what I needed. By that time I had realized that if I wanted to *sell* myself, I might need to market myself a little more aggressively than I was doing, so I decided to try the brochure idea.

We designed a brochure that was printed on an 11-by-17-inch paper folded in half, giving me four pages to tell my story. We artistically mounted a head shot on the front page and printed it in hot pink ink. The inside was crafted with carefully selected words indicating my accomplishments, skills, talents, and the areas in which I could help a company who hired me. The brochures were professionally printed, and I sent them to various record labels, music instrument manufacturers, music publishers, music industry publicity companies, artist managers, and so on. I started getting calls from some of the people who received the brochure, obtained a number of interviews, and even landed a couple of job offers. None of them, however, interested me.

Five years after I sent out my first brochure, I received a call from a major record company who told me that at the time they first received my brochure they didn't need anyone with my skills or talents, but they thought the brochure was so unique that they kept it on file. Voila. Five years passed, they needed an individual with my skills, someone remembered my brochure, pulled it out, and called me. By that time I was already on the road with another group and couldn't take the job, but it was nice to be called.

What was really interesting, however, is that companies and people I originally sent that first brochure years ago still remember it. They can describe it to a T, and many of them still have it in their files.

When creating your brochure, make sure it represents the image you want to portray. Make it as creative, unique, and eye catching as possible. This is especially important if you aspire to work in the creative area of the industry. You can never tell how long someone is going to keep it.

Your Career Portfolio: Have Experience, Will Travel

People in creative careers have always used portfolios to illustrate what they have done and can accomplish. You can do the same in your career in other parts of the art industry. (If you are an artist, craftsperson, designer, or similar, we are also going to discuss more about your portfolio in Chapter 11.)

What exactly is a career portfolio? Basically, it's a portfolio, binder, or book that contains your career information and illustrates your best work. In addition to traditional printed components of your portfolios, many people in the industry are also using multimedia components including video, PowerPoint presentations, and Web pages. Your portfolio is a visual representation of what you have done and often illustrates what your potential might be.

Why do you need one? Because your career portfolio can help you get the positions you want, and that is what this is all about.

Consider this question. What would you believe more, something someone told you or something you saw with your own eyes? If you're like most people, you would believe something you saw. And that's what a good career portfolio can do for you. It can provide actual illustrations of what you've done and what you can do.

For example, you might tell a potential employer that in your last job you brought in a new exhibit to the museum where you worked that increased attendance by 25 percent. If you have a copy of the newspaper story discussing the exhibit and the crowds it drew, he or she can see what you are talking about in black and white.

What would be more impressive to you? Reading over someone's resume and reading that they received the "Web Designer of the Year" award or actually seeing a copy of the award certificate? Would you rather read a bullet listing on someone's resume stating that they had created an award-winning mural or see a picture of it?

Has someone done a feature story or article on you? Have you been quoted in your professional capacity? Have you received awards?

Copies of all these documents can be part of your career portfolio. Often, if you have buzz around you, potential employers feel you will be a commodity,

Don't think that your portfolio will only be useful when you are first trying to land a job. If you continue adding in new accomplishments, skills, and samples of projects you've worked on, your portfolio will be useful in advancement throughout your career. Of course, as time goes on, omit some of your earlier documents and replace them with more current ones.

Having an organized system to present your achievements and successes is also helpful when going through employment reviews or asking for a promotion or a raise. It also is very effective in illustrating what you've done if you're trying to move up the ladder at a different company.

Over the years, I've consistently gotten calls from people who have been to my seminars or called for advice who continue to use their ca-

Tip from the Top

When compiling your portfolio, be careful not to use any confidential work or documents from an organization or company even if you were the one who wrote the report, letter, or other document. A potential employer might be concerned about how you will deal with their confidential issues if you aren't keeping other confidences.

Tip from the Coach

Make copies of key items in your portfolio to leave with interviewers or potential employers, agents, etc. Visit an office supply store to find some professional looking presentation folders to hold all the support documents you bring to an interview.

reer portfolios successfully in their careers in every industry. Work on developing your career portfolio, and this simple tool can help you achieve success as well.

Your portfolio is portable. You can bring it with you when you go on interviews so you can show it to potential employers. You can make copies of things in your portfolio to give to potential employers or have everything at hand when you want to answer an ad or send out cold letters.

How do you build a detailed portfolio illustrating your skills, talents, experiences, and accomplishments? What goes into it? You want your portfolio to document your work-related talents and accomplishments. These are the assets that you will be *selling* to your potential employers. Let's look at some of the things you might want to include.

- Your profile
- Resume
- Bio
- Reference sheets
- Skill and abilities
- Degrees, licenses, and certifications
- Training
- Experience sheet
- Summary of accomplishments
- Professional associations
- Professional development activities (Conferences, seminars, and workshops attended, as well as any other professional development activities)
- Awards and honors
- Volunteer activities and community service
- Supporting documents
- Samples of work
- Newspaper, magazine, and other articles or feature stories about you
- Articles you have written and published
- Reports you've done
- Letters of recommendation
- Letters or notes people have written to tell you that you've done a good job
- Photos of you accepting an award or at an event you worked on
- Photos of events you were involved in
- News stories or feature articles generated by your execution or supervision of a project

Words from a Pro

If you're dealing with an unknown printer or company, ask to see samples of their work ahead of time. Then be sure to get a proof that you can check for errors and approve before your presentation folders are printed.

Sample of Profile for Career Portfolio

PROFILE
Shari Jackson

Education:
- ◎ State University: Master of Fine Arts Degree
- ◎ State University: Bachelor of Fine Arts Degree
 - ⊡ Minor: Business

Additional Training:
- ◎ Workshop: Quark
- ◎ Workshop: Web Design
- ◎ Seminar: Communicating with Clients
- ◎ Seminar: Using Graphics to Increase Business
- ◎ Workshop: Creative Package Design
- ◎ Workshop: Creative Illustration
- ◎ Seminar: Public Speaking Techniques

Goals:
- ◎ Using my skills, talents, education, and training in a creative career.
- ◎ Working in a corporate culture as a graphic designer

Qualifications:
- ◎ Talented graphic artist
- ◎ Skilled in illustration, animation and cartooning
- ◎ Hard working, dedicated, focused, motivated, and energetic
- ◎ Creative thinker
- ◎ Problem solver
- ◎ Ability to stay calm no matter what
- ◎ Computer skills
- ◎ Creative Web designer
- ◎ Verbal and written communication skills
- ◎ Multilingual (English, Spanish, French)

Remember that this list is just to get you started. Some of the components may relate to you and some may not. You can use anything in your portfolio that will help illustrate your skills, talents, and accomplishments.

In order to make it easier to locate information in your portfolio, you might want to develop a table of contents and then utilize dividers.

On the preceding page is a sample profile that someone interested in a career as a graphic designer might use in her portfolio. Use it to give you an idea on getting started on yours.

Whatever segment of the art industry you are pursuing, use every tool you can to make sure you get the edge over others who want the same success you do.

7

GETTING YOUR FOOT IN THE DOOR

One of the keys to a great career is getting your foot in the proverbial door. If you can just get that door open—even if it's just a crack—you can slip your foot in, and then you're on the road to success. Why? Because once you get your foot in, you have a chance to sell yourself, sell your talent, and sell your products or services.

It may seem easy, but the problem is that sometimes the hardest part is getting your foot in the door. Whether you simply walk in off the street to see someone or call to make an appointment, you often are faced with the same situation. You need to get past the receptionist, the secretary, or whoever the "gatekeeper" happens to be between you and the person with whom you want to speak.

And while you may not always need to *get past* a gatekeeper in every situation, you should be aware that there generally still is a gatekeeper.

Whether I'm giving a career seminar or doing a career consultation, people looking for advice on getting that *perfect* job consistently tell me that if they only could get their foot in the door, they would be on their way. In a way they're right.

Here's what you need to know. Whenever there is a job opening, someone will get the job, and unfortunately someone won't. Rejection is often part of the process in getting a job. However, to feel rejected, when you didn't even get the chance to really be rejected because you can't get through to someone, is quite another thing.

It's not personal, but the secretary, receptionist, assistant, and even the person you're trying to reach often think of you and most other unsolicited callers as unwanted intruders who waste their time. It doesn't really matter whether you're trying to sell something or get a job; unless they can see what you can do for them, it's going to be hard to get through.

In reality, you are trying to *sell* something. You're trying to sell *you, your skills,* and *your talents.* You're trying to get a job. You may be trying to get someone interested in your art.

What you need to do is try not to let these gatekeepers know exactly what you want. I am in no way telling you to lie or even stretch the truth. What I'm telling you to do is find a way to change their perception of you and what you want. Get creative.

Some areas of the art industry are easier to enter than others. Some segments of the industry are more competitive. And while there generally always is a gatekeeper, sometimes it's easier to get past him or her.

Being prepared for any situation always gives you the edge. Read over this section, get familiar

with some of the ideas, and use them when needed. Keep in mind that no matter position you are pursuing, the people in charge of hiring have a choice. You want to be the one who is chosen.

There are any number of possible scenarios you might run into a gatekeeper. You might be going after a job that has been advertised. You might be going after a job that is in the hidden job market. You might want to create your own position.

You might be trying to sell an idea or a concept. You might be trying to sell your artwork or design services. You might just want to meet somebody or call someone. There are so many possibilities where there *could* be a gatekeeper in your way during your career that you really need to know how to get past them just in case.

"But I'm just answering an advertisement," you say. "Do I have to worry about getting past a gatekeeper?"

You might not have to worry about getting past gatekeepers, but that doesn't mean they aren't there. You might not see them, but they always are lurking in the background.

What you need to know is that no matter which segment of the industry you are pursuing, there may be times when you need to get past a gatekeeper so you can get your foot in the door. Before you rush in and find the door locked, let's look at some possible keys to help you get in.

Will you need every key? Probably not, but once you learn what some of the keys are, you'll have them if you need them.

Getting Through to People on the Phone

Let's start with the phone. If your goal is to talk to a specific person or make an appointment, it's important to know that many high-level

businesspeople don't answer their own phone. Instead, they rely on secretaries, receptionists, or assistants to handle this task. And that's not even counting the dreaded voice mail.

You can always try the straightforward approach. Just call and ask to speak to the person you are looking for. If that works, you have your foot in the door. If not, it's time to get creative.

Let's look at a couple of scenarios and how they might play out. In this scenario Sheila Masters is trying to land an interview in an attempt to create a position running craft shows on a permanent basis at a shopping center.

Scenario 1

Receptionist: Good afternoon, Green City Mall.

You: Hello, this is Sheila Masters. Can I please speak to your mall manager, Matt West?

Receptionist: Does he know what this is in reference to?

You: No. I want to talk to him about running craft shows in the Green City Mall, and I wanted to see if I could set up an interview.

Receptionist: I'm sorry; we don't need anyone to do that. Thank you for calling.

You: Thanks. Good-bye.

With that said, you're done. Is there something you could have said differently that might lead to a better ending? Sometimes mentioning a job to the gatekeeper is not a good idea. Let's say you are trying to create your own position or you are going after a position that is so coveted that those already working in the company or organization may not be that open about help-

ing those on the outside. What can you do? Creativity is the name of the game. Let's look at another scenario.

Scenario 2

Secretary: Good afternoon, Green City Mall.

You: Is Mr. West in, please?

Secretary: Who's calling?

You: Sheila Masters.

Secretary: May I ask what this is in reference to?

You: Yes, I was trying to set up an informational interview. Would Mr. West be the person who handles this or would it be someone else?

[Asking the question in this manner means that you stand a chance at the gatekeeper giving you a specific name that you can call if Mr. West is the wrong person.]

Secretary: Informational interview for what purpose?

You: I was interested in learning more about careers in malls and shopping centers in the marketing and special events area. I'm also investigating the advantages for facilities using people on staff to run craft shows and other special events in relation to using professional promoters. I'm trying to determine which direction is more effective for shopping centers. I saw Mr. West on the news last week and heard him talking about the challenges malls have in bringing potential shoppers in. I thought he might have some knowledge in that area. Would he be the right person?

[Make sure you are pleasant. This helps the person answering the phone want to help you.]

Secretary: Matt West is our mall manager. You probably would be better off speaking to Ron Kaplan. He deals more with special promotions at all our properties. Would you like me to give you his number?

[What you are really doing is helping her get you off the phone even if it means she is dumping you on someone else.]

You: Yes, that would be great. What was your name?

[Try to make sure you get the person's name. In this manner, when you get transferred, the person answering at the other end will be more apt to help you.]

Secretary: Jane Kelly. I can switch you if you would like.

You: Thanks for your help. I really appreciate it.

Secretary: I'll switch you now.

Sharon Williams: Ron Kaplan's office. This is Sharon. May I help you?

You: Hi, Sharon, Jane Kelly suggested that Mr. Kaplan might be the right person for me to speak to. I was interested in learning more about careers in malls and shopping centers in the marketing and special events area. I'm also investigating the advantages for facilities using people on staff to run craft shows and other special events in relation to using professional promoters. I was hoping he might be able to give me some insight—on a general basis, not necessarily with your malls.

Sharon Williams: Are you working on a project for school or do you work for a craft show promoter?

You: No, I'm out of school. I'm just really gathering information. I thought it might be interesting for a possible article.

[Notice that you are not really answering her question at all. At this point, Sharon Williams probably will either say, "Sorry, Mr. Kaplan is very busy," or keep pumping you for information.]

Sharon Williams: Mr. Kaplan is out of the office this week at a convention. He should be back next Monday.

You: I know he is busy. Do you think he would have 10 minutes for me if I stop in sometime next week, or would it be better to call him? I'm really interested in hearing his thoughts in this area.

Sharon Williams: He is pretty busy next week, but he might be able to spare a few minutes on Wednesday. Would that work for you?

[Do not say, let me check my calendar. If at all possible, take the time you are given for the meeting, no matter what else you have to juggle around.]

Sharon Williams: I'm going to double check with Mr. Kaplan later. If you don't hear from me, why don't you come over around 9:30 a.m. on Wednesday. Do you have our address? We're in the corporate offices attached to the mall. We're on the fifth floor.

You: Great, I'll be there.

Sharon Williams: You might want to also speak to Janine Adams. She is the special events director at the Tri-City Mall down in Florida. She might be able to give you some information as well. Her number is 444-444-4444. You can tell her I suggested that you call.

You: That is so nice of you. I'm going to give her a call as soon as I hang up. You have been really helpful. I'll see you on Wednesday morning.

Here's what you need to know. If you are going in for an informational interview, make sure you *make it* an informational interview. You can, of course, nonchalantly drop information about your qualifications, but make sure you ask questions and get the information you originally said you wanted. Otherwise your credibility may be marred.

You may or may not be successful in planting a seed so Mr. Kaplan thinks about creating an in-house position for you or even just uses your services when needed. However, no matter what, you have made another contact who may be useful in helping you attain your career goals. Mr. Kaplan, for example, may tell a colleague about you, and voila, you have another opportunity.

I can hear you saying, "That kind of thing doesn't really happen."

To that I reply it can and it does. I've seen it happen numerous times. In order for it to happen, however, you have to find ways to get past the gatekeeper. Here's another scenario.

Scenario 3

Receptionist: Good afternoon, ABC Advertising.

You: Hi, I'm working on a project involving graphic arts careers. Do you know who in your company I might

speak to that might know something about that area?

[Here is where it can get a little tricky. If you are very lucky, he or she will just put you through to someone in publicity, public relations, or human resources. If you're not so lucky, he or she will ask you questions.]

Receptionist: What type of project?

You need to be ready with a plausible answer. What you say will, of course, depend on your situation. If you are in college, you can always put together a project with one of your professors and say you are working on a project for school. If not, you can say you are doing research on career opportunities for graphic artists (or whatever area of the industry you are pursuing). If you have writing skills, you might contact a local newspaper or magazine to see if they are interested in an article on careers for graphic artists or how graphic artists bring the product packaging or advertising we know to fruition (or whatever segment of the industry you are targeting). If you can't find someone to write for, you can always write a story on "spec." This means that if you write a story, you can send it in to an editor on speculation. They might take it and they might not. Don't think about money at this point. Your goal here is to get the "right people" to speak to you and get an appointment.

This method of getting to know people is supposed to give you credibility, not make you noncredible. The idea will only be effective if you *really* are planning on writing an article or a story and carry through.

One of the interesting things about writing an article (whether on spec or on assignment) is that you can ask people questions and they will usually talk to you. They won't be looking at you as they might be if you were looking for a job.

> ### ⭐ Voice of Experience
> Make sure you get the correct spelling of the names of everyone who helps you. Send a short note thanking them for their help immediately. This is not only good manners. It helps people remember who you are in a positive way.

What you've done in these situations is change people's perception about why you are talking to them. One of the most important bonuses of interviewing people about a career in various industries is that you are making invaluable contacts.

Remember to use this opportunity to ask questions and network. While it might be tempting, *do not* try to sell yourself. After you write the article, you might call up one of the people you have interviewed, perhaps the human resources director or art director, and say something like, "You made a career as a graphic artist in an advertising agency so interesting, I'd like to explore it more. I believe I have the training and the talent. I just really never thought about working in an advertising agency before I spoke to you. Would it be possible to come in for an interview and show you my portfolio?"

What can you do if none of these scenarios work? The receptionist may not be very eager to help. He or she may have instructions on "not letting anyone through." It may be his or her job to block unsolicited callers and visitors from the boss. What can you do?

Here are a few ideas that might help. See if you can come up with some others yourself.

◎ Try placing your call before regular business hours. Many executives and others you might want to talk to come in

early, before the secretary or receptionist is scheduled to work.

◎ Try placing your calls after traditional business hours when the secretary probably has left. The executives and others you want to reach generally don't punch a time clock and often work late. More important, even if people utilize voice mail, they may pick up the phone themselves after hours in case their family is calling.

◎ Lunch hours are also a good time to attempt to get through to people. This is a little tricky. Executives may use voice mail during the lunch hour period or they may go out to lunch themselves. On the other hand, you might get lucky.

◎ Sometimes others in the office fill in for a receptionist or secretary and aren't sure what the procedure is or who everyone is. While you might not get through on the first shot, you might use this type of opportunity to get information. For example, you might ask for the person you want to speak to, and when the substitute tells you he or she isn't in and asks if you want to leave a message, say something like, "I'm moving around a lot today. I'll try to call later. Is Mr. Brown ever in the office after 6:00 p.m.?" If the answer is yes, ask if you can have his direct extension in case the switchboard is closed.

Remember the three "Ps" to help you get through. You want to be:

◎ Pleasant
◎ Persistent
◎ Positive

Always be pleasant. Aside from it being general good manners to be nice to others, being pleasant to gatekeepers is essential. Gatekeepers talk to their bosses and can let them know if you were annoying or obnoxious. When someone tells you their boss "never takes unsolicited calls or accepts unsolicited resumes," tell them you understand. Then ask what they suggest. Acknowledge objections, but try to come up with a solution.

Be persistent. Just because you don't get through on the first try doesn't mean you shouldn't try again. Don't be annoying, don't be pushy, but don't give up. People like to help positive people. Don't moan and groan about how difficult your life is to the secretary. He or she will only want to get you off the phone.

Persistence and the Guilt Factor

Don't forget the guilt factor. If you consistently place calls to "Mr. Keane," and each time his secretary tells you he is busy, unavailable, or will call you back (and he doesn't), what should you do? Should you give up? Well, that's up to you. Be aware that persistence often pays off. In many cases, after a number of calls, you and the secretary will have built up a "relationship" of sorts. As long as you have been pleasant, he or she may feel "guilty" that you are such a nice person and his or her boss isn't calling you back. In these cases, the secretary may give you a tip on how to get through, tell you to send something in writing, or ask the boss to speak to you.

Words from the Wise
Friday afternoon is the worst time to call someone when you want something. The second worst time is early Monday morning.

Voice mail is another obstacle you might have to deal with. This automated system is often more difficult to bypass than a human gatekeeper. Many people don't even bother answering their phone, instead letting their voice mail pick up the calls and then checking their messages when convenient.

Decide ahead of time what you're going to do if you get someone's voice mail. Try calling once to see what the person's message is. It might, for example, let you know that the person you're calling is out of town until Monday. What this will tell you is that if you are calling someone on a cold call, you should probably not call until Wednesday because they probably will be busy when they get back in town.

If the message says something to the effect of "I'm out of town, if you need to speak to me today, please call my cell phone" and then provides a phone number, don't. You don't *need* to speak to him or her; you *want* to. There is a big difference between *needs* and *wants*. You are cold calling a person who doesn't know you to ask for something. It is not generally a good idea to bother them outside the office.

If you call a few times and keep getting the voice mail, you're going to have to make your move. Leave a message something like this.

You: "Hi, this is George Davis. My phone number is 111-999-9999. I'd appreciate it if you could give me a call at your convenience. I'll look forward to hearing from you. Have a great day."

If you don't hear back within a few days, try again.

You: Hi, Ms. White. This is George Davis. 111-999-9999. I called a few days ago. I know you're busy and was just trying you again. I look forward to hearing from you. Thanks. Have a great day.

You might not hear from Ms. White herself, but one of her assistants might call you. What do you do if you don't get a call back? Call again. How many times should you call? That's hard to say. Persistence may pay off. Remember that the person on the other end may start feeling guilty that he or she is not calling you back and place that call.

Be prepared. When you get a call back, have your ducks in a row and be ready and able to sell yourself. Practice ahead of time if need be and leave notes near your phone.

I suggest when making any of these calls that you block your phone number, so that no one knows who is calling. To permanently block your phone number from showing on the receiver's caller ID, call your local phone company. Most don't charge for this service. You can also block your phone number on a temporary basis by dialing *67 before making your call. Remember that as soon as you hang up, this service will be disabled, so you will need to do this for each call.

Getting Them to Call You

While persistence and patience in calling and trying to get past the receptionist is usually necessary, you may also need something else. You want something to set you apart, so the busy executives not only want to see you but remember you. You want them to give you a chance to sell yourself.

What can you do? Creativity to the rescue! The amount of creativity will depend to a great extent on the specific company or organization to which you are trying to get through. Ideas you use to try to get someone's attention in a corporate situation may differ if you are pursuing a job with a museum or not-for-profit art society. Some will work in certain situations and not in others. Use your judgment and the ideas with which you are comfortable.

Your goal is to get the attention of the important people who can give you a chance to sell yourself. Once you have their attention, it's up to you to convince them that they should meet with you.

Let's look at some ideas that I have either personally used or others have told me worked in their quest to get an individual's attention so they could get a foot in the door. Use these ideas as a beginning. Then try to develop some more of your own. You are limited only by your own creativity and ability to think outside of the box.

There are many unique ideas that can help you get the attention of important people who can give you a chance to sell yourself. I've given you a few that have been successful for others. I would love to see additional ideas that have worked for you and hear your stories. Go to http://www.shellyfield.com and drop me a note.

My Personal Number-One Technique for Getting Someone to Call You

I am going to share my number-one technique for getting someone to call you. I have used this technique successfully over the years to get people to call me in an array of situations and in a variety of industries at various levels in my career. I first came up with it after I graduated from college when I was entering the workforce and wanted to get a job in the music industry.

At the time, there was no book to give me ideas. There was no career coach. There was no one who really wanted to help, and I desperately needed help to get the job I wanted.

I had tried all the traditional methods. I tried calling people, but most of the time I couldn't get past the gatekeeper. When I did, no one called me back. I had tried sending out resumes. As I had just graduated college, I had no "real" experience. I didn't know anyone and didn't even know anyone who knew anyone. I needed a break. Here's what I did.

When I was younger, my parents used to take raw eggs, blow out the contents, and then decorate the shells. Every one always commented on how nice they were and how different they were. One day, for some reason, the eggs popped into my mind, and I came up with my method to get people to call me back. Here's how it works.

Get a box of eggs. Extra-large or jumbo work well. While either white or brown eggs can be used, because of the coloration differences in brown eggs, start with white ones. Wash the raw eggs carefully with warm water. Then dry the shells thoroughly.

Hold one egg in your hand and, using a large needle or pin, punch a small hole in the top of the egg. The top is the narrower end. Then, carefully punch a slightly larger hole in the other end of the egg. You might need to take the needle or pin and move it around in the hole to make it larger. Keep any pieces of shell that break off.

Now, take a straw and place it on the top hole of the egg. Holding the egg over a bowl, blow into the straw, blowing the contents of the

egg out. This may take a couple of tries. Because of concerns with salmonella, do not put your mouth directly on the egg.

Keep in mind that the bigger you have made the hole, the easier it will be to blow the contents out of the egg. However, you want the egg to look as "whole" as possible when you're done. The bigger the hole, the harder this is to accomplish.

After blowing the contents out of the egg, carefully rinse out the shell, letting warm water run through it. Get the egg as clean as possible. Shake the excess water out of the egg and leave it to dry thoroughly. Depending on the temperature and humidity when you are preparing the eggs, it might take a couple of days.

Do at least three eggs at one time in case one breaks or cracks at the next step. You might want to do more. After you get the hang of this, you're going to want to keep a few extra prepared eggs around for when you want to get someone's attention fast and don't have time to prepare new ones.

Next, go to your computer and type the words, "Getting the attention of a busy person is not easy. Now that I have yours, would you please take a moment to review my resume?" You can customize the message to suit your purposes by including the name of the recipient if you have it or specifying your background sheet, CV, or whatever you want the recipient to look at and consider. Then type your name and phone number.

Use a small font to keep the message to a line or two. Neatly cut out the strip of paper with your message. Roll the strip around a toothpick. Carefully insert the toothpick with the strip of paper into the larger of the holes in the egg. Wiggle the toothpick around and slowly take the toothpick out of the egg. The strip of paper should now be in the shell.

Visit your local craft store and pick up a package of those small moveable eyes, minia-ture plastic or felt shaped feet, and white glue or a glue gun. Glue the miniature feet to the bottom of the egg, covering the hole. Make sure you use the glue sparingly so none goes on your message. Now glue on two of the moving eyes, making the egg look like a face.

Go back to your computer and type the following words. "CRACK OPEN THIS EGG FOR AN IMPORTMANT MESSAGE." Print out the line and cut it into a strip. You might want to use bright-colored paper. Glue the strip to the bottom of the feet of the egg.

Now you're ready. Take the egg and place it in a small box that you have padded with cotton, bubble wrap, or foam. These eggs are very fragile, and you don't want the egg to break in transit!

Wrap the egg-filled box in attractive wrapping paper and then bubble wrap to assure it won't move around. Put your resume (or CV, background sheet, etc.) and a short cover letter into an envelope. Put it on the bottom of a sturdy mailing box. Place the egg box over it.

Make sure you use clean boxes and pack the egg as carefully as possible. Address the box. Make sure you include your name and return address. Then mail, UPS, FedEx, Airborne, or hand deliver it to the office of the person you are trying to reach. Even if that person has a secretary opening his or her mail, the chances are good that the "gift" will be opened personally. In the event that a secretary opens the package, he or she will probably bring the egg into the boss to crack.

Now the recipient has the egg in front of him or her. He or she will probably break it open, see the message, and glance at your resume. Here's the good news. By the time the person breaks open the egg, he or she won't even notice the hole on the bottom and usually has no idea how you got the message in there. Generally people who

have seen this think it is so neat that they want to know how you did it, and so they call you to ask. (Believe it or not, everyone has someone else they wish they could get to call them back.)

Once you have them on the phone, your job is to obtain an interview. You want to get into their office and meet with them. When you get that call, tell the recipient that you would be glad to show him or her how you did it; but it's kind of complicated explaining it on the phone. Offer to show them how it is done and ask when they would like you to come in.

Voila, you have an appointment. Now all you have to do is sell yourself.

Is your resume sitting in a pile of countless others? Do you want your resume to stick out among the hundreds that come in? Do you want an interview but can't get one? Are you having difficulties getting people to call you back?

While I love the egg idea and have used it to obtain appointments, call backs, and to get noticed throughout my career, there are other ideas that work too. You might want to try a couple of these.

Have you ever considered using these simple items to help you succeed? If you haven't, perhaps now is the time.

◎ Fortune cookies
◎ Chocolate chip cookies
◎ Candy bars
◎ Mugs
◎ Pizzas
◎ Shoes
◎ Roses

Fortune Cookies

Almost no one can resist cracking open a fortune cookie to see what the "message" says. This can be good news for your career.

Some fortune cookie companies make cookies similar to the ones you get in Chinese restaurants but with personalized messages inside. What could you say? That depends on what you are looking for. How about something like, "*Human Resources Director who interviews Paul Evans will have good luck for rest of day.*" Paul's lucky number: *111-222-3333.*

Whatever message you choose, remember that you generally need to make all the messages the same or it gets very expensive to have the cookies made. You also need to print cards on your computer or have cards printed professionally that read something to the effect of, "Getting the attention of a busy person is not easy. Now that I have yours, could you please take a moment to review my resume?" Or, "Getting the attention of a busy person is not easy. Now that I have yours, I was hoping you would take a few moments to give me a call." (Or set up an appointment or anything else you want. Make sure your name and phone number are on the card.)

Put a couple of cookies with the card and your resume or other material in a clean, attractive mailing box and address it neatly. Make sure you address the box to someone specific. For example, don't address it to "President, Premier Advertising." Instead address it to "Mr. Carl Michaels, President, Premier Advertising." Don't send it to "Manager, B & B Art Gallery." Instead, send it to "Dan Brooks, Manager B & B Art Gallery."

"I've heard of sending fortune cookies," you say. "What else can I do?"

Here's a twist. Send the same package of cookies, the card, and whatever else you sent (your resume, CV, background sheet, and so on) every day for two weeks. Every day, after the first day, also include a note that says, "Cookies For [Name of person] For Day 2," "Cookies For [Name of Person] For Day 3," and so on. At the

end of the two-week period, stop. By now your recipient will probably have called you. If not, he or she will at least be expecting the cookies. If you don't hear from your recipient, feel free to call the office, identify yourself as the fortune cookie king or queen, and ask for an appointment.

This idea can be expensive, but if it gets you in the door and you can sell yourself or your idea, it will more than pay for itself.

Another great idea that can really grab the attention of a busy executive is sending them a gigantic fortune cookie with a personalized message. There are a number of companies that specialize in making cookies like this, which are often covered in chocolate, sprinkles, and all kinds of goodies and almost command people to see who sent it. Send these cookies with the same types of messages and supporting material as the others. The only difference is that if you choose to send the gigantic cookies, you probably only need to send one. If you don't get a call within the first week, feel free to call the recipient yourself.

Chocolate Chip Cookies

Chocolate chip cookies are a favorite of most people. Why not use that to your advantage? Go to the cookie kiosk at your local mall and order a gigantic pizza sized cookie personalized with a few words asking for what you would like done. For example:

◎ "Please Review My Resume . . . Donna Jones"
◎ "Please Call Me for an Interview . . . Toni Harrison"

Keep your message short. You want the recipient to read it, not get overwhelmed. Generally, the cookies come boxed. Tape a copy of your resume or whatever you are sending to the inside of the box.

Write a short cover letter to your recipient stating that you hope he or she enjoys the cookie while reviewing your resume or giving you a call. Put this in an envelope with another copy of your resume, your demo, or other material. On the outside of the box, neatly tape a card with the message we discussed previously stating, "Getting the attention of a busy person is not easy. Now that I have yours, would you please take a moment to review my resume?" Or ask them to give you a call or whatever you are hoping they will do. Make sure your name and phone number are on the card.

If the cookie company has a mail or delivery service, use it even if it is more expensive than mailing it yourself. It will be more effective. If there is no mail or delivery service, mail or deliver the cookie yourself. You should get a call from the recipient within a few days.

Candy Bars

There have been a number of studies that tout chocolate as a food that makes people happy or at least puts them in a good mood. Keeping

> ## ★ Voice of Experience
>
> Do not try to save money by making the cookies yourself. In today's world, many people won't eat food if they don't know where it came from or that was not prepared by a commercial eatery.

this in mind, you might want to use chocolate to grab someone's attention and move them to call you. Most people love chocolate and are happy to see it magically appear in their office. There are a number of different ways you can use chocolate to help your career.

- ◎ Buy a large, high-quality chocolate bar. Carefully fold your resume or a letter stating what you would like accomplished and slip it inside the wrapping of the chocolate bar.
- ◎ Buy a large, high-quality chocolate bar. Wrap the chocolate bar with your resume or the letter stating what you would like accomplished.
- ◎ There are companies that create personalized wrappings for chocolate bars. Use one to deliver your message.
- ◎ Create a wrapping with your message on your computer. Cover the original wrapping with your customized wrapping.

Whatever method you choose, put the candy bar in a clean, attractive box, and attach the card with the message, "Getting the attention of a busy person is never easy. Now that I have yours, would you please take a moment to review my resume?" (Or whatever action you are asking your recipient to take.) Add a cover letter and send it off.

Mugs

When was the last time you threw out a mug? If you're like most people, probably not for a while. How about using this idea to catch the attention of a potential employer? Depending on your career aspiration, have mugs printed with replicas of your business or networking card, key points of your resume, CV, or background sheet, along with your name and phone number.

Add a small packet of gourmet or flavored coffee or hot chocolate and perhaps an individually wrapped biscotti or cookie and, of course, the card with the message stating, "Getting the attention of a busy person is never easy. Now that I have yours, would you please take a moment to check out my resume?" (Or whatever else you are requesting.) Put the mug, a short cover letter, your resume, background sheet, or other material in a box and mail or deliver to your recipient. Remember to always put your return address on the box.

Pizza

Want to make sure your resume or background sheet gets attention? Have it delivered to your recipient with a fresh, hot pizza. This technique can be tricky but effective. However, it does have some challenges.

Here they are. In order to guarantee the pizza gets there with your information, you really need to be in the same geographic location as the company or organization you're trying to reach. You will need to personally make sure that your information is placed in a good quality zip lock bag or better yet, laminated and then taped to the inside cover of the pizza box. You also not only have to know the name of the person for this to be delivered to, but that he or she will be there the day you send it and doesn't have a lunch date. It's difficult to call an office where no one knows you and ask what time the

⭐ The Inside Scoop

Like everyone else, throughout my career there have been times I needed to get past a gatekeeper to get through to someone I needed to talk to. I'm going to share one of my stories here to hopefully inspire you and illustrate how getting past the gatekeeper can lead to great things in your career.

Craft shows are one of the avenues craftspeople use to sell their designs. At the point in my career when I was designing beautiful and unique puppets, I needed to find a way to sell my products. Although I did relatively well selling at craft shows as a rule, I really didn't like having to drag a booth from my car and set it up every weekend. I also didn't like the uncertainty of whether or not I would have a good day or bad day.

Additionally, I think that you either have the personality for selling at craft show or you don't, and I determined that I didn't. On the other hand, I was creating products that I needed to sell. I had to do something. So I decided to try my hand at wholesaling.

I didn't really know anything about wholesaling, and being relatively young at the time, didn't really feel the need to do any research, which I have since learned is a huge mistake. However, I was determined to wholesale my puppets.

One day, I loaded up an old suitcase full of various samples of the puppets, got on a bus, and went to New York City. It was the first time I had ever been there myself. I got off at Port Authority, grabbed a cab, and asked the driver to take me to Bloomingdale's. (I don't know why I chose Bloomingdale's, but it *seemed* to be the place to go.)

Dragging my suitcase full of puppets (they didn't have luggage with wheels on them yet), I asked a sales associate where the toy buyer was located, went to his office, and asked his secretary if he was in.

"Do you have an appointment?" his secretary asked.

"No," I said.

"Well, he is very busy. You can't see him without an appointment."

"Please," I pleaded. "I just came all the way into New York City on a bus, and I want to show him my puppets."

"Absolutely not," she said. "You'll have to make an appointment, and in case you're interested, he doesn't usually see people who aren't already established."

Just then the secretary got a call from her boss asking for a cup of coffee. I heard her say, "You must have had a long night. That's the third cup I've brought you this morning." I had a brainstorm.

Here was my thought. No matter who someone is, rich or poor, busy executive or hourly worker, they all eventually have to go to the bathroom—especially if they are drinking a lot of coffee.

I asked the secretary where the nearest restrooms were. Glad to get rid of me, she pointed me a couple of feet down the hall, just outside out the door.

I stood outside the restrooms with my suitcase full of puppets for about 15 minutes. And then, as luck would have it, the buyer walked out of his office on his way to the restroom.

"Please, can I just show you my puppets?" I asked before he made it in the door.

"Excuse me, Miss," he said. "You'll have to make an appointment."

"Please," I asked again louder.

"No," he said even louder. "You really will have to make an appointment with my secretary, and we really try to do business with established companies."

His secretary hearing the commotion, walked out of her office. "I told her she needed an appointment, and she just won't listen," she said.

"Please?" I asked once more. "I just came all the way in to New York City on a bus, and I really want to show you these. Can't you give me five minutes? I'll wait until after you go to the bathroom."

The toy buyer, who really wanted to use the restroom by this time, finally said, "Yes, go wait in my office."

To this day, I'm sure it was because he realized that otherwise he would never get to use the restroom, at least not in a timely fashion.

The secretary led me into his office, muttering under her breath. The toy buyer came back in and told me I was very persistent. I already knew that but thanked him for giving me the opportunity. I started pulling puppets out of the suitcase, showing them to him. He looked at them and asked about prices.

"Prices?" I said.

"Your wholesale prices," he said. "What are they?"

Well here was something I never thought about. I didn't really know what my wholesale price was. As a matter of fact, at the time, I didn't even really know how you came up with a wholesale price.

However, I wasn't going to let that stop me. I had, after all, just made it over a huge hurdle by getting in to see him. I was not going to blow it even if I didn't know what I was talking about. I quickly thought, wholesale, that is when you take your retail price, double it and add on a couple of dollars. Yes, that was it. I gave him the prices.

"Hmm," he said. "Do you think you can make six dozen?"

"Of course," I said. Off the top of my head, I wasn't sure really how many six dozen really turned into (note to self: never go out without a calculator), but I figured I could make them.

"How long will it take you?" he asked.

"Hmmm." I couldn't even figure out at that moment what six dozen was, let alone how long it would take me to make them.

"When do you need them?" I asked, throwing it back in his court.

"How about November 1?" he replied.

"No problem," I assured him. (At least I didn't think it would be a problem. I made a decision at that moment to be much more prepared next time I went into someone's office.)

He started writing and writing and writing. (This was way before computers were commonplace.) I couldn't figure out why he was writing so much, but I wanted it to appear that I knew what I was doing, and it was normal getting orders, so I just sat there quietly.

He finally finished and gave me what looked like sheets and sheets of paper. "There you go," he said. "I really like these. I'm glad you were persistent. I haven't seen anything like them. He explained something about payment in 30 days after delivery or FOB or something like that, said it was nice meeting me, and I stood up, shook his hand, and walked out the door.

And then, I looked at the sheets of paper. The reason it had taken so long for him to write the order was he didn't just want six dozen puppets; he wanted six dozen of each sample. He wanted a lot of puppets. I had landed a huge order.

I quickly called home to tell my parents about my good luck. My mom congratulated me and then asked me how I priced the puppets. I proudly told her about my "wholesale" price, and she was quick to tell me that was not what wholesale was.

I listened and then told her, "You're right, but I think I did better my way."

After that experience, I learned more about the wholesaling process. I was lucky enough to find additional buyers and other avenues to sell my puppets. I even found a couple of representatives on Fifth Avenue in New York City to sell my designs.

Had I not been persistent in getting past the first gatekeeper, however, none of that would have happened.

Will you run into a situation like this? You might, and then again, you might not. What I want you to take from the story is that you sometimes have to think out of the box to get past your gatekeeper.

recipient goes to lunch. So you are taking the risk that you will be sending a pizza to someone who isn't there. One way to get around this is by sending it in the late afternoon instead. That way your recipient can have a mid-afternoon "pizza break." And even if your recipient isn't there, his or her employees will probably enjoy the pizza and tell their supervisor about it the next day.

If you do this, make sure that you have the pizzeria delivering the pizza tape the card with the message about getting a busy person's attention on the front of the box, so even if the receptionist gets the pizza, he or she will know who it came from.

If you don't get a thank you call that day, call the recipient the next morning. You probably will speak to the secretary or receptionist first. Just tell whoever you speak to that you were the one who sent the pizza the day before in hopes of getting the attention of the recipient so you might possibly set up a job interview.

Over the years, many people have told me that they were successful in garnering interviews after sending their resume in a shoebox with one shoe in it and a note that says something to the effect of "I'm sending you this shoe to try to get my foot in the door. I would like to get both feet in and tell you more about myself and how I can help your company (organization, agency, and so on)."

If you are considering this idea, make sure you send a new shoe. It doesn't have to be a $200 shoe, but it does need to be new. What kind of shoe do you send? That depends. While most people who have told me about this idea used an adult-sized shoe in a shoe box, there have been others who have used children's shoes, doll's shoes, and even miniature shoes from a craft shop.

One man I know even created a sculpture out of the shoe so that it would be a conversation piece. A woman I know crafted a planter in her shoe. If you are a man, by the way, send a man's shoe. If you are a woman, send a woman's shoe.

Roses

A very effective but pricey way to get your recipient's attention is to have a dozen roses delivered to his or her office. No matter how many things you have tried with no response, there are very few people who will not place a thank you call when they receive a dozen roses.

Talk to the florist ahead of time to make sure that the roses you will be sending are fragrant. Send the roses to your recipient with a card that simply says something to the effect of "While you are enjoying the roses, please take a moment to review my resume sent under separate cover." Or, "While you and your staff are enjoying the roses, please take a moment to review my resume sent under separate cover." Sign it, "Sincerely hoping for an interview," and include your name and phone number.

It is imperative to send your information so it arrives on the same day, or at the latest the next day, so the roses you sent are still fresh in the recipient's mind.

It's Who You Know

While of course there are some areas in the art industry that are easier to enter, there generally still is always some amount of competition to get most jobs. There are also individuals who are talented or skilled or have the education yet never get past the front door. Knowing someone who can get you in the door most certainly will help. What that means is that in certain situations contacts will be useful.

Before you say, "Me? I don't know anyone," stop and think. Are you sure? Don't you know someone, anyone, even on a peripheral basis, who might be able to give you a recommendation, make a call, or be willing lend his or her name?

What about your mother's aunt's husband's friend's neighbor's boss? Sure, it might be a stretch. But think hard. Who can you think of who might know someone who might be able to help? This is not the time to be shy.

"But I don't need any help," you say. "I can do this on my own."

You might be able to and you might not, but why wouldn't you give yourself every edge possible? You're going to have to prove yourself once you get in the door. No one can do that for you.

What if you don't have a relative who has a contact down the line? What about your son's teacher's wife? What about one of your sister's neighbors? Does he or she know someone at the company or organization where you want to apply? What about a friend who is already working in the organization or company you want to work? What about the facilitator at a workshop you attended?

What about your UPS delivery person? How about your mail carrier? What about your clergyperson? What about one of your physicians? Your pharmacist? The possibilities are endless if you just look.

The trick here is to think outside the box. If you can find someone who knows someone who is willing to help you to get your foot in the door, then all you will have to do is sell yourself.

If someone does agree to lend their name, make a call, or help you in any manner, it's important to write thank-you notes immediately. These notes should be written whether or not you actually get an interview or set up a meeting.

Tip from the Top
If you are currently working in the industry and are planning on moving to another location, your current supervisor may be able to put in a good word for you. Don't be afraid to ask.

If you do go on an interview, it's also a good idea to either call or write another note letting your contact know what happened.

Meeting the Right People

You think and think and you can't come up with anyone you know with a connection to anyone at all in the area of the art industry in which you are trying to succeed? What can you do? Sometimes you have to find your own contacts. You need to meet the right people. How can you do this? The best way to meet the right people in the area of the art industry you want to pursue is to be around people working in that industry. There are several possible ways you might do this.

To begin with, consider joining industry organizations and associations. Many of these organizations offer career guidance and support. They also may offer seminars, workshops, and other types of educational symposiums. Best of all, many have periodic meetings and annual conventions and conferences. All of these are treasure troves of possibilities to meet people in the industry. Some of them may be industry experts or insiders. Others may be just like you: people trying to get in and succeed. The important thing to remember is take advantage of every opportunity.

Workshops and seminars are great because not only can you make important contacts, but you can learn something valuable about the industry. Most of these events have question and

> ### ⭐ Tip from the Top
>
> When you go to industry events, it is important to have a positive attitude and not to have any negative conversation with anyone about anything at the seminar or in the industry. You can never tell who is related to whom or what idea someone originated. You want to be remembered as the one who is bright and positive, not a negative sad sack.

> ### ⭐ Words from a Pro
>
> Don't just blend in with everyone else at a seminar or workshop. Make yourself visible and memorable in a positive way. Ask questions and participate when possible. During breaks, don't rush to make calls on your cell phone. Instead, try to meet more people and make more contacts.

answer periods built into the program. Take advantage of these. Stand up and ask a good question. Make yourself visible. Some seminars and workshops have break-out sessions to encourage people to get to know one another. Use these to your advantage as well.

During breaks, don't run to the corner to check your voice mail. Walk around and talk to people. Don't be afraid to walk up to someone you don't know and start talking. Remember to bring your business or networking cards and network, network, network!

After the session has ended, walk up, shake the moderator's hand, and tell them how much you enjoyed the session, how much you learned, and how useful it will be in your career. This gives you the opportunity to ask for their business card so that you have the correct spelling of the person's name, as well as their address and phone number. This is very valuable information. When you get home, send a short note stating that you were at the session the person moderated, spoke to them afterwards, and just wanted to mention again how much you enjoyed it.

You might also ask, depending on their position, if it would be possible to set up an informational interview with them at their convenience or if they could suggest who you might

call to set up an appointment. If you don't hear back within a week, feel free to call up, identify yourself, and ask again. These interviews just might turn into an interview for a job or even a job itself.

Another good way to meet people in the industry is to attend industry or organization annual conventions. These events offer many opportunities you might not normally have to network and meet industry insiders.

There is usually a charge to attend these conventions. Fee structures may vary. Sometimes there is one price for general admission to all events and entry to the trade show floor. Other times, there may be one price for entry just to the trade show floor and another price if you also want to take part in seminars and other events.

> ### ⭐ Tip from the Top
>
> If you are currently working in the industry, your employer may or may not pay for conventions, seminars, and workshops. If you approach your employer about one of these events, and he or she can't (or doesn't want to) pay, ask if you can have the time off if you pay for the seminar (or workshop, etc.). If your employer agrees, when you return, be sure to share the new knowledge you have learned with others at your workplace.

⭐ Tip from the Coach

Many industry trade organizations offer special prices for students. If you are still a student, make sure you ask ahead of time.

⭐ The Inside Scoop

Recruiters and headhunters often attend conferences and conventions in hopes of finding potential employees for their clients.

The cost of attending these conventions may be expensive. In addition to the fee to get in, if you don't live near the convention location, you might have to pay for airfare or other transportation as well as accommodations, meals, and incidentals. Is it worth it? If you can afford it, absolutely! If you want to meet people in a specific area of the art industry, these gatherings are the place to do it.

How do you find these events? Look in the appendix of this book for industry associations in your area of interest. Find the phone number and call up and ask when and where the annual convention will be held. Better yet, go to the organization's Web site. Most groups put information about their conventions online.

If you are making the investment to go to a convention or a conference, take full advantage of every opportunity. As we've discussed throughout this book, network, network, and network some more! Some events to take part in or attend at conventions and conferences might include:

◎ Opening events
◎ Keynote presentations

⭐ The Inside Scoop

Many industry organization conference managers have begun having mini career fairs at these events to help industry people who have been downsized as well as for companies looking to fill jobs. Check out Web sites of association conferences ahead of time.

◎ Educational seminars and workshops
◎ Certification programs
◎ Break sessions
◎ Breakfast, lunch, and dinner events
◎ Cocktail parties
◎ Trade show exhibit areas
◎ Career fairs

There is an art to attending conventions and using the experience to your best benefit. Remember that the people you meet are potential employers and new business contacts.

This is your chance to make a good first impression. Dress appropriately and neatly.

Do not get inebriated at these events. If you want to have a drink or a glass of wine, that's probably okay, but don't overdo it. You want potential employers or people you want to do business with to know you're a good risk, not someone who drinks at every opportunity.

It is essential to bring business cards with you and give them out to everyone you can. You can never tell when someone hears about a position, remembers meeting you and getting a card, and will give you a call.

Collect business cards as well. Then when you get home from the convention or trade show, you will have contact names to call or write regarding business or job possibilities.

Walk the trade show floor. Stop and talk to people at booths. They are usually more than willing to talk. This is a time to network and try to make contacts. Ask questions and listen to what people are saying.

If you have good writing skills, a good way of meeting people within the industry is to write an article or interview people for local, regional, or national periodicals or newspapers. We discussed the idea earlier when talking about using your writing skills to help you obtain interviews. It can be just as effective in these situations.

How does this work? A great deal of it depends on your situation, where you live, and the area of the industry you are targeting.

Basically what you have to do is develop an angle or hook for a story on the segment of the art industry in which you are interested in meeting people. For example, does the director of the local art museum go on biking vacations in or out of the country? Perhaps his or her adventures might make a good story. Is the museum curator appearing on a game show? Does the director of the art society not only restore antique cars but also win ribbons nationwide at vintage car shows? Is an interior design company giving a seminar on a subject of interest to the public? Is a renowned fashion designer with local ties receiving a major award? Is a well-known artist coming to town to speak at a conference? These are angles or hooks you might use to entice a local or regional periodical let you do an article.

Your next step is to contact someone who might be interested in the story. If you're still in school, become involved with the school newspaper. If you're not, call up your local newspaper or a regional magazine and see if they might be interested in the article or feature story you want to write. You might even contact one of the trade magazines in your area of interest.

You probably will have to give them some samples of your writing and your background sheet or resume. You might also have to write on "spec" or speculation. What this means is that when you do the story, they may or may not use it. If they do, they will pay you. If not, they won't.

Your goal here (unless you want to be an art critic or art journalist) is not to make money (although that is nice). Your goal is to be in situations where you have the opportunity to meet industry insiders. If you're successful, not only will you be meeting these people, you'll be meeting them on a different level than if you were looking for a job. You'll be networking on a different level as well.

Networking Basics

It's not always what you know but who you know. With that in mind, I'm going to once again bring up the importance of networking. You can never tell who knows someone in some area of the industry so it is essential to share your career dreams and aspirations with those around you. Someone you mention it to might just say, "My cousin is the curator at the Tri-County Art Museum." Or, "Really? I just heard that the Round Lake Gallery is looking for a manager. They didn't even advertise the position yet." Or, "Did you see that the *Daily News* is looking for a new art critic?" Or, "I just saw an advertisement in the classifieds for a job like that."

Think it can't happen? Think again. It's happened to me, it's happened to others, and it can happen to you!

One day I was selling some puppets I designed at a craft show. A woman came up and was admiring the puppets. While she was choosing a few for gifts for her children, she mentioned that she had wanted to make puppets with her Girl Scout troop. "I don't suppose you would give me some pointers for some simple puppets to make with the girls?" she asked. "I know you're making these for a living, but we

wanted to make some puppets to bring up to local hospital for the children."

"I would be glad to," I said. "If you would like, I'll even come to a meeting and show the girls how to make some simple ones. I love showing people how to do things."

We made arrangements, and two weeks later I gave a presentation for the girls. A couple of weeks after that the woman called back. I don't suppose you would like to give another presentation?" she asked. I was telling my boss about you, and he thought some of his guests would be interested.

"Guests?" I asked. It turned out the woman's boss was the activities director for a resort hotel. I ended up giving workshops on a fairly consistent basis for many of the hotel convention's spouse programs as well as one of the regular activities for guests. Not only did I get paid to give the workshops, I had the chance to sell my puppets without any competition from other crafters. It was a win-win situation that I might never have had if I didn't speak up.

People always ask, "But do those things really happen?" and the answer is an unequivocal *yes*. These are not isolated incidents. Things like this happen all the time. Networking and sharing your dreams can and do work for others and can work for you. But in order for it to happen, you have to be proactive.

Knowing how important networking can be to your career, let's talk about some networking basics.

The first thing you need to do is determine exactly who you know and who is part of your network. Then you need to get out and find more people to add to the list.

When working on your networking list, add the type of contact you consider each person. Primary contacts are those people who you know: your family members, teachers, friends, and neighbors. Secondary contacts are those individuals who are referred to you by others. These would include, for instance, a friend of a friend, your aunt's neighbor, your attorney's sister, and so on.

You might also want to note whether you consider each person as a close, medium, or distant relationship. *Close,* for example, would be family, friends, employers, and current teachers. *Medium* would be people you talk to and see frequently such as your dentist, attorney, or your UPS, FedEx, or mail delivery person. *Distant* would include people you talk to and see infrequently or those you have just met or have met just once or twice.

Here's an example.

It would be great to have a network full of people in the segment of the art industry in which you hope to have your career. However, that may not be the case. That does not mean, however, that other people can't be helpful. Your network may include a variety of people from all walks of life. These may include:

- Family members
- Friends
- Friends of friends
- Co-workers and colleagues
- Teachers or professors
- Your doctor and dentist
- Your pharmacist
- Your mail carrier
- Your hairstylist
- Your personal trainer
- Your priest, pastor, or rabbi
- Members of your congregation
- UPS, FedEx, Airborne, or other delivery person
- Your auto mechanic
- Your attorney
- The waitress at the local diner
- The server at the local coffee shop

Networking Worksheet			
Name	Relationship/ Position	Type of Contact (Primary or Secondary)	Closeness of Contact
Jim Helms	College Advisor	Primary	Medium
Nancy Acusta	Bank Teller	Primary	Distant
Brian	UPS Delivery Person	Primary	Medium
John Thomas	Newspaper Reporter	Secondary	Distant
Rosie	Sister-in-law	Primary	Close
Dr. Lincoln	Dentist	Primary	Medium
Allen Roberts	Attorney	Primary	Medium
Donna Phillips	WOTO-TV Reporter	Secondary	Distant
Phillip McCain	Art History Professor	Primary	Medium

◎ Bank tellers from your local bank
◎ Your neighbors
◎ Friends of your relatives
◎ Your college advisor
◎ Business associates of your relatives
◎ People you work with on volunteer not-for-profit boards and civic groups
◎ Co-workers at your current job
◎ Members of the local art society
◎ A firefighter

Now look at your list. Do you see how large your network really is? Virtually everyone you come in contact with during the day can become part of your network. Just keep adding people to your list.

Expanding Your Network

How can you expand your network? There are a number of ways. Networking events are an excellent way to meet people. Industry networking events are, of course, the best, but don't count out nonindustry events too. For example, your local chamber of commerce may have specific networking programs designed to help people in the community meet and network.

How do you know if the people who are at the event have any possibility of being related to the area of the art industry in which you're interested? You don't. But as we've discussed, sometimes you don't really know who people know. People you meet may know others who *are* in the part of the industry you want to pursue.

Civic and other not-for-profit groups also have a variety of events that are great for networking. Whether you go to a regular meeting or you attend a charity auction, cocktail party, or large gala to benefit a not-for-profit, you will generally find people in the community you might not know. As an added bonus, many larger not-for-profit events also have media coverage, meaning that you have the opportunity to add media people to your network.

Networking Worksheet

Name	Relationship/ Position	Type of Contact (Primary or Secondary)	Closeness of Contact (Close, Medium, or Distant)

A good way to meet people involved in the art industry is to attend their events and fund-raisers. Many art museums or art societies, for example, sponsor fund-raising concerts, dances, and openings. These events are well attended by people in all aspects of the industry and from various segments of the community.

Once you're at an event, how do you meet people? How do you take advantage of opportunities? You might just walk around and network. Or you might want to volunteer to help with a fund-raiser or event so people start to know you and what you can do.

Those who take advantage of every opportunity to meet new people will have the largest networks. The idea in building a network is to go out of your comfort zone. If you just stay with people you know and are comfortable with, you won't have the opportunity to get to know others. You want to continually meet new people; after all, you never know who knows who.

Networking Savvy

You are now learning how to build your network. However, the largest network in the world will be useless unless you know how to take full advantage of it. So let's talk a little about how you're going to use the network you are building.

Previously we discussed the difference between skills and talents. Networking is a skill. You don't have to be born with it. You can acquire the skill to network, practice, and improve. What that means is that if you practice networking, you can get better at it, and it can pay off big in your career!

Get out. Go to new places. Meet new people. The trick here is when you're in a situation where there are new people, don't be afraid to walk up to them, shake their hand, and talk to them. People can't read your mind, so it's imperative to tell them about your career goals, dreams, and aspirations.

When you meet new people, listen to them. Focus on what they're saying. Ask questions. Be interested in what *they* are telling you. You can never tell when the next person you talk to is the one who will be able to help you open the door *or* vice versa.

If you're shy, even the thought of networking may be very difficult for you. However, it is essential to make yourself do it anyway. Successful networking can pay off big time in your career. In some situations it can mean the difference between getting a great job or not getting a job at all. It can also mean the difference between success and failure in your career. And that is worth the effort!

Just meeting people isn't enough. When you meet someone that you add to your network the idea is to try to further develop the relationship. Just having a story to tell about who you know or who you met is not enough. Arrange a follow-up meeting, send a note, write a letter, or make a phone call. The more you take advantage of every opportunity, the closer you will be to getting what you want.

A good way to network is to volunteer. We just discussed attending not-for-profit events and civic meetings to expand your network, but how about volunteering to work with a not-for-profit or civic group? There are a ton of opportunities just waiting for you.

I can imagine you saying, "When? I'm so busy now; I don't have enough time to do anything."

Make the time. It will be worth it. Why?

People will see you on a different level. They won't see you as someone looking for a job or trying to succeed at some level. Generally, people talk about their volunteer work to friends, family, business associates, and other colleagues. What this means is that when someone is speaking to someone else, they might mention in passing that one of the people they are working with on their event or project is trying to get a job as the marketing director in an art museum or as a curator or anything else. They might mention that one of the people on their committee is looking for a position as a gallery manager or an artist's representative. They might mention that someone on their committee is a great artist, or craftsperson, or interior designer. They might even mention that they are volunteering with someone who designs awesome clothing or theatrical sets or almost anything else.

Anyone these people mention you or your situation to is a potential secondary networking contact. Those people, in turn, may mention it to someone else. Eventually, someone involved in the area of the art industry you are pursuing might hear about you.

Another reason to volunteer is so people will see that you have a good work ethic. Treat volunteer projects as you would work projects. Do what you say you are going to do and do it in a timely manner. Do your best at all times. Showcase your skills and your talents and do everything you do with a positive attitude and a smile.

Volunteering also gives you the opportunity to demonstrate skills and talents people might not otherwise know you have. Can you do publicity? Can your write? Do you have leadership skills? Are you good at organizing things? Do you get along well with others? Can you design

⭐ **The Inside Scoop**

Volunteer to do projects that no one else wants to do and you will immediately become more visible.

the set for a community theater production? What better way to illustrate your skills than utilizing them by putting together an event, publicizing it, or coordinating other volunteers?

Best of all, you can use these volunteer activities on your resume. While volunteer experiences don't take the place of work experience, they certainly can fill out a resume short of it.

Don't just go to meetings. Participate fully in the organization. That way you'll not only be helping others, you will be adding to your network.

Where can you volunteer? Pretty much any not-for-profit, community group, school, or civic organization is a possibility. The one thing you should remember, however, is that you should only volunteer for organizations in whose causes you believe.

In order to make the most of every networking opportunity, it's essential for people to remember you. Keep a supply of your business or networking cards with you all the time. Don't be stingy with them. Give them out freely to everyone. That way your name and number will be close at hand if needed. Make sure you ask for cards in return. If people don't have them, be sure to ask for their contact information.

Try to keep in contact with people on your network on a regular basis. Of course, you can't call everyone every day, but try to set up a schedule of sorts to do some positive networking each day. For example, you might decide to call one person every day on your networking list. Depending on the situation you can say you were calling to touch base, say hello, keep in contact, or see how they were doing. Ask how they have been or talk about something you might have in common or they might think is interesting. You might also decide that once a week, you will try to call someone and set up a lunch or coffee date.

Be on the lookout for stories, articles, or other tidbits of information that might be of interest to people in your network. Clip them out and send them with a short note saying you saw the story and thought they might be interested. If you hear of something they might be interested in, call them. The idea is to continue cultivating

> ### ★ Tip from the Top
> After you have worked on a volunteer project, ask the executive director or board president if he or she would mind writing you a letter of recommendation for your file.

relationships by keeping in contact with people in your network and staying visible.

Keep track of the contacts in your network. You can use the sample sheet provided, a card file using index cards, a database, or contact software program on your computer. Include as much information as you have about each person. People like when you remember them and their interests. It makes you stand out.

Then use your networking contact list. For example, a few days before someone's birthday, send him or her a card. If you know someone collects old guitars, for example, and you see an article on old guitars, clip it out and send it. Don't be a pest, but keep in contact. People in sales have been using this technique for years. It works for them, and it will help you in your career as well.

You might want to use some of the items here and then add more information as it comes up. You don't have to ask people for all this information the first time you meet them. Just add it when you get it.

Networking and Nerve

Successful networking will give you credibility and a rapport with people in and out of the industry. But networking sometimes takes nerve, especially if you're not naturally outgoing. You have to push yourself to get out and meet people, talk to them, tell them what you are interested in doing, and then stay in contact. On occasion, you

may have to ask people if they will help you, ask for recommendations, ask for references, and so on. Don't let the fear of doing what you need to do stop you from doing it. Just remember that the end result of all this effort will be not only into a career you want but also a shot at success.

As long as you're pleasant and not rude, there is nothing wrong with asking for help. Just remember that while people can help you get your foot in the door, you are going to have to sell yourself once you open it.

Networking is a two-way street. While it might be hard for you to imagine at this moment, someone might want you to help them in some segment of their career. Reciprocate, and reciprocate graciously. As a matter of fact, if you see or know someone you might be able to help even in a small way, don't wait for them to ask; just offer your help.

Finding a Mentor or Advocate

Mentors and advocates can help guide and boost your career. A mentor or advocate in the art industry also often provides you valuable contacts, which, as we now know, are essential to your success. The best mentors and advocates are supportive individuals who help move your career to the next level. While having a mentor in some aspect of the art industry would be the ideal, that doesn't mean others from outside the industry might not be helpful.

Can't figure out why anyone would help you? Many people like to help others. It makes them feel good and makes them feel important. How do you find a mentor? Look for someone who is successful and ask. Sounds simple? It is simple. The difficult part is finding just the right person or persons.

Sometimes you don't even have to ask. In many cases, a person may see your potential

Networking Contact Information Sheet

Name

Business Address

Business Phone

Home Address

Home Phone

E-mail Address

Web Address

Birthday

Anniversary

Where and When Met

Spouse or Significant Other's Name

Children's Name(s)

Dog Breed and Name

Cat Breed and Name

Hobbies

Interests

Things Collected

Honors

Awards

Interesting Facts

★ **Tip from the Coach**

If someone asks you to be their mentor, or asks for your help and you can, say yes. As a matter of fact, if you see someone you might be able to help, do just that. You might think that you don't even have your own career on track or you don't have time. You might be tempted to say no. Think again. You are expecting someone to help you. Do the same for someone else. There is no better feeling than helping someone else. And while you shouldn't help someone for the sole purpose of helping yourself, remember that you can often open doors for yourself, while opening them for someone else.

★ **Words from the Wise**

It is not uncommon to run into someone who doesn't want to help you. This may be for any number of reasons, ranging from their not knowing how they can help or not having the time in their schedule to their thinking that if they help you in your career, it puts their position at risk. If you do ask someone to be your mentor and he or she says no, just let it go. Look for someone else. The opposite of having a great mentor in your life is having someone who is sabotaging your career.

and offer advice and assistance. It is not uncommon for a mentor to be a supervisor or former supervisor. He or she might, for example, hear of a better job or be on a search committee and recommend you. As your career goes on, the individual may follow you and your career, helping you along the way.

If you are an artist, craftsperson, designer, or in a similar field, your mentor may turn into someone who buys your work or uses your service and is supportive and believes you are so special that he or she wants to help you move your career forward.

Time is a valuable commodity, especially to busy people. Be gracious when someone helps you or even tries to help. Make sure you say thank you to anyone and everyone who shares his or her time, expertise, or advice. And don't forget to ask them if there is any way you can return the favor.

No matter what area of the art industry you are pursuing, getting your foot in the door is essential. Whether you need to open the door just a crack or you need it flung wide open to get you where you want to go, use every opportunity.

8

THE INTERVIEW

Getting the Interview

You can have the greatest credentials in the world, wonderful references, a stellar resume, graduate first in your class, and have more talent in your little finger than most other people, but if you don't know how to interview well, it's often difficult to land the job.

No matter where in the art industry your dreams lie, the first step is always getting the job. One of the keys to getting most jobs is generally the interview. Let's take some time to discuss how to get that all-important meeting.

The interview is your chance to shine. During an interview you can show what can't be illustrated on paper. This is the time your personality, charisma, and talents can be showcased. This is where someone can see your demeanor, your energy level, your passion, your talent, and your attitude. Obtaining an interview and excelling in that very important meeting can help get you the job you want.

If you do it right, the interview can help make you irresistible. It is your chance to persuade the interviewer to hire you. It is your main shot at showing why *you* would be better than anyone else; why hiring *you* would benefit the agency, organization, or company; and why *not* hiring *you* would be a major mistake.

There are many ways to land job interviews. Some of these include:

- Responding to advertisements
- Responding to canvassing letters
- Recommendations from friends, relatives, or colleagues
- Making cold calls
- Writing letters
- Working with executive search firms, recruiters, or headhunters
- Working with employment agencies
- Attending job and career fairs
- Finding jobs that have not been advertised (the hidden job market)

The most common approach people generally take in obtaining a job interview is by responding to an advertisement or job posting. Where can you look for advertisements for jobs in the art industry? Depending on the exact type of job you're looking for, you might find them in newspapers or trade journals.

Where else might you see openings advertised or listed?

- Association Web sites
- Art museum Web sites
- Advertising agency Web sites
- Interior designer Web sites

- ◎ Art gallery Web sites
- ◎ Career-oriented Web sites
- ◎ Art society Web sites
- ◎ Art or craft show Web sites
- ◎ Art or craft store Web sites

Let's look at a scenario for a moment. Let's say you open up the paper and see the job opening you've been hoping for advertised in the classifieds. Perhaps it looks like this:

River Valley Art Museum seeking to fill the following positions: Director of Marketing; Publicity Assistant; Education Coordinator; Donor Services Representative; Administrative Assistant to President. For consideration for these positions, fax resume to (111) 000-0000 or mail to P.O. Box 2222, River Valley, NY 11111.

Once you see the ad, you get excited. You have been looking for a job just like one of the positions in the advertisement. You can't wait to send your resume.

Want a reality check? There may be hundreds of other people who can't wait either. Here's the good news. With a little planning you can increase your chances of getting an interview from the ad, and as we've just discussed, this is your key to the job.

Your resume and cover letter need to stand out. Your resume needs to generate an interview. Most importantly, in a broad sense, you want your resume to define you as the one *in* a million candidates an employer can't live without instead of one *of* the million others that are applying for a job.

It's essential that your resume and cover letter distinguish you from every other applicant going for the job. Why? Because if yours doesn't, someone else's will, and he or she will be the one who gets the job.

Let's look at the journey a resume might take after you send it out in response to a classified ad. Where does it go? Who reads it? That depends. In smaller organizations, your resume and cover letter may go directly to the person who will be hiring you. It may also go to that person's receptionist, secretary, administrative assistant, or an office manager.

In larger organizations your resume and cover letter may go to a hiring manager or human resources director. If you are replying to an advertisement placed by an employment agency, your response will generally go to the person at the employment agency responsible for that client and job.

In any of these situations, however, your resume may take other paths. Depending on the specific job and organization, your response may go through executive recruiters, screening services, clerks, secretaries, or even receptionists. Whoever the original screener of resumes turns out to be, he or she will have the initial job of reviewing the information to make sure that it fits the profile of what is needed. But—and I repeat, but—that doesn't mean that if you don't have the exact requirements, you should not reply to a job.

For example, let's say you see an opening for a job in the district attorney's office that looks something like this:

Green City Art Museum—Museum educator for museum tours and docent programs. Dedicated, passionate individual responsible for development and coordinator of museum tours and docent training programs. Must have strong organization skills and excellent verbal and writing skills. Minimum of bachelor's degree in art history or art education. Three years' museum experience. Experience with art museum tour programs preferred. Supervisory experience necessary.

Now let's say that while you are a dedicated, passionate individual with strong organizational skills and excellent verbal and writing sills, and you hold a bachelor's degree in art history, you don't have three years museum experience. You do, however, have three years classroom experience teaching art history in a private high school. While you don't have experience with art museum tours, you were a volunteer docent at the state history museum. You additionally headed a volunteer program for teens interested in helping young children in an after school art program. Should you not apply for the job? If you want it, I say go for it.

In additional to tailoring your resume as closely as possible to the specific job requirements, there are some other things you can do. Stress what you have done successfully, not what you haven't done. Use your cover letter to help showcase these accomplishments.

No matter who your resume and cover letter go to, your goal is to increase your chances of it ending up in the pile that ultimately gets called for an interview. Whoever the screener of the resumes is, he or she will probably pass over anything that doesn't look neat and well thought-out or anything where there are obvious errors.

What can you do? First, go over your resume. Make sure it is perfect. Make sure it is perfectly tailored to the job you are going after. Make sure it is neat and looks clean and not wrinkled, crumpled, or stained. If you are going to mail it, make sure it's printed on high-quality paper.

Human resources and personnel departments often receive hundreds of responses to ads. While most people use white paper, consider using off-white or even a different color such as light blue or light mauve. You want your resume to look sophisticated and classy and to stand out. Of course, the color of the paper will not change what is in your resume, but it will at least help your resume get noticed in the first place.

If the advertisement directs you in a specific method of responding to the ad, then use that method. For example, if the ad instructs applicants to fax their resumes, then fax it. If it says e-mail your resume, use e-mail and pay attention to whether the ad specifies sending the file as an attachment or in the body of your e-mail. The organization may have a procedure for screening job applicants. Not following their instructions may delay your resume being seen.

If given the option of methods of responding, which should you use? Each method has its pros and cons.

◎ E-mail
- ⊡ On the pro side, e-mail is one of the quickest methods of responding to ads. Many companies utilize the e-mail method.
- ⊡ On the con side, you are really never assured someone gets what you sent, and even if they do, you're not sure that it won't be inadvertently deleted. Another concern is making sure that the resume you sent reaches the recipient in the form in which you sent it. If you are using a common word processing program and the same platform (Mac or PC) as the recipient, you probably won't have a problem. If you are using a Mac and the recipient is using a PC, or you are using different word processing programs, you might.

◎ Fax
- ⊡ On the pro side, faxing can get your resume where it's going almost instantaneously.
- ⊡ On the con side, if the recipient is using an old fashioned fax, the paper quality might not be great. The good news is that most companies now are using plain paper faxes.

Tip from the Top

Many organizations require or prefer applicants to apply online. Make sure you follow the directions provided on how to submit your application and any supporting materials, and be sure to keep a copy of everything.

Tip from the Coach

If faxing any documents, remember to use the "fine" or "best" option on your fax machine. While this may take a bit longer to send, the recipients will get a better copy.

◎ Mailing or Shipping (USPS, FedEx, DHL, UPS)
- ⊡ On the pro side, you can send your resume on high-quality paper so you know what it is going to look like when it arrives. You can also send any supporting materials that might help you get the coveted interview. You can send it with an option to have someone sign for it when it arrives, so you definitely know that it arrived.
- ⊡ On the con side, it may take time to arrive by mail. One of the ways to get past this problem is to send it overnight or two-day express. It will cost more, but you will have control over when your package arrives.

When is the best time to send your response to an ad in order to have the best chance at getting an interview? If you send your resume right away, it might arrive with a pile of hundreds of others, yet if you wait too long, the company might have already "found" the right candidate and stopped seriously looking at new resumes.

Many people procrastinate, so if you can send in your response immediately, such as the day the ad is published or the very next morning, it will probably be one of the first ones in. At that time the screener will be reading through just a few responses. If yours stands out, it stands

a good chance of being put into the initial interview pile.

If you can't respond immediately, then wait two or three days so your resume doesn't arrive with the big pile of other responses. Once again, your goal is to increase your chances of your resume not being passed over.

When you are trying to land an interview through a recommendation from friends or colleagues, cold calls, letters, executive search firms, recruiters, headhunters, employment agencies, people you met at job fairs and other networking events, or any aspect of the hidden job market, the timing of sending a resume is essential. In these cases you want the people receiving your information to remember that someone said it was coming, so send it as soon as possible. This is not the time to procrastinate. If you do, you might lose the opportunity to set up that all-important meeting.

Persistence is the word to remember when trying to get an interview. If you are responding to an advertisement and you don't hear

back within a week or two, call to see what is happening. If after you call the first time, you don't hear back after another week or so (unless you've been specifically given a time frame) call back again. Don't be obnoxious and don't be a pain, but call.

If you're shy, you're going to have to get over it. Write a script ahead of time to help you. Don't read directly from the script, but practice, so it becomes second nature. For example: "Hello, this is Robert Brown. I replied to an advertisement you placed in the newspaper for the art director. I was wondering whom I could speak with to find out about the status of the position?"

When you get to the correct person, you might have to reiterate your purpose in calling. Then you might ask, "Do you know when interviewing is starting? Will all applicants be notified one way or the other? Is it possible to tell me whether I'm on the list to be contacted?" Don't be afraid to try to get as much information as possible, once again making sure you are being pleasant.

You want to be friendly with the secretary or receptionist. These people are on the inside and can provide you with a wealth of information.

Be aware that there is a way that you can get your resume looked at, obtain an interview, and beat the competition out of the dream job you want. Remember we discussed the hidden job market? Following this theory, all you have to do is contact a company and land the job you want *before* it is advertised.

While many of positions in the art industry are advertised, we know that there are other jobs that are not. Contacting a company prior to a job being advertised and before anyone else knows of a job can give you a tremendous edge.

"How?" you ask. It can get you the job you want—or at least give you a shot at getting that job.

Take a chance. Make a call or write a letter and ask. You might even stop in and talk to the human resources department or one of the department heads. There is nothing that says you have to wait to see an ad in the paper. Call up and ask to speak to the human resources department, recruitment services, or hiring manager. Once again, write out a script ahead of time so you know exactly what you want to say. Ask for the hiring manager or human resources department. Ask about job openings. Make sure you have an idea of what you want to do and convey it to the person you are talking to.

If you are told there are no openings or you are told that the company or organization doesn't speak to people regarding employment unsolicited, be pleasant yet persistent. Ask if you can forward a resume to keep on file. In many cases, they will agree just to get you off the phone. Ask for the name of the person to direct your resume; then ask for the address to send it *and* the fax number. Thank the person you spoke with and make sure you get his or her name.

Now here's a neat trick. Fax your resume. Send it with a cover letter that states that a hard copy will be coming via mail. Why fax it?

Did you know that when you fax documents to a company, they generally are delivered directly to the desk of the person you are sending it to? They don't go through the mailroom where they might be dumped into a general inbox. They don't sit around for a day. They are generally delivered immediately.

Now that your resume is in the hands of the powers that be, it's your job to call up, make sure they got it, and try as hard as you can to set up an interview. The individual's secretary might try to put you off. Don't be deterred. Thank the secretary and say you understand their position. Say you're going to call in a week or so after the boss has had a chance to review your material. Send your information out in hard copy immediately. Wait a week or so and call back. Remember that persistence pays off.

Depending on the job, you sometimes might reach someone who tells you that, if they weren't so busy, they would be glad to meet with you. They might tell you when their workload lightens or a project is done, they will schedule an interview. You could say thank you and let it go. Or you could tell them that you understand that they're busy. All you are asking for is 10 minutes and not a minute longer. You'll even bring a stopwatch and coffee if they want. Guarantee them that 10 minutes after you get in the door, you will stand up to leave.

If you're convincing, you might land an interview. If you do, remember to *bring* the coffee and that stopwatch. Introduce yourself, put the stopwatch down on the desk in front of you and present your skills and talents. It's essential that you practice this before you get there. Give the highlights of your resume and how hiring you would benefit the company or organization. When your 10 minutes are up, thank the person you are meeting with for their time and give them your resume, any supporting materials you have brought with you, and your business card. Then leave. If you are asked to stay, by all means, stay and continue the meeting. One way or the other, write a note thanking them for their time.

If you have sold yourself or your idea for a position, someone may just get back to you. Once again, remember to follow up with a call after a week or two.

What kind of positions might not be advertised? A variety of jobs could fall into this category. Like what?

Jobs as sketch artists, art critics, art journalist, gallery managers, art directors, graphic artists, art supply sales representatives, exhibit

⭐ Tip from the Coach

While the following incident occurred when I was first trying to enter the music business, I think the concept illustrates how persistence can pay off in any industry. At that time, I met and got to know a young man who was a comedian. He wasn't a very good comedian, but he said he was a comedian and did have a good number of jobs and bookings, so I guess he was a comedian.

During this time, I was trying to land interviews with everyone I could so I could get my own dream job in the music industry.

I made a contact with a booking agent whom I called and developed a business relationship. Every week, I'd call, and every week he would tell me to call him back. It wasn't going anywhere, but at least someone was taking my call. This went on for about three or four months.

One day when I called, the owner got on the phone and said, "Do you know Joe Black [not his real name]? He said he has worked in your area?"

I said, "Yes, he works as a comedian."

"What do you know about him?" he asked.

"He's very nice," I answered.

"But what do you know about him?" the agent asked again. "Is he any good?"

"Well, he's not a great comedian, but he seems to keep getting jobs. He's booking himself," I replied.

"That's interesting," he said. "He has called me over 25 times looking for a job as an agent. What do you think?"

I was wondering why he was asking my opinion, because I had yet to get into his office myself. "If he can book himself, he can probably do a great job for your agency," I said. "You have great clients. I bet he would do a great job."

"Thanks," he said, "I might give him a call."

"What about me?" I asked.

"I still can't think of where you might fit in," he said. "Why don't you give me a call in a couple of weeks."

I waited a couple of weeks, called back and asked to speak to the owner.

"Hello," he said. "Guess who's standing next to me?"

He had hired Joe Black the comedian to work as an agent in his office.

"He had no experience outside of booking himself," the agent said. "But I figured if he was as persistent making calls for our clients as he was trying to get a job, he'd work out for us. Why don't you come in and talk when you have a chance. I don't have anything, but maybe I can give you some ideas."

I immediately said that I had been planning a trip to the booking agent's city the next week. We set up an appointment.

Did the agent ever have a job for me? No, but while in his office, he introduced me to some of the clients he was booking, who introduced me to some other people, who later turned out to be clients of mine when I opened up my public relations agency.

No matter what industry you want a job in, the moral of the story is the same. Networking and persistence always pay off.

curators, and more. Jobs in museums in fundraising, marketing, public relations, and development. As a matter of fact, unless a job is or position is mandated to be advertised for some reason, almost any job might *not* be advertised.

"Can you really land a job like that?" you ask.

Absolutely! While openings for any of these or hundreds of other positions might be advertised, they might not. And that is good news for you if you are job hunting because you can gain an edge. Many others have been successful in this technique and you are no exception.

The Interview Process

You landed an interview. Now what? The interview is an integral part of getting the job you want. Use it to your advantage.

There are a number of different types of interviews. Depending on the specific organization, company, and position, you might be asked to go on one or more interviews ranging from initial or screening interviews to interviews with department heads or supervisors with whom you will be working.

Things to Bring

Once you get the call for an interview, what's your next step? Let's start with what you should bring with you to the interview.

- ◎ Copies of your resume
 - ▫ While they probably have copies of your resume, they might have misplaced it or you might want to refer to it.
- ◎ Letters of reference
 - ▫ Bring your letters of reference, even if you have sent them in with your application and resume. Additionally, even though people have given you their letters of reference, make sure you let them know you are using them.
- ◎ References
 - ▫ When interviewing for jobs, you often need to fill in job applications that ask for both professional and personal references. Ask before you use people as references. Make sure they are prepared to give you a good reference. Then when you go for an interview, call the people on your reference list and give them the heads up on your job hunting activities. Once again, bring these with you, even if you have provided them previously.
- ◎ A portfolio of your achievements and other work
 - ▫ Refer to Chapter 6 to learn how to develop your professional portfolio.
- ◎ Your creative portfolio (if you are pursuing a career in the talent area of the industry)
 - ▫ Refer to Chapter 11 to learn how to develop your creative portfolio.
- ◎ Business or networking cards
 - ▫ Refer to Chapter 6 to learn more about business cards.
- ◎ Other supporting materials
 - ▫ This might include a variety of materials including copies of certifications, licenses, and so on.

You want to look as professional as possible, so don't throw your materials into a paper bag or a sloppy knapsack. A professional looking briefcase or portfolio is the best way to hold your information. If you don't have that, at the very least put your information into a new large envelope or folder to carry into the interview.

Your Interviewing Wardrobe

You've landed an interview, but what do you wear? It's essential that you dress professionally so that interviewers will see you as a professional, no matter what level you currently are in your career.

Let's start with a list of what not to wear.

- Sneakers
- Flip-flops
- Sandals
- Micro-mini skirts or dresses
- Very tight or very low dresses or tops
- Jeans of any kind
- Midriff tops
- Skin-tight pants or leggings
- Very baggy pants
- Sweatshirts
- Workout clothes
- T-shirts
- Heavy perfume, men's cologne, or aftershave lotion
- Very heavy makeup
- Flashy jewelry (This includes nose rings, lip rings, and other flamboyant piercings.)
- Tattoos (If you have large, visible tattoos, you may want to cover them with either clothing or some type of cover-up or makeup.)

Now let's talk about what you should wear.

Men
- Dark suit
- Dark sports jacket, white or light-colored button-down shirt, tie, and dress trousers
- Clean, polished shoes
- Socks

Women
- Suit
- Dress with jacket
- Skirt with blouse and jacket
- Pumps or other closed-toe shoes
- Hose

Interview Environments

In most cases interviews are held in office environments. If you are asked if you want coffee, tea, soda, or any type of food, my advice is to abstain. This is not the time you want to accidentally spill coffee, inadvertently make a weird noise drinking soda, or get sugar from a donut on your fingers when you need to shake hands.

With that said, in some cases, however, you may be interviewed over a meal. In these situations you are going to have to eat. Whether it is breakfast, lunch, or dinner, it is usually best to order something simple and light. This is not the time to order anything that can slurp, slide, or otherwise mess you up. Soups, messy sauces, spaghetti, lobster, fried chicken, ribs, cheese sticks, or anything that you have to eat with your hands would be bad choices. Nothing can ruin your confidence during an interview worse than a big blob of sauce accidentally dropping on your shirt—except if you cut into something and it splashes on to your interviewer's suit. Eating should be your last priority. Use this time to tell your story, present your attributes, and ask intelligent questions.

This is also not the time to order alcoholic beverages. Even if the interviewer orders a drink, abstain. You want to be at the top of your game.

If the interviewer orders dessert and coffee or tea, do so as well. That way, he or she isn't eating alone, and you have a few more minutes to make yourself shine.

Meal interviews are generally not the first interviews you go on. When might you be required to go to a meal interview instead of the

traditional office interview? There are a variety of situations. You may need to go on a meal interview if you are being interviewed by a recruiter or headhunter. You might also be invited on a meal interview if you are pursuing an upper-level position in the business or administrative segment of the industry. You may be asked to participate in a meal interview when an interviewer wants you to meet other people in the company.

In some cases, a company may invite you to participate in a meal interview to see how you will act in social situations. They might want to check out your table manners, whether you keep your elbows on the table or talk with your mouth full. They might want to see whether you drink to excess or how you make conversation. They might want to know if you will embarrass them, if you can handle pressure, or how you interact with others. They might want you to get comfortable so they can see the true you. If you are prepared ahead of time, you will do fine. Just remember that this is not a social meal. You are being scrutinized. Be on your toes.

How can you increase your chances of this specific type of interview going well? During the meal, pepper the conversation with questions about the organization or company and the job. Don't be afraid to say you're excited about the possibility of working with them or that you think you would be an asset to the organization and you hope they agree.

Make eye contact with those at the table throughout the meal. Genuinely listen with interest to what others are saying.

When the interviewer stands up after the meal, the interview is generally over. Stand up, thank the interviewer or interviewers for the

meal, tell them you look forward to hearing from them, shake everyone's hand, and then leave.

Many organizations today pre-interview or do partial interviews on the phone. This might be to prescreen people without bringing them into the office. It also might come about if the employer is interested in a candidate and the individual lives in a different geographic location.

Whatever the reason, be prepared. If the company has scheduled a phone interview ahead of time, make sure your "space" is prepared so you can do your best.

Here are some ideas.

- Have your phone in a quiet location. People yelling, a loud television, or music in the background is not helpful in this situation.
- Have a pad of paper and a few pens to write down the names of the people you are speaking to, take notes, and jot down questions as you think of them.
- Have a copy of your resume near you. Your interviewer may refer to information on your resume. If it's close, you won't have to fumble for words.
- Prepare questions to ask in case you are asked if you have any questions.
- Prepare answers for questions that you might be asked. For example: "Why do you want to work for us?" "What can you bring to the organization?" "What type of experience do you have?" "Why are you the best candidate?" "Where do you see yourself in five years?" "Why did you leave your last job?" "Did you get along with your last boss?" "What are you best at?" "What is your greatest strength?" "What is your greatest weakness?"

Preparing for these questions is essential. While I can't guarantee what an interviewer might ask, I can pretty much guarantee that he or she probably will ask at least one of those questions or at least something similar.

The Inside Scoop

I frequently receive calls from individuals who are distraught after going on a particular interview. It seems while they prepared for answering every question they could possibly think an interviewer might ask about the job they are applying for, they hadn't prepared for the unexpected.

"I prepared for answering every question," a man told me. "And then the interviewer threw me for a loop. He started asking me all kinds of questions that had nothing to do with the job I was applying for. I just couldn't come up with answers that made sense."

"What did he ask?" I questioned.

"He asked me what my favorite book was when I was a child. He asked me what I wanted to be when I was little. He asked me what my greatest strength was in my last job. Then he asked me what my biggest mistake was in my last job. I couldn't think of anything to say that quickly."

Interviewers often come up with questions like this for a variety of reasons. They may want to see how you react to nontraditional questions. They may want to see how well rounded you are. On occasion, they might just be thinking about something at the time they were interviewing you and the questions just popped out of their mouth.

If this has happened to you in the past, instead of beating yourself up about not coming up with what you consider a good answer, prepare for next time. Know there generally isn't any right or wrong answer. When an interviewer asks you a question, its okay to take a moment to compose yourself and think about the answer you want to give.

Other Types of Interview Scenarios

When you think of an interviewing situation, you generally think of the one-on-one scenario where the interviewer is on one side of the desk and you are on the other. At some time during your career you may be faced with some other types of interviews. Two of the more common ones you may run into are group interviews and panel interviews. What's the difference?

A group interview is a situation where an organization brings a group of people together to tell them about the company and job opportunities. There may be open discussions and a question and answer period. During this time, one-on-one interviews may be scheduled.

Organizations use these types of situations not only to bring a group of potential employees together, but to screen potential employees. What do you need to know? Remember that while this may not be the traditional interview setting you are used to, this is still an interview.

From the minute you walk in the door in these settings, the potential employer is watching your demeanor and your body language. He or she is listening to what you say and any questions you might ask. He or she is watching you to see how you interact with others and how you might fit into the company.

How can you increase your chances of being asked to a one-on-one interview?

◎ Actively participate in conversations and activities.
◎ Be a leader, not a follower.
◎ Ask meaningful questions.
◎ Stand out in a positive way.

Panel Interviews

Basically, a panel interview is one in which you are interviewed by a group of people at the same time. While these types of interviews may be used at any time, they are often utilized for higher-level positions. You might, for example go through a panel interview if you are pursuing a position as a museum director. You might also go through a panel interview if you are pursuing a position as the executive director of an art society or the art director of a large advertising agency.

Why do employers use panel interviews? There are a number of reasons. Every member of the panel brings something different to the table. Everyone has a different set of skills and experiences. Many employers feel that a panel can increase the chance of finding the perfect applicant for the job. It also is sometimes easier to bring everyone involved together for one interview instead of scheduling separate interviews.

While there are exceptions, the panel interview is usually not the first interview you go through. Generally, after going on one or more one-on-one interviews, if you become one of the finalists, you will be asked to attend a panel interview.

Who is there? It can be any mixture of people depending on the job. If you are pursuing a job as the director of an art museum, for example, the panel might include the human resources or personnel director, one or more members

of the board of directors, and perhaps the directors of various departments within the museum. Depending on the situation, there might also be members of search committees and so on. It all depends on the specific job.

How can you succeed in a panel interview? Start by relaxing. Looking *or* feeling stressed will not help in this situation. When you walk into the interview, smile sincerely and make sure you shake each person's hand with a firm handshake. You want each person to feel equally important.

Prepare ahead of time. Know what is on your resume or CV. It sounds simple, but believe it or not, when you're on the hot seat, it is very easy to get confused. You want to be able to answer every question about your background without skipping a beat.

Research the museum, agency, organization or company. Have some questions prepared so you can show a true interest in the position for which you are interviewing. Instead of referring to notes you have written, try to have your questions seem part of the conversation.

One of the important things to remember when participating in a panel interview is to make eye contact with everyone. Start by looking at the person who asks you the question. Then as you're answering, glance at the other people sitting around the table, making contact with each of them. You want everyone there to feel that you are talking to each of them.

Timing is everything in an interview. Whatever you do, don't be late. If you can't get to an interview on time, the chances are you won't get to a job on time. On the other hand, you don't want to show up an hour early either.

Try to time your arrival so you get there about 15 minutes before your scheduled interview time. Walk in and tell the receptionist your name and who your appointment is with. When you are directed to go into the interview, walk in, smile sincerely, shake hands with the interviewer or interviewers, and sit down. Look around the office. Does the interviewer have a photo on the desk of children? Is there any personalization in the office? Does it look like the interviewer is into golf, or fishing, or basketball or some other hobby? Do you have something common? You might say something like:

"What beautiful children."

"Is golf one of your passions too?"

"Do you go deep-sea fishing?"

"Those are amazing orchids. How long have you had them?

"What an incredible antique desk. Do you collect antique furniture?"

Try to make the interviewer comfortable with you before his or her questions begin.

Interview Questions

What might you be asked? You will probably be asked a slew of general questions and then, depending on the job, some questions specific to your skills and talent.

◎ Why should we hire you?

 ▫ This is a common question. Think about the answers ahead of time. Practice saying them out loud so you feel comfortable. For example, "I believe I would be an asset to your department (agency, facility, company or organization). I have the qualifications. I'm a team player and this is the type of career I've always wanted to pursue. I'm a hard worker and a quick study, I have a positive attitude, and I'll help you achieve your goals." You can then go on to explain one or two specifics. For example, "While I was in college during an internship, I helped develop a couple of pilot programs. One was a community-based program that got kids involved in painting murals throughout the town to help beautify the village and stop graffiti. Another was an after school program where we brought in guest artists to teach the kids different art

techniques. As part of the program, they worked on special art projects and then exhibited them in an art show at the end of the semester. The participants were allowed to set prices on their artwork. Quite a few of them sold their work. Three of the kids sold their work for over $500. It really helped raise the self-esteem of many of the kids."

◎ What are your qualifications for this job?

 ▫ This is a common question asked during any job interview. When asked, be ready to go over some of the specific qualifications you have for the job.

◎ What makes you more qualified than other candidates?

 ▫ This is another common question. Depending on the situation, you might say something like, "I believe my skills, talent, and experience as a graphic artist and then as the assistant art director with the Billings Advertising Agency have prepared me for this opportunity."

◎ Where do you see yourself in five years?

 ▫ Do not say, "Sitting in your chair," or "In your job." People in every job and every business are paranoid that someone is going to take their job, so don't even joke about it. Instead, think about the question ahead of time. It's meant to find out what your aspirations are and if you have direction.

Depending on your situation, one answer might be, "I hope to be a valued member of the fund-raising and development department. This art museum is such an important part of the city

that I would love to think that I can have a long career here."

◎ What are your strengths?

 ▫ Be confident but not cocky when answering this one. Toot your horn, but don't be boastful. Practice ahead of time communicating your greatest strengths, talents, and skills. "I'm passionate about what I do. I love working at something I'm passionate about. That's one of the main reasons I applied for this position. I am really good at thinking outside of the box. I'm a skilled fund-raiser. I love art and this museum. I have a lot of resources both in the art industry and the community. I'm also a people person and a really good communicator. I pride myself in being able to solve problems quickly, efficiently, and successfully."

◎ Where are your weaknesses?

 ▫ We all have weaknesses. This is not the time to share them. Be creative. "My greatest weakness is also one of my strengths. I'm a workaholic. I don't like leaving a project undone. I have a hard time understanding how someone cannot do a great job when they love what they do."

◎ Why did you leave your last job?

 ▫ Be careful answering this one. If you were fired, simply say you were let go. Don't go into the politics. Don't say anything bad about your former job, company, or boss. If you were laid off, simply say you were laid off, or if it's true, that you were one of the newer employees and unfortunately, that's how the layoff process worked.

You might add in you were very sorry to leave because you really enjoyed working there, but on the positive side, you now were free to apply for this position. If you quit, simply say the job was not challenging and you wanted to work in a position where you could create a career. Never lie. Don't even try to stretch the truth. I've mentioned it before and I'm going to reiterate it again. This is a transient society. People move around. You can never tell when your former boss knows the person interviewing you. In the same vein, never say anything during an interview that is derogatory about anyone or any other organization, facility, or company. The supervisor you had yesterday might just end up transferring or moving to your new company and end up being your new boss. It is not unheard of in the industry.

◎ What have you done to prepare yourself for the position as a graphic artist, art director, exhibit curator, art teacher, museum director, and so on?

 ▫ This is your chance to tell the interviewer some of the things you have done to prepare for the position for which you are applying. Have you attended college? Completed your degree? Taken training? Gone though an internship? Held another position?

◎ Why do you want to work in the art industry? Depending on the specific area of the industry, the question might be, "Why do you want to work in a museum?" or "Why do you want to work at an advertising agency?"

- ☐ Think about it ahead of time and be sure to have an answer ready for this question. Don't just come up with a stock answer. Show your passion.

Depending on the position you are pursuing, the interviewer may ask more industry-specific questions.

- ◎ What do you think is the biggest problem art museums face at this time?
- ◎ If you had to choose your favorite artist of all time, who would it be? Why?
- ◎ What is your favorite exhibit in the museum?
- ◎ What is your favorite art medium?
 - ☐ Think about questions like this ahead of time and come up with answers. There are no right or wrong answers for these types of questions. You just want to be able to come up with answers without saying, "Uh—let me think. Well, I'm not sure."
- ◎ Are you a team player?
 - ☐ No matter what segment of the industry you aspire to work, the answer is, "Yes, it's one of my strengths."
- ◎ Do you need supervision?
 - ☐ You want to appear as confident and capable as possible. Depending on the specific job and responsibilities, you might say, "Once I know my responsibilities, I have always been able to fulfill them. I look forward to doing the same here."
- ◎ Do you get along well with others?
 - ☐ The answer they are looking for is, "Yes, I'm a real people person." Do not give any stories about times where you didn't. Do not say anything like, "I get along better with

women," or "I relate better to men." Even if it's true, don't make any type of comment that can come back to haunt you later.

- ◎ Every now and then, you get a weird question or a question that you just don't expect. If you could be a car, what type of car would you be and why? If you were an animal, what animal would you be? If you could have dinner with anyone alive or dead, who would it be? These questions generally are just meant to throw you off balance and see how you react. Stay calm and focused. Be creative but try not to come up with any answer that is too weird.
 - ☐ An interviewer might ask you about the last book you read, what newspapers you read, or what television shows are your favorites.
 - ☐ Be honest, but try not to say things like, "I don't have time to read," or "I don't like reading." You want to appear well rounded.
- ◎ How do you deal with stress?
 - ☐ Stress is a major factor for people today. The interviewer does not want to hear that you are stressed the max. What he or she wants to hear is that you deal well with stress and you find healthy ways and constructive ways to manage it.
- ◎ Do you deal well with people?
 - ☐ The answer they are looking for is "Yes, I deal well with others. I'm a people person."
- ◎ What type of salary are you looking for?
 - ☐ Depending on the area of the industry you are pursuing and the specific job, this may or may

> **★ Tip from the Top**
>
> Try not to discuss salary at the begin-ning of the interview. Instead wait until you hear all the particulars about the job and you have given them a chance to see how great you are.

not come up at the first interview. Salary is going to be discussed in more detail in a moment, but what you should know now is that this is an important matter. You don't want to get locked into a number before you know exactly what your responsibilities are. If asked, you might say something to the effect of, "I'm looking for a fair salary for the job. I really would like to know more about the responsibilities I'll have here before I come up with a salary range. What is the range, by the way?" You might also turn the tables and say something like, "I am interested in knowing what the salary range is for this position." This turns the question back to the interviewer.

◎ Depending on the specific type of job you are pursuing, interviewers may ask you one or more questions designed to see if you have integrity or what type of judgment you have.

 ▫ If you are asked a question like this, take a moment to formulate your answer in your mind before you speak.

◎ Interviewers may ask you one or more questions designed to see what type of judgment you have.

 ▫ If you are asked a question like this, take a moment to formulate your answer in your mind before responding.

What the interview is trying to do is get inside your head and see how you will react to certain situations.

What They Can't Ask You

There are questions that are illegal for interviewers to ask. For example, they aren't permitted to ask you about age unless they are making sure you are over the minimum age required for the job.

They aren't supposed to ask you about whether you are married, have children, or are in a relationship. Interviewers are not supposed to ask you about your race, color, religion, national origin, or sexual preference.

If an interviewer does ask an illegal question, in most cases it is not on purpose. He or she just might not know that it shouldn't be asked.

Your demeanor in responding to such questions can affect the direction of the interview. If you don't mind answering, then by all means, do so. If answering bothers you, try to point the questions in another direction such as trying to go back to your skills and talents. If you are unable to do so, simply indicate in a nonthreatening, nonconfrontational manner that those types of questions are not supposed to be asked in interviews.

What You Might Want to Ask

Just because you're the one being interviewed doesn't mean you shouldn't ask questions. You want to appear confident. You want to portray someone who can fit in with others comfortably. You want to ask great questions. Depending on the specific job, here are some ideas.

◎ What happened to the last person who held this job? Was he or she promoted or did he or she leave the organization?
 ▫ You want to know whose shoes you're filling.

◎ What is the longevity of employees in the organization?
 ▫ A large number of employees who stay for a length of time generally means they are happy with the organization.

◎ Does the company (agency or department) promote from within as a rule or look outside?
 ▫ This is important because companies that promote from within are good organizations with which to build a career.

◎ Are there opportunities to advance here? Will I be able to take my skills and career to the next level?
 ▫ You want to know if this is an organization where you can build a career, and you are showing your interest in staying with the organization.

◎ Is there a lot of laughing in the workplace? Are people happy here?
 ▫ If people laugh a lot and seem to be happy, it generally means the environment is less stressed.

◎ Is there a probationary period? How long is that period?
 ▫ You want to know how long you will be a provisional employee.

◎ How will I be evaluated? Are there periodic reviews?
 ▫ You want to know how and when you will know if you are doing well in your supervisor's eyes.

◎ How do your measure success on the job? By that I mean, how can I do a great job for you?
 ▫ You want to know what your employer expects from employees.

◎ Who will I report to? What will my general responsibilities be?
 ▫ You want to know what your work experience and duties will be like.

◎ What are some of the challenges of this job?
 ▫ An interviewer may say, for example, "Some feel the job is stressful," or "There is never enough funding here to do as many exhibits as we want," or "We have very tight deadlines here." Whatever he or she says, do not respond with something to the effect of, "Oh, I don't know if I can deal with that."

Feel free to ask any questions you want answered. While it is perfectly acceptable to ask questions, don't chatter on incessantly out of nervousness. You want to give the interviewer time to ask you questions and see how you shine.

It's normal to be nervous during an interview. Relax as much as you can. If you go in prepared and answer the questions you're asked, you should do fine. Somewhere during the interview, if things are going well, salary will come up.

★ Tip from the Top

Make sure you fill in all applications required *before* you get into your interview.

Salary and Compensation

No matter how much you want a job, unless you are doing an internship, the good news is, you're not going to be working for free. Compensation may be discussed in a general manner during your interview or may be discussed in full. In some cases, it might not be discussed at all until you are offered the position. A lot has to do with the specific job. Unless your interviewer brings up salary at the beginning of an interview, you should not. If you feel an interview is close to ending and another interview has not been scheduled, feel free to bring up salary when asked if you have any questions.

A simple question such as "What is the salary range for the job?" will usually start the ball rolling. Depending on the specific job, your interviewer may tell you exactly what the salary and benefits are or may just give you a range. In many cases, salary and compensation packages are only ironed out after the actual job offer is made.

Let's say you are offered a job and a compensation package. What do you do if you're not happy with the salary? What about the benefits? Can you negotiate? That depends on the job. You certainly can try. Sometimes, you can negotiate a better salary. Sometimes you might negotiate better benefits. Sometimes you might be able to negotiate both.

What else? Depending on the job, you might be offered a signing bonus. A lot of it depends on how much they want you, how much of an asset you will be, and what the organization can afford.

When negotiating, speak in a calm, well-modulated voice. Do not make threats. State your case and see if you can meet in the middle. If you can't negotiate a higher salary, perhaps you can negotiate extra vacation days. Depending on the company and job, compensation may include salary, vacation days, sick days, health insurance, stock options, pension plans, or a variety of other things. When negotiating, look at the whole package.

You might do some research ahead of time to see what similar types of jobs are paying. Depending on the specific job, information on compensation may also have been in the original advertisement you answered.

Over the years I have seen many people who are so desperate to get the job of their dreams that once offered the job, they will take it for almost anything. Often when questioned about salary, they ask for salary requirements far below what might have been offered. Whatever you do, don't undersell yourself.

Accepting a job offer below your perceived salary "comfort level" often results in you resenting your company and coworkers, and, even worse, whittles away at your self-worth.

If you want to, feel free to ask for a day or two to consider an offer. Simply say something like "I appreciate your confidence in me. I'd like to think about it overnight if that's okay with you. Can I give you a call tomorrow afternoon?"

Things to Remember

In order to give yourself every advantage in acing the interview, there are a few things you should know. First of all, practice ahead of time. Ask friends or family members for their help in setting up practice interviews. You want to get comfortable answering questions without sounding like you're reading from a script.

Here are some other things to remember to help you land an offer.

◎ If you don't have confidence in yourself, neither will anyone else. No matter how nervous you are, project a confident and positive attitude.

◎ Even if the job is talent based, the one who looks and sounds most qualified has the best chance at getting the job. Don't answer questions in monosyllables. Explain your answers using relevant experiences. Use your experiences in both your work and personal life to reinforce your skills, talents, and abilities when answering questions.

◎ Try to develop a rapport with your interviewer. If your interviewer likes you, he or she will often overlook less than perfect skills because you seem like a better candidate.

◎ Smile and make sure you have good posture. It makes you look more successful.

◎ Be attentive. Listen to what the interviewer is saying. If he or she asks a question that you don't understand, politely ask for an explanation.

◎ Be pleasant and positive. People will want to be around you.

◎ Turn off your cell phone and beeper before you go into the interview.

◎ Be 100 percent truthful and honest during your interview.

◎ When you see the interview coming to a close, make sure you ask when a decision will be made and if you will be contacted either way.

◎ When the interview comes to a close, stand up, thank the interviewer, shake his or her hand, and then leave.

Here are some things you should not do:

◎ Don't smoke before you go into your interview.

◎ Don't chew gum during your interview.

◎ Don't be late.

◎ Don't talk negatively about past bosses, jobs, or companies.

◎ Don't stay "ain't," "heh," "unhuh," "don't know," "got me," or other similar things. It doesn't sound professional and suggests that you have poor communication skills.

◎ Don't wear heavy perfume or men's cologne before going on an interview. You can never tell if the interviewer is allergic to various odors.

◎ Don't interrupt the interviewer.

◎ While you certainly can ask questions, don't try to dominate the conversation to try to "look smart."

◎ Don't swear, curse, or use off-color language.

◎ Don't make sexist or racist remarks.

Thank-You Notes

It's always a good idea to send a note thanking the person who interviewed you for his or her time. Think a thank you note is useless? Think again. Take a look at some of the things a thank you note can do for you.

A thank-you note after an interview can:

◎ Show that you are courteous and well mannered.

◎ Show that you are professional.

◎ Give you one more shot at reminding the interviewer who you were.

◎ Show that you are truly interested in the job.

◎ Illustrate that you have written communication skills.

◎ Give you a chance to briefly discuss something that you thought was important yet forgot to bring up during the interview.

◎ Help you stand out from other job applicants who didn't send a thank you note.

◎ Try to send thank you notes within 24 hours of your interview. You can hand-write or type them. While it's acceptable to e-mail or fax them, I suggest mailing.

What should the letter say? It can simply say thank you for taking the time to interview you or it can be longer, touching on a point you discussed in the interview or adding in something you may have forgotten.

Waiting for an Answer

You've gone through the interview for the job you want. You've done everything you can do. Now what? Well, unfortunately, now you have to wait for an answer. Are you the candidate who was chosen? Hopefully, you are!

If you haven't heard back in a week or so, (unless you were given a specific date when an applicant would be chosen), call and ask the status of the job. If you are told that they haven't made a decision, ask if there is a time frame when a decision will be made and good time to call back to check on the status. If you are told that a decision has been made and it's not you, thank them and say that you appreciated the consideration. Request that your resume be kept on file for the future. You might just get a call before you know it. If the organization is a large one, ask if there are other positions available and how you should go about applying for them if you are interested.

If your phone rings and you got the job, congratulations! Once you get that call telling you that you are the candidate they want, depending on the situation, they will either make an offer on the phone or will ask to come back in to discuss your compensation package. If an offer is made on the phone, as we previously discussed, you have every right to ask if you can think about it and get back to them in 24 hours. If you are satisfied with the offer as it is, you can accept it.

Tip from the Coach
Take every interview seriously. Don't waste any opportunity to sell yourself.

Depending on the job, you may be required to sign an employment contract. Read the agreement thoroughly and make sure that you are comfortable signing it. If there is anything you don't understand, ask. Do not just sign it without reading. You want to know what you are agreeing to.

Interviewing for jobs is a skill. Practice until you feel comfortable answering every type of question and being in a variety of interviewing situations. The more prepared you are ahead of time, the better you'll usually do. The more you do it, the more comfortable you'll be going through the process.

Mastering the art of interviewing can make a huge difference in your interview. Remember the intangible essentials that can help you win the job:

◎ Enthusiasm
◎ Excitement
◎ Passion
◎ Interest
◎ Confidence

Let's discuss these areas for a moment. Enthusiasm is key when interviewing for a job. You want to be enthusiastic at the interview.

"But I don't want them to think I'm desperate," people always tell me.

My response is always the same. You don't want to appear desperate, but you don't want there to be a question in your interviewer's mind that you want the job.

What else? You want to be excited about the possibility of working at the job for which you are interviewing.

Passion is essential. Make sure you let your passion shine. It can make the difference between you getting the job or someone else.

Anything else? You definitely want to appear interested. What does that mean? You want your interviewer to know without a shadow of a doubt that you are interested not only in the job but also in the concept of working at that particular job.

And finally, you want to appear confident. As we have already discussed, if you don't believe you are the best, neither will anyone else.

With some thought, planning, and effort, you can master job interview skills to tip the scale in your favor and land the job you are going after.

9

MARKETING YOURSELF FOR SUCCESS

What Marketing Can Do for You

Who hasn't heard of Nabisco, Pepperidge Farm, and Bird's Eye? How about Coca-Cola, Pepsi, and Dr Pepper? What about McDonald's, Burger King, and Wendy's? Here's a question. Do you know what those companies have in common with Las Vegas, Disneyworld, the Rolling Stones, Elvis Presley, and every other successful corporation and person? It's the same thing that hot trends, major sports events, blockbuster movies, top television shows, hot CDs, mega superstars and even hot new toys have in common. Do you know what it is yet?

Here's the answer. Every one of them utilizes marketing. Do you want to know the inside track on becoming successful and getting what you want no matter what segment of the art industry you're interested in pursuing? It's simple; all you have to do is utilize marketing yourself.

Many people think that marketing techniques are reserved for businesses, products, or celebrities. Here's something to think about. From the moment you begin your career until you ultimately retire, you are a product. It doesn't matter what direction your career is going, what level you're at, or what area you want to pursue.

There are thousands of people who want to work in various segments of the art industry. Some make it, and some don't. Is it all talent? A lot of it has to do with talent, but that is not everything. We all have heard of talented individuals who haven't made it in their chosen field. Is it skills? We have all heard of people who are skilled, yet don't make it either. Is it that one individual has more education or training than another? Many of us have also seen people who are more educated than others yet aren't the ones who have the ultimate success.

So if it isn't just talent or skills and it's not education, what is the answer? What is the key to success? A lot of it is related to working hard and having a strong passion. As we've discussed previously, probably a lot of it may also have to do with luck and being in the right place at the right time. One of the important factors that appears to be related to success, however, is also how one individual sets himself apart from another in the way he was marketed or conversely marketed himself.

Here's something you should know. When major corporations want to turn a new product into a hot commodity they develop and implement a successful marketing plan. When record executives want to turn a CD and an artist into

a hot commodity, they develop and implement a successful marketing plan. When book publishers want to turn a new book into a hot commodity, they develop and implement a successful marketing plan.

What does this mean to you? No matter which segment of the art industry you want to work and succeed, marketing can help *you* become one of the hottest commodities around as well.

While most people can understand how marketing can help a product succeed, a celebrity become more popular, or a book become a best seller, they often don't think about the possibility of marketing themselves if they are pursuing a career in an industry such as art.

When I give seminars and we start discussing this area, there are always a number of attendees who inevitably ask, "Does this relate to me?" "Can't I just look for a job, interview, get it, and forget it?" they ask. "Do I need to go through this extra process? Why do I have to market myself?"

Here's the answer in a nutshell. If you aren't marketing yourself and someone else is, they will have an advantage over you. One of the tricks to success is taking advantage of every opportunity. Marketing yourself is an opportunity you just can't afford to miss. It is important if you are aspiring to a career in the business segment of the industry, the administrative segment, the talent segment, or anywhere in between.

What is marketing? On the most basic level, marketing is finding markets and avenues to sell products or services. In this case, you are the product. The buyers are employers. If you are an artist, craftsperson, or designer, your buyers may be people who are purchasing your work.

To be successful, you not only want to be the product, you want to be the *brand*. Look at

Nabisco, Kellogg's, McDonald's, Coke, Pepsi, and Disney. Look at Orange County Choppers, Martha Stewart, NASCAR, American Idol, and Michael Jordan.

Look at Donald Trump. One of the most successful people in branding, Trump, a master marketer, believes so strongly in this concept that he successfully branded himself. While he made his mark in real estate, in addition to having a number of successful television shows under his belt, Trump has a successful line of hotels, casinos, clothing, water, ice cream, meats, books, seminars, and even a Trump University. He continues to illustrate to people how he can fill *their needs*. Then he finds new needs he can fill. If you're savvy, you can do the same.

"Even if I want to work in the art industry?" you ask.

Absolutely! If you know or can determine what you can do for an employer or what can help them, you can market yourself to illustrate how you can fill those needs. If you can sell and market yourself effectively, you can succeed in your career; you can push yourself to the next level, and you can get what you want.

Is there a secret to this? No, there really isn't a secret, but it does take some work. In the end, however, the payoff will be worth it.

Do you want to be the one who gets the job? Marketing can help. Want to make yourself visible so potential employers will see you as desirable? Marketing can help. Do you want to set yourself apart from other job candidates? Guess what? Marketing can help. It can also distinguish you from other employees. If you have marketed yourself effectively, when possible promotions, raises, or in-house openings are on the horizon, your name will come up. Marketing can give you credibility and open the door to new opportunities.

Do you want to stand out from others in your specific area of the art industry? Do you, for example, want to set yourself apart from museum marketing directors? Do you want to set yourself apart from other artists? Do you want to set yourself apart from other exhibit curators? Do you want to set yourself apart from other craftspeople? What about other fashion designers? Do you want to set yourself apart from other graphic artists? Do you want to set yourself apart from every other person in your field? You know what you have to do? Market yourself!

Do you want to become more visible? Do you want to get the attention of the media? Do you want to get the attention of recruiters, headhunters, industry insiders, and other important people? Do you want to open up the door to new opportunities? Do you want to catch the eye of museum or art society board members? Do you want to get the attention of human resources directors or personnel officers so they want you to be part of their team? Market yourself!

"Okay," you're saying. "I get it. I need to market myself. But how?"

That's what we're going to talk about now. To begin with, understand that in order to market yourself effectively, you are going to have to

Tip from the Coach

Effective marketing focuses on the needs of the customer (in this case, the employer). You want to show employers how you can fill their needs, not what they can do for you. What does this mean to you? You not only want to show potential employers how good you are but also how your skills, talents, and package can help them.

do what every good marketer does. You're going to have to develop your product, perform market research, and assess the product and the marketplace.

Are there going to be differences between marketing yourself for a career in the business or administrative segment of the art industry and marketing yourself if you are an artist, craftsperson, or designer? Are there going to be differences in the way you market yourself if your career aspirations are working in a museum or working in an advertising agency? What about if you want to work hands-on in the industry or in one of the peripherals? Yes, of course, there may be some differences, but in general, you're going to use a lot of the same techniques.

Read over this section and see which techniques and ideas will work best for you. As long as you are marketing yourself in a positive manner, you are on the right track.

The Five Ps of Marketing and How They Relate To Your Career

There are five Ps to marketing whether you're marketing your career, a hot new restaurant, a new product, your art, a brand new book or CD, or anything else. They are:

Tip from the Top

If you want to market yourself effectively, find ways to set yourself apart. One of the ways you can do this is by doing more than is expected of you. If you see something that needs to be done, don't wait for someone to tell you to do it—be proactive and offer to help. If things aren't busy at work, look for something to do. Your extra efforts will not go unnoticed.

◎ Product
◎ Price
◎ Positioning
◎ Promotion
◎ Packaging

Let's look at how these Ps relate to your career.

◎ *Product:* In this case, the product is you. "Me," you say. "How am I a product?" You are a package complete with your physical self, skills, ideas, and talents. (Later in the book, we're going to discuss marketing your artwork as well.)

◎ *Price:* Price is the compensation you receive for your work. One of your goals in marketing yourself is to sell your talents, skills, and anything else you have to offer for the best possible compensation.

◎ *Positioning:* What positioning means in this context is developing and creating innovative methods to fill the needs of one or more employers or potential clients. It also means differentiating yourself and your talent and skills from other competitors. Depending on your career area, this might mean differentiating yourself from other employees, administrators, business people, artists, designers, and so on.

◎ *Promotion:* Promotion is the development and implementation of methods that make you visible in a positive manner. These methods might include a variety of things including advertising, publicity, marketing, and public relations.

◎ *Packaging:* Packaging is the way you present yourself.

Putting Together Your Package

Now that we know how the five Ps of marketing are related to your career, let's discuss a little more about putting together your package.

The more you know about your product (*you*), the easier it is to market and sell it. It's also essential to know as much as possible about the markets to which you are trying to sell. What do you have to offer that a potential buyer (*employer*) needs? If you can illustrate to a market (*employer*) that you are the package that can fill its needs, you stand a good chance to turn the market into a buyer.

Assess what you have to offer as well as what you think an employer needs. We've already discussed self-assessment in a prior chapter. Now review your skills and your talents to help you determine how they can be used to fill the needs of your target markets.

While all the Ps of marketing are important, packaging is one of the easiest to change. It's something you have control over.

How important is packaging? Very! Good packaging can make a product more appealing, more enticing, and make *you* want it. Not convinced? Think about the last time you went to the store. Did you reach for the name brand products more often then the bargain brand?

Still not convinced? How many times have you been in a bakery or restaurant and chosen

⭐ Tip from the Coach

While you can't tell a book by its cover, it is human nature to at least look at the book with an interesting cover first. You might put it back after looking at it, but you at least gave it a first shot. That is why it is so important to package yourself as well as you possibly can.

the beautifully decorated desserts over the simple un-iced cake? Packaging can make a difference—a big difference—in your career. If you package yourself effectively, people will want your package.

Want to know a secret? Many job candidates are passed over before they get very far in the process because they simply don't understand how to package themselves. What does this mean to you?

It means that if you can grasp the concept, you're ahead of the game. In a competitive world, this one area can give you the edge. Knowing that a marketing campaign utilizes packaging to help sell products means that you will want to package yourself as well as you can. You want potential employers, recruiters, headhunters, board members, and others to see you in the most positive manner possible. You want to illustrate that you have what it takes to fill *their* needs.

So what does your personal package include?

People base their first impression of you largely on your appearance. Whether you are going for an interview for a hot job or currently working and trying to move up the ladder of success, appearance is always important.

It might seem elementary, but let's go over the elements of your appearance. Personal grooming is essential. What does that mean?

- Your hair should be clean and neatly styled.
- You should be showered with no body odor.
- Your nails should be clean. If you polish them, make sure that your polish isn't chipped.
- If you are a man, you should be freshly shaved, and mustaches and beards should be neatly styled.
- If you are a woman, your makeup should look natural and not overdone.
- Your breath should be clean and fresh.

Good grooming is important no matter what segment of the industry you are pursuing.

Now let's discuss your attire. Whether you're going on interviews, in a networking situation, or already on the job, it's important to dress appropriately. What's appropriate? Good question.

Appropriateness to a great extent depends on the area of the industry and your specific job.

⭐ Words from a Pro

Even if you are interviewing for an entry-level job, dress professionally. You want your interviewer to see that you are looking for a career, not just a job.

⭐ Tip from the Top

Here's a tip for career advancement. Check out what the higher-ups are wearing and emulate them. If you dress like you're already successful, not only you will feel more successful, but you will set yourself apart in a positive way in your superior's eyes.

If you're working in the business or administrative end of the industry, you of course want to look professional at all times.

While artists or designers often may have some leeway for casual dressing, it's important to remember that dressing professionally can help your career in a number of ways from establishing credibility to maintaining respect to helping create a professional, polished image.

Always dress to impress. Employers want to see that you will not only fit in, but that you will not embarrass them when representing the agency, company, department, or organization. So what should you do? What should you wear?

If you are going on an interview, dress professionally. While we discussed interviewing attire in a previous chapter, let's touch on it again. If you're a man, you can never go wrong in a suit and tie or a pair of dress slacks with a sports jacket, dress shirt, and tie. Women might wear a suit, a professional looking dress, a skirt and jacket, skirt and blouse or perhaps a pantsuit. Once you're hired, learn the company dress pol-

icy. It's okay to ask. No matter what the policy is, observe what everyone else is wearing. If the policy is casual and everyone is still dressed in business attire, dress in business attire.

"But what if I'm working in a museum [or whatever other job you have] and I need to wear a uniform of some type?" you ask. "What do I do then?" If you are wearing a uniform of some type while on duty, be sure that it is clean and pressed and that your grooming is immaculate.

You always want to make a good impression. You want to look like you care, and you want to look like you're serious about your career. You want to look professional. You also want to illustrate that you have respect for the interviewer and the interview process.

You might also want to think about your image when you're *not* working. Why is this important? If you project an unprofessional image off the job, it can possibly affect your career in a negative manner.

This isn't to say that you have to wear a suit all the time or even be dressed up. What it means is that you never want to be in a position where you leave home looking sloppy and then run into someone who could be helpful to your career.

Communication Skills

Your communication skills, both verbal and written, are yet another part of your package.

⭐ The Inside Scoop

It's always easier to make yourself look more casual than it is to make yourself appear dressed more professionally. If in doubt about what to wear in any given situation, err on the side of dressing professionally.

> ### ★ Voice of Experience
> If you're not sure if you should say something, don't say it. If you think something might be off-color or offend someone, keep it to yourself.

> ### ★ Words from the Wise
> Don't say words like "ain't." It makes you sound stupid even if you're not.

What you say and how you say it can mean the difference between success and failure in getting a job or succeeding at one you already have. You want to sound articulate, polished, strong, and confident.

Do you ever wonder how others hear you? Consider using a tape recorder, recording yourself speaking and then playing it back.

Is this scary? It can be if you never have heard yourself. Here's what you need to remember. No matter what you think you sound like, it probably isn't that bad. If you are like most people, you are probably your own worst critic.

When you play back your voice, listen to your speech pattern. You might, for example, find that you are constantly saying "uh" or "uh-huh." You might find that your voice sounds nasal or high pitched or that you talk too quickly. If you're not happy with the way you sound, there are exercises you can do to practice to change your pitch, modulation, and speech pattern.

Because you can't take words back into your mouth after you say them, here are some *don'ts* to follow when speaking.

◎ Don't use off-color language.
◎ Don't swear or curse.
◎ Don't tell jokes or stories that have sexual, ethnic, or racial undertones or innuendoes.
◎ Don't interrupt others when they are speaking.
◎ Don't use poor grammar or slang.
◎ Don't talk about people.

We've discussed your verbal communication skills. Now let's discuss the importance of your written communication skills. Here's the deal. Written communication skills are important in every segment of the art industry, no matter what it is. At the very least, you will need the ability to write reports and simple letters.

If you are uncomfortable with your writing skills, you have a couple of choices. You might pick up a book to help improve your skills or perhaps take a writing class at a local school or college.

Your body language can tell people a lot about you. The way you carry yourself can show others how you feel about yourself. We've all seen people in passing that were hunched over or who looked uninterested or just looked like they didn't care.

Would you want someone like that working for you? Would you want someone like that handling your fund-raising or marketing or pub-

> ### ★ Voice of Experience
> Don't speak negatively about coworkers or superiors to other coworkers. Similarly, don't speak negatively about your coworkers or superiors to people outside of your workplace.

lic relations? Would you like someone like that representing your artwork? Probably not, and generally neither do most employers.

What does your body language illustrate? Does it show that you are confident? That you are happy to be where you are? Do you make eye contact when you're speaking to someone? What about your demeanor? Common courtesy is mandatory in your life and your career. Polite expressions such as "please," "thank you," "excuse me," and "pardon me" will not go unnoticed.

Your personality traits are another part of your package. No one wants to be around a whiner, a sad sack, or people who complain constantly. You want to illustrate that you are calm, happy, well balanced, and have a positive attitude.

You want to show that you can deal effectively with others, are a team player, and can deal with problems and stress effectively. You might be surprised to know that in many cases employers will lean toward hiring someone with a positive and energetic personality over one with better skills who seems negative and less well balanced.

Remember that the education and training you have is an important part of your package. Get the best education and training you can. Don't stop at the minimum requirements. Continue learning throughout your career. Education, both formal and informal, not only helps you increase knowledge and build new skill sets but helps you make new contacts and build your network.

Last but not least in your package are your skills and talents. These are the things that make *you* special. What's the difference between skills and talents?

Skills can be learned or acquired. Talents are things that you are born with and can be embellished. Your personal package includes both.

What you need to do is package the product so the buyer wants it. In this case, as we have discussed, the product is you and the buyer might be a potential employer, recruiter, headhunter, human resources director, and so on.

Now that you know what goes into your package, and you are working on putting together your best possible package, what's next?

Marketing Yourself Like a Pro and Making Yourself Visible

How can you market yourself? If you're like many people, you might be embarrassed to promote yourself, embarrassed to talk about your accomplishments, and embarrassed to bring them to the attention of others. This feeling probably comes from childhood when you were taught "it wasn't nice to brag."

It's time to change your thinking. It's time to toot your own horn! Done correctly, you won't be bragging. Done correctly, you are simply taking a step to make yourself visible. You are taking a step to help let potential employers know that you are the one who can fill their needs.

Want to know the payoff to doing this? You can move your career in a positive direction quicker. Career success can be yours, but you need to work at it.

Visibility can help. Visibility is important in climbing the career ladder in every industry. No matter the segment of the art industry in which

> ### Tip from the Coach
> Be positive about yourself and never be self-deprecating, even in a joking manner. The truth is when you're self-deprecating, you will start believing it and so will the people with whom you are speaking.

you want to succeed, visibility can assist you in attaining your goals.

How? To begin with, it can help set you apart from others who might have similar skills and talents.

How can you make yourself visible?

◎ Tell people what you are doing.
◎ Tell people what you are trying to do.
◎ Share your dreams.
◎ Live your dreams.
◎ Toot your own horn.
◎ Get into the media.
◎ Get involved in the community.
◎ Do more than is expected of you.
◎ Make it happen.

When you make yourself visible, you will gain visibility in the workplace, the community and more. This is essential to get what you want and what you deserve in your career whether it's the brand new job or a promotion pushing you up the career ladder.

We'll discuss how you can you tell people what you're doing without bragging later, but first, let's discuss when it's appropriate to toot your own horn. Here are some situations.

◎ When you get a new job.
◎ When you get a promotion.
◎ When you are giving a speech.
◎ When you are giving a presentation.
◎ When you are going to be (or have already appeared) on television or radio.
◎ When you have a major accomplishment.
◎ When you receive an honor or an award.
◎ When you chair an event.
◎ When you graduate from school, college, or a training program.
◎ When you obtain professional certification.

◎ When you work with a civic, not-for-profit, or charity organization on a project (as a volunteer).
◎ When your artwork (or designs) are on display in a prominent location. (This might be a museum, gallery, bank, or an event.)

And the list goes on. The idea isn't only to make people aware of your accomplishments, but to make yourself visible in a positive manner.

How do you do it? Well, you could shout your news from a rooftop or walk around with a sign, but that probably wouldn't be very effective.

One of the best ways to get the most bang for your buck is by utilizing the media.

"I don't have money for an ad," you say.

Here is the good news. You don't have to take out an ad. You can use publicity and publicity is free. Newspapers, magazines, and periodicals *need* stories to fill their pages. Similarly, television and radio need to fill airspace as well. If you do it right, your story can be one of the ones filling that space and it won't cost you anything.

How do you get your news to the media? The easiest way is by sending out press or news releases.

How do you write a news release? It really isn't that difficult once you get the basics down. You can always ask a professional publicist for some pointers. You also might ask the publicity

⭐ Tip from the Top

A press release is not an ad. Ads cost money. There is no charge to send press releases to the media. Press releases are used by the media to develop stories or are edited slightly or published as is.

chairperson from a local not-for profit organization if he or she would mind giving you the basics on developing press releases. Local community colleges and schools often offer noncredit classes, seminars, and workshops that can help you learn how to write news releases effectively.

Basically, however, if you want to get started, you should know that news releases are developed by answering the five Ws. These are:

- ◎ Who?
 - ▫ Who are you writing about?
- ◎ What?
 - ▫ What is happening or has happened?
- ◎ When?
 - ▫ When did it happen or is it happening?
- ◎ Where?
 - ▫ Where is it happening or has it happened?
- ◎ Why?
 - ▫ Why is it happening or why is it noteworthy or relevant?

While it would be nice for everyone to have their own personal press agent or publicist, this is not generally the case. So until you are lucky enough to have one, you are going to have to be your own publicist. You're going to have to develop your own personal publicity and marketing plan.

How do you do this? In order to market yourself, you are going to have to find opportunities to issue press releases, develop them, and then send them out. You want your name to be visible in a positive manner as often as possible.

Let's look at a possible scenario. Let's say Seth Meyer just received his degree in fine art and landed a job as a graphic artist for a printer.

Seth was watching television one night when he heard a story on the news talking about the demise of main streets in towns throughout the country as a result of the increase of malls and shopping centers. The story went on to discuss how while the impact was economic, it also created eyesores. Seth thought about his own area. It was full of dreary storefronts and buildings too. There was also a lot of graffiti. Seth thought about it. Surely there was something that could be done—at least in the area he lived and worked.

By the next day when Seth went to work, he had formulated an idea. Knowing his boss was also the president of the local chamber of commerce, Seth decided to see if he could enlist his boss's help. He told him about the story he heard the night before on the news.

"It sounds like our main street," said his boss.

"There are a lot of talented people around here," continued Seth. "What do you think about getting some of them together and painting murals on some of the empty buildings

throughout the town? We might even be able to get some of the kids who are painting the graffiti, recruiting them to help us paint some murals." He continued, "I was thinking, we can even put together teams and have some sort of competition."

"That's a great idea," his boss said. "We probably can even get the chamber involved. Maybe we can get the businesses to donate the materials and some of the prizes for the competition." The two spoke a bit more and decided to bring up the idea at the chamber meeting the next week.

During the chamber meeting, Seth brought up the idea, which was met with enthusiasm by the chamber members. Seth volunteered to be chair of the project he called *A Place for Art.*

Over the next few weeks, Seth used every free minute he had outside of work to get the project underway. He spoke at civic meetings in an effort to get people in the community and businesses involved. He recruited local artists as well as many of the teens who were spraying graffiti on buildings. He went from someone who no one knew to a man who everyone knew and began to respect.

People in the community began to get excited. Some donated prizes for the mural competition. Others volunteered to help design and paint the murals. Before long, *A Place for Art* was underway with 10 teams painting 10 different murals.

As the murals began to take shape, *A Place For Art* began gaining momentum, garnering the interest of the media. Seth Meyer was always the spokesperson. He consistently promoted the project in every manner possible.

By the time the murals were completed, local, regional, and even national media had covered the story. People from other areas began

> ### ★ Tip from the Coach
> Contacts are an important part of your career. Once you make them, don't risk losing your relationships. Stay in contact by periodically sending e-mails, cards, and letters, making periodic calls, and arranging to meet for lunch, coffee, or just to get together and talk.

visiting to see the murals, each of which had a different theme.

With all the media attention, Seth started receiving calls about other job possibilities. While he loved his current job and wasn't planning on leaving, he received an offer he couldn't refuse. Another community who had been following *A Place for Art* saw Seth as a valuable commodity, offering him a paid position putting together and maintaining a similar program in their city.

Think it can't happen this way? Well, it can! While you might not live this exact scenario, you can potentially create your own scenario with a similar outcome if you are creative and think outside of the box.

In this scenario Seth Meyer gained visibility in a number ways. Not only did he gain visibility in his place of employment, but he also gained visibility and respect in the community from people who might not have otherwise known him.

This type of scenario also affords people the opportunity to send out press releases, which not only further market and promote a project but can help market and promote a person.

Here's an example of a press release that Seth Meyer might have sent out.

NEWS FROM A PLACE FOR ART

P.O. Box 422
Some City, NY 11111
Media: For additional information, contact:
Seth Meyer, 111-999-9999

For Immediate Release:

Seth Meyer of Some City, NY will be a guest on WRAN's popular talk show, *Life Lessons,* on Tuesday, June 19, at 8:00 p.m. He will be discussing a pilot project he is chairing with the Some City Chamber of Commerce called *A Place for Art.* The mission of *A Place for Art* is to help beautify Some City by having local artists design and paint murals on buildings within the community that are either eyesores or have been sprayed with graffiti.

Meyer started the project after seeing a story on the news discussing the demise of main streets in America as a result of the increase of malls and shopping centers. The story went on to say that many of the main streets were turning into rows of graffiti-covered eyesores.

Meyer, a graphic artist for the Elegant Printing Company, heard the story and realized that Some City, the area in which he lives and works, had a similar problem.

"I had just graduated from State College with a bachelor's degree in fine arts and landed my first job," said Meyer. "I knew I wanted to do something, but wasn't sure if I should approach my new boss. I'm so glad I did. He was awesome."

Meyer's boss is Gary Reynolds, owner of Elegant Printing and president of the Some City Chamber of Commerce. "After Seth outlined his plan for using art and local artists to help beautify Some City, I knew he was onto something," said Reynolds. "When he suggested letting some of the kids who had sprayed the buildings with graffiti help paint the murals, I knew the idea was a winner," he continued. "The icing on the cake was his idea of the competition. It helps everyone in the community get involved."

Meyer thought the idea of using some of the teens who originally spray painted graffiti on the building was important for a number of reasons. "I could see that many of those kids were talented," said Meyer. "I felt that giving them a canvas to express that talent would give them a feeling of self-worth as well as some positive reinforcement regarding their talent."

Other artists were recruited from Some City and the surrounding areas. To date, 10 teams of artists are working on 10 different murals each with a different theme. A competition for prizes will be held after all murals are completed. The public will vote and ultimately choose the winners.

All the artists for the project are volunteering their time and talent. Businesses in the community are donating the materials as well as prizes for the competition, which will take place after the murals have been completed.

Murals are not new to Meyer. He was one of three artists who helped design and paint a mural depicting singers and entertainers who made it big from the Green City area when he was in college. That mural, incidentally, has been featured on a number of national television shows including *Entertainment Tonight* and *20/20*.

"We're trying to beautify one building at a time," said Meyer. "I'm so excited to be part of a project that not only impacts the community but gives artists an opportunity to showcase their work in a unique way. I can't wait to see how the program progresses."

Individuals interested in learning more about *A Place for Art* can contact Meyer by calling 111-999-9999 and leaving a message.

-30-

What does this press release do? In addition to publicizing Meyer's radio appearance, it gets his name in the news. It gets his message out. It exposes his career accomplishments and helps keep him in the pubic eye in a positive way. By Meyer using this avenue to market himself, he is putting himself in a different light from those who are not doing so.

"Well, that's a nice story," I can hear you saying. "But in the real world, does that kind of thing happen?"

You might not hear about it all the time, but those situations do happen and they can happen to you. The key here is that in order for them to occur, you're going to have to start thinking outside of the box.

> ### ⭐ Voice of Experience
> It's difficult to proofread your own press releases to catch errors. Always have someone else read them not only for errors but also to make sure they make sense.

Make sure your press releases look professional by printing them on press or news release stationary. This can easily be created on your computer. Have the words "News" or "News From" or something to that effect someplace on the stationary so the media is aware it is a press release. Also make sure to include your contact information. This is essential in case the media wants to call to ask questions about your release. In many instances, the media just uses the press release as a beginning for an article. Once you pique their interest, they use the press release as background and write their own story.

You've developed a press release. Now what? Whether it's about getting a promotion, being named employee of the month, having a piece of your sculpture showcased at the opening of a new facility, or anything else, developing and

> ### ⭐ Tip from the Top
> Be sure to add in either the symbol -30- or the number sign #, centered at the end of your press release. This lets the editor reading your press release know that the press release is completed.

writing a great press release is just the first step. Once that's done, you have to get the releases to the media.

How do you do this? You have a few options. You can print the press releases and then send or fax them to the media or you can e-mail them. Either way it's essential to put together a media list so you can reach the correct people. Look around your area. What media is available?

Start by getting the names of the local media. Then find regional media. If your stories warrant it, national or trade media should also be included. Don't forget any Web or online publications.

Call up each media outlet and ask who press releases should be directed towards. Sometimes it may just be "News Editor" or "Business Editor." Sometimes it will be a specific person. Get their contact information. Put together a data base consisting of the name of the publication or station, contact name or names, address, phone, and fax numbers, e-mail, and any other pertinent information.

Send your press releases to all applicable publications and stations. The idea with press releases is to send them consistently. Keep in mind that while you don't want to write a press release about *nothing,* anytime you have *anything* noteworthy to send out a press release about, you should.

Becoming an Expert

Want another idea to make yourself visible? Become an expert. You probably already are an expert in one or more areas either in or out of some area of the art industry. Now it's time for you to exploit it.

Many people are so used to the things they do well that they don't give enough credence to being great at them. It's time to forget that type of thinking!

> ### ★ The Inside Scoop
> Always be ready for the media. Keep stock paragraphs on your computer so you can turn out press releases quickly when needed. As a matter of fact, you might want to keep stock press releases and bios on hand so you're always ready when the media calls.

One of the wonderful things about being an expert in any given area is that people will seek you out. Everyone knows how to do something better than others. What you have to do is figure out what it is that you do.

"Okay," you say. "You're right. Let's say I'm a gourmet chef. What does that have to do with the art industry?"

Well, it might have nothing to do with the art industry on the surface. However, if it can help you gain some positive attention and visibility, it will give you another avenue to get your story out. This will help you achieve the career success you desire. So with that in mind, it has everything to do with it.

"How could that happen?" you ask.

In any number of ways. You might, for example, be the assistant director of development at a medium-sized art museum. You entered a recipe contest and won the grand prize. The contest sponsor sent out a press release to the local paper about the promotion and your winning recipe. The press release mentioned a bit about your career including where you work and some of your accomplishments. The sponsor also sent the press release to various other media. It was picked up by a number of museum trade publications as well as a couple of the local television news shows.

Coincidentally, a larger art museum is looking for a new director of development. They see the story first in the museum publication and then on the news. Between the story in the museum publications and the other press from your winning recipe, you are brought to the attention of the powers that be. Before you know it, you get a call asking you if you would be interested in coming in for an interview.

While your scenario might be different, you just might end up with a similar result if you take advantage of every opportunity.

Let's begin by determining where your expertise is. Sit down with a piece of paper and spend some time thinking about what you can do better than anyone else in or out of the art industry. What subject or area do you know more about than most? Do you volunteer in an interesting area? Are you a gourmet chef? Can you teach almost anyone how to pitch a ball? Can you teach senior citizens how to use a computer? Can you spell words backwards? Can you teach children how to draw?

Need some help? Can't think of what you're expertise is? Here are some ideas to get you started.

◎ Are you a gourmet cook?
◎ Do you bake the best brownies?
◎ Are you a sports trivia expert?
◎ Are you a master gardener?
◎ Do you design jewelry?
◎ Are you a trivia buff?
◎ Do you know more about art history than almost anyone else you know?
◎ Can you speak more than one language fluently?
◎ Do you love to shop?
◎ Do you know how to coordinate just the right outfit?
◎ Do you know how to write great songs?
◎ Can you put together events with ease?
◎ Do you know how to write great press releases?

◎ Do you know how to pack a suitcase better than most people?

◎ Are you an expert organizer?

◎ Do you know how to arrange flowers?

◎ Are you an expert in building things?

◎ Are you an expert wood carver?

◎ Do you know everything there is to know about trees?

◎ Are you a marathon runner?

◎ Were you a golden gloves champ?

◎ Are you a great fund-raiser?

◎ Have you set a world record doing something?

◎ Do you volunteer teaching people to read?

◎ Do you know about helping children with special needs?

◎ Do you volunteer reading books for the blind?

◎ Do you have special skills or talents that others don't?

Are you getting the idea? You can be an expert in almost any area. It's the way in which you exploit your expertise that can make a difference in your career.

You want to get your name out there. You want to draw positive attention to yourself. You want others to know what you can do. That way, you can market yourself in the areas in which you are interested.

How do you get your name and story out there? Developing and sending out press releases is one way, but what else can you do?

You can become known for your expertise by talking about it. How? Most areas have civic or other not-for-profit groups that hold meetings. These groups often look for people to speak at their meetings. You can contact the president of the board or the executive director to find out who sets up the speakers for meetings. In some

areas, the chamber of commerce also puts together speaker lists.

You might be asking yourself, "Unless I'm a rocket scientist, why would any group want to hear me speak about anything? Why would anyone want to know about me knowing how to pack a suitcase?" "Why would anyone be interested in my organizing ability?" "Why would anyone want to hear me talk about keeping their home safe?" "I'm not famous."

Here's the answer: They might not, *unless* you tailor your presentations to their needs. If you create a presentation from which others can learn something useful or interesting, they usually will. For example, if you're speaking to a group of businesspeople, you might do a presentation about "The Stress-Free Bag: Packing Easily for Business Trips," "Organize Your Career, Organize Your Life," "Helping Children Feel Good About Themselves Through Art," "Using Cooking to Build Teamwork," "Crafting a Stress-Free Life," or "Keeping Your Home Safe."

Whatever your subject matter is, when you speak in front of a group, whether it be 20 or 2,000 people, you will gain visibility. When you are introduced, the host of the event will often mention information about your background to the audience. Make sure you always have a short paragraph or two with you to make it easy for the emcee to present the information *you* want to convey.

For example, based on information you provide, the emcee might introduce you like this: "Good evening ladies and gentlemen. Our dinner speaker tonight is Ryan Holmes. Some of you might know him from his weekly column, *Art Happenings,* in the *Town Times*. Some of you might have been trained by him to be a docent in the Circle Valley Art Museum or lucky enough to be on a museum tour with him. This evening he will be

speaking about planning great vacations around visits to art museums throughout the country. Please join me in welcoming Ryan Holmes."

As you can see, Ryan is getting exposure that can help him gain career visibility. Ryan may make contacts and increase his network. The important thing to remember is to use every opportunity as an opportunity to get what you are looking for in your career.

On a local level, you will generally get no fee for most of these types of presentations. The benefit of increased visibility, however, will usually be well worth it. When you are scheduled to do a presentation, make sure you send out press releases announcing your speech. If it was a noteworthy event, you might also send out a release after the event as well. Many organizations will also call the media to promote the occasion. Sometimes the media will call you for an interview before the event. Once again, take advantage of every opportunity.

It's exciting once you start getting publicity. Take advantage of this too. Keep clippings of all the stories from the print media. Make copies. If you have been interviewed on television or radio, get clips. Keep these for your portfolio. Every bit of positive exposure will help set you apart from others and help you market yourself to career success.

I can almost hear some of you saying, "Oh, no! I'm not getting up to speak in public."

Tip from the Coach

If you aren't comfortable speaking in front of large groups, consider joining Toastmasters or the Dale Carnegie Institute. Both will help you gain experience in a nurturing and comfortable environment.

Words from a Pro

The media works on very tight deadlines. If they call you, get back to them immediately or you might lose out.

Here's the deal. If you don't feel comfortable speaking in public, you don't have to. These ideas are meant to be a springboard to get you thinking outside of the box. Use any of them to get you started and then find ways you *are* comfortable in marketing yourself.

More Strategies to Market and Promote Yourself

If you aren't comfortable speaking in public, how about writing an article on your area of expertise instead?

What about writing a column for your weekly newspaper? How about writing an article for a trade journal? The idea once again is to keep your name in the public's eye in a positive manner. While it's helpful to write about something in your career area, it is not essential.

For example, you might write an article on what life is like traveling around doing craft shows. You might write an article on the interesting people you meet as a docent in the art museum in which you work. (Of course, you need to check with your employer first to make sure you are able to write about these things.) You might write an article on collecting coins or cookbooks. You might write articles on organizing your office, your schedule, or your life. You might write an article on stress management or laughter or humor. If you can tailor the articles in some manner to your career area, all the better. If not, that's okay as well.

If you look at similar types of articles or stories in newspapers, you will notice that if the article is not written by a staff reporter, after the article there generally is a line or two about the author. For example, "Amanda Johnston is the marketing director for the Two Circles Art Gallery." Or, "John Anderson is a graphic artist at BMG Graphics."

How do you get your articles in print? Call the editor of the publication you are interested in writing for and ask! Tell him or her what you want to do and offer to send your background sheet, resume, or bio, and a sample. Small or local publications might not pay very much. Don't get caught up on money. You are not doing this for cash. You are doing it to get your name and your story before the public.

Don't forget to tell media editors about your expertise. You can call them or send a short note. Ask that they put you on their list of experts for your specific area of expertise. When they are doing a story on something that relates to your subject area, it will be easy to get in touch with you.

Remember that if you don't make the call or write the note, no one will know what you have to offer. You have to sometimes be assertive (in a nice way) to get things moving.

Consider teaching a class, giving a workshop, or facilitating a seminar in your area of expertise. Everyone wants to learn how to do something new, and you might be just the person to give them that chance. Every opportunity for you is an opportunity to become visible and move your career forward. Can you give someone the basics of writing a press release or doing publicity? Offer to teach a class at a local college or school. Can you easily explain how to understand what you see when watching a football game on television? Offer to teach a workshop.

> ⭐ **The Inside Scoop**
> Don't get caught up in the theory that if you help someone do something or learn how to do something, it will in some way take away opportunities from you. Help others when you can.

Do you think you can illustrate the basics of putting together a fund-raiser? Suggest a workshop! What a great way to get your name out!

There are a plethora of possibilities. You just need to use your imagination.

What can your expertise do for you? It will get your name out there. It will give you credibility and it will give you visibility. Of course, when you're at meetings or speaking to the media, it's up to you to network. Tell people what you do. Tell people what you want to do. Give out business or networking cards. This technique works effectively no matter what area of the art industry in which you want to succeed. As a matter of fact, this technique can help you succeed in any venture.

Join professional associations and volunteer to be on committees or to chair events that they sponsor. Similarly, join civic groups and not-for-profit organizations volunteering to work on one or two of their projects.

"I don't have time," you say.

Make time. Volunteering, especially when you chair a committee or work on a project, is one of the best ways to get your name out there, obtain visibility, and network. In many cases, your volunteer activities can help you jump to the next rung on the career ladder quicker than your counterparts who do not volunteer.

The radio and television talk show circuit is yet another means to generate important vis-

ibility. Offer to be a guest on radio, cable, and television station news, variety, and information shows.

"Who would want me?" you ask.

You can never tell. If you don't ask, no one will even know you exist in many instances. Check out the programming to see where you might fit. Then send your bio, resume, or CV with a letter to the producer indicating that you're available to speak in a specific subject area. Pitch an idea. A producer just might take you up on it.

Here's a sample pitch letters to get you started.

ALISON HARDING
P.O. Box 922
Some Town, NY 12222

Neil Gibson-Producer
WNOW Radio
Talk Tonight Show
P.O. Box 3333
Anytown, NY 44444

Dear Mr. Gibson:

As far back as I can remember, I have wanted to be a fashion designer. Only six short years ago, I graduated from college with a degree in fashion design. I landed a job working for LMAR Fashions as a junior designer. I loved the job. Unfortunately (or fortunately) LMAR Fashions was bought out by Premier Fashions. As they had their own designers, I was laid off.

Needing money, I started creating my own line of women's tops and jackets with unique appliqués and selling them at craft shows. They were very well received, but I dreamed of a bigger market.

Three months into my new venture, I heard about a competition for new designing entrepreneurs. The grand prize included a meeting with one of the buyers from the TV Best Shopping Channel and the chance to have a seven-minute slot to sell your product.

I know that it was a dream many had. I got lucky. I not only won, but my shirts sold out in five minutes. My dream is now coming true. I have my own clothing design company with a regular slot on TV Best Shopping Channel. My line has also been picked up by many of the major department stores in the country.

It is my mission to help other people see that they can achieve their dreams as well. I would love to share some of my stories with your listeners. I regularly listen to your program and believe that the subject matter fits well into your show's format.

I have included my background sheet for your review. Please let me know if you require additional information.

I look forward to hearing from you.

Sincerely,
Alison Harding

Wait a week or so after sending the letter. If you don't hear back, call the producer and ask if he or she is interested. If there is no interest, simply thank the producer for his or her consideration and request that your background sheet can be kept on file.

Remember that people talk to each other: Every person you speak in front of, who reads an article about you, who hears you on the radio, or sees you on television has the potential of speaking to other people who might then speak to others.

As we've discussed, networking is one of the best ways to get a job, get a promotion, and advance your career. Even if your expertise is in something totally unrelated to the art industry, just getting your name out can help boost your career.

If your expertise happens to be something related to the art industry, that's even better. Whatever your expertise, exploit it and it will help your career move forward.

More Ways to Market Yourself

Here's another idea that can get you noticed: a feature story in a newspaper or magazines. How do you get one of these? Everyone wants a story about themselves or their product or service, so you have to develop an angle to catch people's attention. Then contact a few editors and see if you can get one of them to bite.

Before you call anyone, however, fully think out your strategy. What is your angle? Why are *you* the person someone should talk to or do a story on? Why would the story be interesting, unique, or entertaining to the reader?

How do you develop an angle? Come up with something unique that you do or are planning to do. What is the unique part of your package? Were you the one that was so afraid to speak in high school that you skipped the class where you had to give a report, yet today you are the spokesperson for an art museum? Were you the one who succeeding despite severe adversities? Do you have a human interest story?

Send a letter with your idea and a background sheet, bio, CV, or resume. Wait a week and then call the editor you sent your information to. Ask if he or she received your information. (There is always a chance it is lost, if only on the editor or reporter's desk.) If the answer is no, offer to send it again and start the process one more time. Sometimes you get lucky. Your angle might be just what an editor was looking for or they might need to fill in a space with a story.

Opening Up the Door to New Opportunities

If you keep on doing the same old thing, things might change on their own, but they probably won't. It's important when trying to create a more successful career to find ways to open up the door to new opportunities.

Start to look at events that occur as new opportunities to make other things happen. If you train yourself to think of how you can use opportunities to help you instead of hinder you, things often start looking up.

Do you want to be around negative people who think nothing is going right? Do you want to be around people who think they are losers? Probably not. Well, neither does anyone else. Market yourself as a winner, even if you are still a winner in training.

The old adage "misery loves company" is true. One problem people often have in their career and life is that they hang around other people who are depressed or think that they're not doing well. Remember that negative energy attracts negative results, so here's your choice.

Tip from the Coach

Do not be negative in the workplace. It harm your career. I've seen countless cases of people in every industry who were negative in their day-to-day work life who consistently lost out on promotions and job opportunities.

Words from the Wise

Many people go to networking events and social occasions where they meet people and make important contacts. They then proceed to "forget" who they met.

It's essential to keep track of business cards, names, people you meet, and where you met them. To do this, after any event where you make contacts, make it a habit to write notes about who you met, where you met them, and any other pertinent details. Do it quickly. While you think you can't possibly forget meeting someone important to your career, you would be surprised how easy it is to forget details.

You can either stay with the negative energy, help change the negative energy, or move yourself near positive energy. Which choice do you want to make?

Work on developing *new* relationships with positive, successful people. Cultivate new business relationships. When doing that, don't forget cultivating a business relationship with the media. How? Go to events where the media is present. Go to chamber of commerce meetings, not-for-profit organization events, charity functions, entertainment events, sports events, meetings, and other occasions.

Walk up, extend your hand, and introduce yourself. Give out your business cards. Engage in conversation. If a reporter writes an interesting story about anything, drop him or her a note saying you enjoyed it. If a newscaster does something special, drop a note telling him or her. People in the media are just like the rest of us. They appreciate validation. Most people don't give it to them. If you do, you will be the one they remember.

Don't just be a user. One of the best ways to develop a relationship with the media or anybody else is to be a resource. Help them when you can.

Want to close the door to opportunity? Whine, complain, and be a generally negative person who no one wants to be near. Want the doors to opportunity to fly open? Whatever level you are in, more doors will open if you're pleasant, enthusiastic, and professional.

Dreams can come true. They can either happen to you or happen to someone else. If you want it badly enough and market yourself effectively, you will be the winner.

It's essential in marketing yourself and your career to move out of your comfort zone even if it's just a little bit. Take baby steps if you need to, but learn to move out of your comfort zone. Find new places to go, new people to meet, and new things to do.

You can be the number one factor in creating your own success. Don't let yourself down! Market yourself and reap the rewards of the great career you've been wishing for in the art industry.

10

SUCCEEDING IN THE WORKPLACE

Learning As You Go

Congratulations! You got the job. Now what? Are you ready to succeed or are you going to just leave things to chance and hope your career goes in the direction you want?

No matter what segment of the art industry you are pursuing, there are things you can do that can help you increase your chances of success—things you can do that can turn your job into the career of your dreams.

"Can't I worry about that later?" you ask. "I just got the job."

Lots of people have jobs. You don't just want a job. You want a great career! It doesn't matter which segment of the art industry you are pursuing. In order to succeed and move up the career ladder, you sometimes have to do a little extra, do more than is expected of you, and put some effort into getting what you want.

No matter how it looks, there are very few overnight successes. Appearances can be very deceiving. While it may seem that some individuals just appear to get their foot in the door one day and zoom to the top rung of the career ladder the next, it generally doesn't happen like that.

Although there are exceptions, more than likely, the people you *think* are overnight suc-

cesses have been working at it and preparing for their dream career for some time. Many of them were probably in the same position you are in now.

What looks like someone who just became an overnight success is generally an individual who had a well-thought-out plan, did a lot of work, had some talent and a bit of luck, and was in the right place at the right time.

Unfortunately, just getting your foot in the door is not enough. It's essential once you get in to take positive actions to climb the ladder to success. If you don't take those actions, someone else will.

Once you get your foot in the door, you want to create your perfect career. Getting a job is a job in itself. However, just because you've been hired doesn't mean your work is done. It's essential once you get in to learn as you go.

If you look at some of the most successful people, in all aspects of life and business, you'll see that they continue the learning process throughout their life. If you want to succeed, you'll do the same.

Learning is a necessary skill for personal and career growth and advancement. Many think that your ability and willingness to learn is linked to your success in life. This doesn't

necessarily mean going back to school or taking traditional classes, although in some situations you may want to. In many cases, it means life learning.

What's life learning? Basically, it's learning that occurs through life experiences. It's learning that occurs when you talk to people, watch others do things, work, experience things, go places, watch television, listen to the radio, hear others talking, or almost anything else. Every experience you have is a potential learning experience.

Not only that, but almost everyone you talk to can be a teacher. If you're open to it, you can usually learn something from almost everyone you come in contact with.

"What do you mean?" you ask.

Look for opportunities. Be interested. Everything you learn might not be fascinating, but it might be helpful—maybe not today or tomorrow, but in the future. Sometimes you might learn something work related, sometimes not. It doesn't matter. Use what you can. File the rest away until needed.

How do you learn all these things? Observe what people say or do. Sometimes you might see that someone has a skill you want to master. You might, for example, see an interesting method a fund-raiser uses to solicit funds, a different way to use a computer graphics program, a unique way to develops resources in the community, or an interesting technique an artist uses in painting.

Tip from the Coach

Career progression does not always follow traditional paths. Treat supervisors, colleagues, and subordinates all with the same respect.

Don't be afraid to ask others how to do something. Whether it's simple or complicated, most people are flattered when someone recognizes they're good at something and asks for their help.

Challenge yourself to learn something new every day. Not only will it help improve your total package, but it will make you feel better about yourself. Whether it's a new word, new skill, new way to do something, or even a new way to think about things, continue to learn as you go.

How else can you continue to learn? Take advantage of internships, formal and informal education, company training programs, in-service programs, and volunteer opportunities.

Volunteer opportunities can also be helpful. What can you learn? The possibilities are endless. You might learn a new skill or a better way to get along with others. You might learn how to coordinate events, how to run organizations, or pick up some leadership skills. You might learn almost anything. As a bonus, if you volunteer effectively, you not only will get some experience, but you might obtain some important visibility,

Words from the Wise

While success does sometimes just fly in the window, it always helps to at least open the window up.

Tip from the Coach

Don't assume that because someone is under you on the career ladder they know less than you.

get your name known in the community, and make important contacts.

Don't discount books as a learning tool. As the saying goes, reading is fundamental. Are you a museum grant writer who wants to be a museum public relations director? Are you a gallery administrative assistant who aspires to be a gallery manager? Are you a graphic artist who wants to be an art director? What about an exhibit coordinator who hopes to be a curator? Do you want to move up the career ladder in any manner? Look for a book. Read more about it.

Are you employed at a small art museum, but dream of working in a large, prestigious facility? Check out some of the possibilities you want to pursue in a book. Are you interested in learning more about interior design? What about fashion design? Find a book. Need help improving your leadership skills? Check out some books for ideas? Want to know more about the lives of artists? Look for a book! Want to know more about any aspect of the art industry? There are tons of books on all aspects of art in the business, administration, and talent areas. The more you read, the more you'll know. Books often hold the answer to many of your questions. They give you the opportunity to explore opportunities and learn about things you didn't know.

Trade journals offer numerous possibilities as well. They help keep you up to date on industry trends and let you know about industry problems and solutions. What else can you find in the trades? You might discover advertisements for job openings or notices for trade events, seminars, and current news.

How do you find trade journals? You might check with your local library. If your library doesn't have the periodical you are looking for, try your local community college or university library. If you happen to live in an area with a college offering a degree in the area of the art industry in which you are interested, the bookstore may offer some periodicals. You can also always surf the net to check out journals specific to area of the art industry in which you are interested.

If you are already working in some aspect of the industry, these trades may also be available in your workplace. If you're not currently working in the industry, you still might be able to contact a museum, art gallery, or advertising agency to see if anyone there will let you browse through some of their trade journals.

National bookstore chains such as Borders or Barnes and Noble may also often carry some of the more popular trade publications. Be sure to check out the online versions of trade publications. While many require subscriptions to access some areas of the site, they often carry the latest news and job openings in the free section.

How about workshops, seminars, and other courses? In addition to learning new skills in or out of the area you are pursuing in the art industry, there are a number of added benefits to going to these. First, you'll have the opportunity to meet other people interested in the same subject area as you are. You also will be able to network. Instructors, facilitators, and even other students in the class are all potential contacts who might be instrumental in your career.

"But," you say, "I'm busy enough without doing extra work. Is this really necessary? Do I have to take classes?"

No one is going to make you do anything, but you should be aware that they can help take your career to a new level. Classes, workshops, and seminars will help give you new ideas and help you to look at things from a different per-

⭐ Tip from the Top

Seminars in the area of the industry in which you are working are so important that even if your agency, company, organization, or department won't pay for them, you should find a way to attend.

spective. And if you are already working in the industry, they will often give you the edge over others.

If you see an industry-related seminar in which you are interested, ask your supervisor if the organization will pay for you to attend. If you are told that they can't afford it or it's not the policy of the company to pay for seminars, don't just decide not to go. Ask, instead, if you can be given the time off to attend on your own.

Whether you are taking workshops, seminars or classes, learning new techniques or honing skills the results will help you in your quest to be the best at what you do. If you continue to navigate your way through formal and informal learning experiences throughout your life and career, you will be rewarded with success and satisfaction.

Workplace Politics

In order to succeed in your career in the art industry, it is essential to learn how to deal effectively with some of the challenging situations you'll encounter. Workplace politics are a part of life. And depending what area of the art industry you are pursuing, the *workplace* can be almost anyplace.

The real trick to dealing with workplace politics is trying to stay out of them. No matter which side you take in a workplace dispute, you are going to be wrong. You can never tell who the *winner* or *loser* will be, so try to stay neutral and just worry about doing your job. Is this easy? No. But for your own sake, you have to try.

Will keeping out of it work all the time? Probably not, and therein lies the problem. There's an old adage that says the workplace is a jungle. Unfortunately that's sometimes true.

If you think you're going to encounter politics only in the office, think again. As we just mentioned, the *workplace* can be almost anyplace. It can be in a museum, gallery, art show, craft show, or a client's place of business. It can even be in the community in which you work.

What all this means is that no matter what part of the art industry you are working, you often may have additional challenges. In many cases, workplace politics will now be expanded to every area of your life from your personal relationships to your family to work. With this in mind, let's learn more about them.

Why are there are politics in the workplace? Much of it comes from jealousy. Someone might think you have a better chance at a promotion

⭐ Tip from the Coach

In some situations having additional education or training may help you get a better job, a new promotion, or even higher compensation. It will also open up more opportunities.

⭐ Words from the Wise

Workplace politics cause people to take sides. It doesn't only put stress on you; it often puts stress on your supervisor. This can negatively affect *your* career. Do everything possible to stay out of them.

that they think they deserve. Someone might think that you are better at your job than they are at theirs, or they might think that they are better but you are getting the accolades. Someone might think you slighted them. Believe it not, someone just might not like you.

In any business setting there are people who vie for more recognition, feel the need to prove themselves right all the time, or just want to get ahead. There really is nothing you can do about workplace politics except to stay clear of them to the best of your ability.

In certain segments the art industry, feelings of jealousy sometimes escalate. There are many reasons for this. Someone may feel they are more talented than you in their area of the industry. They may, for example, feel that they are a better artist, craftsperson, designer, administrator, curator, and so on.

Often jealousy surfaces when someone doesn't understand why *you* got the job or the promotion and he or she did not. Some may not understand why you are a department head and they can't get a promotion. Some may not understand why you were snagged for a plumb assignment and they weren't even asked.

★ Words from the Wise

We've all heard of someone whom others others refer to by saying, "You know, he (or she) is such a nice man (or woman). He (or she) never says a bad word about anyone." These people stay out of office politics. They stay out of office squabbles, and they stay out of trouble in the workplace. If you can keep this in mind and try to follow their lead, you will be ahead of the game. It may not be easy, but before you decide to speak about someone, remember that office politics and gossip can be problematic.

Sometimes people may want to protect themselves from feeling like a failure or may just be frustrated with their career (or lack thereof).

In these situations, many lash out and talk about others. Real or not, these words can hurt. Worse than that, your words can come back to haunt you—big time.

Office Gossip

Gossip is a common form of office politics. Anyone who has held a job has probably seen it, and perhaps even participated in it in some form. Have you? Forget the moral or ethical issues. Gossip can hurt your career.

Here's a good rule of thumb. Never, ever say anything about anyone that you wouldn't mind them hearing and knowing it came from you. If you think you can believe someone who says, "Oh, you can tell me, it's confidential," you're wrong.

"But she's my best friend," you say. "I trust her with my life."

It doesn't matter. Your friend might be perfectly trustworthy, but trust is not always the problem. Sometimes people slip and repeat things during a conversation. Other times a person might tell someone else whom they trust what you said and ask him or her to keep it confidential, but then that person tells another person, and so it goes down the line. Eventually, the person telling the story doesn't even know it's supposed to be confidential and might even mention it to a good friend or colleague of the person everyone has been gossiping about.

The reason people gossip is because it makes them feel like part of a group. It can make you feel like you're smarter or know something other people don't. Most of the time, however, you don't even know if what you're gossiping about is true, yet once a gossip session gets started, it's difficult to stop.

Most people are good at heart. After gossiping about someone else, they often feel bad. It might just be a twinge of conscience, but it's there. Is it worth it? No. Worse than that, it's safe to assume that if you are gossiping about others, they are gossiping about you.

How do you rise above this? Keep your distance. People generally respect that you don't want to be involved. Don't start any gossip, and if someone starts gossiping around you, just don't get involved.

How do you handle the conversation?

Suppose someone says to you, "Did you hear that the boss got so drunk that he fell over at a fund-raising dinner in the city last week?"

You respond, "No, didn't hear about that. Did you see the game last night?"

Of course, some people might not let it go and might want to keep the conversation going. The person might respond, "No, I didn't catch it. And I hear he wasn't even with his wife. He was with his girlfriend. No wonder she got a promotion."

All you have to do is either change the subject again or say, "I made a decision a long time ago not to get involved in gossip. It can only get me in trouble."

Every now and then, you hear through the grapevine that people are gossiping about you. It might be related to your job or your personal life. It's not a good feeling, but you might have to deal with it. What do you do? You have a few options.

◎ You can ignore it.
◎ You can confront the person or people who are gossiping about you.
◎ You can start gossiping about the person or people gossiping about you.

What's your best choice? Well, it's definitely not gossiping about the person who is gossiping about you. Ignoring the gossip might be your best choice except that suppressing your feelings of betrayal and anger can be stressful. How about confronting the person or people who are gossiping about you? If you're certain about who has been spreading the gossip and you can do this calmly and professionally, it often resolves the situation.

Whatever you do, don't have a public confrontation and don't ever confront a group. Instead, wait until the person is alone. Calmly approach him or her and say something like this:

"John, I didn't want to bring this up in front of anyone else because I didn't want to embarrass you, but I've heard that you've been talking to others here in the department about my performance and discussing my personal life. I've always had respect for you, so I really questioned the people who told me it was happening. I'd just like to know if it's true."

At this point, John probably will be embarrassed and claim that he doesn't know what you're talking about. He might ask you who mentioned it.

"Who told you that?" he might ask. "I want to straighten them out."

Do not give out any names. It's better to let him start questioning the trust of all the people he's been talking to and gossiping with.

While he might tell a couple of people you confronted him on the gossip subject, John will

⭐ **Tip from the Top**
Use coffee breaks and meetings at the water cooler or break room to your advantage. Instead of gossiping, try using the situations as opportunities. A few pleasant words or a smile can often win over even those with conflicting opinions.

⭐ Words from a Pro

Do you like to be around negative people? Probably not. Well, neither does anyone else. We all have bad days when we complain and whine that nothing is going right. The problem comes when it occurs constantly. If you want to succeed in your career, try to limit the negativity, at least around your colleagues. While they say misery loves company, in reality after a while people won't want to be around you. Eventually, they'll start to avoid you.

On the other hand, most people like to be around positive people who make them smile and laugh. If you can do this, you'll have an edge over others.

⭐ Tip from the Top

It is never a good idea to speak badly about your employer, your supervisors, or your colleagues no matter what. When you do, people on the outside start doubting your loyalties.

It's essential to your success and your career not to spread rumors in the workplace or out. Don't talk about the inside information you have whether it's good or bad. If anyone pumps you for information, learn to simply say, "Sorry, that's confidential."

Money, Money, Money

How upset would you be if you found out that a co-worker who had a job similar to yours was making more money than you? If you're like most other people, I'm assuming you probably would be pretty upset. Whether it's what you're making, your co-worker is making, or someone else is making, money is often a problem in the workplace. Why? Because as a rule, everyone wants to earn more. Generally, no matter how much money people are paid for a job, they don't think they're getting enough. If they hear someone is getting paid better than them, it understandably upsets them.

probably find someone else to gossip about in the future—or at least do so with more discretion.

In some situations, gossip may often lead to bigger problems. Depending on your work environment, you might be privy to information about others in either your work environment or the community.

Here's the deal. Gossiping about what happens in the workplace, what you hear, or what you know (even if it is true) can seriously affect your career in a negative manner especially if it leads to the embarrassment of powerful people or breeches confidentiality in your organization.

Here's the deal. If you know you're making more than someone else, keep it to yourself. If you're making less than someone else, keep it to yourself. No matter what your earnings are, keep it to yourself. Don't discuss your earnings with co-workers. The only people in the workplace you should discuss your earnings with are the human resources department and your supervisors.

Here's the deal on earnings. If you've just landed a big promotion, a new job, or you got a raise, it's okay to be happy; it's even okay to

⭐ Tip from the Coach

Remember the philosophy that on the ladder to success, *real* successful people are the ones who pull others up the ladder with them. The ones who try to push others down the ladder will never be real successes themselves.

be ecstatic, but it probably isn't a good idea to walk around the workplace gloating, especially around colleagues who may not have the great salary you do.

Why would one person be earning more than another in a similar position? There might be a number of reasons. In some situations, compensation for many positions is negotiated, and the person might be a better negotiator. He or she might have more experience, more education, seniority, different skills, or more responsibilities. An employer may also classify two similar employees in different positions, which would affect salaries.

Some individuals may be working overtime. In some situations, employers may also badly need someone with certain skills or attributes. There are any number of scenarios.

"But it's frustrating," you say.

I understand, but being frustrated won't help. Worry about your own job. Don't waste time comparing yourself to your co-workers, colleagues, or others in position you consider similar. Definitely, don't whine about it in your workplace. It will get on people's nerves.

What can you do? Make sure you are visible in a positive way. Make sure you're doing a great job. If you're already doing a great job, try to do a better job. Keep notes on projects you've successfully completed; ideas you've suggested

that are being used; and things you are doing to make things better in the department, agency, organization, or company. Then, when it's time for a job review and possible promotion, you'll have the ammunition to ask for the compensation you deserve.

Dealing with Colleagues

Whatever area of the art industry you choose, you're going to be dealing with others at work. Whether they are superiors, subordinates, or colleagues, the way you deal with people you work with will impact your opportunities, your chances of success, and your future.

Many people treat colleagues and superiors well, yet treat subordinates with less respect. One of the interesting things about the art industry is that, like other industries, career progression doesn't always follow a normal pattern. What that means is that with the right set of circumstances, someone might potentially jump a number of rungs up the career ladder quicker than expected. The end result could be someone who is a subordinate might technically become either a colleague or even a superior. It's essential to treat everyone with whom you come in contact with dignity and respect.

Want to know a secret about dealing effectively with people? If you can sincerely make every person you come in contact with feel special, you will have it made. How do you do this? There are a number of ways.

When someone does or says something interesting or comes up with a good idea, mention it to them. For example, "That was a great idea you had at the meeting, Eric. You always come up with interesting ways to solve problems."

Sometimes you might want to send a short note instead. For example:

★ Tip from the Coach

It's very easy to start comparing your earnings with those of others who are making more and start feeling sorry for yourself. Try not to compare yourself, your job, or your earnings to anyone else. Instead of concentrating on what "they're making," try to concentrate on how you can get "there."

Jean,

While I'm sure you're ecstatic that the press conference for the new museum exhibit is over, I hope you know how impressed everyone was with the event. You handled the coordination like a seasoned pro. No one would ever have guessed that this was the first time you ever put a press conference together.

Everything was perfect. But the real coup was getting the story about the new exhibit on *Good Morning America*, *The Today Show*, *The Morning Show,* and *20/20*. You did a great job. I'm glad we're on the same team.

Daniel

If another employee does something noteworthy, write a note. If a colleague receives an award or an honor, write a note. It doesn't make you any less talented or less skilled or even less valuable to the organization. Your words, however, can not only make someone else's day but help you build a good relationship with a colleague.

Everyone likes a cheerleader. At home, you hopefully have your family. In your personal life, you have friends. If you can be a cheerleader to others in the workplace, it often helps you to excel yourself.

Never be phony and always be sincere. Look for little things that people do or say as well. "That was a great idea for the design of the advertisement, John. I'm sure it will create a lot of positive buzz." "Nice suit, Amy. You always look so put together." "That was a great presentation you did on art history, Jim. The audience loved it."

Notice that while you're complimenting others, you're not supposed to be self-deprecating. You don't want to make yourself look bad; you want others to look good. So, for example, you wouldn't say, "Nice suit Amy. You always look so put together. I couldn't coordinate a suit, a

Tip from the Coach

In an attempt to build themselves up, many try to tear others down. Unfortunately, it usually has the opposite effect.

blouse, and shoes if I tried." "Great job on the press conference. I never could have coordinated an event like that. It would have been a disaster."

The idea is to build people up so they feel good about themselves. When you can do that, people like to be around you, they gain self-confidence, and they pass it on to others. Best of all, you will start to look like a leader. This is a very important image to be building when you're attempting to move up the career ladder.

Dealing with Your Superiors

While you are ultimately in charge of your career, superiors are often the people who can help either move it along or hold it back. Try to develop a good working relationship with your superiors. A good supervisor can help you succeed in your present job as well as in your future career.

One of the mistakes many people make in the workplace is looking at their bosses as the enemy. They get a mind-set of *us* against *them.* Worse than that, they sit around and boss bash with other colleagues.

Want to better your chances of success at your job? Make your boss look good. How do you do that?

◎ Don't boss bash.
◎ Speak positively about your boss to others.
◎ Do your work.

◎ Cooperate in the workplace.

◎ If you see something that needs to be done, offer to do it.

◎ Volunteer to help with projects that aren't done.

◎ Come through in a crisis.

◎ Ask your supervisor if he or she needs help.

"But what if my boss is a jerk?" you ask.

It's still in your best interest to make him or her look good. Believe it or not, it will make you look good.

While we're on the subject, let's discuss jerky bosses. With any luck, your boss will be a great person who loves his or her job. But every now and then, you just might run into a bad boss.

He or she might be a jerk, a fool, an idiot. But that really doesn't matter.

"I could do a better job than him (or her)," you say.

Well you might be able to, but not if you can't learn to deal with people so you still have a job. In many cases, your supervisor has already proven him- or herself to the organization and is therefore more of a commodity than you are at this point. So just how do you deal with a bad boss and come out on top?

Let's first go over a list of don'ts.

◎ Don't be confrontational. This will usually only infuriate your boss.

◎ Don't shout or curse. Even if you're right, you will look wrong.

◎ Don't talk about your boss to co-workers. You can never tell who is whose best friend or who is telling your boss exactly what you're saying.

◎ Don't send e-mails to people from your office about things your boss does or says.

◎ Don't talk about your boss to colleagues, clients, board members, or people in the community. It's not good business and it's not really ethical.

◎ Don't—and I repeat don't—cry in your workplace. No matter how mad your boss or supervisor makes you, no matter what mistake you made, no matter what nasty or obnoxious thing someone says about you, keep your composure until you're alone. If you have to, bite your lip, pinch yourself, or do whatever you have to do to keep the tears under control.

◎ Think twice before you go over your boss's head to complain about a situation where you think you have been wronged. Is the problem you are having one which you can work out? Will you win the battle, but lose the war? Take some time, look at all angles, and think about repercussions before you make a move.

Now let's go over a list of do's that might help.

◎ Do a good job. It's hard to argue with someone who has done what they are supposed to do.

◎ Complete all reports thoroughly, completely, and in a timely manner.

◎ Be at work when you are scheduled to be there and always be on time.

◎ Attend all scheduled meetings.

◎ Keep a paper trail. Keep notes when your supervisor asks you to do things and when you've done them. Keep notes regarding calls that have been made, dates, times, and so on. Keep a running list of assignments you've completed successfully. Do this as a matter of

course. Keep it to yourself. When you need something to jog your memory, you can refer to it.

◎ Volunteer to help a colleague when you see he or she needs help—especially if your department is working on an important project or is in a time crunch. It shows you are a team player.

◎ Wait until there is no time constraint to finish something and there is no emergency, and ask your supervisor if you can speak to him or her. Then say you'd like to clear the air. Ask what suggestions he or she can give you to do a better job.

 ▫ You might say, for example, "Mr. Briggs, we're on the same team, and if there is something I can be doing to do a better job, just let me know. I'll be glad to try to implement it.

◎ Think long and hard before you decide to leave. If your supervisor is as much of a jerk as you think, perhaps he or she will find a new job or be promoted.

No matter what type of boss or supervisor you have, learning to communicate with him or

Tip from the Top

Check out your workplace's policy on private e-mail. Be aware that in many situations private e-mails are not allowed.

her is essential. Some supervisors communicate primarily on a face-to-face basis. Others communicate primarily via the phone. Everyone has a different communicating style, and it's up to you to determine what his or her style is.

Does your supervisor like to communicate through e-mail? Some organizations today communicate almost totally through e-mail. Everything from the daily "Good morning" until "See you tomorrow" and everything in between will be in your inbox. If this is the way it is at your office, get used to it. E-mail will be your communication style. The good thing about e-mail is you pretty much have a record of everything.

Some bosses communicate mainly on paper. He or she may give you direction, tell you what's happening, or ask for things via typed or handwritten notes. Sometimes communications may be in formal memos; other times informal or even on sticky notes.

Words from the Wise

Do not put anything in e-mail that you wouldn't mind someone else reading. No matter what anyone tells you, e-mail is not confidential. (Even if you delete it, your e-mails may still be on your company's server.) Furthermore, be aware that in many situations your e-mails, private or business, may be classified as company property. What this means is that management may have the right to access your e-mail.

Tip from the Top

If you carry a personal cell phone, set it to the vibrate mode while working. Getting constant calls from friends when you are working—even on your cell phone—is inappropriate. While we're on the subject, it is not appropriate to take calls on your personal cell phone while you are performing any work-related tasks.

> ### ⭐ Tip from the Top
> Actively look for ways to assist others in your job, even if you do it on your off time. Why would you do this? Aside from being part of a team, doing a little extra keeps you visible in a positive manner. Why is this important? When a new assignment, opening, or promotion comes up, you will have a good chance of someone thinking of you.

Learn to communicate with your supervisor effectively and you will increase your chances of success in the workplace.

It's important to realize that you have a choice in your career. You can sit there and hope things happen or you can make them happen. You can either be passive or proactive. In order to succeed in your career, being proactive is usually a better choice.

You can go to work every day and let your supervisor tell you what to do, or you can do that little bit extra, share your dreams and aspirations, and work toward your goals. No matter what segment of the industry you are pursuing, supervisors can help you make it happen.

Ethics, Morals, Integrity, and More

We all have our own set of ethics and morals. They help guide us on what we think is right and wrong. Ethics, morals, and integrity are essential to success in your career. Let's take a few moments to discuss these a bit.

We have already covered the importance of honesty. Lying is never a good idea—especially if you are looking forward to a successful career. If you tell the truth, you never have to remember what story you told.

In your career you may be faced with situations where a person or group of people wants you to do something you know or feel is wrong. In return for doing it, you may be promised financial gain or career advancement.

Would you do it? "Well," you might say. "That depends on what I'd have to do and what I'd get." Here's the deal. No matter what anyone wants you to do, if you know it's wrong—even if you only think it *might* be wrong—it probably is a bad idea.

"But they told me no one would know," you say. Most people are not that good at keeping secrets, and if *they* get caught, you're going down too. If you're just getting started in your career, you might be looking at ending it for a few dollars. If you're already into your career, are you really prepared to lose everything you worked that hard to get?

"But they told me if I did this or did that, they'd remember me when promotions came up," you say. How do you know someone isn't testing you to see what your morals are? And exactly what are you planning on doing after you do whatever the person asked you to do and he or she doesn't give you the promotion? Report them? Probably not.

It's important to realize that people move around. They move from job to job and location to location. It is not unheard of for someone to take a job on the other side of town or the other side of the country. And don't forget that with a click of the mouse, you can find out almost anything about anyone.

What this means is that while every supervisor you have may not know every other supervisor, there is a chance that some of them may know other people in the industry. With this in mind, do you really want to take a chance doing something stupid or unethical? Probably not.

And forget getting caught. Do you want to build a great career—a long-term career that you can be proud of—on unethical activities? Once again, the answer is probably not.

How do you get out of doing something you don't want to do? You might simply say something like, "My dream was to work in this industry. I am not about to mess it up for something like this." Or "I've worked so hard to get where I am now, I really don't want to want to lose what I have." What about, "No can do. Sorry." How about, "Sorry, I'm not comfortable with that."

But what do you do if a supervisor wants you to do something you consider unethical? How do you handle that? You can try any of the lines above, but if your job is on the line, you have a bigger problem to deal with. In cases like this, document as much as you can. Then, if you have no other choice, go to human resources, a higher supervisor, or someone else you think can help.

"What do I do if I see something going on around me?" you say. What if I'm not involved, but I see a supervisor or colleague doing something that I know is wrong? Then what?"

This is a tough one as well. No one likes a tattle-tale, but if something major is going on, you have a decision to make.

Do you say something? Bring it to the attention of a higher up? Mention it to the alleged wrong doer? Or just make sure you're not involved and say nothing?

Hopefully at the time, you'll make the right choice. It generally will depend on the position you hold, your responsibilities, and the alleged crime. It's a difficult decision. If you decide to say something, be very sure that you are absolutely sure about your information.

What else do you need to know? It isn't a good idea to use illegal drugs nor to drink al-cohol excessively. Never, ever, ever go to work under the influence of alcohol or drugs. And finally, if you are drinking, do not drive. Aside from it being dangerous, a DWI will not look good to your employer.

Accountability

No one is perfect. We all make mistakes. No matter how careful anyone is, things happen. Accept the fact that sometime in your career you are going to make one too. In many cases it's not the mistake itself that causes the problem, but the way we deal with it.

The best way to deal with it is to take responsibility, apologize, try to fix it and go on. Be sincere. Simply say something like, "I'm sorry; I made a mistake. I'm going to try to fix it and will make sure it doesn't happen again." With that said, it's very difficult for anyone to argue with you.

If, on the other hand, you start explaining mitigating circumstances, blame your colleagues, your coworkers, your secretary, your boss, or make excuses, others generally go on the defensive.

When you're wrong, just admit it and go on. People will respect you, you'll look more professional, and you'll have a lot less turmoil in your life.

For example, "I was wrong about the report. You were right. Good thing we're a team." Or, "I am so sorry I was late today. I know we had a meeting scheduled. I'll make sure it doesn't happen again. Thanks for covering for me."

Okay, you're taking credit for *your* mistakes, but what happens if someone else makes a mistake and you're blamed or you're the one who looks like you're unprepared? What do you do? Blame someone else?

The best thing to do in these types of situations is just acknowledge the problem, apolo-

gize without blaming anyone else, and see what you can do to fix it quickly. The result? What could have been a major faux pas or problem is now just a minor inconvenience which no one will probably even remember a few weeks down the line.

In work as in life, many people's first thoughts when there is a problem is to cover themselves. So when things go wrong, most people are busy reacting or coming up with excuses.

Here's something to remember. The most successful people don't come up with excuses. Instead, when something goes wrong, their first thoughts are how to fix the problem, mitigate any damages, and get things back to normal. If you can do this and remain cool in a crisis, it will enhance your position no matter which segment of the art industry in which you are involved.

Time, Time Management, and Organization

Here's a question for you. What is one thing every person on the planet has the same amount of? Do you know what it is?

Here's a hint. I have the same amount you have. Bill Gates has the same amount I have. Oprah Winfrey has the same amount Bill Gates has. William Shakespeare had the same amount

as Oprah Winfrey does. Do you know what it is yet?

Every person in this world, no matter who they are or what they do has the same 24 hours a day. You can't get less and you can't get more no matter what you do. It doesn't matter who you are or what your job is. You don't get more time during the day if you're young, old, or in-between. You don't get more time if you're a millionaire or you're making minimum wage. You wouldn't even get more time if you were a Nobel Prize winner who had discovered a cure for cancer or accomplished any other amazing feat.

With all this in mind it's important to manage your time wisely. That way you can fit more of what you need to fit into your day and get the most important things accomplished.

To start with, let's deal with your work day. Try to get in to work a little earlier than you're expected. It's easier to get the day started when

you're not rushing. On occasion, you might also want to stay late. Why? Because when superiors see you bolting at 5 p.m. (or whenever your work day ends), it looks like you're not really interested in your job.

You also want to be relaxed before dealing with your job, not stressed because you got stuck in a traffic jam and started worrying that you were going to be late getting to work.

No matter what your career choice, in order to be successful, you will need to learn to prioritize your tasks. How do you know what's important?

If your supervisor needs it now, it's important. If it's dealing with a life or death situation, it's important. If someone is in trouble and there is something you can do about it, it's important. If you promised to do something for someone, it's important. If something is happening today or tomorrow and you need to get a project done, it's important. If there is a deadline, it's important. If things absolutely *need* to get done now, they're important.

Generally what you need to do is determine what is most important and do it first. Then go over your list of things that need to get done and see what takes precedence next.

The more organized you are, the easier it will be for you to manage your time. Make lists of things you need to do. You might want to keep a master list and then a daily list of things you need to do. You might also want a third list of deadlines that need to be met.

It's important to remember that just making lists won't do it. Checking them on a consistent basis to make sure the things that you needed to do actually were done is the key.

Here's an example of the beginnings of a master list. Use it to get you started on yours.

- ◎ Call Matt Alexis to set up appointment.
- ◎ Finish Mathews report.
- ◎ Check into dates and times of seminar.
- ◎ Check class schedule for certification program.
- ◎ Confirm in-service meeting time.
- ◎ Talk to human resources regarding health insurance.
- ◎ Dinner meeting with James Franklin, Monday, 7:00 p.m.
- ◎ Go over brochure for errors.
- ◎ Chamber of Commerce get together, Tuesday, March 9.
- ◎ Call Josh Meyers Monday at 11:30 a.m.

Writing things down is essential to being organized. Don't depend on your memory—or anyone else's. Whatever your job within the art industry, it is sure to be filled with lot of details, things that need to get done, and just plain stuff in general. The more successful you get, the busier you will be and the more things you'll have to remember. Don't depend on others reminding you. Depend on yourself.

If you want, you can input information into your Blackberry or another device. However, always keep a backup.

Here's an idea if you want to be really organized. Keep a notebook with you where you jot things down as they occur during your day. Date each page so you have a reference point for later. Then make notes. Like what?

★ Words from the Wise

In prioritizing, don't forget that you must fit in the things you promised others you would do. Don't get so caught up in wanting to be liked or wanting to agree or even wanting to be great at your job that you promise to do something you really don't have time to get done. Doing so will just put you under pressure.

- The dates people called and the gist of the conversation.
- The dates you call people and the reason you called.
- Notes on meetings you attend. Then when someone says something like, "Gee, I don't remember whether we said May 9 or May 10, you have it.
- Names of people you meet.
- Things that happened during the day.

After you get used to keeping the notebook, it will become a valuable resource. You might, for example, remember someone calling you six months ago. "What was his name," you ask yourself. "I wish I knew his name." Just look in your notebook.

"It seems like a lot of trouble," I hear you saying.

Well, it is a little extra effort, but I can almost guarantee you that once you keep a notebook like this for a while, you won't be able to live without it. You won't be looking for little sheets of paper on which you have jotted down important numbers and then misplaced. You won't have to remember people's names, phone numbers, or what they said. You won't have to remember if you were supposed to call at 3:00 or 4:30. You'll have everything at your fingertips.

A Few Other Things

It's important to realize that while of course you want to succeed in your career, everything you do may not be successful. You might not get every job you apply for. You might not get every promotion you want. Every idea you have may not work out. Every project you do may not turn out perfectly. And every job may not be the one you had hoped it would be.

It also is essential to remember that none of these scenarios mean that you are a failure.

What they mean simply is that you need to work on them a little bit more. Things take time. Careers take time—especially great careers.

Be aware that success is often built on the back of little failures. If you ask most successful people about their road to success, many will tell you it wasn't always easy. And no matter what it looks like, most people are not overnight successes.

While some may have it easier, others may have had one or more rejections or failures before they got where they were going. What you will find, however, is those who are now successful didn't quit. After keeping at it and plugging away, they landed the jobs they aspired to, got the promotions, received good work reviews, and got where they are today.

You might not get the promotion you wanted right away. You might not have the job of our dreams—yet. That does not mean it won't happen. Keep plugging away and work at it and success will come to you.

Most successful people have a number of key traits in common. They have a willingness to take risks, a determination that cannot be undone, and usually an amazing amount of confidence in themselves and their ideas.

Can they fail? Sure. But they might also succeed and they usually do. What does this have to do with you? If you learn from the success of others, you can be successful too. If you emulate successful people, you too can be on the road to success.

Don't be so afraid of getting things right that you don't take a chance at doing it a better way, a different way, or a way that might work better. Don't get so comfortable that you're afraid to take a risk. Don't get so comfortable that you don't work toward a promotion or accept a new job or new responsibilities. Be determined that you know what you want and how to get it, and you will.

If you want to succeed in your career and your life, I urge you to be confident and be willing to take a risk. Success can surprise you at any time.

Take advantage of opportunities that present themselves, but don't stop there. Create opportunities for yourself to help launch your career to a new level by using creativity and innovative ideas.

Know that not only can you *have* success in your career in the art industry, but you *deserve* success, and, if you work hard enough, you can achieve your goals and dreams.

Whether your dreams or career aspirations are to be in some aspect of the talent segment of the industry, the business or administrative segment of the industry, the periphery, or anywhere in between, know this. The more you work toward success, the quicker it will come.

Your success is waiting. You just need to go after it!

11

SUCCEEDING AS AN ARTIST
OR CRAFTSPERSON

We've discussed a multitude of things throughout this book that can help you in your quest for a great career in the art industry. We've talked about a variety of jobs and career options in various areas of the industry. We've discussed making your job into a career. We've investigated ways to get past the gatekeeper, some unique ways to obtain interviews, and interview tips.

We've discussed developing resumes and cover letters and putting together action plans. We've talked about job search strategies and tools for success. We've discussed why marketing is so important and how to market yourself.

You may have picked up this book for many reasons. I'm assuming if you're still reading, you want to work in some sector of the art industry. While there are a wide array of career options you might choose in this industry, what I want to do now is take some time to focus specifically on careers in the talent segment of the industry for those aspiring to be artists or craftspeople.

If a career in this area is not your choice, you can skip over the chapter if you wish. However, no matter what your aspirations, you might find some of the information helpful to you as well.

Many young people dream of careers as artists. Some get grow up, change their dreams,

and go on to careers in other fields, while others grow up and follow their original dream. Which scenario is yours? While I'm guessing I know the answer, let's be sure. Here are some things you might want to think about.

How many times have you read a story in the newspaper about an artist whose work was being exhibited in a new gallery and wished it were you the story was about? How many times have you seen an artist sketching a scene in the park and wished you were the one doing the sketching?

How many times have you walked through a museum and wished it was your artwork people were gazing at? How many times have you been in an art gallery and wished it was your art on the wall or sitting on a display pedestal?

How many times have you gazed at a piece of amazing art in progress and wished you were the one creating it? How many times have you watched a sculptor and wished you were the one sculpting they clay? How many times have you watched a glassblower and wished you were the one deciding what the finished piece would look like?

How many times have you walked through a craft show and wished it was your booth instead of someone else's everyone was gathered

around? How many times have you wished that you were the successful artist or craftsperson people were talking about and imagined yourself receiving the accolades? How many times have you wished you had followed your dream?

I'm betting if you are reading this section of the book, there's a good chance you see yourself in one of these scenarios.

There is certainly nothing wrong with wishing. It definitely can't hurt, and as a matter of fact, it sometimes helps you focus more clearly on what you want. But wishing alone can't make something happen. In order to succeed in the talent end of the art industry it's essential to take some positive actions.

Have you ever wondered why some artists or craftspeople struggle while others succeed? Is it that some have more talent…or is it something else? While of course talent has a lot to do with success, as we've discussed throughout this book, talent alone doesn't guarantee success. It's no secret that the industry is competitive, but why shouldn't you be the one on top?

While some artists *say* they don't *need* success, telling others they just need the ability to express themselves creativity, most artists truly want to be successful. They want their artwork to be recognized in a positive manner. They want financial success. And in many cases they even hope that their work will have a place in art history. If this is you, read on.

This section of the book is going to explain some of the things that might help you move ahead if you are an artist, craftsperson, or in another area of the talent end of the industry.

The Art Industry Is a Business

Do you want to use art as a vocation instead of an avocation? If so, there's an important fact

you need to remember. It's crucial to your success to understand that the art industry is a business, and no matter what type of career you are pursing, it needs to be treated as such.

Yes, it can be fun; it can be exciting; it can be glamorous; and it is something you have a passion for and love to do; but in the end, it is business. In order to succeed you need to act in a professional manner in every situation.

How can you be professional? Simply put, remember that you're not an amateur. Present yourself professionally. If you say you're going to be someplace, be there. If you say you're going to call somebody, call them. If someone calls you and leaves a message, call them back in a timely basis. If you say you're going to do something, do it. Most important, be on time for everything. There is nothing worse for your career than being known as the artist who is always late.

Professionalism doesn't only mean the way you act. It also encompasses how you present yourself. Are you ready to make it? Are you prepared?

Do you have a professional looking portfolio? Is it perfect? Do you have professional slides and photos of your work?

Do you have your bio completed? Do you have professional head shots that can be used for publicity? What about your resume, your CV, your bio, and your press kit? If you want industry professionals to take you seriously, make sure everything you do is professional.

"I'm talented," you say. "Isn't that all anyone is really interested in anyway? What difference does it make if I'm not all that professional right now?"

True, talent is what industry professionals (and your potential buyers) are looking for,

but it's not always that simple. Here's the deal. There are a lot of talented artists and craftspeople. You want to give yourself the best shot possible at success. You don't want someone to say, "What a great sculptor, but I hear he shows up to openings drunk." Or "She's a great artist, but she doesn't complete anything on time."

You want everything about you and your work to stand out from others in a positive manner. Even if you're not a professional yet, you want it to appear that you are. A professional stands out from the crowd.

What else should you know? To give yourself the best chance at success, learn as much as possible about the business end. Knowledge is power. The more you know, the more you can help yourself in your quest for success.

You've already started by reading this book. Don't stop here. Read everything you can about the business. Read everything you can about the industry. Go to the library or the bookstore and find books on different segments of the art industry. Find books on artists who have made it. Find books on craftspeople who have been successful. Look for books on designers who have achieved success. Seek out books on marketing, public relations, and publicity. Look for books on selling and creating a brand. Read trade publications. Find other magazines and periodicals with articles on art,

> ### ★ The Inside Scoop
>
> Learn the lingo of the industry. Every industry has its own set of words, jargon, terms, and acronyms. If you don't know the lingo of the industry, not only will others know you are an amateur, but you can make crucial mistakes doing business.
>
> Earlier in the book I told you my story of wholesaling my crafts. While I was lucky and everything ended up working out well, at the time I had no idea what terms like FOB meant, what a wholesale price was, and so on. Had I done some research ahead of time, I would have known these things.

the art industry, crafts, and designers. Scour the Internet for information.

"But I'm busy," you say. "I spend every spare moment working and honing my craft. I don't have time to continually read books and magazines and surf the Internet."

Make time. If you just find one thing in a book or magazine or on the Internet that you can relate to your career, it will be worth it.

And don't stop there. Take classes, workshops, and seminars, both in your talent and craft and in the business end of the industry. Why? You will gain valuable information, learn new skills, hone your craft, and have the opportunity to network and make important contacts.

> ### ★ Tip From The Top
>
> The more you know about the industry, the less of a chance there will be that someone will try to take advantage of you. Learn something new every opportunity you get.

> ### ★ Words from a Pro
>
> *FOB* is a shipping term meaning *freight on board*, which indicates that the seller is responsible for paying the transportation of the goods to the place of shipment.

And that is what can help you in the talent end of the industry.

Moving Up and Taking the Next Step

There is a big difference between being an amateur artist or craftsperson and working as a professional in the field. As a professional, you will continually work toward building success in your given area; you will continually work toward building a career. You need a strategy and a plan.

Have you decided that you're ready to commit to a career as a professional artist or craftsperson? Are you ready to put in the hard work and perseverance that's necessary? Do you have the passion? Are you ready to pursue your dream? If your answer is a definitive yes, let's take some time to discuss some additional actions that can help you get where you want to go.

What's your next move if you are an artist and ready to take the next step toward success? How can you get attention for your artwork? How can you start to make a living from your passion?

What's your next move if you have been creating crafts as a hobby and want to become a professional craftsperson? What's your next move if you have honed your skills as an accessory designer or fashion designer and want to move up the ladder of success? How do you move from amateur to pro as an artist or craftsperson?

Whatever the case, no matter what segment of the art industry you aspire to pursue, you need to take stock of where you are in your career and get ready for your journey to success. You have a lot of work ahead of you, but you not only can do it, and you can do it successfully.

In your quest for success, get as much experience as you can. Look for internships and apprenticeships with other skilled artists and craftspeople.

★ The Inside Scoop

I recently visited the gallery of a skilled glassblower with some friends. He was demonstrating his work, creating beautiful three-foot long blown glass flowers. As he was working, he was explaining to his assistant what he was doing and what the next step would be. The assistant would then help the artist with the task.

After finishing a piece, the artist came over and asked if we had any questions. We spoke for a while and the conversation turned to how he had started his career. He told us that he had worked in a totally different industry for a number of years when he lost his job. He had nothing to do and ended up hanging around a glassblower in his area who let him help out around the shop by cleaning up. The man was intrigued with artist's work. The artist asked him if he wanted to try something simple, and the rest is history. While the man helped the artist around the shop and with his business, the artist taught the man the craft of blowing glass.

The man told me at the time he didn't care what he had to do around the shop or how long the hours were, because it was worth learning the skill he loved. He hoped he could pass his skills on to his assistant as well so he, too, could create beautiful blown-glass pieces.

I asked if he were concerned his assistant would be a competitor, and the artist told me he was not. He explained that everyone has their own talent that they bring to a skill and he was sure the world was big enough for everyone's art. He not only wanted to pass along the skill; he wanted his assistant to be successful.

Actively seek out opportunities. How? If you know a professional artist or craftsperson working in the medium you aspire to work, ask if he or she needs help. Even if you are just doing the grunt work, you might pick up a new technique or skill.

Show your work where you can. Look for opportunities here as well. Is a bank looking for artwork to display? You'll never know if you don't ask. What about your county government offices? Any blank wall is a possibility.

Have you heard about a fund-raiser for a not-for-profit or civic group? Offer to donate a piece of your work for a raffle or silent auction. What about giving a few pieces of your work for a gift bag or favor giveaway at a charity gala or dinner?

One of the most exciting things about deciding to become an artist or craftsperson is that you can do it at any age and any stage of life. There are some people who decide to take their avocation to a new level and craft a career in the some aspect of art later in life. While I've discussed it before, I want to reiterate that whatever your age, it is never too late to pursue your dream.

It also bears repeating that no matter what you *think* you want to do and how far you have gone in your career, you are allowed to change your mind. You may, for example, work toward becoming a successful fine artist and decide along the way that you really would rather work in the business end of the industry. That's okay. Conversely, you may have been working in the business segment of the art industry and decide that *you* want to be the one creating the art instead. That, too, is okay. As long as you keep pursuing your dreams, you are going in the right direction.

One of the other great things about a career in the talent end of the art industry is that you can work in various mediums. There is nothing that says just because you are a painter you can't be a fabric designer. Just because you are a wood worker doesn't mean you can't also be an interior designer. Just because you want to be a fine artist doesn't mean you can't also create some type of crafts. There is nothing that even says you have to work in the talent aspect of the art industry exclusively. Flexibility is one of the keys to a successful career in the talent end of the art industry.

Do you want to be the next Salvador Dali, Pablo Picasso, Vincent Van Gogh, Georgia O'Keeffe, Claude Monet, or Leonardo da Vinci? Do you want to be the next Andy Warhol? Do you want to be the next Michelangelo? Do you want to be the next William Wegman? No matter what area of the industry you are interested in and who you want to emulate, creating your work is just the beginning. In order to succeed, you're going to have to do a lot more. You're going to have to do everything you can to get an edge over others.

While no one can guarantee success, a combination of education and training, hard work, good business sense, being in the right place at the right time, talent, and of course a bit of luck will stack the deck in your favor.

Training and Education

Let's take a few minutes to discuss education. Many people ask when pursuing careers as artists whether they need a formal art education. While a college degree or art school won't guarantee a successful career, it is helpful in honing skills and learning new techniques. College also provides you with a broad background and the ability to make contacts. It additionally offers opportunities you might not otherwise have. Many people want to know if

it is more advantageous to get a college or university degree such as a Bachelor of Fine Arts (BFA) or Master of Fine Arts (MFA) or go to an art school.

The answer is that there are pros and cons to both. Only you decide. Often, the answer will be dependent on the specific medium you are pursuing and which school will provide the best training.

How do you choose the school, college, or university you should attend? Do some research. What schools or universities offer the best programs for you? You want to find a program that offers a good combination of studio classes, practical classes, and instructional classes in your chosen medium. You want to find a program that has excellent instructors who can inspire and motivate you to do your best.

Competition to get into many programs can be fierce. Whether you are considering applying to an art school or college or university with a BFA program or MFA program, there are a number of things that can increase your chances of getting accepted.

You generally are going to have to provide a portfolio of your work. In order to do this effectively, gather samples of your best work and take pictures and slides. If you can't take good, professional quality photos or slides yourself, either find someone else who can to take them for you or hire a professional photographer. Depending on the situation, your portfolio may also contain sketches and other artwork.

As you are competing against a lot of other talented people, your goal is to create the best portfolio possible. In order to grab the attention of those on the admissions committee, make sure your portfolio demonstrates creativity, that you have strong technical skills, and that you can work in a variety of media.

What else do you need to know? While all schools do not always personally interview perspective students, if you do have the opportunity to meet one on one with someone from the school of your choice, make sure that you demonstrate that you are both committed and passionate about both your art and art in general. You also want to show that you are open to new ideas and can deal well with critiques. You additionally want to indicate that you really *want* to go to that school and are excited about the opportunity.

If you are interested in a career in the visual arts or a related field and looking for just the right college or university, you might be interested in attending an event called *National Portfolio Day.* These events are hosted by the National Portfolio Day Association (NPDA) and held in various locations throughout the country. The NPDA is made up of representatives from accredited colleges and universities who are also members of the National Association of Schools of Art and Design.

These events are generally well attended both by schools and perspective students. During National Portfolio Day you will be able to meet with representatives from various colleges and get information on their programs. You will also have the ability to show them your portfolio. In these situations, you may show completed artwork, projects that you are still working on, sketchbooks, tear sheets, and so on. The representatives from the various schools assess

your work and give you their opinions. Some may give you advice on how to improve your portfolio or do things differently.

Remember that this is not a competition, and no admission decisions are generally made on that day. The event is, however, a great opportunity to put you together with other people interested in the same things you are. It also is a great opportunity to meet with a large number of representatives from different schools in one location to help you see what the differences in each school may be.

If you are interested in learning more about National Portfolio Day events as well as specific dates and locations, check out their Web site at http://www.portfolioday.net.

The National Association of College Admissions Counselors holds similar events throughout the country for individuals interested in careers in the visual arts as well.

Whether or not you have formal education, it is important to constantly hone your craft. Take classes. Look for workshops. Find seminars. Learn new skills. Learn new techniques. In addition to the educational value of these classes, workshops, and seminars, they give you the opportunities to meet new people, make new contacts and get new ideas.

It's essential to remember that whether you are an artist or a craftsperson, you *and* your art are products. Why do I keep stressing this? Because I believe that if you keep that fact in mind, you will

have a better chance at success. When you start looking at things this way, you will begin looking for ways to exploit and market yourself and your art. (In this case, the word *exploit* is a good thing.)

Selling Your Work

It takes talent be a first-rate artist or craftsperson. Unfortunately, as we keep mentioning, talent alone doesn't always translate into success in the art world. Becoming a recognized and financially successful artist or craftsperson is going to also take time, effort, a good business sense, marketing, a lot of hard work, and determination.

While of course it's nice to have your work critically acclaimed and be recognized as a talent in the art world, in order to be financial successful, selling your work is the bottom line. Let's take some time to go over this all-important task.

There are a variety of options for selling both your artwork and/or crafts. We're going to go over a few of them. As you go through your career, you will find other opportunities and options. These are just a beginning.

Art Shows, Craft Shows, Fairs, and Festivals

There are a number of different types of art shows, craft shows, and festivals. Some shows are put together by professional promoters. Others are put together by volunteers or organizers. These shows can be located throughout the country. They are often found in shopping center and malls, schools and colleges, churches and synagogues, auditoriums and arenas, hotels and resorts, conference centers and community centers, and city parks and county fairgrounds. While many shows are held in inside locations, there are a large number also held outside in the warm weather months.

Whether they are huge events with hundreds of exhibitors or small shows with a lesser number,

⭐ **Tip from the Coach**

If you are still in school, look for summer art programs in which to participate. They will help you learn new skills and techniques and often give you an edge over others.

these shows are one of the most common ways artists and craftspeople sell their work.

"Where do I find the shows?" you ask. That depends on what types of shows you're looking for. Local craft fairs or art shows put on by community groups or other not-for-profit organizations usually advertise for exhibitors. They may put up flyers or signs or have a small ad in the local newspaper.

Craft fairs and festivals and art shows put on by professional promoters can often be located in trade publications or online. Many promoters have their own Web sites listing dates and locations of shows. There are also sites that list shows and festivals by date and location.

Here are a few sites to get you started. Use this list as a beginning. As you surf the net, you will find many more.

- ◎ http://www.craftsreport.com/showfinder
- ◎ http://www.artfaircalendar.com
- ◎ http://festivalnet.com
- ◎ http://festivalsandevents.com
- ◎ http://www.festivals.com
- ◎ http://www.artandcraftshows.net
- ◎ http://www.artandcrafts.com

If you know an event is being held at a specific location, such as a mall or shopping center, you can always call up the mall management office and ask how to get in touch with the promoter. You might also talk to other artists or craftspeople and ask if they know when and where the "good" shows are. Most artists and craftspeople are very friendly and more than happy to help others in the field.

Open Shows, Juried Shows, and Invitational Shows

Whether you are considering exhibiting in an art show or a craft show you should know that there are a number of different types of shows. These include open shows, juried shows, and invitationals. What's the difference?

Open shows are art or crafts shows where individuals must generally just request an application, pay a fee, and if there is room, they can become exhibitors. That's not to say that open shows don't have any restrictions, because often they do. The exhibitor may have to agree, for example, that all the work is handcrafted. Additionally, even though shows are classified as "open," they may still have standards to assure that the show will be composed of attractive, well-made crafts or artwork.

Juried shows are art or craft shows where the work of the artist or craftsperson is judged or at least reviewed in some manner. This is generally accomplished by the individual sending pictures, slides, or transparencies of his or her work, which is then reviewed by a panel or committee of people. The panel may look for any number of things including creativity, uniqueness, quality, technical skill, or even a specific medium. You should be aware that if you are applying to a juried show, you may be required to send in a jury fee with your application, which may or may not be returned whether or not you are accepted. This fee is in addition to the exhibit fee you will be charged if you are accepted to exhibit in the show.

Why would a promoter jury a show? There are a number of reasons. A juried show helps maintain the standards of the event and can assure the quality of the exhibit. It also can be used to limit the number of similar types of art or crafts.

If you are want to be accepted into juried shows, it is necessary to have good quality slides, photographs, or transparencies of your work. It is additionally important that the photos illus-

trate your product effectively. Otherwise, even though your work may be superior, it may not be accepted.

How do you get good photos of your work? Unfortunately, unless you are a professional photographer, it is not always as easy as it looks. Here are some guidelines that might help.

◎ Use a solid background for your photo. Don't photograph your work using your printed sofa, patterned wallpaper, or even wrinkled sheets or tablecloths as backdrops.

◎ Center one piece of your work in the photo so it fills the picture. Your work should be the focus.

◎ Make sure there are no shadows in your picture.

◎ Make sure the colors of your work are true.

If, after you have tried to take good quality photos of your work, you find you are not successful, enlist the services of a professional. These photos are very important and you want them to be as perfect as possible.

Invitationals are art or craft shows where the promoter or organizer actually invites artists and craftspeople to exhibit their work. Other individuals are not allowed to apply.

Words from the Wise

Always label your photos and slides with your name and address. Never send original photos or slides with your show application. Even if you request having them sent back, things sometimes happen. After you have gone through so much trouble to get the perfect photo or slide, it's not worth taking a chance.

Words from the Wise

When applying to a juried show, always follow the instructions to the letter. If the instructions ask you to send three photos of your work and one of your display, do just that. Don't send more and don't send less. If the instructions tell you to send slides, send slides, not photographs.

Which Show Is Best for You

Generally, most artists and craftspeople who are interested in selling their work start out by exhibiting and selling at some sort of art or craft shows. As discussed previously, there are an array of different types of shows. How do you decide which shows to apply to? Should you start off with a show at a shopping center or mall? Should you apply to a show at a large exhibition hall? Should you try to get into a juried show or should you apply to open shows? Here's my advice.

Choosing the right show can mean the difference between success and failure in sales. Do research ahead of time. If the event has been help before, ask questions. Do you know what the attendance was last year? Are a lot of the exhibitors repeat vendors? Does the promoter or organizer advertise the show? Is the show going to be free to attend by the public or is the promoter charging a fee? Do you know how many exhibitors there will be? Do you know if they limit the number of similar types of work? These are some of the questions for which you might try to find answers. Don't be afraid to ask the promoter or organizer questions. You can also ask other artists or craftspeople. The more informed you are on shows, the better.

You also are going to want to know what the exhibit fee is going to be for the show. There are

a tremendous range of exhibit fees depending on the specific show. Some small shows, for example, may charge $30–$50 to exhibit for the day. Large juried shows may charge hundreds of dollars. A lot depends on the size of the show and its location, prestige, and reputation. There are some shows that may also charge a percentage of your sales.

Many want to know if shows that charge higher exhibit fees will be better. There are so many variables related to shows that this is another of those questions that is difficult to answer. The problem is that higher exhibit fees don't always translate into higher sales for you. A lot of that has to do with your specific art or craft, how well a show is attended, how many other vendors there are in your medium, whether people are buying that day, and so on.

It should be noted, however, that shows that charge higher fees may be more prestigious, may advertise more, or may bring in higher numbers of admissions. The more people who pass by your booth, the better your chance of selling.

If you are new to the art or craft show circuit, it is often helpful talking to vendors who have exhibited at some of the shows in which you are interested so you can get a *feel* for the shows ahead of time. If you're just starting out, you probably will also want to find a few shows with lower exhibit fees to get your feet wet and work out the kinks, before spending a lot of money on fees.

Look for shows appropriate to your work. While some shows are generic, some are more specialized. If you are a fine artist, you probably don't want to be doing a country craft show. If you are a silversmith specializing in jewelry, you probably wouldn't want to participate in a folk festival. You want to find shows where there is the best possibility that there are going to be visitors who want to buy your work.

> ### ⭐ Tip from the Top
> The art show and craft show circuit is very small. Everyone knows everyone. You don't want to be known as the difficult exhibitor. Don't whine, threaten, or start acting like an idiot in general if you don't like the space assigned to you or your neighbor on either side. An exhibit space is temporary. It is not a lifelong residence. If there is a problem with your assigned space, it is acceptable to calmly discuss the problem with the promoter. State the problem and see if there is anything that can be done. If not, say you understand and just accept the situation for the day. If you do another show with the same promoter, try to deal with the situation ahead of time.

You will generally have to sign a contract that spells out among other things the dates of the show, hours, fees, location, size and/or type of booth or booth space, what is expected of you, and what the promoter will provide. Some contracts will also tell you where you will be located on the exhibit floor.

Read the contract carefully *before* you sign it. Ask questions and get clarification on key points if you don't understand something.

Setting Up an Attractive Show Booth

Now let's take some time to discuss your display booth. A good display can draw customers into your booth. Booth sizes will vary depending on the specific show. Some may be eight by 10 feet, while others are six by nine, or even 10 by 10. Some promoters provide draped exhibit booths in which you put your display. Others just mark your space with chalk, paint, or tape.

The way you design your booth can impact your sales. If your booth isn't customer friendly, potential buyers will often just pass you by. Some people use commercially designed booth displays. Companies that sell these booth displays often advertise in trade publications. These are useful if you are doing a lot of shows and want an easy and attractive set up. Many people also create their booth display design effectively themselves.

No matter how you set your booth up, make sure it looks as professional and attractive as possible. There are some people who simply set up tables covered with cloths to exhibit their work. Others construct their displays with a variety of materials including metal, wood, glass, plastics, PVC piping, fabric, and so on.

Don't just throw your products down on a table or put your paintings on the ground or in a box and expect them to sell. Try to display things at different levels to create interest. You might use boxes, steps made out of wood, or even glass bricks to do this. Some people use lattice or fencing to add interest to their displays as well. Almost anything can be used as long as it is done in an attractive manner.

If you are using tables, make sure each one is covered with clean, pressed fabric, making sure the fabric is down to the ground. Aside from this being more attractive, it provides you with someplace to store your excess stock. Don't forget to bring stools or chairs. You also want to make sure you have someplace in your booth where customers can easily write checks, get their cash out, or do a credit card transaction.

Your exact display will depend on what you are exhibiting. For example, if you are displaying and selling paintings or wall sculptures, you might hang them on fabric-covered screens. If you are displaying three-dimensional sculptures,

you might use pedestals of varying heights. Jewelry might be displayed in jewelry cases or hung on hooks. Designer clothing might be displayed on screens, coat racks, dress forms, or hanging rods. The idea is to attract people into your booth so that they want to buy your product.

When I exhibited my puppets, I created a display that resembled a puppet theater. It brought a lot of children over to my booth as well as their parents. My display also contained an 18-inch painted circle of wood that was on an electric turntable. I displayed smaller finger puppets on small dowels which were hammered into the wood so when turned on, it looked like a small carousel. I knew from experience, if I attracted people over to my booth and got one of the puppets on their hand, I would make a sale. As an artist or craftsperson, sales are what you are looking for at these types of shows.

No matter how you set up your display, make sure you have a sign prominently displayed with your name (or business name) and perhaps your hometown and state. You want people to know who you are and you want potential customers to be able to find you.

It's vital that your booth be easy to set up, easy to break down, and easy to transport. As a professional artist or craftsperson you probably

★ Words from the Wise

It's important to remember that both art and craft shows are retail settings. It is therefore essential to guard against shoplifting. When designing your display set up, try to do it in a way that protects your products from potential theft. You might, for example, want to put your more expensive items such as expensive jewelry in a closed glass case.

will be doing a large number of shows. You want to make it as easy as possible to move your exhibit around.

If you are doing inside shows, don't forget about auxiliary lighting. You may have to pay an extra fee for electricity, but it will be worth it. Spotlights, clip-on lights, flexible-arm lighting, and even lamps may be used effectively. Don't forget to bring a lot of electrical tape, heavy-duty extension cords, multiplug outlets, and extra light bulbs in case you need them.

If you are doing outside shows, you might consider buying a tent or canopy to protect you and your product from the elements.

Increasing Sales at Art Shows, Craft Shows, and Festivals

There is nothing more exciting than going to a show and having people come up to you and tell you how wonderful your work is and how much they love it—except having them do that *and* making a purchase. How can you increase sales? There are a number of ways.

Here are some things you should do.

◎ Make your booth inviting. Look at your booth objectively and ask yourself whether you would you stop by to browse.

◎ Take a photo of your booth once it is set up and stocked. How does it look? If you're happy with it, great. If not, what can you do to improve it?

◎ When people pass by, smile. Sometimes just doing that will get someone to stop and look at your work. The more people who stop and look, the better your chances of making sales.

◎ Some people find that a dish of wrapped candy sitting in their booth brings people in. If it is very hot, make sure not to use chocolate.

◎ Make sure customers and potential customers know you value them. Don't ignore people because you think they won't buy something. Every person passing by is a potential customer.

◎ Make sure you have business cards in your booth. Encourage people to take them. You might just get sales in the future.

◎ If possible, bring enough people with you to help you in case it gets busy. You don't want to lose sales because you are helping one customer and another wants to buy something. Some people won't wait. An extra set of eyes is also helpful in discouraging potential shoplifting. Additionally, you might need a break to use the restroom, get something to eat, or make some contacts.

◎ Make sure you have change before the show. You don't want to lose a $50 sale because all someone has is a $100 bill and you don't have another $50 lying around.

◎ The easier you make it for customers to pay, the more sales you will have. In addition to accepting cash and checks, you should seriously consider accepting credit cards. Many people will buy something using a credit card that they wouldn't buy using cash. Many will not buy something, simply because the vendor does not take credit cards. Talk to the bank where you have your business account and ask if they can help you get a merchant account.

◎ Start building a mailing list. Get the name and address or e-mail address of people

who stop by your booth as well as people who buy your art or crafts. Next time you are doing a show in that particular area, send a card or an e-mail telling people where you will be. It often helps to offer a discount coupon if they bring the card or e-mail. For example, "Bring this card and get 10% off your purchase of $100 or more at the Something City Craft Expo on August 3."

◎ Send out a press release to the local media announcing that you will be exhibiting at a specific show. If you make your press release interesting or come up with a unique angle, it increases the chances of getting in the paper.

◎ Demonstrate your art or craft during the show. Studies have shown that demonstrating not only attracts people to your booth but also helps increase sales.

◎ Even though you set a price for your work, be aware that people like to bargain. Decide ahead of time if your prices are negotiable. If they are, fine; if they are not, find a way to nicely tell customers that unfortunately your prices are set and you can't negotiate.

◎ People's tastes vary widely. To the extent you can, offer a variety of products within your medium.

◎ Offer products in a variety of price ranges. Even if the main focus of your sales is high end, you might want to also have some smaller, lower-priced items.

◎ Make it easy for the customer to make a decision and buy your products. If you are selling jewelry, make sure you have a mirror so that they can see what the piece will look like on them. If you are selling handcrafted dolls or toys, make sure your customers know the age group the toys are appropriate for.

◎ Create special offers to tempt potential customers to spend a little more at your booth. You might, for example, offer a "Buy 2, Get 1 Free" on a specific product.

◎ Be professional, be courteous, and treat customers the way you would like to be treated.

Here are some things you should not do.

◎ Do not leave your booth unattended. Aside from the potential of theft, the minute you leave your booth, you may lose potential sales. Bring someone else with you to help. That way when you are talking to one customer about your work, someone else can be writing a sales receipt for another customer.

◎ Do not sit and read a book while in your booth. Potential customers may think you are not interested. Some may want to ask a question and not want to bother you while you are busy.

◎ Do not talk on your cell phone unnecessarily while in your booth. It makes people think they are interrupting you, and it is much easier to move on to the next booth.

◎ Do not complain to customers and other vendors how bad business is or how dead it has been all day. No one wants to hear people whining and complaining. Furthermore, people may think something is wrong with *your* work.

◎ Do not pressure customers to buy. It makes many people very uncomfortable and they will do everything possible to get away from you.

⭐ **Tip from the Top**

When you accept checks, make sure you ask for identification. Write down your buyer's driver's license on his or her check as well as their phone number and address, if it isn't already printed on the check.

Taking Care of Business

Whether you are selling your work at an art show, a craft fair, or in any other retail situation, there are certain things you need to do to take care of business in a professional manner. One of the first things you need to do is select your business name. It might be as simple as, "John Roberts Glassblowing" or "Erin Wright, Artist." Your business name does not have to have your name in it. For example, "Silver Baubles" or "Rainbow Batiks" would be fine.

You might also want to think about your business structure. There are a lot of questions you need to answer. Are you going to be a sole proprietor? Are you going to incorporate? Do you need to have a legal partnership with one or more other people? What should you do? Do some research. You might want to speak to an attorney to decide what is the best path for you to take. Each option has its pros and cons.

Many cities and counties also require businesses to have business permits or business licenses. Contact your city and county government offices to see if this necessary and what you need to do to get the required licenses and permits.

Once you decide upon your business name and set up your business, you are probably going to also want to get a separate bank account just for your business.

You might also consider business insurance. The type you need will depend on the type of product you have and the business setup you have decided on. Do you need it? Once again, only you can make the final decision. You might want to speak to your insurance agent, tell him or her what you are doing, and get some feedback and ideas. Then make your decision. Your agent might also be able to tell you if you need any other type of insurance for your particular business as well.

What else? You're going to have to get a sales tax number and a permit to collect sales tax. When you are selling your art or crafts in a retail setting, you are required to collect sales tax. It doesn't matter if you are selling it at an art show, a craft fair, a school bazaar, a private home, or in any other location.

I can already hear you saying, "But the man next to me at the last show didn't charge sales tax. Why do I have to?" I can hear you saying, "No one will know if I don't charge sales tax." Or, "My customers don't want to pay sales tax. They argue with me."

Here's what you need to know. No matter what anyone tells you, you not only have to collect sales tax for every retail sale you make, you have to put that money aside and send it to your state's department of taxation in a timely fashion.

The easiest way to get information on sales tax in your state is to contact your state's department of taxation. You can either call them directly or you can usually find the information on their Web site. Don't forget that when you are participating in events outside of your state of residence, you must also get a permit to collect sales tax from that state as well.

Keeping Records

Keep accurate records of all monies you have coming in and all monies going out in relation

to your business. This is important for tax purposes as well as to know how your business is doing. Some people do this accounting by hand. Others use computer programs.

Keep records of all expenses incurred creating your art or craft as well as those incurred selling it. Keep records of show fees, jury application fees, travel expenses, meals, and lodging.

You also need to keep accurate records of all your sales. If you are selling at shows or fairs, you are going to want to keep track of how well you do at each. In this manner you can decide what shows to do again and which you want to skip the next year. If you are wholesaling, you also need to keep track of your accounts receivable as well as tracking who still owes you monies.

Consignment

There are many ways to sell your art or crafts. We've just discussed selling at art shows and craft fairs. Consignment is another option. What's consignment? On the most basic level, it is giving a store or individual your art or craft to sell on speculation. If and when they sell it, you will receive payment. So, for example, if you are a batik artist, you might give one or two to a gift shop. The shop will display your work, offering it for sale. When one of your batiks sells, the shop will pay you.

How do you get paid? That depends on the deal you negotiated. Shops have different policies on pricing. In some instances you will tell the shop what you want to receive for an item. They will then add on a percentage for their markup. In other situations, the shop may tell you what they want to pay you for a product. If you agree, when the item sells, you will get the agreed-upon price. It's not unheard of for a shop to take from 33 to 50 percent of the retail price.

Where can you find places to sell your product on consignment? Almost anyplace. Depending on your product, you might try boutiques, department stores, craft stores, art shops, gift shops, galleries, and so on.

Get everything that you and the shop owner (department store, gallery owner, and so on) have agreed upon in writing. Make sure both of you sign and date the agreement and get a copy. Don't forget to get a signed receipt for each piece of your work you leave.

Galleries and Gallery Shows

Whether you are an artist or a craftsperson, a gallery showing can provide a great opportunity to get exposure and sell your work. Galleries provide an established location to showcase your work with an ever-changing group of potential customers.

How do you get a gallery show? How do you get an exhibit? If you have an artists' representative, he or she may work on trying to arrange it for you. If not, you will have to work on this task yourself. Visit a number of galleries to see where you think your work would fit. Then call the gallery manager and make an appointment. While there are some people who just walk in and speak to the gallery manager without an appointment, doing so often puts you at a disadvantage. While the manager might speak to you on the spot, you might not be getting the undivided attention you would be getting if you had taken the time to make an appointment.

What do you bring when you meet with a gallery owner or manager? You are going to want to bring a printed portfolio of your work. Don't bring your actual work. You might also want to bring an extra copy of your printed portfolio or a CD of your work to leave for review. You might also want to have a copy of your resume

or CV, copies of any press you have received, and your press kit if you have one.

Always be pleasant, polite, and patient to gallery managers. Most truly like art. Even if their galley is not the one for you, they often will help with an idea or even an encouraging word. What you are looking for, however, is to develop a relationship with a gallery. For most people, this doesn't happen overnight.

Chances are, especially if you are a new artist, the gallery owner won't make a decision on the spot. He or she will want to think about it.

When you get home, be sure to send a thank you note to the gallery manager (or whoever reviewed your work). Some people send the note on a card or postcard with one of the images of their artwork. By doing this, you are not only thanking the person for their time but reminding them who you are and what your work was.

If your work isn't accepted for an exhibition, you can wait about six months and make another appointment. At that time, however, be sure to show the gallery manager a new portfolio.

Let's assume that your work is accepted at a gallery and you will be having an exhibition. What happens now? The gallery will generally do everything possible to help give your exhibit exposure. To pique interest, they will generally promote and advertise the showing of your work.

Just exhibiting an artist's work is not enough, however. The way most galleries make money is by selling the work of the artist or craftsperson. With that in mind, the gallery needs people to buy the work that is being exhibited.

In order to accomplish this, the gallery will often hold special invitational exhibits where they invite people on their customer list as well as the media.

What happens then? As the artist whose work is being exhibited, you will be expected to be on hand for the opening so you can mingle with the attendees. The opening often includes a cocktail party or reception. For most artists, openings are exciting events. Take advantage of the opportunity. People like to meet the artist who created the work they are looking at and may potentially buy. Walk around and mingle. Meet as many people as possible and tell them how happy you are they are there. By doing this you will be creating relationships with people who may become collectors of your work.

You should be aware that there are a number of different types of galleries. These include residential galleries that showcase the work of resident artists; residential galleries that showcase both resident artists and guest artists; galleries that primarily show the work of new artists; show galleries that may showcase the work of a number of artists at one time; and the galleries of art associations that mainly showcase the work of their members. Some galleries are a combination. It all depends.

If you are just getting started, one of the easiest ways to get a gallery exhibit is through an art association in which you are a member. You should be aware, however, that these types of gallery exhibits don't always get the same amount of promotion or marketing as other exhibits. On the other hand, these types of exhibits will get you exposure and usually charge a smaller commission on sales.

Financial arrangements for gallery exhibits vary. In some situations, the gallery buys the art outright and then sells it for whatever price they want. In other situations the artist pays the gallery a commission or percentage of sales. This can range from 20% to 50%. Be sure you know ahead of time what the financial arrangements will be. You generally will be required to sign a contract, which will include the dates of the

gallery exhibit, financial arrangements, what the gallery is responsible for, and your responsibilities.

Online Sales

Most businesses today have some sort of online presence. As an artist or craftsperson, you probably will want to have one as well. You can use this presence to let people know you exist, promote yourself, and attract potential customers.

Today, you also have an opportunity that artists and craft people years ago did not have. You can sell your work online. One of the great things about this is that you can potentially reach customers anyplace in the world.

There are a number of options for selling online, depending on your specific media. These include:

◎ Building your own Web site to sell your arts or crafts
◎ Getting involved with an online art or craft gallery
◎ Getting involved with a Web site that sells art online
◎ Getting involved with a Web site that sells crafts online
◎ Getting involved with an online catalog
◎ Selling on eBay or another auction site

Online sales can be yet another method to getting exposure for your work and making sales. Do you want to get involved? This is another decision only you can make. There are pros and cons to each option. On the pro side, online sales can bring in added revenue. On the con side, online sales can be a lot of work. Do you have the time? Do you have the expertise? Look into the possibilities and see if it is worth it to you.

Wholesaling

Another viable option for selling your art or crafts might be wholesaling. A lot of artists and craftspeople find that wholesaling is a good alternative to selling their work at craft fairs, art shows, or galleries. Others find that wholesaling is a good way to add revenue garnered from traditional retail selling.

When wholesaling, you will be selling your product to retail outlets who in turn will resell it to the public. Be aware that by the very nature of wholesaling, you will be selling your product for a lower price in return for selling in greater volume. When selling your products wholesale, you should require either a minimum number of pieces or a minimum dollar amount.

How do you go about wholesaling? Where do you find outlets to sell your product? What can you expect?

Start by determining what your pricing structure. Earlier in the book I told my story of wholesaling by puppets to Bloomingdale's. As I mentioned in the story, I didn't put any thought at all in my pricing structure *before* I walked in the buyer's door. While I was lucky and it worked out that time, I learned that going in to try to make a sale unprepared was not the smartest thing in the world to do.

Begin looking for retail outlets that might be potential outlets for your product. "Where?" you ask.

Here's a list to get you started.

◎ Boutiques
◎ Gift shops
◎ Department stores
◎ Specialty shops
◎ Craft galleries
◎ Art galleries
◎ Interior decorator companies

◎ Real estate staging companies
◎ Hotels, motels, casinos, and resorts
◎ Wholesale art or craft shows

Check out the yellow pages, surf the internet and look in the newspaper to find specific potential outlets to target to wholesale your work. Remember that the places to which you may want to wholesale do not necessarily need to be in your local area. You can wholesale anyplace you can personally deliver or send your products.

How do you make a contact? It's not as difficult as you might think. Get the phone number to the retail outlet to which you are interested in wholesaling. Call up and ask the name of the buyer of the store or department you are targeting. Then simply call up and ask to speak to the buyer and ask for an appointment. If you are have trouble getting through to someone or getting someone to call you back, refer to Chapter 7: Getting Your Foot in the Door.

While you can also send letters to buyers, I have found making at least an initial phone contact is more effective. Depending on your work, however, you might also want to send a mailing to potential buyers complete with product and pricing sheets.

When you meet with the buyer, bring samples of your work, making sure the samples are perfect. While your products should be able to speak for themselves, be ready to tell the buyer about your art (or craft.) Have you won any awards? Have any celebrities bought your product? What makes your product different from other similar art or craft products?

Don't forget to bring your pricing structure. You want to be able to speak knowledgably about your prices. The buyer may give you an order on the spot or may tell you he or she wants to think about it.

If you do get an order, be sure to find out all the particulars. Who pays shipping costs? Is there a specific delivery method that needs to be used to deliver your order? What is the address of delivery? How do products need to be packaged? Do products need to have specific labeling? What are the payment arrangements?

What else do you need to know? You want to know about the production schedule. In other words, when do you need to deliver the goods? Can you meet the deadline? You should be aware that some organizations won't accept a wholesale order that arrives even one day late.

If you are dealing with an unknown retailer, you might want to ask for payment ahead of time. While you might not be able to get that, you should at least get a deposit of approximately 50% of the order. Depending on the situation, you might also ask for payment C.O.D.

As in all other business transactions, you will want to sign an agreement spelling out all the details of the sale. If you are creating the agreement, include information such as exactly what the order is for, prices, the date it is expected to be delivered, the location the order is to be delivered to, which party is paying shipping or delivery costs, and of course payment information.

The document might state, for example, XLP Gift Shop agrees to pay Rainbow Designs $5,000 via certified bank check upon delivery of merchandise. If the retailer provides the agreement, be sure to read it thoroughly before you sign it. If there is anything that you don't understand or agree to, bring it up before signing as well.

Wholesale Art and Craft Shows

Every industry has trade shows where buyers can purchase products for resale. The art and

craft industry is no exception. Just as there are art shows and craft fairs and festivals for the public, there are similar shows for the wholesale market.

In some cases, big retail art or craft shows will have a one- or two-day wholesale show before their retail event. On those days buyers specifically from the wholesale market can come browse and put in their wholesale orders. There are also shows that are solely geared to the wholesale market.

These shows are a great way for artists or craftspeople to create business relationships with wholesale buyers they might not otherwise get the opportunity to meet with. They are also another wonderful avenue to get exposure for your work as well as giving you the opportunity to sell large orders to retail outlets without having to actually seek each buyer out.

Because of the volume of potential sales from these types of trade shows, exhibit fees are usually higher than traditional art or craft shows. If you are just starting out, this is not the type of show for you. For artists or craftspeople who are ready, however, a wholesale art or craft show can be a tremendous boost to their business.

In order to be effective at these shows make sure you have all your ducks in a row. Can you produce enough quantity of your product to fill sales in a timely basis?

Do you have professional literature? It's imperative you have something to give buyers when they stop by your booth so they remember who you are later. What do you need? Among other things:

◎ Slick printed color fliers
◎ Price sheets
◎ Order forms
◎ Business cards

What else do you need? While it's important to have enough people manning your booth when you are doing a retail show, it's essential at a wholesale show. Losing a sale at one of these events can mean losing big money.

What else? Keep a scheduling book to keep track of when orders are due, when orders must ship, and how many pieces will ship. This will be a lifesaver when a potential buyer wants a huge sale delivered on the same date that you have already promised a big sale.

How do you find these shows? Advertisements for wholesale art or craft shows can often be located in trade magazincs or on the Internet.

Depending on your product, you might also want to look for other trade shows specific to your art or craft. For example, if you are a woodworker creating furniture, you might want to look for a wholesale furniture trade show or a trade show designed for interior designers. If you create handcrafted bears, you might look for a wholesale trade show geared toward toys or bear collectors. Once again, surf the net for opportunities and ideas.

Pricing

It's hard to put a price on your creativity and talent. Therefore, pricing your product is one of the most difficult things to do for an artist or craftsperson. So what do you do? There are a number of different ways to set your price.

Begin by determining what your product costs you to make. What that means is what are the actual costs of the materials you need to create your product? Then determine how long it takes you to make your product. You then have to decide what your hourly rate is. Once you have determined all this, you can determine your minimum base price. Of course, you don't want to sell your product at the minimum price,

so you are going to need to add in your profit margin.

There are some people who simply just double the cost of the product for a 100% markup. Others take the information and then do some additional research. What are other artists or craftspeople selling similar work for? What do you think customers are willing to pay for your work? When you answer these questions, it is often easier to determine the retail price you are comfortable with charging.

Make sure you feel comfortable with your pricing. While you don't want to overprice your work so no one buys it, you certainly don't want to underprice it either.

While many don't agree, I am a firm believer that if you think your work is worth more, you should ask for more. Once you set a price, you can always go down, but it is very difficult to go up. In order to do this, the quality of your product has to be exemplary. It doesn't hurt for your product to have some unique aspects as well. If you feel comfortable with the quality of your product, go for it!

"But what if no one will pay my price?" you ask. "The economy is not great. No one is going to buy my work when they can get something like it less expensive."

Well, they might, and then again they might not. A lot of it has to do with your product. If you are a stained glass artist who is creating the same type of stained glass pieces as other stained glass artists, you probably won't be able to sell your product for more than everyone else. On the other hand, if you have amazing stained glass pieces that don't look like anyone else's, you most definitely can charge more for your pieces and most likely will get it.

Now let's talk about wholesale pricing for a bit. How do you determine your wholesale price? There are no set rules for doing this.

> ### ⭐ Tip from the Coach
> Did you ever wonder why one artist can fetch thousands of dollars for his or her artwork while another similar artist can hardly give his or hers away? Sometimes it just is because one artist had enough confidence in his or her work to ask for that high price. Don't undervalue your talent or your time.

Some individuals simply take their retail price and divide it in half. Others discount their retail price depending on the volume a retailer purchases. In some cases, even though you have set a wholesale price, a retailer may have other ideas. The retailer may, for example, tell you what *they are willing to pay* for your product. You can then make the choice if it is acceptable to you or not. Should you take a lower wholesale price? You have to look at the whole picture. Are you building a lasting relationship with a retailer? Can this lead to more sales? Look at the numbers and see if they make sense. Is it worth a big sale even if the numbers are lower than you wanted them? If so, congratulations; you've made a sale.

Putting Together Your Portfolio

Earlier in the book we talked about your career portfolio. As an artist or a craftsperson, you will also need a portfolio illustrating your work. You might need it for any number of reasons. You might need a portfolio when applying for a job or trying to get a gallery exhibit. You might need one when you are applying for a freelance assignment. You might need it to show your work to a potential buyer.

What exactly is a portfolio? Basically, it is a presentation of samples of your best work. It is used to illustrate your skills and talents to poten-

tial employers, clients, gallery managers, artists' representatives, and so on.

Packaging of your portfolio is important. You want your presentation to be neat and clean. You want it to be pleasing to the eye. Visit an art shop or office supply store to see what type of portfolio cases they have and what will fit your needs best.

Exactly what should your portfolio contain? That depends to a great extent on what you're trying to do. Your portfolio might contain different types of work if you are a fine artist selling paintings to collectors or looking for gallery exhibition than it would if you are a commercial artist aspiring to work in an advertising agency. It will contain different types of work if you are a photographer or a stained glass artist.

Your portfolio may contain photographs of your work, prints, and, in some cases, actual artwork. Some people add in slides or a CD of work as well. Unless you are showing your portfolio to get into school, don't include work in progress. Make sure everything is completed and perfect. If work is matted, be sure it is matted attractively. Your portfolio represents you.

Prepare your portfolio so that it looks professional. Never put anything in your portfolio that does not reflect your best work. No matter what type of artist you are, you want to illustrate that you have technical skills in your medium and a vision.

Your portfolio should illustrate continuity. Try to put things in an order that is easy for the viewer to look through. How many pieces should you include? While it is tempting to show everything, you don't want to overwhelm the person reviewing your portfolio. Ten to twenty pieces are a good number.

Some artists also prepare online versions of their portfolio. These should augment your physical portfolio, not replace it.

Your Artist Statement

When people are interested in an artist or his or her work, they sometimes want to know more about how they think, how they feel, and what their art is all about. As a professional fine artist, one of the things you will want to prepare is your artist's statement.

"What's that?" you ask. In a nutshell, your artist's statement is a short document that will tell others what your art is about. It might focus on either all your work in general or on just one of the pieces of your work.

What does it say? It might explain your creative process or your vision. It might explain why you do what you do. It helps people looking at your artwork understand more about you and your artwork.

It isn't a resume. It isn't a CV. It doesn't tell about your awards or how many paintings you have sold. What it does, however, is help put your art into words. It helps other people see your art through your eyes. It tells others what your art means to *you*. It tells others the techniques you used to create your work. It explains what you believe to be the important aspects of your artwork.

How do you write your artist's statement? Take some time to think about what you want your statement to say. Then sit down with a pencil and paper or at your computer and draft your statement. Here's an example.

I love incorporating the elements of art in my all my work. My paintings illustrate this by showing line, color, and shape. While I enjoy working in a variety of mediums, one of the things that most excites me when painting with oils is the ability to make my picture come to life using an interesting technique I first saw a number of

years ago when on vacation on the beaches of Australia.

Using this particular technique after painting my picture, I crumple a piece of plastic wrap, open it and lightly press it on top of the wet oils letting it dry in the hot sun. While the paint is still slightly tacky, I carefully take the plastic off, creating the amazing illusion of motion. Clouds almost appear to be floating through the sky, the ocean seems to be moving and you can almost see the waves cresting. Looking at each picture done with this method, many can feel that they are seeing the ever-changing sea as well as the horizon.

When writing your artist statement, use simple words and simple wording. You want to explain your work, not bog people down with a long document.

Marketing Your Art or Craft

We discussed marketing and its importance in your career in Chapter 9. What you need to know here is that as an artist or craftsperson, marketing can help advance your career as well. Use every opportunity to market yourself and your product.

What can marketing do for you? Depending on where you are in your career marketing can help establish you as a new artist or craftsperson, help enhance your reputation, help you introduce new products, and, most of all, increase your bottom line.

Before you embark on a marketing program, it's essential for you to determine who your potential customers are. Will you be targeting gallery owners, wholesalers, retailers, or consumers?

Once you know that, you can determine how to market yourself and your art or craft.

Will television exposure help? What about guest appearances on radio shows? Will sending out postcards with your images of your artwork help? What about sending out press releases on a new product or a gallery opening? What about sending e-mail blasts out to your mailing list to tell people who have expressed an interest in your work that you are going to be exhibiting at a craft show? There are a ton of ideas.

In Chapter 9 we discussed the five Ps of marketing and how they related to your career. Let's briefly look at out the five Ps of marketing relate to your art or craft.

- ◎ Product
 - ▫ This is your art or craft.
- ◎ Price
 - ▫ This relates to the price you have determined is best for your products. One of your goals in marketing is getting the best price possible for your work.
- ◎ Positioning
 - ▫ This relates to how you can fill the needs of potential buyers with your products. It also relates to how you and your art or craft are different from your competitors—other artists and craftspeople.
- ◎ Promotion
 - ▫ Promotion relates to the way you promote you and your art or craft to gain visibility in a positive manner. Promotional methods might include a variety of things including advertising, publicity, marketing, public relations, and so on.
- ◎ Packaging
 - ▫ Packaging in this context refers to the way your art or craft looks. Is it unique? Is it good quality? It is finished

properly? Is it done in a professional manner? Just as *your* packaging in the way you look and dress and the way you conduct yourself can affect your career, the packaging of your product can affect sales.

Finding and taking a class or seminar in marketing methods can be very useful to your career. A seminar or workshop geared toward marketing for artists or craftspeople will be even more helpful. These can often be located in community colleges or through business centers or art societies. There are also a number of professional companies which specifically target teaching methods for marketing for artists and craftspeople.

Don't discount the power of marketing in your success as an artist or craftsperson. Use it every opportunity you can. Done correctly, together with your talent, marketing can assist you in creating a presence in the art or craft world that can help catapult you to success.

Dealing with Rejection

As an artist, you are going to learn to deal with rejection. You are going to have to learn to have

> **Tip from the Coach**
> There are hundreds of opportunities in between the point where you might currently be in your career and where you want to be. Becoming a successful artist or craftsperson is a journey. Some people get there faster than others. Whatever your final destination, you can have a successful and fun career getting there. The important thing to remember is to look at every opportunity as a way to get where you want to go.

> **Tip from the Coach**
> Believe in yourself. No one will believe in you, unless you do so first.

a thick skin. Just because someone doesn't like your work does not necessarily mean you are a bad artist. It doesn't mean you are less talented. It doesn't mean that you are no good. It might mean that a buyer saw something they liked better. It means that they might have different taste then you. It might mean that they are jealous and wished it was their work, so they don't like yours. It could mean almost anything.

While it is very easy to start feeling like it's you or feeling rejection or feeling any other number of emotions, try to stop yourself. Train yourself not to take it personally.

What do you do when someone actually *tells* you they don't like your work? What do you do when someone passing by makes a rude comment and says he or she doesn't like your work? What do you do if an art critic pans your work at an exhibit?

If you get a bad review from a critic, let it be that—one person's opinion, one person's perception. If you can learn anything from it, do so. If not, let it go. If someone passing by doesn't like your work, who cares? Everyone has their own opinion. Don't let someone else's

> **Tip from the Coach**
> You might be able to get another opportunity, but you can never get back the opportunity you missed.

opinion or words make you doubt yourself or your talent. Don't let it ruin your day. Just let it go.

No matter what type of artist or craftsperson you aspire to be, you can have a long and successful career. Continue working toward your goals. You will be rewarded with an exciting and fulfilling career that many only dream of.

12

SUCCESS IS YOURS FOR THE TAKING

Do You Have What It Takes?

Art is all encompassing. The influence of art in its various forms surrounds us every day. Perhaps it's not always the traditional fine art many commonly think of when referring to art, but it is a form of art just the same.

Art is not only found in museums and art galleries. It's not only the paintings and pictures we have hanging on the walls or the sculptures or crafts we have decorating our homes. If you look, art is all around us.

The influence of art is in the fabric and clothing we wear every day. It's in the furniture we have in our home. Art influences our dishes and silverware and even the way many of us set our dining room tables. Art influences flower arrangements and gardens. It influences the interiors of homes as well as the exterior landscaping,

Art influences the packaging of many of the products we see in the store and ultimately purchase. It influences the print ads we see in newspapers, magazines, and billboards as well as the commercials we see on television. It influences the sets of movies and television shows we watch. Art influences the covers of books we read and the jackets of CDs we listen to.

Art influences the scenery and sets at plays in theaters as well as the actors' and actresses' costumes. It influences the decorated cakes and desserts we see in bakeries and the way food is arranged on the plates in restaurants. It influences cosmetics women wear as well as their hairstyles. As a matter of fact, without the influence of art, our world would probably be bleak, boring, and blank.

There is virtually no industry that isn't influenced by art in some manner. It isn't surprising then, that there are a myriad of people in a wide array of careers involved in various segments of the art industry. One of them can be you.

Imagine working in an industry knowing you are not only living your dream, you are succeeding. If you are reading this book, you don't have to imagine one more second. You are closer than ever to your dream career in the art industry.

This book was written for every person who aspires to work and succeed in any capacity of the art industry. It was written for those who dream of a career in the talent segment of the industry, those who dream of a career in the business or administrative areas of the industry, and those who dream of a career in any seg-

ment in between. If this is you—and you know who you are—I need to ask you a very important question.

Do you have what it takes?

"What do you mean, do I have what it takes?" you ask.

Do you have what it takes to be successful in this industry?

"Well, I think so," you say.

You think so? That's not good enough. You have to know so! Why? Because if you don't believe in yourself, no one else will.

"Okay," you say. "I get it. I *know* I can be successful."

That's good. That's the attitude you need to succeed!

With that out of the way, let's go over a couple of other facts that can help you in your quest for success in the art industry. You have to remember that no matter what comes your way, you can't give up. Whatever you have to deal with, when you achieve your goals, you most likely will feel it was worth it. There may be stumbling blocks. You may have to take detours. There may even be times when you have to choose a fork in the road. But if you give up, it's over.

Here's another fact you should know. When you share your dreams and goals with others about working in any aspect of the art industry, there will always be some people who insist on telling you their version of the statistics of success (or lack of success) within the industry.

They may try to tell you how few people make it as artists. "Successful artists are few and far behind," someone may say. "You're chances of success are limited."

They may ask you if you think you are special. "Lots of people are talented," someone may say. "What makes you think you will make it?"

They may tell you how many people they have heard about who wanted to be artists (or craftspeople or designers) who tried and failed.

"Why do you want to put yourself through that?" someone may ask. "Why don't you just use art as a hobby and get a real job?"

"You must have heard of starving artists?" someone else might ask. "Do you want to go through your life worrying about where your next dollar is coming from?"

They may tell you that they have heard that graphic artists (or graphic designers, or art directors, or whatever they come up with) are a dime a dozen. "The competition isn't worth it," they may say. "The only people who stand a chance are people with connections."

They may rattle off some statistics they think they have on how many people want to work in a museum and how few jobs there are. They may tell you that they heard that people don't earn a good living in museums because they are not-for profit organizations.

Others might tell you how difficult it is to climb the career ladder in your chosen field. There might be people who quote statistics on everything from burnout and high stress levels within the industry, to the chances of failure, and the list will go on. It probably doesn't matter what area of the art industry in which you are trying to create a career. There will be people who will try to make you feel like if you go after your dreams, statistically you will stand absolutely *no* chance of success at all.

If you listen to those people and start believing them, you probably will become one of their statistics. If you pay attention to them, a career in any aspect of the art industry probably isn't for you. I'm willing to bet that no matter what career you choose and in what industry, there

will be people who will probably have something negative to say about it.

However, if you have gotten to this section of the book, I'm guessing you aren't going to let anyone negatively influence you. I am also betting that you are still going to go after your dream.

Here's something to think about. Let's look at a few analogies. Statistically, it's difficult for most people to lose weight, yet there are many people who do. Statistically, most people who play the lottery don't win—yet there are always winners. Statistically, the chances of winning the Publishers Clearing House Sweepstakes aren't great—yet someone always wins. Will it be you? Not if you don't enter.

With those analogies in mind, I stand behind what I have said throughout this book. No matter what the statistics are, someone has to succeed. Why shouldn't it be you? Someone has to be at the top. Why shouldn't it be you? If you give up your dream, someone else will be there. You will be standing on the outside looking in and watching someone doing what you want. I don't think that's your dream.

Will it be easy? Not always. But the industry is full of fine artists, craftspeople, and designers. It's filled with people who work in art museums in various positions including directors, curators, exhibit designers, exhibit developers, public relations managers, grant writers, marketing directors, development directors, and more.

It's filled with people who work in art galleries and at art shows and craft shows. It's filled with art directors, graphic artists, and graphic designers. It's filled with Web designers. It's filled with interior designers, fabric designers, fashion designers, set designers, and landscape artists. It's filled with art teachers, sketch artists, and art critics.

The industry is full of people working in the business and administration segments of the industry, the talent and creative segments of the industry, the teaching segment of the industry, sales, and everywhere in between. It's full of people working in various trade associations and organizations in all aspects of the art industry. It's full of art historians and researchers, people who develop programs, and more. The industry is huge and all encompassing. It is jam-packed with wonderful and fulfilling opportunities. Why shouldn't you live your dream and be part it?

Many are concerned about their chances for success. Often they are concerned that there are too many variables. Will there be jobs? Will you have to move to a different geographic location? Will you be good enough? Will you be talented enough? Will you get burned out? Will this? Will that? What happens if? And the list goes on.

Many are concerned that in certain parts of the industry, success (or failure) is too dependant on others. What you need to know is that while it is true that others can affect your career, they can't stop it—unless you let it happen. You are in the driver's seat. You can make it happen! What I am saying, in essence, is that the decision to keep on working toward your goal is yours.

You have the power. Are you going to quit?

Here's what I want you to remember. Whether you are dreaming of success in some aspect of the talent, business, or administrative segment of the industry; whether you want to be in the forefront of the industry, behind the scenes, or anywhere in between, know this: You *can* do it and do it successfully as long as you don't give up.

Throughout your journey, always keep your eye on the prize—the great career you are working towards in the art industry.

Sometimes your dreams may change. That's okay. As long as you are following *your* dreams, not those of others, you usually are on the right road.

Whatever segment of the art industry in which you are interested, your choices are huge. What is going to be your contribution to this very important industry?

What path do you want to follow? Where do you envision yourself? What do you see yourself doing? Seize your opportunity. It's there for you. Grab onto your dream to start the ball rolling.

Over the years, I've talked to many people who are extremely successful in a variety of careers and an array of industries. One of the most interesting things about them is that most were *not* surprised at all that they were successful. As a matter of fact, they expected it.

While researching this area, I found that while some decided as young adults what their career path would be, many people knew from the time that they were children what their career choice was. Not only that, they also knew they would be successful and great at their job. Those working in the art industry were no different.

I want to share a story with you, which while isn't about someone in the art industry, does help illustrate the point of just how important a positive focus can be in your career. This focus can help drive you toward success.

One night I was on the road with one of the acts I represented and we were sitting backstage before the concert. I was talking to one of the singers and we were discussing some of the other hot artists in the industry. The singer was telling me a story of another artist who was on the charts.

"We knew he was going to be a star," he said about the other artist. "When he was still in school, he told everyone he was going to be a star, and that's all he talked about."

"Doesn't everyone say that?" I asked.

"Sometimes they do," he continued, "but what made him different was he was specific about what he was going to do and when. He told everyone he was going to have a hit record before he graduated. [At the time, the man hadn't even recorded anything yet.] He started acting like a star and then dressing the part of a star. He went on and on about it so much that he almost had to become a star to save face. Funny thing was, he did have a hit before he graduated and he did turn into a huge star."

This is not an isolated story. There are probably hundreds like it in every industry. Stories like this do help prove the point of just how important not only a positive focus can be in your career but believing in yourself as well. What's really interesting is that in many cases, way before successful people even plan their success, they expect it.

Is it the planning and the work that creates the reality or is it the dream that puts them on the road to success? I think it's a combination.

And in case you're thinking that you're only supposed to expect success in the art industry if your career aspirations are to work in the talent segment of industry, think again. You are supposed to expect success in what ever area of the industry you pursue. Every job is important. Every job can make a difference to someone in

some manner. Every job can ultimately make a difference in your career.

Are you ready for success? Are you really ready?

Do you know what you're going to say when you're being interviewed by the television news after you beat out all the competition to win the opportunity to design an elaborate sculpture for the city? Can you imagine the feeling you will have as you hear the news?

Can you imagine how proud you will feel when you land the job you have been dreaming about as the director of the art museum you have been visiting since you were a child?

Can you imagine how you will feel when you become the art director of the prestigious advertising agency? Can you almost feel the excitement you experience when you and your team create an award-winning ad?

Can you imagine how you will feel when a big department store calls and wants to buy a large quantity of your crafts? Can you just feel the excitement when you have your first gallery show? Can you almost see your sketches on the television news of the courtroom from the big trial?

Can you imagine the feeling you will have when you instill the love of art to your students? Can you imagine the feeling you will have as the art therapist who helped a patient finally make a breakthrough?

Can you imagine what it will feel like to see your paintings hanging on the wall at a museum? Can you imagine how excited you will feel when you get the call telling you got the job? Can you see the press release in the newspaper when you are named for this important position?

Have you chosen the perfect suit you're going to wear to the press conference you are facilitating at the art museum? Can you hear the introduction you are given when you are presenting a paper at a major art conference?

The Inside Scoop

Before writing my first book, I mentioned to a number of people that I wanted to write a book and was looking for a publisher. Their response was always the same. "It is very difficult to get a publisher. It's very hard to write a book. Don't get your hopes up."

While my book wasn't yet written, I had already seen it in my mind. I knew what it would look like; I knew what it was going to say.

I had a plan and told everyone the same story. I was going to send out queries to publishers whose names started with A and go through the alphabet until I reached Z and knew I would find a publisher. The book would be a reality no matter what anyone thought.

By the time I got to the Fs, I had sold my book idea. I wasn't surprised, because I not only knew it could happen; I expected it. That first book, *Career Opportunities In The Music Industry*, is now in its fifth edition. Shortly after that, I sold other book ideas. The rest is history. Over 25 books later...my dream turned into reality.

Can you almost see what you will be wearing when you sign an employment contract? Can you picture what your office will look like?

If not, you should—at least in your mind. Why? Because if you claim something, you're often closer to making it happen.

Over the years, I have heard many similar stories from people who are very successful in their careers of choice. Was it they knew what they wanted to do and focused on it more than others? Was it they had a premonition and things just worked out? Were they just lucky? Were they more talented than others? Was it visualization? Or was it that a positive attitude helped create a positive situation? No one really knows. The only thing that seems evident is that

those who expect to be successful usually have a better chance of achieving it. Those who have a positive attitude usually have a better chance of positive things happening.

We've covered visualization earlier in the book. Whether you believe this theory or not, one thing is for sure: It can't hurt. So start planning your acceptance speech for becoming Artist of the Year. Start planning the party you are going to have you're your book on art history is published.

Plan on what you will say when you are offered the job you wanted. Plan your own celebration for your promotion or for the career of which you've been dreaming. Plan for your own success, and then get ready for it to happen.

Creating a Career You Love

While working toward your perfect career, it's important to combine your goals with your life objectives. The trick to success in any industry is not only following your interests but following your heart. If you're working toward your dream, going that extra mile and doing that extra task won't be a chore.

And when you run into obstacles along the way, they won't be problems, just stepping-stones to get you where you're going.

By now, you have read some (if not all) of this book. You've learned that there are certain things you need to do to stack the deck in your favor no matter what segment of the industry in which you aspire to work.

You know how to develop your resume and a CV, captivating cover letters, career portfolios, business cards, and other tools. You know how to get past the gatekeeper. You know what to do in interviews—and what not to do.

You know how important it is to help develop a plan and know how essential it is to have a good attitude.

You know that it is crucial to read everything before you sign it so you can protect yourself, and you know how important good communications skills are no matter what segment of the art industry you are pursuing.

You know a bit about what it's going to be like working in the talent end of the art industry and you know how to increase your chances of success as an artist, craftsperson, or designer.

You've learned how to network and how to market yourself and your artwork. You've learned some neat little tips and tricks to get your foot in the door. You've learned that you need to find ways to stand out from the crowd.

Most of all, you've learned that it's essential to create a career you love. You've learned that you don't ever want to settle and wonder "what if?"

Creating the career you want and love is not always the easiest thing in the world to accomplish, but it is definitely worth it. In order to help you focus on what you want, you might find it helpful to create a personal mission statement.

Your Personal Mission Statement

There are many people who want a career in various areas of the art industry. Some will make it and some will not. I want you to be the one who makes it. I want you to be the one who succeeds.

Throughout the book, I've tried to give you tips, tricks, and techniques that can help. I've tried to give you the inspiration and motivation to know you can do it. Here's one more thing that might make your journey easier.

Create your personal mission statement. Why? Because your mission statement can help you define your visions clearly. It will

give you a path, a purpose, and something to follow. Most important, putting your mission statement in writing can help you bring your mission to fruition.

What's a mission statement? It's a statement declaring what your mission is in your life and your career. How do you do it? As with all the other exercises you've done, sit down, get comfortable, take out a pen and a piece of paper, and start writing. What is your mission? What do *you* want to accomplish in your career?

Remember that your mission statement is for *you.* You're not writing it for your family, your friends, or your employer. It can be changed or modified at any time.

Think about it for a moment. What do you want to do? Where do you want to be? What's the path you want to take? What are your dreams? What is your mission?

There is no one right way to write your mission statement. Some people like to write it in paragraph form. Others like to use bullets or numbers. It really doesn't matter as long as you get it down in writing. The main thing to remember is to make your statement a clear and concise declaration of your long-term mission.

Your mission statement might be one sentence, one paragraph, or even fill two or three pages. It's totally up to you. As long as your mission statement is clear, you're okay.

Here are some examples of simple mission statements.

◎ Fine artist
 ⊡ My mission is to use my talent, training, education, skills, and passion to become a successful fine artist. I want my work to be critically acclaimed by the best art critics in the world. I want to build up a roster of people who collect and commission my work. I want to be not only financial stable but also very financially successful selling my work.

◎ Art director
 ⊡ My mission is to use my talent, education, training, and skills to have a successful career as an art director in a large, prestigious advertising agency.

◎ Graphics designer
 ⊡ My mission once I get my degree in fine arts is a job designing the graphics for a record label in the music industry. I want to design the graphics for CD covers, T-shirts, and other merchandise. After I get some experience, one of my goals is to eventually start my own graphics business designing the graphics for clients in the music industry.

◎ Art museum exhibit developer
 ⊡ It is my mission to use my passion, talent, and education to develop innovative and interesting new exhibits for art museums. I also want to create a series of exhibits that travel throughout the country so that people who aren't in locations near art museums can still have the experience of visiting one.

◎ Executive director of an art museum
 ⊡ It is my ultimate goal to become the executive director of a major art museum. On the road to accomplishing that goal, I want to hold various jobs in art museums to help prepare myself. It is my mission to start my career working in the development office of an art museum.

◎ Art teacher
- ▫ My mission is to have a career as an elementary school art teacher in a rural area in New York State. I want to use my skills, training, talent, and education to help create a love of art in young children. I eventually would like to write a book to help other teachers and parents find ways to stimulate creativity in children.

◎ Marketing director at an art museum
- ▫ My mission is to combine my love for art with my passion for marketing to create a career handling the marketing for a major art museum.

◎ Courtroom sketch artist
- ▫ My mission is to use my talent, education, skills, and passion to have a career as a courtroom sketch artist. I want my sketches to be the ones that help bring the action of the courtroom to life to those who are not there.

◎ Interior designer
- ▫ My mission is to use my passion of design, fabrics, and colors to have a great career as an interior designer. I want to turn houses into beautiful homes. One of my goals is do the interior design for celebrity homes. Another goal is to "stage" homes to help homeowners who want to sell their home do so quickly and effectively. I also want to write a book on using interior design to turn your house into a home. (I want it to be a best seller.)

◎ Fashion designer
- ▫ My mission is to be a fashion designer. I specifically want to design clothing for women in the workplace. I also want to design a line of attractive maternity clothing for women in the workplace. It is my goal to not only have my own line of clothing in the next five years but have it selling in all the top department stores.

> ⭐ **Tip from the Coach**
> Put your personal mission statement on post-it notes and stick them up all around to help keep you focused.

What do you do with your mission statement? Use it! Review it to remember what you're working toward. Use it as motivation. Use it to help you move in the right direction.

You would be surprised how many successful people have their personal mission statement hanging on their wall, taped to their computer, or in their pocket. I know individuals who keep a copy of their mission statement in their wallet; taped to their bathroom mirror; and placed in the inside of a desk drawer or in another location where they can regularly glance at it.

Wherever you decide to place your mission statement, be sure to look at it daily so you can always keep your mission in mind. It makes it easier to keep focus on your ultimate goal.

Success Strategies

We have discussed marketing, promotion, and publicity. Used effectively, they can help your career tremendously. Here's what you have to remember. Don't wait for someone else to recognize your skills, accomplishments, and tal-

ents; promote yourself. There are many keys to success. Self-promotion is an important one.

Don't toot your own horn in an annoying or obnoxious manner, but make sure people notice you. You want to stand out in a positive way. Don't keep your accomplishments a secret. Instead claim them proudly.

We've all been taught to be modest. "Don't boast," your mother might have said as you were growing up. But if your goal is success in your career, sometimes you can just be too quiet for your own good.

Your ultimate challenge is to create buzz. You need to create spin. You need others to know what you've done and what you're doing in the future. Some people aren't willing or able to do what it takes. If you want to succeed, it's imperative that you get started. Buzz doesn't usually happen overnight, but every day you wait is another day you're behind in the job.

Begin to think like a publicist. Whatever segment of the art industry you're working in, you need to constantly promote yourself or no one will know you exist. While others may help, the responsibility really is on *you* to make your career work and make your career successful.

No matter what segment of the industry you are in, or what level you are at, continue to look for opportunities of all kinds. Search out opportunities to move ahead in your career and then grab hold of them.

You need to be aware that in your life and career, on occasion, there may be doors that close. The trick here is not to let a door close without looking for the window of opportunity that is always there. If you see an opportunity, jump on it immediately. It is usually there just waiting for you!

Throughout the book we've discussed the importance of networking. Once you become

> ### ★ The Inside Scoop
> Don't procrastinate when an opportunity presents itself. Someone else is always on the lookout just like you, and you don't want to miss your chances.

successful, it's important to continue to network. Just because you landed a new job as the assistant director of fund raising in an art museum, doesn't mean you don't want to meet other people in fund raising, marketing, and development. Just because you just landed a job in an art gallery doesn't mean you don't want to meet other people in other galleries. Just because you sold your crafts to one store doesn't mean you don't want to sell your work in other places. Just because you've landed a new job as a curator doesn't mean you don't want to meet other people in the industry.

Once you've landed a new job, keep networking. Continue meeting people. Continue getting your name out there. You can never tell who knows who and what someone might need. There are always new opportunities ahead, and if you don't keep networking, you might miss some of them. Keep nurturing your network and developing contacts. This is also true as your career progresses. Keep on networking, meeting people, and making contacts. It is essential to the success of your career.

Don't be afraid to ask for help. If you know someone who can help you in your career, ask. The worst they can say is no. The best that can happen is you might get some assistance. Of course, if you can help someone else do that as well.

Always be prepared for success. It might be just around the corner. Whatever segment of

the industry you are pursuing, continue honing your skills. Keep taking classes, attending seminars, and going to workshops. If you want to move up the ladder and there are exams, prepare for them and then take them.

Every industry continues to change and evolve. Keep up with the trends, read the trades, and make sure you know what is happening today.

Don't get caught into the thought pattern of "that's not how we did it in my other job." Get used to the idea that in our ever-changing world, there will be change. Instead of pushing it away or making believe it doesn't exist, embrace it. You might just come up with a better or more effective way to do things.

Stay as fit and healthy as you can. Try to eat right, get sleep, exercise, and take care of yourself. After all your hard work, you don't want to finally succeed and be too sick or tired to enjoy it.

Stay away from illegal drugs. Don't take them and don't hang around with people who take them. Why? Aside from the obvious, you don't want anyone or anything hurting your career.

Whatever facet of the industry you are involved with, you are going to be selling yourself. You might be selling yourself to a hiring committee or a human resources manager. You might be selling yourself to a gallery manager or the director of a department.

What else? You might be selling or *pitching* your story for publicity or a variety of other situations. You might be selling your artwork, your crafts, or your designs. Take a lesson from others who have made it to the top and prepare ahead of time. That way, when you're in a situation where you need to say something, you'll be ready.

Sales skills are essential. Know that you are the best and know how to sell yourself the best

> ### ⭐ Tip from the Coach
>
> They say it takes approximately 21 days to break one habit and form a new one. With that in mind, if there is any habit you have that bothers you or is detrimental to your career, or any part of your life for that matter, know that you can not only change it but do so fairly quickly. If, for example, you find yourself speaking over others when they are talking, begin today by consciously making an effort to listen, then speak. You will find that if you continue to do that on a daily basis, soon it will become a habit.
>
> Similarly, if you are told that you are negative at work, start today by consciously making an effort to be positive. Before you make a comment about something, stop, think about what you are saying, and try to put a positive spin on it. Continue doing this, and a few weeks later, you will find that not only will your attitude be perceived more positively, it will be more positive.

way possible. Come up with a pitch and practice it until you're comfortable.

Always be positive. A good attitude is essential in your life and your professional success. Here's the deal. We've discussed this before. People want to be around other people who are positive. If there is a choice between two people with similar talents and skills and you have a better outlook than anyone else, a more positive type of personality and passion, you're going to be chosen. You're going to get the job. You're going to succeed.

Change the way you look at situations and the situations you look at will change. What does that mean? If you look at a situation as a problem, it will be a problem. If, on the other hand, you look at a situation as an opportunity, it becomes one.

If all you see are the trials and tribulations of trying to succeed in your career in the art industry, all you will have are trials and tribulations. If, on the other hand, you look at the road to success in this industry as a wonderful and exciting journey, it will be.

Keep Things Confidential

Privacy and confidentiality are crucial in every industry, and the art industry in no exception. What this means is that it is your responsibility to keep people's names and issues private and confidential when required.

Climbing the Career Ladder

Generally, whatever you want to do in life, you most likely are going to have to pay your dues. Whatever segment of the industry you've chosen to pursue, most likely you're going to have to pay your dues as well. Now that we've accepted that fact, the question is, how do you climb the career ladder? How do you succeed?

How do you go, for example, from a job as an administrative assistant to the coordinator of a department? How do you move up to become a supervisor? How do you go from a job as an assistant director to the full-fledged director of a department?

How do you move from a position as a local art critic for a weekly paper to becoming a successful art critic for a major publication? How do you go from a weekend craftsperson to a successful full-time craftsperson? How do you go

from a fledging artist to one who is sought out? How do you move up the ladder from a position as a graphic artist to an art director? How do you get that promotion? How do you climb the career ladder?

There are many things you're going to have to do to climb the career ladder, but it can be done. We've covered a lot of them. Work hard, keep a positive attitude, and act professionally at all times. Stay abreast of the changes in the industry, network, and hone your skills and talents so you can back up your claims of accomplishments.

Look for a mentor who can help you move your career in the right direction and propel you to the top of your field. Join trade associations and the unions. Read the trades; take seminars, classes, and workshops; and take part in other learning opportunities. Continue your education when you can. Be the best at what you do. Keep your goal in mind.

Look at every opportunity with an open mind. When you're offered something, ask yourself:

◎ Is this what I want to be doing?
◎ Is this part of my dream?
◎ Is this part of my plan for success?
◎ Is this opportunity a stepping-stone to advancing my career?
◎ Will this experience be valuable to me?
◎ What are the pros?
◎ What are the cons?

Fortunately or unfortunately, job progression in this industry doesn't always follow the normal or traditional career path. An artist who is virtually unknown one day may get a big break and be sought out before his or her counterparts who have been trying for success for a longer period of time. An unknown artist or craftsperson, for example, may get a mention on *Oprah* about

his or her work and be catapulted to tremendous success in a fairly short period of time.

An assistant director of fund-raising in a museum may land a number of large grants or donations and be named the director of development before the fund-raising director who has seniority. Similarly, a graphic artist who creates a great campaign for a client may become an art director before another employee who has been there longer.

It all depends. If success can happen to someone else, it might happen to you. That is one of the greatest things about your career. You just never know what tomorrow might bring.

You never know when a chance meeting is going to land you a great job, or someone passing through town might see read about one of your accomplishments in a local newspaper and recruit you for a position in a larger or more prestigious museum, organization, company, or situation. You never know who will tell a headhunter, recruiter, or human resources director about you and when you will get a call. You never know when someone will be at an art show where you are exhibiting and decide that they want to commission you to do the artwork for a major project. You really never know when success will come your way. It can happen at any time.

It should be noted that success means different things to different people. There are many people who work in local art societies, lesser known art museums, and small advertising agencies. There are many people working in museums who never become the executive director or even a director or department head. There are artists and craftspeople who are successfully making a living, yet they are not well known. There are fashion designers and accessory designers who are doing well, yet not household names. There are interior designers who, while earning a good living, are not designing homes for the rich and famous. Yet these people are all still successful. They are earning a living, doing what they love, and living their dream.

There are thousands of individuals working in all segments of the art industry and the peripheral fields who may not be the ones you hear of or might not be the ones winning the awards. That doesn't preclude them from having a successful career. To the contrary, they are successful just the same.

It's important to realize that no matter what your job, it almost always has some sort of an impact on others. Every job can make a difference—even if it's just a little one. And that little difference can make a big difference in the lives of others as well as you.

Risk Taking—Overcoming Your Fears

Everyone has a comfort zone from which they operate. What's a comfort zone? It's the area where you feel comfortable both physically and psychologically. Most of the time, you try to stay within this zone. It's predictable, it's safe, and you generally know what's coming.

Many people get jobs, stay in them for years, and then retire. They know what's expected of them. They know what they're going to be doing. They know what they're going to be getting. The problem is that it can get boring, there's little challenge, and your creativity can suffer.

★ **Tip from the Coach**

If you're starting to feel comfortable in your career or starting to feel bored, it's time to step out of your comfort zone and look for new challenges.

Stepping out of your comfort zone is especially important to your career. Wanting to step out of your comfort zone is often easier said than done, but every now and then you're going to have to push yourself.

The key to success in your career as well as your own personal growth is the willingness to step outside of your comfort zone. Throughout your career you're going to be faced with decisions. Each decision can impact your career. Be willing to take risks. Be willing to step out of your comfort zone.

Is it scary? Of course, but if you don't take risks you stand the chance of your career stagnating. More important, you take the chance of missing wonderful opportunities.

Should you take a promotion? Should you stay at the same job? Should you go to a different department? Should you move from a small organization to a large one? Should you go back to school? Should you move? Should you start your own business? Should you take a chance?

How do you make the right decision? Try to think about the pros and cons of your choices. Get the facts, think about them, and make your decision.

"What if I'm wrong?" you ask.

Here's the good news. Usually you *will* make the right decision. If by chance you don't, it's generally not a life and death situation. If you stay at the same job and find you should

have left, for example, all you need to do is look for a new job. If you change jobs and you're not happy, you can usually find a new job as well. Most things ultimately work out. Do the best you can and then go on.

If your career is stagnant, do something. Don't just stay where you are because of the fear of leaving your comfort zone and the fear of the unknown.

Some Final Thoughts

No matter where you are in your career, don't get stagnant. Always keep your career moving. Once you reach one of your goals, your journey isn't over. You have to keep set new goals and move on to reach them.

Keep working toward your goal. It can happen. Don't settle for less than what you want. Every goal you meet is another steppingstone toward an even better career no matter what segment of the industry you are pursuing.

While I would love to promise you that after reading this book you will become a better artist, a more talented designer, a sought-after craftsperson, the executive director of one of the most prestigious art museums in the world, a sought-after art critic, or the art director of a prominent advertising agency, unfortunately I can't.

What I can tell you is that the advice in this book can help you move ahead and stack the deck in your favor in this industry. I've given you the information. You have to put it into action.

There are numerous factors that are essential to your success. You need to be prepared. There's no question that preparation is necessary. Talent in your field is critical as well. Being in the right place at the right time is essential, and good luck doesn't hurt. Perseverance is vital to success, no matter what you want to do, what

> ★ **Words from the Wise**
> Persevere. The reason most people fail is because they gave up one day too soon.
> —Shelly Field

area of the industry you want to enter, and what career level you want to achieve.

Do you want to know why most people don't find their perfect job? It's because they gave up looking *before* they found it. Do you want to know why some people are on the brink of success yet never really get there? It's because they gave up.

Do you want to know what single factor can increase your chances of success? It's perseverance! Don't give up.

Have fun reading this book. Use it to jump-start your career and inspire you to greater success and accomplishments. Draw on it to achieve your goals so you can have the career of your dreams. Use it so you don't have to look back and say, "I wish I had." Use it instead so you can say, "I'm glad I did."

I can't wait to hear about your success stories. Be sure to let us know how this book has helped your career by logging on to http://www.shellyfield.com. I would also love to hear about any of your own tips or techniques for succeeding in any aspect of the art industry. You can never tell. Your successes might be part of our next edition.

APPENDIX I

TRADE ASSOCIATIONS, UNIONS, AND OTHER ORGANIZATIONS

Trade associations, unions, and other organizations can be valuable resources for career guidance as well as professional support. This listing includes many of the organizations related to the art industry. Names, addresses, phone numbers, fax numbers, e-mail addresses, and Web sites (when available) have been included to make it easier for you to obtain information. Check out the Web sites to learn more about organizations and what they offer.

Advertising Photographers of America
PO Box 250
White Plains, NY 10605
800-272-6264
(888) 889-7190 (fax)
president@apanational.com
http://www.apanational.org

Affiliated Woodcarvers (AWC)
PO Box 104
Bettendorf, IA 52722
(563) 359-9684
cornwell@dpc.net
http://www.awcltd.org

African American Visual Arts Association (AAVA)
3403 Milford Mill Road
Baltimore, MD 21244
(410) 521-0660
(410) 521-4053 (fax)
gboone8715@aol.com
http://aavaa.org

Aid To Artisans (ATA)
331 Wethersfield Avenue
Hartford, CT 06114
(860) 947 3344
(860) 947 3350 (fax)
http://aidtoartisans.org

Alliance for American Quilts (AAA)
PO Box 6521
Louisville, KY 40206
(502) 897-3819
(502) 897-3819 (fax)
info@quiltalliance.org
http://www.quiltalliance.org

Alliance For The Arts (AFTA)
330 W 42nd Street

New York, NY 10036
(212) 947-6340
(212) 947-6416 (fax)
info@allianceforarts.org
http://www.allianceforarts.org

Alliance of Artists Communities

255 S Main Street
Providence, RI 02903
(401) 351-4320
(401) 351-4507 (fax)
aac@artistcommunities.org
http://www.artistcommunities.org

Alliance of Professional Tattooists (APT)

9210 S Highway 17-92
Maitland, FL 32751
(407) 831-5549
into@safe-tattoos.com
http://www.safe-tattoos.com

Allied Artists of America (AAA)

15 Gramercy Park South
New York, NY 10003
(212) 582-6411
ronbeuzenburg@alliedartistsofamerica.org
http://www.alliedartistsofamerica.org

American Abstract Artists (AAA)

194 Powers Street
Brooklyn, NY 11211
americanabart@aol.com
http://www.americanabstractartists.org

American Advertising Federation (AAF)

1101 Vermont Avenue NW
Washington, DC 20005
(202) 898-0089
(202) 898-0159 (fax)
aaf@aaf.org
http://www.aaf.org

American Art Deco Dealers Association (AADDA)

PO Box 2454
Cordova, TN 38088
aadda@bellsouth.net
http://www.aadda.org

American Artists of Chinese Brush Painting (AACBP)

PO Box 4256
Huntington Beach, CA 92605
aacbp@purpleweb.com
http://www.aacbp.org

American Artists Professional League (AAPL)

47 Fifth Avenue
New York, NY 10003
(212) 645-1345
(212) 645-1345 (fax)
aaplinc@aol.com
http://www.americanartistsprofessionalleague.org

American Arts Alliance

1112 16th Street NW
Washington, DC 20036
(202) 207-3850
(202) 833-1543 (fax)
rlyons@artspresenters.org
http://www.americanartsalliance.org

American Art Therapy Association (AATA)

1202 Allanson Road
Mundelein, IL 60060
(847) 949-6064
(847) 566-4580 (fax)
info@arttherapy.org
http://www.arttherapy.org

American Association of Advertising Agencies (AAAA)

405 Lexington Avenue
New York, NY 10174
(212) 682-2500
http://www.aaa.org

American Association of Museums (AAM)

1575 Eye Street. NW
Washington, DC 20005
(202)289-1818
(202)289-6578 (fax)
aam-icom@aam-us.org
http://www.aam-us.org

American Association of University Professors (AAUP)

1012 14th Street, NW
Washington, DC 20005
(207) 737-5900
aaup@aaup.org
http://www.aaup.org

American Color Print Society (ACPS)

c/o Ms. Marlene Adler
2090 Jenkintown Road
Glenside, PA 19038
idwill@patmedia.net
http://www.americancolorprintsociety.org

American Craft Council (ACC)

72 Spring Street
New York, NY 10012
(212) 274-0630
(212) 274-0650 (fax)
council@craftcouncil.org
http://www.craftcouncil.org

American Design Drafting Association (ADDA)

105 E Main Street
Newbern, TN 38059

(731) 627-0802
(731) 627-9321 (fax)
corporate@adda.org
http://www.adda.org

American Federation of Teachers (AFT)

555 New Jersey Avenue. NW
Washington, DC 20001
(202) 879-4400
(202) 879-4545 (fax)
online@aft.org
http://www.aft.org

American Guild of Judaic Art (AGJA)

15 Greenspring Valley Road
Owings Mills, MD 21117
(410) 902-0411
(410) 581-0108 (fax)
office@jewishart.org
http://www.jewishart.org

American Institute for Conservation of Historic and Artistic Works (AICHAW)

1717 K Street, NW
Washington, DC 20006
202-452-9545
info@aic-faic.org
http://aic.stanford.edu

American Institute of Graphic Arts (AIGA)

164 Fifth Avenue
New York, NY 10010
(212) 807-1990
(212) 807-1799 (fax)
comments@aiga.org
http://www.aiga.org

American Photographic Artists Guild (APAG)

c/o John McCarthy, President
568 Main Street

Wilbraham, MA 01095
fordstudio@comcaStreetnet
http://apag.net

American Print Alliance

302 Larkspur Turn
Peachtree City, GA 30269
printalliance@mindspring.com
http://www.printalliance.org

American Sewing Guild (ASG)

9660 Hillcroft
Houston, TX 77096
(713) 729-3000
(713) 721-9230 (fax)
info@asg.org
http://www.asg.org

American Society of Artists (ASA)

PO Box 1326
Palatine, IL 60078
(312) 751-2500
asoa@webtv.net
http://www.americansocietyofartists.com

American Society of Botanical Artists (ASBA)

47 Fifth Avenue
New York, NY 10003
(212) 691-9080
(212) 691-9130 (fax)
asba@aol.com
http://huntbot.andrew.cmu.edu/ASBA/as-botartists.html

American Society of Contemporary Artists (ASCA)

c/o Joseph Lubrano, President.
130 Gale Place, 9H
Bronx, NY 10463
(718) 548-6790
http://www.anny.org/2/orgs/0050/asca.htm

American Society of Interior Designers (ASID)

608 Massachusetts Ave. NE
Washington, DC 20002
(202) 546-3480
(202) 546-3240 (fax)
asid@asid.org
http://www.interiors.org

American Society of Magazine Photographers (ASMP)

150 N Second Street
Philadelphia, PA 19106
(215) 451-2767
(215) 451-0880 (fax)
mopsik@asmp.org
http://www.asmp.org

American Society of Marine Artists (ASMA)

PO Box 369
Ambler, PA 19002
asma@icdc.com
http://www.americansocietyofmarineartists.com

American Society of Landscape Architects

636 Eye Street NW
Washington, DC 20001
(202) 898-2444
(202) 898-1185 (fax)
nsomerville@asla.org
http://www.asla.org

American Society of Media Photographers Inc.

150 N Second Street
Philadelphia, PA 19106
(215) 451-2767
(215) 451-0880 (fax)
mopsik@asmp.org
http://www.asmp.org

American Society of Portrait Artists (ASOPA)

PO Box 230216
Montgomery, AL 36106
800-622-7672
info@asopa.com
http://www.asopa.com

Americans for the Arts

1000 Vermont Avenue NW
Washington, DC 20005
(202) 371-2830
(202) 371-0424 (fax)
bookstore@arts.org
http://www.arts.org

Animators Unite

525 85th Street
Brooklyn, NY 11209
rkohr@animatorsunite.com
http://www.animatorsunite.com

Art Dealers Association of America (ADAA)

575 Madison Avenue
New York, NY 10022
(212) 940-8590
(212) 940-6484 (fax)
adaa@artdealers.org
http://www.artdealers.org

Art Directors Club (ADC)

106 W 29th Street
New York, NY 10001
(212) 643-1440
(212) 643-4266 (fax)
info@adcglobal.org
http://www.adcglobal.org

Art Dreco Institute (ADI)

PMB 131

2570 Ocean Avenue
San Francisco, CA 94132
(415) 333-8372
director@artdreco.com
http://www.artdreco.com

Artists Helping Artists (Aha!)

300 Redwood Drive
Santa Cruz, CA 95060
(831) 457-2476
ahawonders88@yahoo.com
http://www.artistshelpingartists.org

Artists Rights Society (ARS)

536 Broadway
New York, NY 10012
(212) 420-9160
(212) 420-9286 (fax)
info@arsny.com
http://www.arsny.com

Art Students League of New York

215 W 57th Street
New York, NY 10019
(212) 247-4510
(212) 541-7024 (fax)
info@artstudentsleague.org
http://www.theartstudentsleague.org

Association of Art Museum Directors (AAMD)

41 East 65th Street
New York, NY 10021
212-249-4423
http://www.aamd.org

Association of Internet Professionals (AIP)

4790 Irvine Boulevard
Irvine, CA 92620
(866) 247-9700

info@association.org
http://www.association.org

Association of Medical Illustrators (AMI)

5475 Mark Dabling Boulevard
Colorado Springs, CO 80918
(719) 598-8622
ami@capsys.com
http://medical-illustrators.org

Association of Moving Image Archivists (AMIA)

1313 North Vine Street
Hollywood, CA 90028
(323) 463-1500
amia@amianet.org
http://amianet.org

Association of Stylists and Coordinators (ASC)

24 Fifth Avenue
New York, NY 10011
(212) 780-3483
http://www.stylistsASC.com

Ceramic Manufacturers Association (CMA)

47 North Fourth Street
Zanesville, OH 43701
(740) 588 0828
(740) 588 0273 (fax)
http://www.cerma.org/index.html

College Art Association (CAA)

275 Seventh Avenue
New York, NY 10001
(212)691-1051
(212)627-2381
nyoffice@collegeart.org
http://www.collegeart.org

Costume Designers Guild (CDG)

4730 Woodman Avenue
Sherman Oaks, CA 91423
(818) 905-1557
(818) 905-1560 (fax)
cdgia@earthlink.net
http://www.costumedesignersguild.com

Costume Society of America (CSA)

55 Edgewater Drive
PO Box 73
Earleville, MD 21919
(800) 272-9447
national.office@costumesocietyamerica.com
http://www.costumesocietyamerica.com

Craft and Hobby Association

319 East 54th Street
Elmwood Park, NJ 07407
(201) 794-1133
(201) 797-0657 (fax)
http://www.hobby.org

Custom Tailors and Designers Association of America (CTDAA)

P.O. Box 53052
Washington, DC 20009
(202) 387-7720
http://www.ctda.com

Federation of Modern Painters and Sculptors (FMPS)

c/o Anneli Arms
113 Greene Street
New York, NY 10012
(212) 966-4864
(212) 966-4864 (fax)
aarms2001@yahoo.com

Folk Art Society of America (FASA)

PO Box 17041
Richmond, VA 23226

800-527-FOLK
fasa@folkart.org
http://www.folkart.org

Graphic Artists Guild
90 John Street
New York, NY 10038
(212) 791-3400
(212)791-0333 (fax)
admin@gag.org
http://www.gag.org

Guild of Fine Craftsmen and Artisans
c/o Leland R.S. Torrence
17 Vernon Court
Woodbridge, CT 06525
(203) 397-8505
(203) 389-7516 (fax)
info@lelandtorrenceenterprises.com
http://www.lelandtorrenceenterprises.com/guild.
html

Guild of Natural Science Illustrators (GNSI)
PO Box 652
Ben Franklin Station
Washington, DC 20044
(301) 309-1514
gnsihome@his.com
http://www.gnsi.org

Hispanic American League of Artists
c/o Luis Figueroa
1301 Maumee Avenue
Allentown, PA 18103
(610) 570-4368
luissalsa@yahoo.com
http://grupohala.com

Industrial Designers Society of America (IDSA)
45195 Business Court

Dulles, VA 20166
(703) 707-6000
http://www.idsa.org

Intermuseum Conservation Association (ICA)
2915 Detroit Avenue
Cleveland, OH 44113
(216) 658-8700
http://www.ica-artconservation.org

International Animated Film Society (IAFS)
2114 Burbank Boulevard
Burbank, CA 91506
(818) 842-8330
info@asifa-hollywood.org
http://www.asifa-hollywood.org

International Artists Network (IAN)
PO Box 182
Bowdoinham, ME 04008
(207) 666-8453

International Arts and Artists (IA&A)
9 Hillyer Court NW
Washington, DC 20008
(202) 338-0680
(202) 333-0758 (fax)
info@artsandartists.org
http://www.artsandartists.org

International Association of Art Critics - United States Section (AICA)
35-15 84th Street, No. 3D
Jackson Heights, NY 11372
(718) 478-2929
(718) 478-2916 (fax)
board@aica.org
http://www.aica.org

International Association of Pastel Societies (IAPS)

PO Box 2057
Falls Church, VA 22042
(703) 241-2826
(703) 536-0308 (fax)
sn@pastelinternational.com
http://www.pastelinternational.com

International Chain Saw Wood Sculptors Association (ICSWSA)

c/o Tom Rine
14041 Carmody Drive
Eden Prairie, MN 55347
(952) 934-8400
(612) 378-4778 (fax)

International Comic Arts Association (ICAA)

533 Johnson Avenue
Morris, IL 60450
(815) 942-1819
info@comicarts.org
http://www.comicarts.org

International Doll Makers Association (IDMA)

c/o Sherlyn Lovell, President
1110 Jungle Drive
Duncanville, TX 75116
(972) 298-5662
srlovell@swbell.net
http://www.idmadolls.com

International Colored Gemstone Association

19 W 21st Street
New York, NY 10010
(212) 620-0900
(212) 352-9054 (fax)

ica@gemstones.org
http://www.gemstone.org

International Guild of Glass Artists (IGGA)

c/o Katherine Bell, Membership Director
4735 Waverly Lane
Jacksonville, FL 32210
(904) 388-4213 (fax)
jpreston43@cfl.rr.com
http://www.igga.org

International Guild of Miniature Artisans (IGMA)

PO Box 629
Freedom, CA 95019
(831) 724-7974
(831) 724-8605 (fax)
info@igma.org
http://www.igma.org

International Quilt Association (IQA)

7660 Woodway
Houston, TX 77063
(713) 781-6864
(713) 781-8182 (fax)
iqa@quilts.com
http://www.quilts.org

International Society of Copier Artists (ISCA)

759 President Street, No. 2H
Brooklyn, NY 11215
(718) 638-3264
isca4art2b@aol.com

International Society of Glass Beadmakers (ISGB)

1120 Chester Avenue, No. 470
Cleveland, OH 44114
888-742-0242
(216) 696-2582 (fax)

president@isgb.org
http://www.isgb.org

Landscape Artists International (LAI)
c/o Karl Eric Leitzel
Karl Eric Leitzel Studio
155 Murray School Lane
Spring Mills, PA 16875
(814) 422-8461
karl@keleitzel.com
http://l-a-i.com

National Art Education Association (NAEA)
1916 Association Drive
Reston, VA 20191
(703) 860-8000
naea@dgs.dgsys.com
http://www.naea-reston.org

National Artists Equity Association (NAEA)
c/o Artists Equity
PO Box HG
Pacific Grove, CA 93950
(831) 479-7226
duffyart@sbcglobal.net
http://www.artists-equity.org

National Art Materials Trade Association
15806 Brookway Drive
Huntersville, NC 28078
(704)892-6244
(704)892-6247 (fax)
info@namta.org
http://www.namta.org

National Arts Foundation
4444 Oakton Street
Skokie, IL 60076
(847) 674-7990

(847) 675-8116 (fax)
info@nafgallery.com
http://www.nafgallery.com

National Assembly of State Arts Agencies (NASAA)
1029 Vermont Avenue NW
Washington, DC 2005
(202) 347-6352
nasa@nasaa-arts.org
http://www.nasaa-arts.org

National Association of Artists and Crafters (NAAC)
c/o Founding Comm.
8630-M Guilford Road
PMB No. 300
Columbia, MD 21046
(410) 744-2296
info@nationalaac.org
http://www.nationalaac.org

National Association of Artists' Organizations (NAAO)
c/o Intermedia Arts
2822 Lyndale Avenue South
Minneapolis, MN 55408
(612) 871-4444
info@naao.net
http://www.naao.net

National Association of Independent Artists (NAIA)
72 Douglas Street
Homosassa, FL 34446
michaelkopald@naia-artists.org
http://naia-artists.org

National Association of Latino Arts and Culture (NALAC)
1204 Buena Vista Street

San Antonio, TX 78207

(210) 432-3982

(210) 432-3934 (fax)

info@nalac.org

http://www.nalac.org

National Association of Schools of Art and Design (NASAD)

11250 Roger Bacon Drive

Reston, VA 20190

(703) 437-0700

info@arts-accredit.org

http://www.www.arts-accredit.org/nasad

National Association of Women Artists (NAWA)

80 Fifth Avenue, Ste. 1405

New York, NY 10011

(212) 675-1616

(212) 675-1616 (fax)

nawomena@msn.com

http://www.nawanet.org

National Cartoonists Society (NCS)

1133 W Morse Boulevard

Winter Park, FL 32789

(407) 647-8839

(407) 629-2502 (fax)

phil@crowsegal.com

http://www.reuben.org

National Center of Afro-American Artists (NCAAA)

c/o Mr. Edmund Barry Gaither, Director

300 Walnut Avenue

Boston, MA 02119

(617) 442-8614

(617) 445-5525 (fax)

bgaither@mfa.org

http://www.ncaaa.org

National Costumers Association (NCA)

6914 Upper Trail Circle

Mesa, AZ 85207

(800) 622-1321

http://www.costumers.org

National Council on Education For The Ceramic Arts

77 Erie Village Square

Erie, CO 80516

(303) 828-2811

(303) 828-0911 (fax)

office@nceca.net

http://www.nceca.net

National Crafts Association

2012 E. Ridge Rd.

Suite 120, Rochester, NY 14622

(212) 274 0650

(212) 274 0650 (fax)

http://www.craftassoc.com/index.shtml

Natural Figure Art Association (NFAA)

PO Box 374

Stockholm, NJ 07460

(973) 697-6773

fineart@writeme.com

National Foundation for Advancement in the Arts (NFAA)

444 Brickell Avenue, P-14

Miami, FL 33131

(305) 377-1140

(305) 377-1149 (fax)

info@nfaa.org

http://www.artsawards.org

National Institute of American Doll Artists (NIADA)

c/o Diana Rew, Treasurer

8320 Maplewood Street

Lenexa, KS 66215
(913) 894-2382
(913) 888-5167 (fax)
rewbird@aol.com
http://www.niada.org

National Museum of Women in the Arts (NMWA)

Library and Research Center
1250 New York Avenue NW
Washington, DC 20005
(202) 783-7365
(202) 393-3234 (fax)
library@nmwa.org
http://www.nmwa.org/library

National Needle Arts Association

PO Box 3388
Zanesville, OH 43702
(740) 455-6773
(740) 452-2552 (fax)
tnna.info@offinger.com
http://www.tnna.org

National Polymer Clay Guild (NPCG)

1350 Beverly Road, Suite 115-345
McLean, VA 22101
info@npcg.org
http://www.npcg.org

National Press Photographers Association (NPPA)

3200 Croasdaile Drive
Durham, NC 27705
(919) 383-7246

National Sculpture Society (NSS)

237 Park Avenue
New York, NY 10017
(212) 764-5645
(212) 764-5651 (fax)

info@nationalsculpture.org
http://www.nationalsculpture.org

National Society of Artists (NSA)

PO Box 1885
Dickinson, TX 77539
(281) 337-4232
rmorris@houston.rr.com
http://www.nsartists.org

National Society of Mural Painters (NSMP)

450 W 31st Street
New York, NY 10001
(212) 244-2800
info@nationalsocietyofmuralpainters.com
http://nationalsocietyofmuralpainters.com

National Society of Painters in Casein and Acrylic (NSPCA)

969 Catasauqua Road
Whitehall, PA 18052
(610) 264-7472
psychoanalyze@softhome.net
http://www.bright.net/~paddy-o/art/nspca.htm

National Watercolor Society (NWS)

915 S Pacific Avenue
San Pedro, CA 90731
(310) 831-1099
nws-website@cox.net
http://www.nws-online.org

New York Artists Equity Association (NYAEA)

c/o Regina Stewart, Exec. Dir.
498 Broome Street
New York, NY 10013
(212) 941-0130
(212) 941-0138 (fax)
reginas@anny.org
http://www.anny.org/2/orgs/0033/nyae.htm

Oil Painters of America (OPA)

PO Box 2488
Crystal Lake, IL 60039
(815) 356-5987
(815) 356-5987 (fax)
mail@oilpaintersofamerica.com
http://www.oilpaintersofamerica.com

Original Doll Artists Council of America (ODACA)

c/o Myra Sherrod
1251 Garden Circle Drive, 2C-C
St. Louis, MO 63125
(314) 894-1489
robin@odaca.org
http://www.odaca.org

Pastel Society of America (PSA)

15 Gramercy Park South
New York, NY 10003
(212) 533-6931
(212) 353-8140 (fax)
pastelny@juno.com
http://www.pastelsocietyofamerica.org

Pen and Brush (P&B)

16 E 10th Street
New York, NY 10003
(212) 475-3669
(212) 475-6018 (fax)
info@penandbrush.org
http://www.penandbrush.org

Portrait Society of America

PO Box 11272
Tallahassee, FL 32302
(850) 878-9996
(850) 222-7890 (fax)
info@portraitsociety.org
http://www.portraitsociety.org

Potters Council

735 Ceramic Pl., Ste. 100
Westerville, OH 43081
866-721-3322
(614) 794-5842 (fax)
info@ceramics.org
http://www.ceramics.org/potterscouncil

Precious Metal Clay Guild

PO Box 3000
Denville, NJ 07834
(859) 586-0595
office@pmcguild.com
http://www.pmcguild.com

Professional Photographers of America (PPA)

229 Peachtree Street NE
Atlanta, GA 30303
(404) 522-8600
(404) 614-6400 (fax)
csc@ppa.com

Public Relations Society of America (PRSA)

33 Maiden Lane
New York, NY 10038
(212) 460-1400
(212) 995-0757 (fax)
http://www.prsa.org

Recycled Art Association

PO Box 1142
Eugene, OR 97405
(541) 345-1411
clliffmar@efn.org

Sculptors Guild (SG)

110 Greene Street
New York, NY 10012
(212) 431-5669

(212) 431-5669 (fax)
sculpt3d@sculpture.net
http://www.sculptorsguild.org

Society for Calligraphy (SfC)
PO Box 64174
Los Angeles, CA 90064-0174
(323) 931-6146
describe25@aol.com
http://www.societyforcalligraphy.org

Society for Environmental Graphic Design (SEGD)
1000 Vermont Avenue
Washington, DC 2005
(202) 638-5555
sedg@sedg.org
http://www.segd.org

Society of American Mosaic Artists (SAMA)
PO Box 624
Ligonier, PA 15658
(724) 238-3087
(724) 238-3973 (fax)
info@americanmosaics.org
http://www.americanmosaics.org

Society of American Silversmiths (SAS)
PO Box 72839
Providence, RI 02907
(401) 461-6840
(401) 461-6841 (fax)
sas@silversmithing.com
http://www.silversmithing.com

Society of Animal Artists (SAA)
47 Fifth Avenue
New York, NY 10003
(212) 741-2880

(212) 741-2262 (fax)
admin@societyofanimalartists.com
http://www.societyofanimalartists.com

Society of American Archivists (SAA)
527 South Wells Street
Chicago, IL 60607
(312) 922-0140

Society of Decorative Painters (SDP)
393 N McLean Boulevard
Wichita, KS 67203
(316) 269-9300
(316) 269-9191 (fax)
sdp@decorativepainters.org
http://www.decorativepainters.org

Society of Illustrators (SI)
128 E 63rd Street
New York, NY 10021-7303
(212) 838-2560
(212) 838-2561 (fax)
info@societyillustrators.org
http://www.societyillustrators.org

Society of Photographers and Artists Representatives (SPAR)
60 E 42nd Street
New York, NY 10165
(212)779-7464
(212)675-6341 (fax)

Society of Publication Designers (SPD)
17 E 47th Street
New York, NY 10017
(212) 223-3332
(212) 223-5880 (fax)
mail@spd.org
http://www.spd.org

Stained Glass Association of America (SGAA)

10009 E 62nd Street
Raytown, MO 64133
(816) 737-2090
(816) 737-2801 (fax)
headquarters@sgaaonline.com
http://www.stainedglass.org

Studio Art Quilt Associates (SAQA)

PO Box 572
Storrs, CT 06268
(860) 487-4199
msielman@sbcglobal.net
http://www.saqa.com

United Scenic Artists

29 W 38th Street
New York, NY 10018
(212) 581-0300
(212) 977-2011 (fax)
mail@829.org
http://www.829.org

Visual Artists and Galleries Association (VAGA)

350 Fifth Avenue
New York, NY 10118
(212) 736-6666
(212) 736-6767 (fax)
info@vagarights.com

Women in the Arts (WIA)

PO Box 1427
Indianapolis, IN 46206
(317) 713-1144
wia@wiaonline.org
http://www.wiaonline.org

Wood Products Manufacturers Association (WPMA)

175 State Road East
Westminster, MA 01473
(978) 874-5445
(978) 874-9946 (fax)
woodprod@wpma.org
http://www.wpma.org

APPENDIX II
CAREER WEB SITES

The Internet is a premier resource for information, no matter what you need. Surfing the net can help you locate almost anything you want, from information to services and everything in between.

Throughout the appendices of this book, whenever possible, Web site addresses have been included to help you find information quicker. This listing contains an assortment of both general and art industry–specific career related Web sites. Use this list as a start. More sites are emerging every day. This listing is for your information. The author is not responsible for any site content. Inclusion or exclusion in this listing does not imply that any one site is endorsed or recommended over another by the author.

ABC Teaching Jobs
http://abcteachingjobs.com

Ad Age TalentWorks
http://adage.com/talentworks

American Association of Museums/Job HQ
http://museumcareers.aam-us.org/search.cfm

Americas Job Bank
http://www.jobbankinfo.org

Aquent
http://www.aquent.com

Art Career.net
http://www.artcareer.net/jobs.asp

Art Gallery Jobs
http://artgalleryjobs.com

Artjobonline
http://www.artjob.org

Art Institute of Chicago
http://www.artic.edu/aic/jobs/index.html

Artist Resource
http://www.artistresource.org/jobs.htm

Artist Search Agency
http://www.artistsearchagency.com

Art Links
http://www.artlinks-staffing.com

Art Squad
http://www.artsquad.com

Blizzard Entertainment
http://www.blizzard.com/us/jobopp

Careerbuilder.com
http://www.careerbuilder.com

Cool Jobs
http://www.cooljobs.com

Craigslist
http://www.craigslist.org

Creative Freelancers
http://www.freelancers1.com

Creative Hotlist
http://www.creativehotlist.com

Creative Options
http://www.creativeopts.com

Desktop Publishing.com
http://www.desktoppublishing.com/employ.html

Fashion Career Center
http://www.fashioncareercenter.com/jobboard

Filter Talent
http://www.filtertalent.com

Hot Jobs.com
http://www.hotjobs.com

Indeed.com
http://www.indeed.com

Interior Design Jobs
https://interiordesignjobs.sellisp.com/default.asp

Job Central
http://www.jobcentral.com/

Monster.com
http://www.monster.com

Museum Employment Resource Center
http://www.museum-employment.com

Museum Jobs.com
http://www.museumjobs.com

Museum Market
http://www.museummarket.com

Museum of Modern Art Employment
http://www.moma.org/about_moma/employment

National Art Gallery Jobs
http://www.nga.gov/resources/employ.shtm

Opportunity Knocks.com
http://www.opportunitynocs.org

The Pauper
http://www.thepauper.com

Seattle Art Museum Jobs
http://www.seattleartmuseum.org/Jobs/jobs.asp

Simply Hired
http://www.simplyhired.com/job-search

Smart Hunt
http://www.smarthunt.com/Smart-jobs.
cfm?catid=16

Walters Art Museum
http://www.thewalters.org/museum_art_baltimore/
themuseum_jobs.aspx

BIBLIOGRAPHY

A. Books

There are thousands of books on all aspects of the art industry. Sometimes just reading about someone else's success inspires you, motivates you, or helps you come up with ideas to help you attain your own dreams.

Books can be a treasure trove of information if you want to learn about a particular aspect of a career or gain more knowledge about how something in the industry works.

The books listed below are separated into general categories. Subjects often overlap. Use this listing as a beginning. Check out your local library, bookstore, or online retailer for other books that might interest you about the industry.

Artists

Basa, Lynn. *The Artist's Guide to Public Art: How to Find and Win Commissions*. New York: Allworth Press, 2008.

Henry, Colette. *Entrepreneurship in the Creative Industries: An International Perspective*. Northampton, MA: Edward Elgar Publishing, Incorporated, 2008.

Larkin, Susan G. *Artists In Their Studios: Where Art Is Born*. Victoria, British Columbia: Heritage House, 2007.

Marks, Lander. *Artist's Proof*. Las Vegas: Stephens Press, 2008.

Read, Peter. *Picasso and Apollinaire: The Persistence of Memory*. Berkeley, CA: University of California Press, 2008.

Simon, Mark. *Thriving Artist*. Orlando, FL: Animatics & Storyboards, 2006.

Smith, Anna Deavere. *Letters to a Young Artist: Straight-Up Advice on Making a Life in the Arts-For Actors, Performers, Writers, and Artists of Every Kind*. Ashland, OR: Blackstone Audio, 2006.

Art Business

Braathen, Martin. *The Price of Everything: Perspectives on the Art Market*. New Haven, CT: Yale University Press, 2008.

Crawford, Ted. *Business and Legal Forms for Fine Artists*. New York: Allworth Press, 2005.

Davey, Barney. *How to Profit from the Art Print Market*. Scottsdale, AZ: Bold Star Communications, 2005.

Davis, Ron. *Art Dealer's Field Guide: How to Profit in Art, Buying and Selling Valuable Paintings*. Jacksonville, FL: Capital Letters Press, 2005.

Grant, Daniel. *Selling Art without Galleries: Toward Making a Living from Your Art*. New York: Allworth Press, 2006.

Art Consulting

Abbott, Susan. *Corporate Art Consulting.* New York: Allworth Press, 1999.

Art Marketing

Art Calendar Editors. *Getting Exposure: The Artist's Guide to Exhibiting the Work.* Guilford, CT: Lyons Press, 2002.

Dougherty, Barbara L. *101 Frequently Asked Art Marketing Questions . . . And Their Answers.* Upper Fairmount, MD: Art Calendar, 1999.

Oconnell, Erika. *Artist's and Graphic Designer's Market.* Cincinnati: F & W Publications, Incorporated, 2006.

Smith, Constance. *Art Marketing 101: A Handbook for the Fine Artist.* Nevada City, CA: ArtNetwork, 2007.

Talbot, Jonathan. *The Artist's Marketing and Action Plan Workbook.* Warwick, NY: Jonathan Talbot, 2005.

Art Publicity

Abbott, Susan. *Fine Art Publicity: The Complete Guide for Galleries and Artists.* New York: Allworth Press, 2005.

Art Teaching

Campana, D M. *The Teacher of Pastel Painting: Art Text Book.* Whitefish, MT: Kessinger Publishing, LLC, 2007.

Evans, Joy. *How to Teach Art to Children, Grades 1–6.* Montery, CA: Evan-Moor Educational, 2001.

Hume, Helen. *A Survival Kit For The Elementary/Middle School Art Teacher.* Hoboken, NJ: John Wiley, 2004.

———. *The Art Teacher's Book of Lists.* Hoboken, NJ: Jossey-Bass, 2003.

Keane, Dave. *The Art Teachers Vanishing Masterpiece.* New York: HarperCollins, 2007.

Koster, Joan Bouza. *Growing Artists: Teaching the Arts to Young Children.* Albany, NY: Cengage Delmar Learning, 2008.

Biographies/Autobiographies

Brown, Virginia. *Mildred Miller Remembered: An Intimate Portrait of an American Artist.* Philadelphia: Xlibris Corporation, 2006.

Houser, Connie. *The Letters: Portrait of an Artist, Jim Houser.* Philadelphia: Xlibris, 2007.

Lawson-Johnston, Peter. *Growing Up Guggenheim.* Willmington, DE: ISI Books, 2006.

May, Gita. *Elisabeth Vigee le Brun: The Odyssey of an Artist in an Age of Revolution.* Cumberland, RI: Yale University Press, 2005.

Wilson, Derek. *Hans Holbein: Portrait of an Unknown Man.* New York: Random House, 2006.

Potok, Andrew. *Ordinary Daylight: Portrait of an Artist Going Blind.* New York: Bantam Books, 2003.

Crafts Business

Christian, Kandi L. *Turning Your Passion into Profits: How to Make Money Selling Your Sewing and Crafts.* Irvine, CA: Classic Press, 2007.

Crawford, Tad. *Business and Legal Forms for Crafts.* New York: Allworth Press, 2005.

Entrepreneur Press. *Start Your Own Arts and Crafts Business.* Irvine, CA: Entrepreneur Press, 2007.

Ilasco, Meg Mateo. *Craft Inc: Turn Your Creative Hobby into a Business.* San Francisco: Chronicle Books, 2007.

Kadubec, Philip. *Crafts and Craft Shows: How to Make Money.* New York: Allworth Press, 2007.

Oberrecht, Kenn. *How to Start a Home-Based Craft Business.* Guilford, CT: Globe Pequot Press, 2007.

———. *How to Start a Home-Based Photography Business*. Guilford, CT: Globe Pequot Press, 2005.

Petrow, A B. *Marketing Your Woodcraft*. Sebastopol, CA: Craftmasters Books & Videos, 2005.

Reed, Becky. *How to Start and Maintain a Profitable Sewing Business*. North Charleston, SC: BookSurge, 2006.

Robbins, Rogene. *Creating a Successful Craft Business*. New York: Allworth Press, 2003.

Jewelry Making

Babineau, Carol A. *Metal Clay Beyond the Basics*. Waukesha, WI : Kalmbach, 2008.

Fox, Danielle. *Simply Modern Jewelry: Designs from the Editor of Stringing Magazine*. Loveland, CO: Interweave Press, 2008

Peterson, Linda. *How to Make Polymer Clay Beads*. London, UK: CICO Books, 2008.

Wuller, Cynthia, B. *Inspired Wire: Learn to Twist, Jig, Bend, Hammer, and Wrap for the Prettiest Jewelry Ever*. Waukesha, WI: Kalmbach, 2008.

Licensing Art

Woodward, Michael. *Licensing Art 101*. Nevada City, CA: ArtNetwork, 2007.

Museum Business

Ambrose, Timothy. *Forward Planning: A Handbook of Business, Corporate and Development Planning for Museums and Galleries*. New York: Routledge, 1996.

Ambrose, Tim. *Museum Basics*. Philadelphia: Taylor & Francis Group, 2006.

Merritt, Elizabeth E. *Covering Your Assets: Facilities and Risk Management in Museums*. Washington, DC: American Association of Museums, 2005.

Paine, Crispin. *Museum Basics*. New York: Routledge, 2006.

Sachatello-Sawyer, Bonnie. *Adult Museum Programs: Designing Meaningful Experiences*. Blue Ridge Summit, PA: AltaMira Press, 2002.

Sandell, Richard. *Museum Management and Marketing*. New York: Routledge, 2007.

Weaver, Stephanie. *Creating Great Visitor Experiences: A Guidebook for Museums and Other Cultural Institutions*. Walnut Creek, CA: Left Coast Press, 2007.

Woollard, Vicky. *The Responsive Museum: Working with Audiences in the Twenty-First Century*. Aldershot, UK: Ashgate, 2007.

Museum Exhibits

Dernie, David. *Exhibition Design*. New York: W. W. Norton & Company, 2006.

Newhouse, Victoria. *Art and the Power of Placement*. New York: Monacelli Press, 2005.

Parman, Alice. *Exhibit Makeovers: A Do-It-Yourself Workbook for Small Museums*. Blue Ridge Summit, PA: AltaMira Press, 2008.

Pearlstein, Ellen J. Conserving Collections: Environmental Principles and Methods. London, UK: Earthscan/James & James, 2007.

Weisberg, Shelley Kruger. *Museum Movement Techniques: How to Craft a Moving Museum Experience*. Blue Ridge Summit, PA: AltaMira Press, 2006.

Museum Marketing

Kotler, Neil, Kotler, Phillip, & Kotler, Wendy. *Museum Marketing and Strategy: Designing Missions, Building Audiences, Generating Revenue and Resources*. Hoboken, NJ: John Wiley, 2008.

Museums

Danziger, Danny. *Museum: Behind the Scenes at the Metropolitan Museum of Art*. New York: Penguin Group, 2007.

Galitz, Kathryn Calley. *Masterpieces of European Painting, 1800–1920, in the Metropolitan Muse-*

um of Art. Cumberland, RI: Yale University Press, 2007.

Dean, David. *Museum Exhibition.* New York: Routledge, 1996.

Dean, David, and Gary, Edson. *Handbook for Museums.* New York: Routledge, 1997.

Hooper-Greenhill, Eilean. *The Educational Role of the Museum.* New York: Routledge, 1999.

Pollock, Griselda & Zemans, Joyce. *Museums after Modernism: Strategies of Engagement.* Oxford, UK: Wiley-Blackwell, 2007.

Swain, Hedley. *An Introduction to Museum Archaeology.* New York: Cambridge University Press, 2007.

Whitehead, Christopher. *The Public Art Museum in Nineteenth Century Britain: The Development of the National Gallery.* Aldershot, UK: Ashgate, 2005.

Photographers/Photography

Adams, Ansel. *Ansel Adams: 400 Photographs.* New York: Little Brown, 2007.

Ewing, William A. *Edward Steichen: Lives in Photography.* New York: W. W. Norton & Company, 2008.

Simon, Joan. *William Wegman: Funney/Strange.* New Haven, CT: Yale University Press, 2006.

Tippett, Maria. *Portrait in Light and Shadow: The Life of Yousuf Karsh.* New Haven, CT: Yale University Press, 2008.

Wegman, William. *William Wegman Polaroids.* New York: Harry N. Abrams, 2005.

Wegman, William. *How Do You Get to MOMA QNS?* New York: Museum of Modern Art, 2002.

Sculptors

Black, Jonathan. *Dora Gordine: Sculptor, Artist, Designer.* London, UK: Philip Wilson Publishers, 2008.

Plowman, John. *The Sculptor's Bible: The All-Media Reference to Surface Effects and How to Achieve Them.* Iola, WI: Krause Publications, 2005.

Vasari, Giorgio. *Lives of the Most Eminent Painters, Sculptors and Architects.* Whitefish, MT: Kessinger Publishing, 2007.

Selling Art

Dvorak, Robert Regis. *Selling Art: 101.* Nevada City, CA: ArtNetwork, 2007.

Web Design

Evans, Charlotte. *How to Open and Operate a Financially Successful Web Site Design Business.* Ocala, FL: Atlantic Publishing Company, 2008.

Sklar, Joel. *Principles of Web Design.* Boston: Course Technology, 2008.

B. Periodicals

Magazines, newspapers, membership bulletins, and newsletters may be helpful for finding information about a specific job category, finding a job in a specific field, or giving you insight into what certain jobs entail.

This list should serve as a beginning. Many periodicals could not be listed because of space limitations. The subject matter of some periodicals may overlap with others. Look in your local library, in a newspaper/magazine shop, and online for other periodicals that might interest you.

Names, addresses, phone numbers, Web sites, and e-mail addresses have been included when available.

ADVERTISING

Ad Media
Ad Media Enterprises, Inc.
224 Joseph Square
Columbia, MD 21044

AAF Communicator
American Advertising Federation
1101 Vermont Avenue, N W
Washington, DC 20035
http://www.aaf.org

Advertising Age
Crain Communications, Inc.
711 Third Avenue
New York, NY 10017
(212) 210-0281
(212) 210-0200 (fax)
info@crain.com
http://www.crain.com

Advertising and Marketing Review
Advertising & Marketing Review
622 Gardenia Court
Golden, CO 80401
(303) 277-9840
(303) 278-9909 (fax)
http://www.ad-mkt-review.com

ANIMATION

Animation Magazine
30941 W. Agoura Road
Westlake Village, CA 91361
(818) 991-2884
(818) 991-3773 (fax)
info@animationmagazine.net
http://www.animationmagazine.net

ART

Art Revue
Innovative Artists Agency
302 W 13th Street
Loveland, CO 80537
artrevue@aol.com

ART AND CRAFT SHOWS

Crafts Fair Guide
PO Box 688
Corte Madera, CA 94976
(415) 924-3259
leecfg@pacbell.net

ART DIRECTORS

Art Directors Annual
Art Directors Club Inc.
106 W 29th Street
New York, NY 10001
(212) 643-1440
(212) 643-4293 (fax)

ARTISTS

American Artist
770 Broadway
New York, NY 10003
(646) 708-7300
(646) 708-7399 (fax)
bmcomm@vnuinc.com
http://www.myamericanartist.com

Art Calendar
PO Box 2675
Salisbury, MD 21802
(410) 749-9625
(410) 749-9625 (fax)
http://www.artcalendar.com

Art Times
C S S Publications, Inc.
16 Fite Road
Saugerties, NY 12477
(845) 246-6944
info@arttimesjournal.com
http://www.arttimesjournal.com

Art Week
PO Box 52100
Palo Alto, CA 94303
(262) 495-8703
editorial@artweek.com
http://www.artweek.com

ART THERAPY

AATA Newsletter
American Art Therapy Association
5999 Stevenson Avenue
Alexandria, VA 22304
(847) 949-6064
(847) 566-4580 (fax)
info@arttherapy.org
http://www.arttherapy.org

American Journal of Art Therapy
Vermont College of Norwich University
36 College Street
Montpelier, VT 05062
(802) 828-8540
(802) 828-8585 (fax)

CERAMICS

American Ceramics
9 East 45th Street
New York, NY 10017
(212) 944-2180

Ceramics Monthly
American Ceramics Society, Inc.
735 Ceramic Place
Westerville, OH 43086
(614) 895-4213
(614) 891-8960 (fax)
http://www.ceramicsmonthly.org

COMIC ART

International Journal of Comic Art
669 Ferne Boulevard
Drexel Hill, PA 19026
(610) 622-3938
(610) 622-2124 (fax)
jlent@temple.edu
http://www.ijoca.com

CRAFTS

Art Doll Quarterly
Stampington & Company LLC
22992 Mill Creek
Laguna Hills, CA 92653
(949) 380-7318
(949) 380-9355 (fax)

American Crafts
72 Spring Street
New York, NY 10012
(212) 274-0630
(212) 274-0650
amcraft@craftcouncil.org
http://www.americancraftmag.org

Art & Crafts
Krause Publications, Inc.
700 E State Street
Iola, WI 54990
(715) 445-2214
(715) 445-4087 (fax)
info@krause.com
http://www.krause.com/static/crafts.htm

Basket Bits
PO Box 8
Loudonville, OH 44842
(419) 994-3256

Bead Dreams
Kalmbach Publishing Company
21027 Crossroads Circle
PO Box 1612
Waukesha, WI 53187
(262) 796-8776
(262) 796-1615 (fax)
http://www.kalmbach.com

Bead Style
Kalmbach Publishing Company
21027 Crossroads Circle
PO Box 1612
Waukesha, WI 53187
(262) 796-8776
(262) 796-1615 (fax)
customerservice@kalmbach.com
http://www.beadstylemag.com

Beads
Interweave Press, LLC
201 E Fourth Street
Loveland, CO 80537
(970) 669-6117
(970) 667-8317 (fax)
customerservice@interweave.com
http://www.interweave.com

Carving Magazine
All American Crafts, Inc.
7 Waterloo Road
Stanhope, NJ 07874
editors@carvingmagazine.com
http://www.carvingmagazine.com

Clay Times Journal
15481 Second Street
PO Box 365
Waterford, VA 20197
(540) 882-3576
(540) 882-4196 (fax)
claytimes@aol.com
http://www.claytimes.com

Contemporary Folk Art
Long Publications, Inc.
8393 E Holly Road
Holly, MI 48442
(248) 634-9675
(248) 634-0301 (fax)
longpub@tri.com
http://www.countryfolkart.com

Craft
O'Reilly Media, Inc.
1005 Gravenstein Highway North
Sebastopol, CA 95472
(707) 827-7000
(707) 829-9043 (fax)
http://craftzine.com/magazine

Craft International
Craft International Publications, Inc.
C/O New York University
239 Greene Street
New York, NY 10003

Crafts News
8601 Georgia Avenue
Silver Spring, MD 20910
(301) 587-4700
(301) 587-7315 (fax)
craftscenter@chfng.org
http://www.craftscenter.org

The Crafts Report
Crafts Report Publishing Company, Inc.
100 Rogers Road
PO Box 1992
Wilmington, DE 19801
(302) 656-2209
theeditor@craftsreport.com
http://www.craftsreport.com

Doll Artisan
Jones Publishing, Inc.
N 7450 Aanstad Road
PO Box 5000
Iola, WI 54945
(715) 445-5000
(715) 445-4053 (fax)
jonespub@jonespublishing.com
http://www.jonespublishing.com

Fired Arts and Crafts
Jones Publishing, Inc.
N 7450 Aanstad Road
PO Box 5000
Iola, WI 54945
(715) 445-5000
(715) 445-4053 (fax)
jonespub@jonespublishing.com
http://www.jonespublishing.com

Glass Workshop
Stained Glass Club
4481 Edinbridge Circle
Sarasota, FL 34235

FASHION AND ACCESSORY DESIGN

National Association of Fashion and Accessory Designers. Newsletter
2180 E 93rd Street
Cleveland, OH 44106
(216) 231-0375

GRAPHIC ARTISTS

Artist's and Graphic Designer's Market
F + W Publications, Inc.
4700 E Galbraith Road
Cincinnati, OH 45236
(513) 531-2690
(513) 531-2902 (fax)
wds@fwpubs.com

Graphis Advertising Journal
Graphis Inc
307 Fifth Avenue
New York, NY 10016
(212) 532-9387
(212) 213-3229 (fax)
info@graphis.com
http://www.graphis.com/journals

Graphis Design Journal
Graphis Inc
307 Fifth Avenue
New York, NY 10016
(212) 532-9387
(212) 213-3229 (fax)
info@graphis.com
http://www.graphis.com/journals

Guild News
Graphic Arts Guild
90 John Street
New York, NY 10038
(212) 791-3400
(212) 791-0333 (fax)
http://www.gag.org

ILLUSTRATORS

American Illustration Showcase
200 Park Avenue South
New York, NY 10003
(212) 941-2496
(212) 941-5490 (fax)
info@amshow.com
http://www.showcase.com

AMI News
Association of Medical Illustrators
PO Box 1897
Lawrence, KS 66044
(785) 843-1235

(785) 843-1274 (fax)

hq@ami.org

http://www.medical-illustrators.org

INTERIOR DESIGN

Accent

Trends Marketing Group Inc.

37 Water Street

Exeter, MH 03833

(603) 772-5770

http://www.accentmagazine.com

Interior Design

Reed Business Information

360 Park Avenue South

New York, NY 10010

(646) 746-7215

(646) 746-7428 (fax)

http://www.interiordesign.net

MARKETING

Journal of Marketing

American Marketing Association

Robert H. Smith School of Business

3451 Van Munching Hall, University of Maryland

1708 21st Avenue South

College Park, MD 20742

(301)405-4300

(301)405-0146 (fax)

http://www.marketingpower.com

Marketing News

American Marketing Association

311 S Wacker Drive

Chicago, IL 60606

(312)542-9000

(312)542-9001 (fax)

news@ama.org.

http://www.marketingpower.com

MUSEUMS

Art and Museum Law Journal

Thomas M. Cooley Law School

300 S. Capitol Avenue

Lansing, MI 48901

(517) 371-5140 ext 4501

Aviso

1575 Eye Street NW

Washington, DC 20005

(202)289-1818

(202)289-6578 (fax)

aam-icom@aam-us.org

http://www.aam-us.org

Professional Practices in Art Museums

120 E 56th Street

New York, NY 10022

(212) 754-8084

(212) 754-8087 (fax)

http://www.aamd.org

Volunteer Committees of Art Museums of Canada and the United States—News

Volunteer Committees of Art Museums of Canada

and the United States

c/o Council of the Virginia Museum of the Fine

Arts

2800 Grove Avenue

Richmond, VA 23221

(804) 367-0844

PUBLIC RELATIONS

Public Relations Tactics

The Public Relations Society of America, Inc.

33 Maiden Lane

New York, NY 10038

(212) 460-1400

(212) 995-0757 (fax)

john.elsasser@prsa.org
http://www.prsa.org

Public Relations Strategies

The Public Relations Society of America, Inc.
33 Maiden Lane
New York, NY 10038
(212) 460-1400
(212) 995-0757 (fax)
john.elsasser@prsa.org
http://www.prsa.org

Public Relations Journal

The Public Relations Society of America, Inc.
33 Maiden Lane
New York, NY 10038
(212) 460-1400
(212) 995-0757 (fax)
john.elsasser@prsa.org
http://www.prsa.org

Index

T